A Terrible Beauty

Heather Robertson

A Terrible Beauty
The Art of Canada at War

James Lorimer & Company, Publishers
in association with
The Robert McLaughlin Gallery, Oshawa
and
National Museum of Man
National Museums of Canada, Ottawa
1977

ISBN 0-88862-144-2

Canadian Cataloguing in Publication Data
Main entry under title:
A Terrible beauty
The paintings reproduced are from the war art collection held by the Canadian War Museum.
ISBN 0-88862-144-2
1. Painting, Canadian. 2. Painting, Modern — 20th century — Canada. 3. War in art. 4. European War, 1914-1918 — Personal narratives, Canadian. 5. World War, 1939-1945 — Personal narratives, Canadian. I. Robertson, Heather, 1942— II. Canadian War Museum.

ND245.T47 759.11 C77-001392-9

James Lorimer and Company, Publishers
35 Britain Street
Toronto
M5A 1R7

Credits

ILLUSTRATIONS

The government of Canada holds the copyright for most of the works of art in this book, and has given permission for their reproduction. Also reproduced by permission are the following.

Unloading L.S.T. 2 Mike Beach, Juno Sector, Normandy, June 1944 by A. G. Broomfield. © A. G. Broomfield/*Forging 4-inch Shells* by G. A. Reid. © Ontario College of Art/*Canadian Soldier* by F. H. Varley © the Varley estate.

Every reasonable effort was made to locate the copyright owners for permission to reproduce the following works. The owners, if they wish, should contact James Lorimer & Company, 35 Britain Street, Toronto M5A 1R7.

Arc Welders by Night by Caven Atkins/*Women Making Shells* by Henrietta Mabel May/*Christmas Eve in Giessen Camp* by Arthur Nantel/*Moonrise over Mametz Wood* by William Thurston Topham

TEXT
ARCHIVES
Many of the excerpts in the text come from tapes and unpublished papers held in the collections of Canadian archives.

Public Archives of Canada, Ottawa
George Bell manuscript/John Creelman diary/Tom Forsyth diary/I. J. Gillen memoirs/Stuart Kettles memoirs/Anthony Law manuscript/John McNab diary/Talbot Papineau letters/E. J. Spillett memoirs/Albert West papers/Don Wilson letters

CBC Archives, Toronto
Leonard Brockington/H. R. H. Clyne/Matthew Halton/Robert Joiner/Elmer McKnight/Bud Street/Bing Whittaker

Other Archives
Miller Gore Brittain letters, Canadian War Museum, Ottawa/Canadian soldier, History Division, Department of National Defence, Ottawa/Gordon Howard manuscript, John Robarts Research Library, Toronto

LEGION MAGAZINE
The following writers gave permission to reprint from their contributions to *Legion Magazine*.

George G. Blackburn/Cliff Bowering/Jean Margaret Crowe/Joyce Nelson

Reasonable efforts were made to locate the following *Legion Magazine* contributors or their representatives. They should, if they wish, contact James Lorimer & Company, 35 Britain Street, Toronto, M5A 1R7.

Donald McDonald/Victor Maistrau/Gitz Rice/Gerald Wright

BOOKS
Excerpts from the following books are reprinted with the permission of their publishers or other owners of copyright.

Will Bird, *And We Go On*, Hunter Rose, Toronto, 1930/Earle Birney, *The Collected Poems of Earle Birney*, McClelland and Stewart, Toronto, 1975/W. A. Bishop, *Winged Warfare*, Doubleday & Company, 1967/William Boyd, *With a Field Ambulance in Ypres*, Musson, Toronto, 1916, (Hodder & Stoughton, Canada)/Charles Comfort, *Artist at War*, Ryerson, Toronto, 1956, (McGraw-Hill Ryerson, Toronto)/Edward Corrigan, *Tales of a Forgotten Theatre*, D Day, Winnipeg, 1969/Frederic Curry, *From the St. Lawrence to the Yser*, McClelland and Stewart, Toronto, 1916/Thomas Dinesen, *Merry Hell!* Jarrolds, London, 1930, (Hutchinson, London)/Alan Easton, *50° North: An Atlantic Battleground*, Ryerson, Toronto, 1963, (McGraw-Hill Ryerson, Toronto)/Jean Ellis, *Face Powder and Gun Powder*, S. J. R. Saunders, Toronto, 1947/Leslie Frost, *Fighting Men*, Clarke Irwin, Toronto, 1967/Jacques Gouin, *Lettres de guerre d'un Québécois*, Editions du Jour, Montreal, 1975/Sandham Graves, *The Lost Diary*, C. F. Banfield, King's Printer, Victoria, B.C., 1941/Charles Harrison, *Generals Die in Bed*, 1929, (Potlatch Publications, Hamilton, 1975)/Wilfred Kerr, *Shrieks and Crashes: being memories of Canada's corps, 1917*, Hunter Rose, Toronto, 1929/J. G. Magee from MacIntosh et al., *High Flight*, Copp Clark, Toronto, 1951/Herbert McBride, *The Emma Gees*, Bobbs Merrill, Indianapolis, 1918/Alexander McClintock, *Best O'Luck*, McClelland and Stewart, Toronto, 1917/Nellie McClung, *Next of Kin*, Thomas Allen, Toronto, 1917/John McCrae, *In Flanders Fields and Other Poems*, Sir Andrew Macphail (ed.), W. Briggs, Toronto, 1919, (McGraw-Hill Ryerson, Toronto)/Jerrold Morris, *Canadian Artists and Airmen*, Morris Gallery, Toronto, 1975/Armine Norris, *Mainly for Mother*, Ryerson, Toronto, 1920, (McGraw-Hill Ryerson)/Donald Pearce, *Journal of a War*, Macmillan, 1965/James Rawlinson, *Through St. Dunstan's to Light*, Thomas Allen, Toronto, 1919/Kathleen Robson Roe, *War Letters from the C.W.A.C.*, Kakabeka Publishing, Toronto, 1975/F. G. Scott, *The Great War as I Saw It*, Clarke and Stewart, Vancouver, 1934/Robert Service, *Rhymes of a Red Cross Man*, W. Briggs, Toronto, 1916, (McGraw-Hill Ryerson, Toronto)/Lionel Shapiro, *They Left the Back Door Open*, Ryerson, Toronto, 1944, (McGraw-Hill Ryerson, Toronto)/Raymond Souster, *So Far So Good*, Oberon, Ottawa, 1969 and *Extra Innings*, Oberon, Ottawa, 1977/George Whalley, *No Man an Island*, Clarke Irwin, Toronto, 1948/*Some Letters and Other Writings of Donald Albert Duncan*, Imperial Publishing, Halifax, 1954

Reasonable efforts were made to trace the owners of copyright for the following books. They, if they wish, should contact James Lorimer & Company, 35 Britain Street, Toronto, M5A 1R7.

Coningsby Dawson, *The Glory of the Trenches*, Gundy, Toronto, 1918, (Oxford University Press)/Lucien Dumais, *The Man Who Went Back*, Leo Cooper, London, 1975/George Herbert Rae Gibson, *Maple Leaves in Flanders Fields*, W. Briggs, Toronto, 1916, (McGraw-Hill Ryerson, Toronto)/Charles Johnson, *Action with the Seaforths*, Vantage Press, New York, 1954/Louis Keene, *Crumps, The Plain Story of a Canadian who Went*, Houghton Mifflin, Boston, 1917/R.A.L., *Letters of A Canadian Stretcher Bearer*, Little Brown, Boston, 1918/A. J. Lapointe, *Souvenirs d'un soldat du Québec: 22e Batallion, 1917-18*, Editions du Castor, Montreal, 1944/Douglas Le Pan, *The Net and the Sword*, Chatto and Windus, London, 1953/Edgar McInnis, *Poems Written at the Front*, Irwin Co., Charlottetown, 1918/James Pedley, *Only This: A War Retrospect*, Graphic Press, Ottawa, 1927/J. G. Poulin, *696 Heures d'enfer avec le Royal 22e Régiment*, Editions A-B, Quebec, 1946/Arthur Wilkinson, *Ottawa to Caen*, Tower Books, Ottawa, 1947/*Unknown Soldiers, by one of them*, Vantage Press, New York, 1959

Lili Marlene used by permission of Gordon V. Thompson Limited, Toronto, Canada, on behalf of Peter Maurice Music Co. Ltd., London, England.

Acknowledgements

On behalf of the board of trustees of the Robert McLaughlin Gallery I would like to thank Heather Robertson who initiated the idea of an exhibition of Canadian war art. For the funding of the exhibition, I would like to thank the National Museums of Canada. Their generous participation has made possible the nation-wide tour to our sister galleries across the country as well as assisting with the colour reproductions in the catalogue text.

For their efforts to help make this book/catalogue an appropriate documentation of the exhibition, I thank the National Museums of Canada, the Samuel and Saidye Bronfman Family Foundation and the government of Ontario through Wintario.

I gratefully acknowledge the assistance and co-operation of Dr. William E. Taylor, Director of the National Museum of Man, and Lee Murray, Chief Curator of the Canadian War Museum, for making available these paintings for exhibition and publication.

Joan Murray, Director,
Robert McLaughlin Gallery

The paintings, drawings and sculpture presented in this selection of Canadian war art were chosen from the collections at the Canadian War Museum and The National Gallery of Canada.

I would like to thank Joan Murray, Director of The Robert McLaughlin Gallery in Oshawa, for organizing the exhibition and for her advice in choosing the paintings. Jennifer C. Watson, Assistant Curator/Registrar of the same gallery, catalogued almost all the more than one hundred works in the show; the remaining few were left to Claire Smith, Conservator at the Canadian War Museum, who was responsible for any conservation treatment required prior to exhibition. I also appreciate the assistance of War Museum Curators Hugh Halliday and Vic Suthren, and Assistant Curator Fred Azar.

In selecting the text, I acknowledge the assistance of the Public Archives of Canada, the program archives of the Canadian Broadcasting Corporation and the Royal Canadian Legion's *Legion Magazine.* The memoirs and letters originally in French were found by David Lobdell; background information and comments from war artists were provided by CBC radio's *Nightcap* program.

Heather Robertson

Contents

Introduction

THE KILLING GROUND:
CANADA'S EXPERIENCE OF WAR

Question for any Soldier

How many dead will you have to see in the war
before you'll know it's Death that you're fighting for?

Raymond Souster

War is a mystery. It is full of ironies, contradictions, secrets. Its consequences are often more profound and unpredictable than the military exercise intended. War has had a traumatic, cataclysmic, revolutionary effect on Canada; its impact remains unstated, unexplored, unconscious, more powerful for its lack of recognition. Canadians are an unmilitary people, yet we can be a violent and bloody people. War and rebellion are a central fact of Canadian experience. No generation has escaped.

We have been lavish with our lives. Sixty thousand Canadians were killed in the First World War, forty thousand in the Second War; nearly a quarter of a million more were wounded. More than half a million Canadians served in the armed forces between 1914 and 1918; a million and a half enlisted between 1939 and 1945. It was a civilian army. Farmers, teachers, clerks, salesmen, truck drivers laid their work aside and signed up. Millions more, both men and women, worked in war industries.

For some of us, war gave Canada a national identity. It gave us a sense of solidarity, shared goals and common effort; it defined us in the eyes of the world. War, according to historian Donald Creighton, also divorced Canada from the British Empire and wedded us to the American Empire. It gave Canada the bureaucratic state and the welfare economy; it transformed our economy and our culture. It gave us the experience of totalitarian government, specifically the War Measures Act which was used to intimidate, imprison and deport Canadians in both wars and used again, in Quebec, in 1970. War created profound contradictions in Canadian society which have never been resolved. It gave

us a cult of violence and a passion for peace; it legitimized the expression of racism, cruelty and fanaticism, and created a reaction in favor of tolerance, pacifism and reason. It gave Canada an officer class, an elite of men comfortable with military society; it also gave us the comradeship of the trenches, a democratic, egalitarian brotherhood with considerable disrespect for authority. War created a chasm between Quebec and the rest of Canada, a wound which has never healed.

The First World War, 1914–1918

The Great War was Canada's first experience with a war that would be fought as bitterly at home as at the front. Within four years Canadian society was transformed. The nation we live in today was created at midnight, August 4, 1914 when Canada, as a member of the British Empire, declared war on Germany. "Ready, aye ready!" cried the politicians. The only dissenting public voice belonged to French-Canadian journalist Henri Bourassa, who wrote in September, 1914: "Canada has no pressing reason to intervene in this conflict. She has very serious reasons for staying out of it; the future will show, harshly perhaps, whether her military intervention, of little help to the warring nations, will have disastrous consequences for herself."

Overnight a 33,000-man expeditionary force was raised, in a stunning feat of magicianship, by the Minister of Militia, Sam Hughes. "There is only one feeling as to Sam, that he is crazy," a cabinet colleague confided to his diary. An amateur soldier and rabid Orangeman whose behaviour alternated between tears and obscenities, Hughes marshalled his troops at Valcartier, a tent city he had thrown up near Quebec City. This rag-tag, bobtail army, this "undisciplined mob," as one of their officers called them, sailed from Quebec in October, 1914, on thirty-three ships. "We are Sam Hughes' army," sang the soldiers gleefully, "We are his infantry. We cannot shoot, we cannot fight, no bloody good are we!" Raised on the romance of Walter Scott and Tennyson and the imperialism of Kipling, the young troops were filled with martial enthusiasm;

they soon discovered, when they arrived in Belgium in the spring of 1915, that they were, in fact, cannon fodder.

The Canadians' first major battle was, by accident, one of the most significant battles of history, the Second Battle of Ypres, April 22, 1915, when poison gas was used for the first time in war. The French colonial troops in the front line broke and fled before the rolling cloud of chlorine; the Canadians pissed on their handkerchiefs, tied them over their mouths, and held. Casualties were heavy, but the German advance stopped. Canada had a reputation.

"We mustn't boast too much," says Ypres veteran V.W. Odlum. "It wasn't heroism that made us stay there and fight through that battle. We just didn't know how to get out. The only thing to do as far as we could see was to stay where we were. So we did." Ypres was the beginning of a nightmare which would haunt Canadian troops for three-and-a-half years. During the entire war Canadians fought back and forth over an area, as Ralph Allen describes it in *Ordeal by Fire*, "hardly bigger than three or four Saskatchewan townships." This was the killing ground of Flanders, a small patch of mud where millions of men slaughtered each other to gain a few yards of quagmire. Vimy Ridge, where Canadians won their greatest victory in April, 1917, is twenty miles south of Ypres; Passchendaele, where they drowned in mud and blood in the fall of 1917, is five miles north-east of Ypres; Mons, where they celebrated the armistice in 1918, is forty miles east of Ypres.

On this battleground men burrowed into the earth like animals, cowered in caves like wild beasts. "We were pre-historic men," says Canadian writer Greg Clark. "We were troglodytes!" For almost four years Canadian soldiers endured extreme physical degradation and psychological terror; the desperation of the trenches created a new kind of war. Says Ralph Allen:

> Its shape and nature were dictated by one thing; the private soldier's stubborn — in the circumstances it sometimes seemed his unreasonable and inexplicable — desire to live. The time for genius and mighty utterance was done. The ordinary human being was now in charge of human fate. . . . In the animal life they had to learn to live, there was an animal brutality; there was an animal stupidity; there was an animal acceptance of the need to carry out orders, however absurd and fatal they might seem. But there was too a continuing testament to the spell and magic of the human will. Often, in defiance of all reason, the muddy beaten soldier in the front line trenches, half drunk with noise and fear and mud and cold and insects and the approach of a tomorrow that could only be more uncomfortable and menacing than today, rose to acts of exaltation, courage and endurance that had never been surpassed in any place or time.

The first two years of war were a debacle. Troops were order to attack impregnable positions against impossible odds and to hold on until they were killed to the last man. Retreat was unthinkable; the strategy was suicide. The Canadian government had no say in the conduct of the war. "The Canadian government has had just what information could be gleaned from the daily press, and no more," said Prime Minister Sir Robert Borden in January, 1916.

The moment of truth for Canada came during the Battle of the Somme during the summer and fall of 1916. It cost 25,000 Canadian casualties out of a British total of over six hundred thousand, more than twice the German total. No ground was gained. "We went into the Somme in the same spirit of dedication as the earliest battles," says veteran G.L. Stevens, "and we came out with a bad taste in our mouths." Disillusionment spread swiftly to Canada. It came on the hospital ships, railings lined with men on crutches; it came on the silent trains with drawn blinds that rattled across the country disgorging at every whistlestop the pitiful, disfigured, trembling remains of sons and lovers. The war came home. The wounded spoke, and Canada listened. In March, 1916, enlistment figures had reached a record 34,913; in July they dropped to 8,389 and by December they dwindled to a meagre 5,279. The mood of the country is summed up by A.Y. Jackson in a letter he wrote before he enlisted. "The hero's job is a pretty thankless one.

There are lots of institutions and big fatheads in this country not worth laying down one's life to preserve."

It was obvious by 1917 that some big fatheads were doing very well out of the war: Sam Hughes' friends in meat packing and other war industries were making fortunes and being knighted, like Hughes himself, for their war effort. The Conservative government was shaken by scandal: shoddy boots, inferior rifles, kickbacks on munitions contracts, excessive profits. Revulsion against corruption and carnage rolled into a groundswell of passive resistance against the war: when eligible men were canvassed by mail for military service, twenty percent neglected to return their registration cards to Ottawa. The feeling was perfectly expressed by Bourassa: "Canada has had enough!"

The crisis came with the capture of Vimy Ridge on April 9, 1917. It was a triumph for Canadian troops, but Vimy had cost more than ten thousand casualties in six days; enlistments for April were half that number. Canada was faced with a painful alternative: to lose face by cutting back on her military commitment, or to raise more men. More troops meant conscription, a policy to which Quebec was fiercely and implacably opposed.

Liberal leader Sir Wilfrid Laurier refused to join a Union government to impose conscription; he was deserted by prominent English-speaking Liberals. In the election of 1917 the Liberals were crushed. Canada had conscription. Riots broke out in Quebec; Bourassa was a hero. A frenzy of racist jingoism swept across English-speaking Canada. In Ottawa, Mackenzie King confided his ardent pacifism to the privacy of his diary and retreated to Kingsmere; pacifist J.S. Woodsworth was fired from his civil service job in Manitoba.

"If war is one of those shared experiences which transform a people into a nation," says historian Desmond Morton about the conscription crisis of 1917, "Canada indeed became a country of two nations."

The Second World War, 1939–1945

In Canada the Second World War is often called "a good war." Casualties were lower than in the First War, and represented a smaller proportion of the troops; the political issues were more clear-cut; the war ended the Depression and created unprecedented prosperity. Although Canada had virtually disbanded her armed forces during the thirties and strongly supported appeasement, neutrality was never an issue. "I hold up both my hands to keep out of war!" cried Woodsworth in the House of Commons on September 8, 1939. He stood alone.

The First Canadian Division landed in England in December, 1939. Their job was to defend Britain against German invasion. The invasion didn't come. For most Canadian troops, the first three years of war were an idyll of English lanes, draught ale and sex; the biggest enemy was boredom. The war aroused more bitterness and strife at home. Political controversy began with the surrender of the British garrison at Hong Kong to the Japanese on Christmas Day, 1941. Only two Canadian regiments — the Winnipeg Grenadiers and the Royal Rifles — were involved, but the shame of defeat, compounded by the hopelessness of the situation and the stupidity of the strategy, increased as the extent of the casualties and the suffering of the prisoners of war became known. The disaster of Hong Kong was followed by the massacre at Dieppe in August, 1942, in which several Canadian regiments were virtually annihilated in a raid that seemed to have little purpose and less chance of success.

Tension was increased by old war horses in the Conservative Party who raised the cry for conscription long before the majority of Canadian troops even saw combat; pressure to "blood" the Canadian forces contributed to the humiliating forced resignation of the Canadian Commander-in-Chief, General Andrew McNaughton, who wished to maintain the Canadian army as a single fighting unit in preparation for the invasion of Normandy. The army was split; Canadian troops were sent to Sicily in July, 1943 as part of the Eighth Army invasion. They fought their way inch by inch up the spine of Italy, through Campobasso, Monte Cassino, Ortona, in some of the bloodiest hand-to-hand fighting of any war. Full Canadian participation came on June 6, 1944 when the Canadian army was part of the Normandy invasion.

Most of the one hundred thousand Canadian casualties came in the last eleven months of the war. Canadians fought ferociously at Caen and Falaise in Normandy and spent a dismal winter near Nijmegen, Holland where the rain-soaked fields and muddy trenches reminded more than one soldier of a previous war. Some of the most important fighting of the war took place in areas which were remote, vague and shrouded in secrecy. The war at sea and the war in the air both lasted for the full six years and accounted for some of the most important Canadian contributions. In the long, deadly Battle of the Atlantic Canadian corvettes escorting merchant convoys kept the shipping lanes open in the face of devastating attacks by German submarines; the toll in ships and supplies was staggering but it was a triumph for the small, inexperienced Canadian navy. As the tide of war turned the R.C.A.F. flew countless bombing missions into Germany. The air force was the most dangerous service: of eighteen thousand casualties in the R.C.A.F., seventeen thousand were fatal, almost half the total fatalities in the Canadian armed forces.

As casualties mounted the clamour for conscription became louder and hostility in Quebec intensified; so did opposition among the "Zombies," the army of men conscripted for home defence. In November, 1944, Prime Minister Mackenzie King capitulated: Zombies were sent overseas to fill in the gaps in the Canadian forces. Conscripts rioted in British Columbia; thousands deserted. Once more the war ended in bitterness and internecine strife, and once more Quebec was betrayed.

The full extent of war's impact on Canada cannot be measured: sixty thousand men lost in the First War out of a total population of seven million, and many of their sons later killed and maimed, two generations decimated. Who knows what Canada would be like had there been no wars? Who can measure lost lives, lost years, lost opportunities, lost ambitions?

For those Canadians who have grown up since 1945, children of the Cold War, war has been an absence punctuated by occasional images and objects: a rusty uniform hanging in the attic, snapshots, ribbons tucked away in a drawer, pictures that little boys draw in school, planes and ships spitting bullets at each other depicted by fine dots of red crayon crisscrossing the page interspersed by great bursts of red and orange flames and clouds of black smoke. War is a two-minute silence on Remembrance Day. It is awkward, uncomfortable, embarrassing. Jean Margaret Crowe recalls:

> When I was a child living in a small town in Saskatchewan, I was taken every year to the armistice service that was held in the town hall. I remember that the main speech of the evening was delivered by a man named Ed Harris. He ran the local livery stable and was of rather minor importance in the town, or so it seemed to me then. But that night he put on his uniform, wore his ribbons, and talked about Hill 120 at Mons and cried openly at what had happened, as many others did with him.
>
> I was twelve years old then. The war had only been over twelve years and neither what he had to say nor the daily sight of many others, my uncle for one, who had been shell-shocked and was, as they say, "never the same," our neighbour who walked with a cane and swung his leg in an awkward arc, the doctor who reminisced to my father that he had amputated sixteen limbs in one night, the young man who lived near the railroad track and had shattered his knees deliberately with a piece of metal rather than go over the top, nothing altered my feeling that it had happened so long ago that it wasn't real.

The mystery of war does not end with it but the terrible questions have never since been thoroughly debated: What were we fighting for? What did it do to us? Was it worth it? War is ugly, obscene. Better to forget. War is made into stories, transformed into myth. War is taboo. It is an experience loaded with so much human anguish, freighted with so much primaeval terror, that we seem afraid to speak the word for fear it will all come crashing down on us once more. Our silence is a prayer, a spell. We must forget, yet we can't forget. We must remember. If we do not, the

sacrifice of those one hundred thousand Canadian lives will be meaningless. They died for us, for their homes and families and friends, for a collection of traditions they cherished and a future they believed in; they died for Canada. The meaning of their sacrifice rests with our collective national consciousness; our future is their monument.

ENCHANTED WOOD:
THE WORLD OF THE WAR ARTIST

In a muddy dressing station near Ypres in the spring of 1915, as he listened to the thunder of the guns and watched his dead friends being buried in the farmer's field outside his door, Canadian surgeon John McCrae scribbled in his notebook one of the great war poems in the English language, "In Flanders' Fields." The poem was a brilliant accident of war, yet McCrae is only one of many Canadians who were able to create works of great beauty and emotional power out of the chaos and carnage of war.

Many of them — painters A.Y. Jackson, David Milne, Arthur Nantel, Miller Brittain, Will Ogilvie, Molly Lamb Bobak; poets Robert Service, Raymond Souster, George Whalley, F.G. Scott, Edgar McInnis; writers Charles Harrison and Will Bird—served in the Canadian armed forces as plain soldiers, sailors or airmen, dashing off sketches and giving them away to their friends, keeping illegal diaries or, like Canon Scott, reciting their poems to any audience, however reluctant, they could capture in an officers' mess or dirty dugout. Gunner Louis Keene and naval Lieutenant-Commander Anthony Law produced both paintings and manuscripts. These artists were technically amateurs; they were being paid to fight, not to immortalize the war. In many cases, however, they were recognized during the war and given official status as Canadian war artists.

Perhaps our most important and enduring legacy from both world wars is the art and literature produced, often under fire, by Canadians in the armed services. When Canadians weren't fighting they were writing, sketching, telling jokes, singing, inventing stories, staging musicals, painting their airplanes, gossiping, and plastering walls with signs, murals and graffiti. War produced a unique and inventive military culture with its own colloquial language, its own style, rituals, symbols, secret codes and folk heroes. Isolated by distance and military mystique, the world of war was a separate, self-sufficient universe as remote from normal experience as the moon, or Mars or Hell. It was an upside down universe, a violent, amoral, grotesque looking-glass culture, masculine, almost monastic in its voluntary deprivation and self-imposed suffering, a fantasy world where women were idealized as Virgins or execrated as whores, a charnel house where death was often a long and hideous torture, where men were exposed, for long periods of time, to sights of ghastly mutilation. It was an obscene world, without past or future, frozen in time, an absurd, macabre dream.

Stranded like Gullivers in a bizarre, ambiguous, threatening land, soldiers were forced to name and describe their world in order to survive it. They turned to stories and songs, to drawings, journals and letters. Most of the sketches, drawings and paintings are now in the possession of the Canadian War Museum; some have been purchased by other galleries and a great many remain in private hands. Letters were often published posthumously in family editions; journals and diaries were worked up into memoirs and published during or after the war in small editions that are long out of print. Some have recently been reprinted. A considerable amount of original material has been given to the Public Archives in Ottawa.

Some of the war literature is the work of professional writers; most is not. It is rough and ready, sincere, innocent, astonishingly frank and powerful in its immediacy. Canadian attics are full of war letters. Servicemen wrote, often more than once a day, to family, lovers and friends. The men's letters were censored by the officers who took out the military information but left the loneliness, the homesickness, the lies and bravado, the trivia and corny jokes and pleas for cigarettes, the courage and fear and love, the whole heartrending human dimension of war. No one censored the officers' letters and some of them, such as Talbot Papineau's exceptionally perceptive accounts,

provide an amazing insight into the everyday life of the Canadian soldier.

Men found in creativity a refuge from the grinding boredom and vulgarity of army life; a secret diary or journal gave them a sense of privacy and permanence in a totally public, capricious world, an identity in a world where they had none. The best Canadian war literature is autobiographical. It speaks out with a strong, defiant "I", the individual personality triumphant over death and anonymity. It is eye-witness literature, straightforward, graphic, relentless in its honesty. The psychic stress of battle heightened men's perceptions and allowed them to see in sharp focus, like a painter.

A number of soldiers' books were published during 1917 when the government was desperately trying to raise more troops; they start off full of patriotic clichés, but a few pages in become so gory, cynical and horrifying they must have discouraged even the bloodthirsty. The gap between the official version of the war and the personal vision of each soldier gave many men a desperate need to tell the truth. Their memoirs are written with a feeling of compulsion; they were fighting for truth and telling it was the only way they could justify their own actions or the deaths of their comrades. The accounts are written in a confessional style, an exhaustive, guilty, merciless exposure, as if the soldier were seeking absolution in his painful revelations. It is a violent literature, yet it is a literature of spiritual as well as physical pain, rich in humour and passion and tenderness, intensely political in its implications and profoundly pacifist in its impact. The letters and diaries often have a conspiratorial tone, as if the writers were aware of their subversion; many were published anonymously or under pseudonyms, frequently several years after the war had ended.

During both wars there was also a highly public official culture: John McCrae, Robert Service and Canon Scott all enjoyed enormous celebrity during the First War. On the whole this official culture was trite, bombastic and false; only the best has survived. Every school child knows "In Flanders Fields." McCrae's other poems have been mercifully forgotten. Poets like McCrae and Service were war heroes.

The most famous Canadian war artists were the Dumbells, a troup of eight musicians pulled from the ranks who travelled throughout the Canadian Corps bringing down the house with their witty songs and satiric sketches. They popularized the songs of Montreal entertainer Gitz Rice who wrote three of the greatest hits of the First War — "Mademoiselle from Armentières," "I Want to Go Home," and "Dear Old Pal of Mine." During the Second War, radio brought a similar popularity to the CBC's war correspondents—Matthew Halton, Leonard Brockington, Bob Bowman — whose sepulchral Churchillian voices and purple prose brought a thrilling hush into every Canadian living room. To a lot of people listening to the evening news, CBC announcer Lorne Green *was* the war.

The first Canadian to understand the importance of accurately recording war in painting was Sir Max Aitken, Lord Beaverbrook, the eccentric genius from New Brunswick who had invested his Canadian millions in British newspapers. Beaverbrook was appointed Canadian "Eye-Witness" in 1916, a sort of roving ambassador to the First War, and, in 1917, head of the Canadian War Records in London. Beaverbrook originally commissioned British painters to paint Canada at war but then began to choose Canadians.

The Canadian war art program was an immediate success. It was the largest war art program ever undertaken by any country and the first great official commission for Canadian artists. It encompassed almost all the most outstanding Canadian painters, including men of established reputation like Maurice Cullen and promising unknowns like David Milne. It included four painters—A.Y. Jackson, Frederick Varley, Arthur Lismer and Franz Johnson—who would get together to found the Group of Seven in 1920.

When the war art program was reactivated in 1943, every painter was a Canadian; they were commissioned into the armed services and divided equally among the army, navy and air force. Molly Lamb Bobak, Pegi Nicol MacLeod and Paraskeva Clark painted women in the forces; Charles

Goldhamer painted burned R.C.A.F. fliers at a plastic surgery hospital in England; E.J. Hughes and Albert Cloutier followed Canadian troops to the Arctic; Aba Bayefsky and Alex Colville went to the Nazi concentration camp at Belsen. Although they were expected to produce an accurate record and were frequently ordered to paint certain subjects, the war artists enjoyed great freedom of subject and interpretation; their legacy of almost six thousand oils, watercolours, drawings and bronzes is not only an exhaustive visual study of war but a great contribution to contemporary Canadian art.

Many painters were inspired by the situations into which they were thrust. War broke down old preconceptions, old inhibitions; it offered subject matter — death, mutilation, destruction—they had never dealt with before. They had to render the obscene tolerable, the ugly beautiful, create life out of death. Under the stress of this dance macabre, some painters created extraordinary and unforgettable works of art: Alex Colville's "Dead Women, Belsen" and "Bodies in a Grave," Charles Goldhamer's "Burnt Airman with Wig," and Varley's "Canadian Soldier" have the force of revelation. They are indelible, definitive images that transform the vision of war for every person who sees them. Their emotional power is characteristic of the best Canadian war art; it is passionate, sometimes almost overwhelming in its truth, compassion and horror. The brutal sexuality of Lawren P. Harris's "Tank Advance," the tenderness and compassion of Varley's "Sunken Road," the joyful beauty of Pegi Nicol MacLeod's "C.W.A.C. Officer" are intensely personal statements about war unequalled in Canadian art or literature.

A great collection of works by Canada's best known artists, the war art collection has been ignored and neglected, almost censored. Perhaps it is revulsion against war which has led to the rejection of the beauty it produced. Until now the quality of the works has never been adequately assessed and much of the material has remained virtually unseen. For a long time the Canadian war paintings were denigrated in favor of the bravura heroics of British war artists, yet today the sentimental jingoism of these works seems false and offensive and the Canadian collection, seen separately and seen whole, takes on a surprising strength. The Canadian paintings are exceptionally quiet, understated, still, frozen in a kind of enchanted sleep. They have a great clarity and precision of detail, costume and light, the acute, heightened perception of a visit to a magic, macabre planet. Their mood is not one of swagger or hate or frenzy, but rather of peace, compassion and love, a mood which perfectly expresses the eternal tragedy of war.

H. Mabel May *Women Making Shells*

The First World War 1914–1918

All changed, changed utterly:
A terrible beauty is born.

W.B. Yeats,
"Easter 1916"

A time of innocence

We were the usual beach crowd, with our sport suits, our silk sweaters, our Panama hats, our veranda teas and weekend guests, our long, lovely, lazy afternoons in hammocks beside the placid waters of Lake Winnipeg. Life was easy and pleasant, as we told ourselves life ought to be in July and August, when people work hard all year and then come away to the quiet greenness of the big woods, to forget the noise and dust of the big city.

When the news of war came, we did not really believe it! War! That was over! There had been war, of course, but that had been long ago, in the dark ages, before the days of free schools and peace conferences and missionary conventions and labour unions! Christian nations could not go to war!

The first news had come on the 9:40 train, and there was no more until the 6:20 train when the men came down from the city; but they could throw no light on it either. The only serious face that I saw was that of our French neighbour, who hurried away from the station without speaking to anyone. When I spoke to him the next day, he answered me in French, and I knew his thoughts were far away.

The days that followed were days of anxious questioning. The men brought back stories of the great crowds that surged through the streets, blocking the traffic in front of the newspaper offices reading the bulletins, while the bands played patriotic airs; of the misguided German who shouted, *Hoch der Kaiser!* and narrowly escaped the fury of the crowd.

We held a monster meeting one night at "Windwhistle Cottage," and we all made speeches, although none of us knew what to say. The general tone of the speeches was to hold steady—not to be panicky—Britannia rules the waves — it would all be over soon.

The crowd around the dancing pavilion began to dwindle in the evenings — that is, of the older people. The children still danced, happily; fluffy-haired little girls, with "headache" bands around their pretty heads, did the foxtrot and the one-step with boys of their own age and older, but the older people talked together in excited groups.

Every night when the train came in the crowds waited in tense anxiety to get the papers, and when they were handed out, read them in silence, a silence which was ominous.

A shadow had fallen on us, a shadow that darkened the children's play. Now they made forts of sand, and bored holes in the ends of stove-wood to represent gaping cannon's mouths, and played that half the company were Germans; but before many days that game languished, for there were none who would take the German part; every boat that was built now was a battleship, and every kite was an aeroplane and loaded with bombs!

We closed our cottage on August 24th. That day all nature conspired to make us feel sorry that we were leaving. A gentle breeze blew over the lake and rasped its surface into dancing ripples that glittered in the sun. Blueberry Island seemed to stand out clear and bold and beckoning. White-winged boats lay over against the horizon and the chug-chug of a motorboat came at intervals in a lull of the breeze. The more tender varieties of the trees had begun to show a trace of autumn coloring, just a hint and a promise of the ripened beauty of the fall — if we would only stay!

Before the turn in the road hid it from sight we stopped and looked back at the "Kee-am Cottage"—my last recollection of it is of the boarded windows, which gave it the blinded look of a dead thing, and of the ferns which Grandma had brought from the big woods beyond the railway track and planted all round it, and which had grown so quickly and so rank that they seemed to fill in all the space under the cottage, and with their pale-green, feathery fringe, to be trying to lift it up into the sunshine above the trees. Instinctively we felt that we had come to the end of a very pleasant chapter in our life as a family; something had disturbed the peaceful quiet of our lives; somewhere a drum was beating and a fife was calling!

Not a word of this was spoken, but Jack suddenly put it all into words, for he turned to me and asked quickly, "Mother, when will I be eighteen?"

Nellie McClung

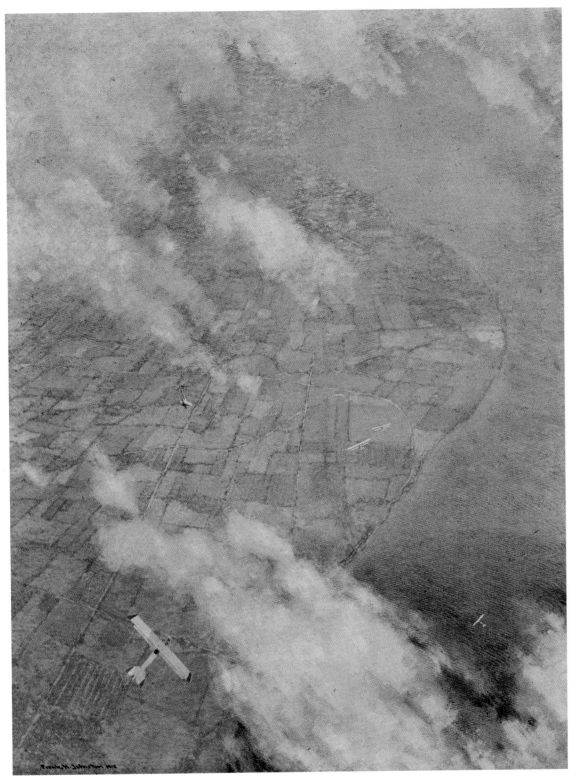

Franz Johnston *Beamsville* 1918 19

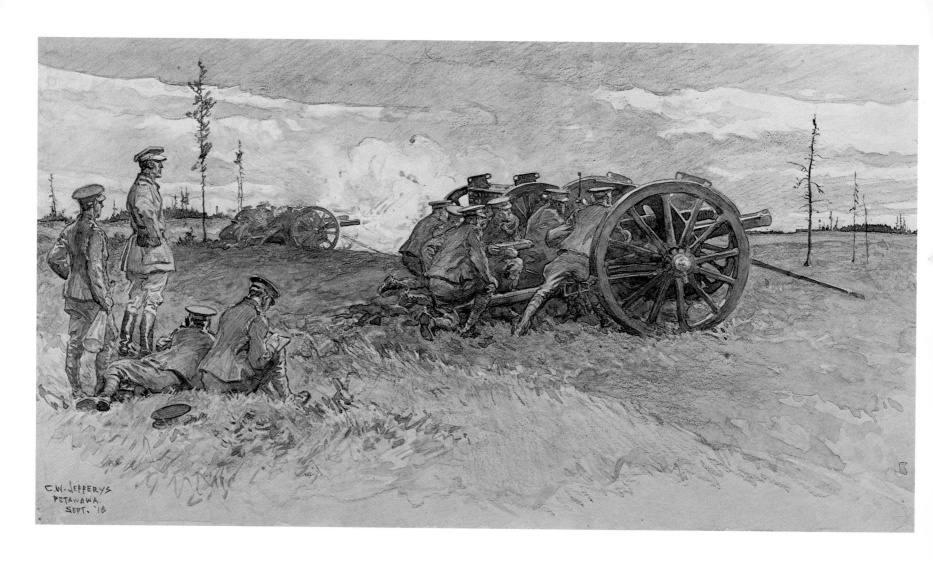

C. W. Jefferys *85th Battery at Firing Practice* 1918

Volunteers

It was like an oil boom, or the subdivision of a new town site; offices sprang into existence, crowds waited at the doors, and, inside, the investors made their deposits. This was no idle punting in oil shares or mining stock; it was a solid investment in flesh and blood.

Day by day the recruits swarmed in. Such recruits were surely never seen before. The woods disgorged them, the mountains shook them clear; they deserted from the ships and the harbour, they hit the ties from across the great divide. The mines, the camps, the canneries and the orchards, all sent their share.

The doctor, persistent, profane, particular, measured their heights and chests — this for a matter of form, for scarcely one but exceeded the requirements prescribed by many inches. But there were fingers gnawed off by frostbite, and the axe had taken its toll of many toes, and these deficiencies had to be carefully sorted out and weighed in the balance.

Pete Sornson from Fort Charles was deficient of a hand, and kept the stump carefully hidden behind his back, until told to spread his fingers out. That ditched him! Andie Mack from Squamish, with a wooden leg, the result of a badly primed dynamite cartridge, kept the fact concealed until told to take his trousers down. Private Purdy, late of the Argyll and Sutherland Highlanders, insisted on seeing ten spots where there were only five. Fresh air and exercise was his portion, until such time as he was sober enough to see his way through the eyesight test.

There were lumberman and railwaymen, prospectors, surveyors, bankers, brokers, stokers, teamsters, carpenters, and schoolmasters. Many had not seen a city for months, and they were frequently drunk; but the material!

Herbert Rae

Why not?

I enlisted because I hadn't the nerve to stay at home. Oh yes, Canada is worth dying for, but that didn't occur to me until after I had enlisted. Before—I was thinking mostly of my own desires and ambitions and of Mother and Dad and all my friends. . . .

Armine Norris

God be with you

Twenty-two volunteers were chosen and on Friday, August 14th, clad in their red tunics, blue trousers and white helmuts, they marched to the railway station, led by the officers who carried their unsheathed swords. They were supported by the Citizens' Band and the Collegiate Cadets Bugle Band. They were followed by the fire brigade and a large number of autos and horses and buggies decorated with flags. It was a gala event. The women of the town presented $80 to the contingent, and the Council the next day presented each man with $10 and each officer with $15. The war, of course, would be over in three months. These men probably would not see action. Nevertheless, it was a great demonstration of Orillia's support of the Empire. War was still a chivalrous, romantic thing. After the speeches, as the train was about to pull out, Band Master Mitchell ordered his band to play "God Be With You Till We Meet Again." With this a hush fell over the crowd. Perhaps, after all, this was serious business. Both soldiers and citizens seemed to be affected for a few minutes. However, the enthusiasm soon again prevailed. The band struck up "The Cock o' the North," the Simcoes' regimental march, and the train pulled out amid the farewell cheers of the huge crowd.

Leslie Frost

Farewell

As long as I live I shall not forget that day. For the most part we were youngsters; many had never been away from home before. As a sergeant in the signal section my place was in rear of that section, and therefore I was the last man in the parade. I marched through Victoria in a warm kind of a daze. Victoria had turned out to the last man, woman, and child. Even the dogs were there, marching. The cheers swelled into one constant roar, echoing and reverberating along the canyon walls of the business district. The crowd flooded in behind, in a great surging wave. We all were excited, and embarrassed at being cheered, not having done anything yet. Attempts to keep ranks were futile. Pipes and brass bands and cheers intermingled in one flat roar of sound.

Having gone to great pains to shut in my own family, as tail man in the parade I found myself surrounded by men and women I had never seen before. One dear old lady caught hold of my arm and marched along with me for two blocks. She was laughing, and crying, and laughing again, all in one piece; and quite out of breath. Her son, she said, was "up there," ahead in the column. His name was Jack. Did I know him? Heaven forgive me, I said I knew Jack like a brother. That he was a fine fellow. That we all thought the world of him. That seemed to comfort her; and at any rate "Jack" wouldn't mind. At the Legislative Buildings, a brother I had neglected to see struggled through the crowd and pump-handled me. The crowd swelled around us. A sergeant of signals was very nearly left behind. He had to fight his way on to the *Sophia*; but he made it, and so did every man in the parade, though how it was done will always be a mystery.

Standing on the decks of the ferry-steamer, swarming into the rigging, clustered wherever an inch of height gave any advantage, men who were to become one with the fighting 16th and 7th Battalions of the First Canadian Division watched the pier recede; watched the sea of handkerchiefs, fluttering and waving faster and faster as the distance lengthened; watched until unaccountable films came over the eyes, and lumps that had never been there before rose in their throats. Then they found voice, and cheered; cheered and sang, and cheered again, until the lumps rose and choked them into a self-conscious silence.

Sandham Graves

Station at Mont Joli

Another twenty minute stop at Mont Joli. My heart pounds in my chest. Will I ever see my family again? I have no idea if they received the notice of my departure in time. Suddenly, in the crowd on the station platform, I spot my brother Alphonse. I dash towards him. To my disappointment he's alone. The rest of the family doesn't know I'm leaving. Despite all my efforts to appear courageous, I cannot control the intense emotion that fills my heart, and I feel sobs rising in my throat. I can't speak a single word, yet I have so many things to say. In a minute it will be too late. The train will leave and I'm certain that I'll never see this brother who stands before me again. Through the tears I gaze at him, wanting to engrave his face in my memory. An officer's voice calls out; to me it seems so harsh. The moment of parting has come. For the last time I hold out my hand to my brother. God! what a sacrifice. I never would have believed it could be so painful. The officer's tough voice again. I manage to utter a few words despite the emotion that grips my throat: "Kiss them all for me, especially my poor mother."

The train jerks into motion and I jump into a car. I look for my brother from the window, but he's lost in the crowd. I fall back on a bench, exhausted by the effort of these final moments.

The train flies along at full speed, as if eager to put as much distance as possible between us and all that we love. I gaze out absently at the fleeting landscapes. Still, I notice that the wheat is ready for harvest, and further along on a hillside, the trees have put on their autumn colours.

A.J. Lapointe

Heroes

Our train is to leave Bonaventure Station at eight. At four the officers try to get the men in shape. More than half the battalion is drunk. Pails of black coffee are brought around. Some of the bad ones have buckets of cold water sluiced over them.

It takes an hour to line the men for parade outside the barracks. Men are hauled out of their bunks and strapped into their equipment. They stare vacantly into the faces of those who jostle them.

Outside in the streets we hear the sounds of celebration.

Fireworks are being exploded in our honour.

The drunks are shoved into position.

The officers take their places.

The band strikes up and we march and stagger from the parade square into the street.

Outside a mob cheers and roars.

Women wave their handkerchiefs.

When we come to the corner of St. Catherine and Windsor Streets a salvo of fireworks bursts over the marching column. It letters the night in red, white and blue characters. The pale faces of the swaying men shine under the sputtering lights. Those of us who are sober steady our drunken comrades.

Flowers are tossed into the marching ranks.

Sleek men standing on the broad wide steps of the Windsor Hotel throw packages of cigarettes at us. Drunken, spiked heels crush roses and cigarettes underfoot.

The city has been celebrating the departure of the battalion. All day long the military police had been rounding up our men in saloons, in brothels. We are heroes, and the women are hysterical now that we are leaving. They scream at us:

"Good-bye and good luck, boy-y-y-ys."

They break our ranks and kiss the heavily laden boys. A befurred young woman puts her soft arm around my neck and kisses me. She smells of perfume. After the tense excitement of the day it is delightful. She turns her face to me and laughs. Her eyes are soft. She has been drinking a little. Her fair hair shines from under a black fur toque. I feel lonely. I do not want to go to war. She marches along by my side. The battalion is no longer marching. It straggles, disorganized, down the street leading to the station.

"Kiss me, honey," she commands. I obey. I like all this confusion now. War — heroes — music — the fireworks — this girl's kiss. Nobody notices us. I hang on to her soft furry arm. I cling to it as the station looms at the bottom of the street.

She is the last link between what I am leaving and the war. In a few minutes she will be gone. I am afraid now. I forget all my fine heroic phrases. I do not want to wear these dreadfully heavy boots, nor carry this leaden pack. I want to fling them away and stay with this fair girl who smells faintly of perfume. I grip her arm tightly. I think I could slip away unseen with her. We could run through the crowd, far away somewhere. I remember the taunting song, "Oh, My, I'm Too Young To Die." I am hanging on to her arm.

"Hey, soldier boy, you're hurting my arm."

We are at the station. We are hustled inside. We stagger into the trains. We drop into seats. We wait, for hours, it seems. The train does not move. The singing and cheering outside dies down. In a little while the station is deserted. Only a few lonely baggage men and porters move here and there. At last the train slowly begins to move. . . .

The boys lie like sacks of potatoes in the red plush-covered seats. Some of us are green under the gills. White-faced, we reel to the toilets. The floor is slimy and wet.

Charles Harrison

23

The Call

(France, August 1st, 1914)

Far and near, high and clear,
Hark to the call of War!
Over the gorse and the golden dells,
Ringing and swinging of clamorous bells,
Praying and saying of wild farewells:
 War! War! War!

High and low, all must go:
Hark to the shout of War!
Leave to the women the harvest yield;
Gird ye, men, for the sinister field;
A sabre instead of a scythe to wield:
 War! Red War!

Rich and poor, lord and boor,
Hark to the blast of War!
Tinker and tailor and millionaire,
Actor in triumph and priest in prayer,
Comrades now in the hell out there, —
 Sweep to the fire of War!

Prince and page, sot and sage,
Hark to the roar of War!
Poet, professor and circus clown,
Chimney-sweeper and fop o' the town,
Into the pot and be melted down:
 Into the pot of War!

Women all, hear the call,
The pitiless call of War!
Look your last on your dearest ones,
Brothers and husbands, fathers, sons:
Swift they go to the ravenous guns,
 The gluttonous guns of War.

Everywhere thrill the air
The maniac bells of War.
There will be little of sleeping tonight;
There will be wailing and weeping tonight;
Death's red sickle is reaping tonight:
 War! War! War!

Robert Service

Separation

August 29, 1914

Dearest Mother,
 I do not allow myself to think and therefore I cannot write about my feelings at leaving you. You must know that I love you more than anything else on earth. I will not speak as though this were more than an ordinary separation and I want you to keep the same thing in mind. I should be mad with sorrow if I allowed myself to imagine what might occur. I am steeled to take things as they come and not to anticipate sorrow. You must do the same. You simply must. Otherwise you will worry yourself sick and as I have told you I must find you there and in good health to make my homecoming bearable.

Talbot Papineau

Over the Ocean

They say we're going over the ocean,
They say we're going over the sea,
They say we're going over the ocean,
But it all sounds like bullshit to me!

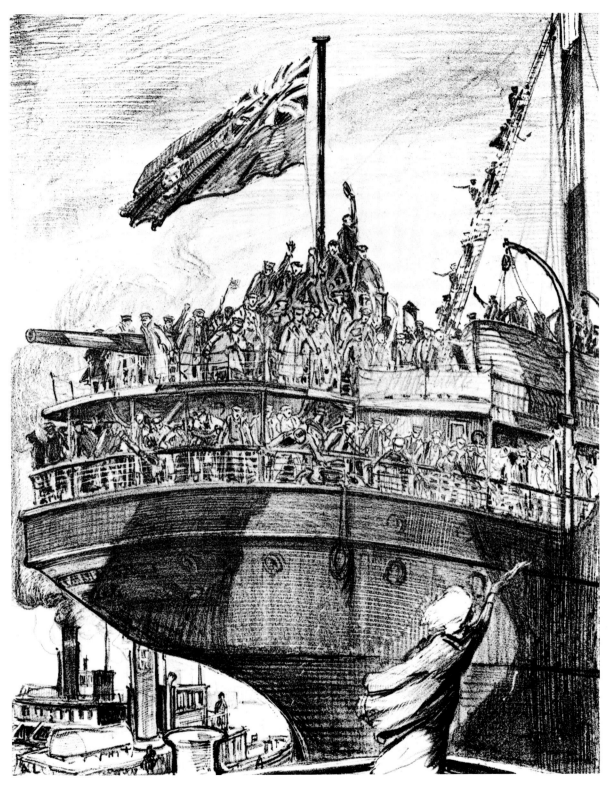

Arthur Lismer *Departure of a Troopship* 25

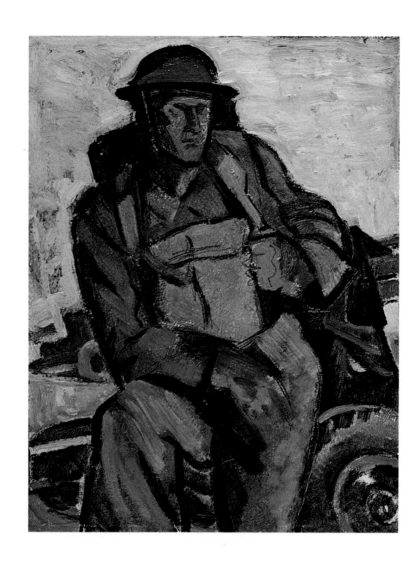

Lillias Torrance Newton *Portrait of Private Alexander*

Man with a number

Every man, on becoming a soldier, becomes a man with a number and an identification disk. My number is 45555 and my "cold meat ticket," a tag made of red fiber, is hanging round my neck on a piece of string.

Louis Keene

Boots

Orders yesterday stated that no Canadian boots were to be taken to Europe and we have sent in size rolls for English boots. About time too, as the Canadian boots issued to the men were made of brown paper.

John Creelman

Uniforms

We have been given new black boots, magnificent things, huge, heavy "ammunition boots," and the wonderful thing is they don't let water in. They are very big and look like punts, but it's dry feet now. I can tell you I am as pleased with them as if someone had given me a present of cold cash. At first they felt something like the Dutch sabots. They seemed absolutely unbendable and so we soaked them with castor oil. Once they become moulded to the feet they are fine. Of course they are not pretty, but they keep the wet out.

We have had new tunics issued to us of the regular English pattern, much more comfortable than our other original ones, and then instead of the hard cap we now have a soft one, something like a big golf cap with the flap on to pull down over the ears. These are much more comfortable. They have one great advantage over the old kind —we can sleep in them. We can lie down in our complete outfits even to our hats. Once I considered it a hardship to sleep in my clothes. Now to go to bed we don't undress; we put on clothes.

Louis Keene

Sentry challenge

Sentry: Halt! Who goes there?
Answer: First Grenadiers.
Sentry: Pass, First Grenadiers. All's well.
Sentry: Halt! Who goes there?
Answer: What the hell is it to you?
Sentry: Pass, Canadians. All's well.

Ready for anything

Our kits needed a lot of consideration. Thirty-five pounds per officer, including bedding, is hardly sufficient to go honeymooning on, and our effects needed a lot of whittling down. Some of the officers were glorious sights, hung round with automatic pistols, binoculars, water-bottles, periscopes, wire-cutters, electric torches, haversacks, amputating knives, can-openers, corkscrews, oyster knives, range-finders, cameras, compasses, flasks, marlingspikes, and other fancy trinkets! The old campaigners had little or no kit. What there was, was done up in a couple of sandbags, and consisted mainly of two blankets and a waterproof sheet.

Every item was gradually weighed in the balance, and as the time grew shorter one trinket after another was discarded, and we gradually began to look less like Christmas trees.

Herbert Rae

Caravan

An army on the march is the queerest sight in the world. You imagine great rows of men in neat uniforms swinging along to the sound of the band. Nothing could be further from the truth! As you see the column winding away in front of you (and you may see it for a couple of miles in this flat land), it looks like an immense tinkers' encampment on the move, for the greater part of the the column consists of wagons — baggage wagons, ammunition limbers, horse ambulances, motor ambulances, water carts, camp cookers busy preparing a meal for the men at the end of the march, mules laden with entrenching tools, etc., etc. The men also are hung around with haversacks, mess tins, water bottles, ground sheets, etc., till they look like veritable bagmen.

William Boyd

Behind the lines

We marched along between the never-ending poplars, and our men fell by the wayside as the *pavé* twisted and blistered their feet. Presently the poplars ceased, and we were passing between rows of mean two-storied buildings which crowded forward to the street. Women gazed at us from the doorways, and now and then came out and gave us beer.

This was an industrial centre, a district of brick houses and factory employees; and now we left the main road and turned to one side across the series of cross-roads. It was getting dark. "Keep to your right," shouted the Staff Officers who rode up from behind. "Right! Right!" shouted the non-commissioned officers. We bumped into a regiment going to rest billets; they were Imperials — the Scottish Light Infantry. "Hullo, Canadians!" they shouted to us in welcome.

There was a little hen,
And she had a wooden leg,

And she laid more eggs
Than any chickens on the farm;
And another little drink
Wouldn't do us any harm,

sang the Canadians, who, if they were tired, didn't want to show it.

Herbert Rae

Marching

We started out as fresh and gay as boys on a picnic, with howls and yells and laughter; every petticoat we met on our way was greeted with a wonderful mixture of Anglo-French salutation. Again and again we go back to the good old "Pack Up Your Troubles"; or else we roar so that the whole countryside may hear: "The Gang's All Here!" But the best of the lot is the everlasting and ever - varying song of "Mademoiselle from Armentières":

Oh, madam, have you any good wine?
 parley voo,
Oh, madam, have you any good wine?
 parley voo,
Oh, madam, have you any good wine,
Fit for a soldier from the line?
 Hinky dinky, parley voo.

It continues: "Oh, madam, have you a daughter fine?" "Yes, I have a daughter fine." "Then . . . Our imagination pictures the continuation of the song in lusty and vivid colouring, although in any case we have now turned our back on all such pleasures for some time to come.

But by degrees — as we put mile after mile behind us — the straps across our shoulders begin to cut most damnably; we try adjusting our packs, but it makes no difference. The rifle feels as heavy as a ship's mast and has to be shifted continually from one shoulder to the other; we march with drooping heads and bowed backs, sore from the tips of our toes to the hair on our heads.

Thomas Dinesen

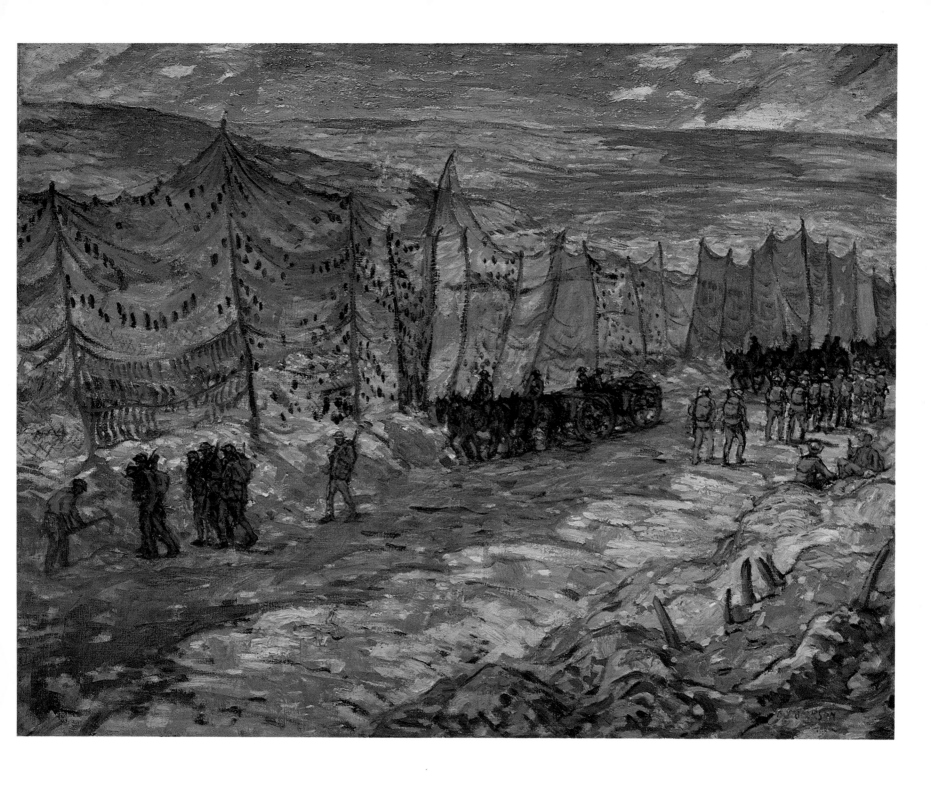

A. Y. Jackson *Screened Road to 'A'* 1918 29

Digging in

The draft was immediately ordered to "dig in," as the plane we had been watching a few minutes before had dropped its signal directly over this position.

We lost no time in digging more of these shallow pits, that reminded one rather gruesomely of graves, and had barely scraped them deep enough to roll into before a hail of small high explosive shell fell all around us.

For half an hour the whoop and crash of falling and bursting shells kept us alternately ducking our heads and raising them again to see "where that one went," for curiosity is many times a stronger impulse than fear.

Curious things happened. A tree was cut in half by a shell, and the plumed top, falling clear of the stump, planted itself like a dart in the ground a few feet away.

A pack horse suddenly bolted across the open field with a slight cut on one flank, and half a dozen men made wild grasps at its bridle. And here and there groups of men finding their corner of the field a bit too "hot" for comfort would just as suddenly bolt across to another part and start feverishly digging in anew.

At seven o'clock the battalion fell in to move up to the front line and dig some trenches.

The greatest secrecy was observed, and nobody but the guides knew our destination, and we followed them in silence up the shell-pitted road and across the pontoon bridge that spanned the Yser Canal.

On either side of the road was a ruined trench, and even in the weird half-light of the flares we could see what a shambles they had become. The road was well called "Suicide Alley"!

Then suddenly we left the road and took to the open fields on the left. The advance continued up a gentle slope across which — nearly a thousand yards of bare bullet-swept field — the Ghurkas had a day or so previously tried to charge. The bodies still lay there in rows just as they had fallen under the bursts of fire that mowed them down — pitiful huddled figures in the grass staring ahead into the great void. Few of the faces showed signs of suffering — such is the mercy of the rifle bullet; and so great was the resemblance to sleep that later, when we came to retire, we shook the bodies mistaking them for our own men.

In the midst of this ghastly scene, lit up by fitful glances of moonlight as clouds scudded over the sky, two companies moved forward, a long line of shadowy forms, to act as a covering party while the remaining half-battalion dug the new trench.

As we moved forward and lay down we could hear the thudding of the picks as they were driven into the ground, and from somewhere in the darkness ahead the plick-plock of the sniper began.

The sniping increased, and a farmhouse ahead of us that had been smouldering for some time burst into flame. Two colts that were evidently confined near the blaze started to whinny and neigh, and a man who had been hit began to curse vilely.

From somewhere in the rear a battery of French "seventy-fives" opened up with their ear-splitting reports, and we could see the outlines of the ruined farm ahead of us silhouetted against the crimson flashes of their bursting shrapnel. But of the enemy there was no sign—nothing but the arching trail of the flares that shot up and the steady plick-plock of the snipers.

It was nearly two o'clock before the trench was completed and we wakened our shivering men to retire, for so exhausted were they that, despite the cold and danger, many had dozed there on the body-strewn field with one hand firmly grasping the rifle.

Frederic Curry

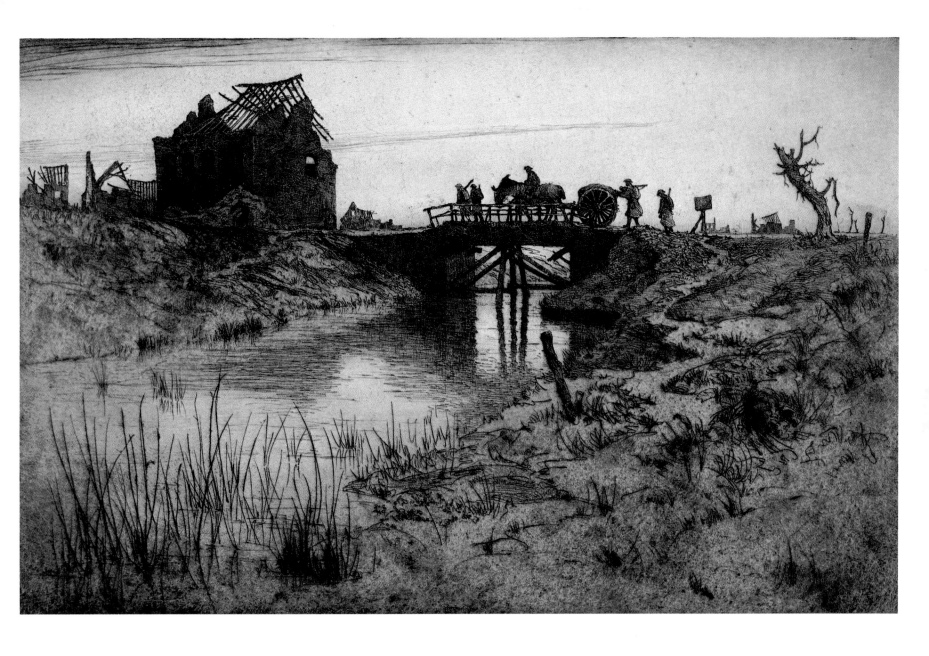

Cyril H. Barraud *Entering Ypres at Dawn* 31

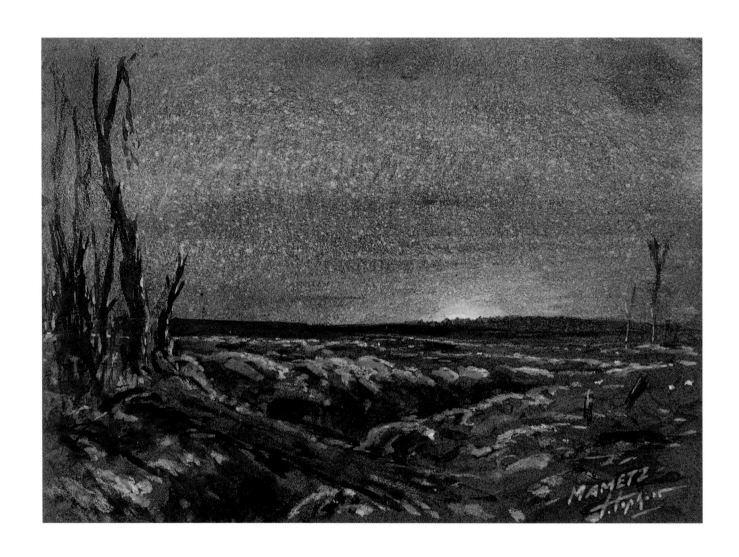

32 Thurston Topham *Moonrise over Mametz Wood*

On guard

We are out in the front line for the first time. Jack and I are alone at a listening post—an advanced post in the foremost trench.

It took us nearly an hour after nightfall to get up here from our cellar, the trench getting lower and narrower—at last it is really nothing but a shallow ditch, and we were told to crawl the last distance on our hands and knees, though they didn't expect us to do it of course—the mud was too deep.

The trenches have been laid through gardens (with not one single tree left standing) as well as round the corners of houses which just protrude above the ground. Once in our way up here last night we had to squeeze past a bedstead that stuck out from the ground, whilst a little further on we passed through a cellar, which stank horribly.

Here at our listening post the ditch had been widened and made deeper — a hole filled with slushy mud. I am standing on a piece of board stuck like a step into the wall of the trench, and gaze across the parapet over the desolate No Man's Land. Immediately in front of me is a big heap of debris and masonry—all that is left of a tall house, whilst a little to the left the roof of another house is lying as if it had just slid down, and whenever a star shell lights up the scenery I can see the rafters protruding like the ribs of some huge animal.

The moon is in its first quarter, shining brightly in the clear, cold sky; but the eastern side of the gravel heap is quite dark. I am staring as hard as I can, with eyes and ears wide open, watching for the least sign of movement out there in the bewildering waste land. One must not, though, keep staring too long at the same object on such a night as this, or the deceitful light of the moon will make things move. . . . A little while ago I found that two wooden posts at which I had been staring hard for a while began to move backwards and forwards. In an awestruck voice I whispered to Jack that he had better call the lieutenant. After what seemed an endless wait, I heard them come, splash-ing through the mud, and full of eager interest: "Is there anything—really?" "Where did you see them . . . just near those two wooden posts, eh?" "Yes, that was where I saw them—but they have gone away now." Maybe tomorrow's regimental records will tell of a hostile raid discovered and frustrated just in time!

All night long the guns boom intermittently; some of them are quite near, others far away, both northwards and southwards . . . boom . . . boom . . . boom . . . boom-boom . . . BOOM! Just behind us we hear the shrapnel whizzing through the air. The small shells, when far away, creak just like a cycle on a gravel path; others hiss immediately above one's head, like the sound of a Rolls-Royce going at top speed. In between, comes the sound of the English machine-guns, suddenly stopping, then commencing again all through the night: *dah-dah-dah . . . dah-dah-dah . . . dah-dah-dah-dah!* Of course, they ought to be our best friends, but all the same some of the shots come very close, whizzing just above our heads! *Swu-upp!* there's a "dart", a big shell from a trench mortar, shooting into the air from Fritz's firing trench over there in the dark, some two or three hundred yards away. It rises in the same manner as a rocket, in a big sparkling curve, humming as it sweeps along in our direction! I press myself flat against the soft walls of the slope and can feel it hitting me just between my shoulder blades! But it falls in No Man's Land, right in front of our post, making a crash like ten thousand thunderclaps. A stray piece of the shell sings in the air above us and buries itself in the wall of our trench.

A couple of officers on their round of inspection are coming up to us now. They stop and chat with us; their merry laughter rings out so loudly in the night that it invites the enemy to send us a new "dart" — a little nearer this time. I am longing to shout "Shut up, for Christ's sake!" but their indifferent ease stops the words on my tongue.

Jack is relieving me now; we have two hours' turn alternately. I throw myself down in the mud against the wall of the trench and look up in the star-strewn sky above me. *Gyw! gyw! gyw!* resounds in the air: Duck, wild geese, woodcock—they seem indifferent to the roar of the guns.

We ourselves are also getting used to it. Strange how easily one adjusts oneself to such conditions — trench life becomes so simple and matter-of-course. We feel quite at home here already, yet just a bit disappointed at the monotony of the entertainment provided for us.

How cold it is. In spite of our Arctic outfit, the chill of the mud around your feet rises gradually till your teeth begin to chatter; and it's incredibly hard work getting up again when your turn comes round. There's a frost, I see now; the surface of the mud is glittering with a thin layer of ice.

And now the moon is setting. . . . It is pitch-dark—only the red flashes of the explosions light up the shattered ruins. There's nothing much happening here tonight, and Lieutenant Scott gives us permission to do some spadework. Jack slips away to the neighbouring post and borrows a shovel, and we take turns digging in the heavy mud. An hour after, our post is neat and dry and we are perspiring all over from the exertion.

At 6:00 a.m. the night watches are done with. All of a sudden we see a file of grey forms appearing in the dim morning light out of the trench on the right. They are the posts already relieved. All through the daytime only a few snipers and machine guns are left out here in covered positions; that's all that is needed to guard against a surprise attack. Jack and I fall in behind the rest, spent and weary, and we trudge heavily through the windings of the communication trenches—"home" to tea and bacon, and a well-earned rest in our damp cellar.

Thomas Dinesen

Our Dugout

When the lines are in a muddle—as they very often are—
When the break's a mile away from you, or maybe twice as
 far,
When you have to sort the trouble out, and fix it on the run,
It's fine to know that you can go, when everything is done,

To a cosy little dugout (and the subject of this ode)
Just a comfy little bivvy on the —— Road,
A sheltered, sandbagged doorway with the flap flung open
 wide,
And a pal to grin a greeting when you step inside.

When the weather's simply damnable — cold sleet and
 driving rain —
When the poles snap off like matches and the lines are
 down again,
And you rip your freezing fingers as you work the stubborn
 wire,
It's great to get back home again, and dry off by the fire,

In a cheery little dugout (and you know the kind I mean)
With a red-hot stove a-roaring, and a floor that's none too
 clean,
A pipe that's filled and waiting and a book that will not
 wait,
And a cup of steaming coffee if you come back late.

It may look a little crowded, and the roof's a trifle low,
But it's water-tight — or nearly — and it wasn't built for
 show,
And when Woolly Bears are crumping and the shrapnel
 sprays around,
You feel a whole lot safer if you're underneath the ground,

In a rat-proof, rain-proof dugout (and it's splinter-proof as
 well)
Where we got the stuff to build it is a thing I mustn't tell,
But we've made it strong and solid, and we're cosy, rain or
 shine,
In our happy little dugout on the firing line.

Edgar McInnis

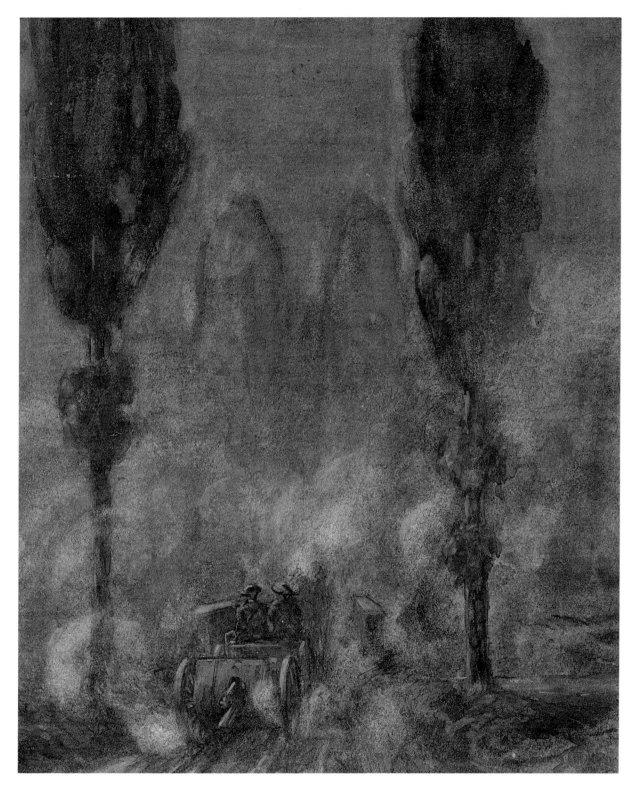

Thurston Topham *Guns, Dust and Moonlight* 1918 35

The snuggest place in the world

We all think that our little home here is the snuggest place in the world. Of course when we were boys we thought such a cave wondrous beyond any expression. We are boys again, that's all.

We enter our dugout through a hole in the trench wall; there is no door, but a thick rug which can be drawn in case of gas attacks covers the opening. Beside the entrance is a primitive gong arrangement, consisting of an old shell-case, to be sounded as a warning to the inmates. A staircase, from ten to fifteen yards in length, narrow and slippery, and consisting of nothing but pieces of wood stuck into the ground as steps, leads down into the darkness, terminating in a long communication passage, meant to be used as exit in case our other passage should cave in or be blocked. From this passage a number of smaller separate caves are scooped out, supported by pit-props against their walls and ceiling — otherwise they would collapse when the big shells explode above. The floor simply consists of mud, which is covered by several layers of our splendid rubber sheets. The dirt and the vermin, the thick, full-flavoured air—all this only serves to increase our feelings of comfort when we sit together here, warm and safe, chatting, singing, and burning our fingers vainly endeavouring to make a basin of porridge boil over a sardine tin filled with bacon grease and with a wick made of rags from a piece of old sandbag!

And as for hard work—why, we ought to be ashamed of the small amount of work we do! Three hours' trench-digging is considered a feat, and the longest march we have on record up till now was only fifteen miles. Easy days all round.

Thomas Dinesen

Dawn

Yes, there in the front line we were cheerful. But there are the wee sma' hours just abune the twal, when the vital tides are at their teeniest, weeniest ebb. Then the sentries, staring across the dripping wire, waiting for the dismal dawn, as the chill creeps into their bones, are apt to let their thoughts wander. Then the imagination gets to work and conjures up happy images of comfortable beds, eider-downs, and hot water bottles. Yes, and more than hot bottles, too! Then you wonder which is the bigger, the hollow in your stomach or the ache in your heart.

The morning was cold — cold with the dampness of clinging vapour. Major Berkeley and Captain Wallace, lingering in the dismal chillness, noted the growing dawn and the gloomy frigidity of the surroundings. The sentries on the firing-step, gazing through the misty drizzle at the sodden wire, were silent; occasionally one stamped his feet or buried his chin more deeply in his upturned collar. The world seemed sad, slushy, and sunk in a sea of mud and despondency.

A man passed carrying a pannikin, then another. In the grey east a haggard dawn was struggling with the desolate darkness; then, somewhere along the trench someone started to whistle; the lilt of a song rose in the gloom. Down the trench three figures, grouped round an object on the ground, were laughing. It was a rum-jar, the concrete means of bringing new comfort to sixty-four willing souls. "Have some rum, Wallace," said the Major. "Good wine gladdeneth the heart; it goes just right at this time in the morning." As the two officers retired into their dugout, the day, already brightening, was glowing in the east, and the whole trench was singing.

Herbert Rae

Rum up

Some of our men were in a dugout so close to our own that we could hear movements and voices through the earthen wall. No bunks there—nothing but the plank floor laid on moist earth and a few candles and brazier fires making shadows everywhere as the men, filing in, dropped down in little silent groups and fell to unfastening their clothing. A feeling of intense, almost inhuman desolation. A swarm of men, smelly in the dark air, tired and empty-minded, spread about the floor like animals. It was good to leave them and get away to our own quarters, where at least we were individuals, and not just a mass of ebbed-out energy.

For five or ten minutes, as I sat on my bunkside, or looked at pictures of actresses in an old magazine, there would be silence in the men's dugout—thick silence you seemed able to feel. Then a murmur, gradually swelling. I soon learned to know that that meant "rum up." As the N.C.O.s moved among the sodden men measuring out to each one his tot, as the hot liquor found its way to their hearts and to their limbs, the murmur would grow into a sort of busy turmoil. Had you been in the desolate dugout next door at that moment you would have seen a transformation — tongues wagging in reminiscence and in argument; each candle the centre of a noisy group up-raised on elbows or to sitting posture, eagerly joining in colloquy, jest, or song; here the greasy pack of cards produced and euchre hands dealt on the floor; yonder a thrifty soldier toasting a saved crust of bread at his brazier; this man with his tunic off "reading" the seams of it with a candle, for lice, another perusing with soft eyes his letter from home. Cold and weariness forgotten, the rum gave them (as it gave us, too) a few moments of exhilaration. Then, inevitably, the second stage of intoxication would follow fast upon the first. Sleep would not be denied. Their bodies still warm with the tingle of the stuff, their hearts beating high and breath coming full, they would stretch out in their greatcoats and fall into the deep sleep that children and soldiers know.

James Pedley

Small enemies

The men are hunting for lice in their underwear. This is the kind of conversation that is coming through from the next cellars: "I've got you beat — that's forty-seven." "Wait a minute"—a sound of tearing cloth—"but look at this lot, mother and young." "With my forty and these you'll have to find some more." They were betting on the number they could find. I peel off my shirt myself and burn them off with a candle. I glory in the little pop they make when the heat gets to them. All the insect powder in the world has been tried out on them and they've won. Everybody up here is infested with them. I have tried smearing myself with kerosene, but that does not seem to trouble them at all. Silk underwear is supposed to keep them down. I suppose their feet slip on the shiny surface.

Louis Keene

Ironing

We are filthy, our bodies are the colour of the earth we have been living in these past months. We are alive with vermin and sit picking at ourselves like baboons. It is months since we have been out of our clothes.

Fry suddenly appears at the door with a flatiron in his hand.

"What's that for?" Broadbent asks.

"The god-damned lice," Fry grunts.

"What are you going to do? Brain 'em?"

"You just watch."

He takes a board and places his tunic on the board. We watch closely. He heats the iron over the fire and then runs the hot iron down the seam. There is a quick series of cracks. Little spurts of blood come in a stream from the inside of the seam. Fry looks up triumphantly.

"That's the way to kill 'em, by God. And it kills the eggs, too."

We all take our tunics and trousers off and begin to iron the lice out of our clothes.

Charles Harrison

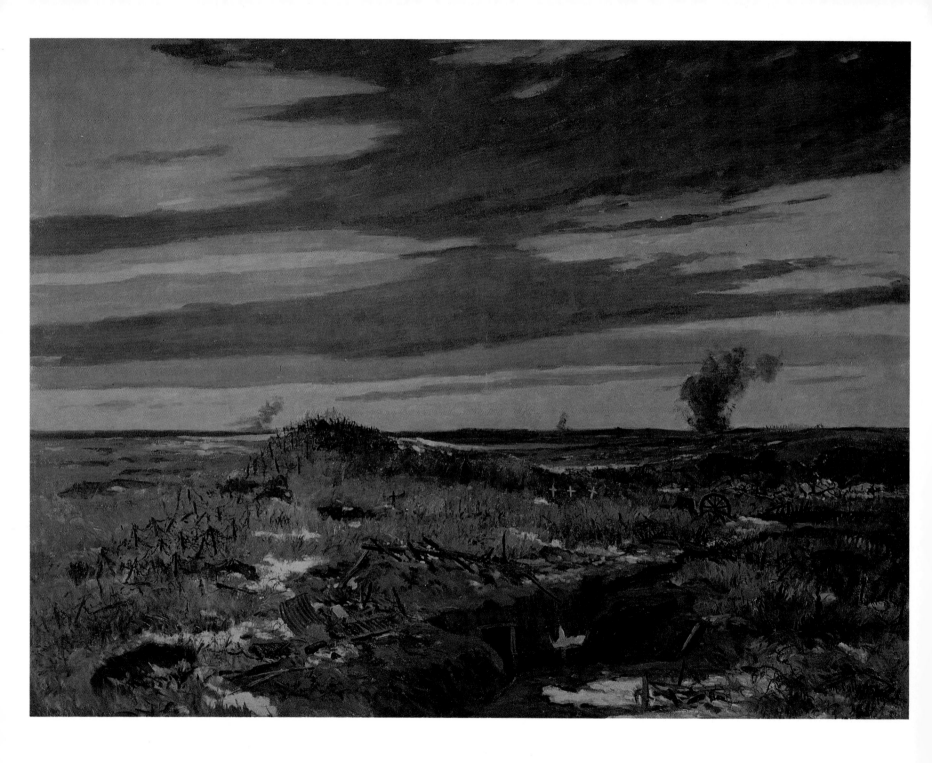

38 Maurice Cullen *No Man's Land* 1919

No Man's Land

A time came when I did not sleep; the night of my first patrol. When I got to bed in the dark, fear came over me. I began to think of No Man's Land as I had read about it, and as it had been vividly described to me. I began to imagine knifings and shootings, and the horror of being overwhelmed out there between the lines of wire. Time after time I threw off the thought; but each time it returned. I grew cold, and shivered, and the chatter of my teeth bade fair to break my nerve. In vain I told myself that twelve brave fellows, armed aplenty, would be with me; that we would meet no prowling enemy, and if we did, would give a good account of ourselves. In vain I forced myself to think how nature had provided the remedy for all suffering — unconsciousness, and if need be, death. In vain I laughed at myself for a poor thing and turned my thoughts to happier scenes far away. Always the vision of No Man's Land returned to mock me, and I felt around me the wire and the corpses and the stinking shell holes and (after the killings achieved) came the fatal bayonet thrust, making me wince with imagined pain, and shiver, cold as ice, as I restlessly changed position and cursed my unmanliness.

No one who has not gone through that vale of fear can understand it. A few hours before, I would have laughed at the suggestion. Later that night when in real danger, though my heart beat fast my head was cool and I did not panic in the least. But alone in the dark room I went all to pieces; and my eyes must have shown it when at last, being called to the mess table, I emerged and arrayed myself for the open air. The psychology of the room itself had something to do with it, I know. As I have said, we never lit a candle there for fear of what we might see. The bed was wide, and piled deep with mattresses, but these had been used by so many that we knew they must be filthy and lousy beyond description. And rats kept running back and forth in that place. God knows how many men had died in there, how much of their blood, Boche and Anglo-Saxon alike, stained those mattresses.

James Pedley

Routine mission

My major told me that I was to be ready at 3:30 next morning to accompany him up front to register the guns.

It had been raining when we crept out of our kennels to go forward. It seems unnecessary to state that it had been raining, for it always has been raining at the front.

Everything was dim, and clammy, and spectral. It was like walking at the bottom of the sea, only things that were thrown at you travelled faster. We struck a sloppy road, along which ghostly figures passed with ground sheets flung across their head and shoulders, like hooded monks. At a point where scarlet bundles were being lifted into ambulances, we branched overland. Here and there from all directions, infantry were converging, picking their way in single file to reduce their casualties if a shell burst near them. The landscape, the people, the early morning — everything was stealthy and walked with muted steps.

We entered a trench. Holes were scooped out in the side of it just large enough to shelter a man crouching. Each hole contained a sleeping soldier who looked as dead as the occupant of a catacomb. Some of the holes had been blown in; all you saw of the late occupant was a protruding arm or leg. At best there was a horrid similarity between the dead and the living. It seemed that the walls of the trenches had been built out of corpses, for one recognised the uniforms of Frenchmen and Huns. They *were* built out of them, though whether by design or accident it was impossible to tell. We came to a group of men, doing some repairing; that part of the trench had evidently been strafed last night. They didn't know where they were, or how far it was to the front line. We wandered on, still laying in our wire.

Things were getting distinctly curious. We hadn't passed any infantry for some time. The trenches were becoming each minute more shallow and neglected. Suddenly we found ourselves in a narrow furrow which was packed with our own dead. They had been there for some time and were partly buried. They were sitting up or lying forward in every attitude of agony. Some of them clasped their wounds; some of them pointed with their hands. Their

faces had changed to every colour and glared at us like swollen bruises. Their helmuts were off; with a pitiful, derisive neatness the rain had parted their hair.

We had to crouch low because the trench was so shallow. It was difficult not to disturb them; the long skirts of our trench coats brushed against their faces.

All of a sudden we halted, making ourselves as small as could be. In the rapidly thinning mist ahead of us, men were moving. They were stretcher-bearers. The odd thing was that they were carrying their wounded away from, instead of towards us. Then it flashed on us that they were Huns. We had wandered into No Man's Land. Almost at that moment we must have been spotted, for shells commenced falling at the end of the trench by which we had entered. Spreading out, so as not to attract attention, we commenced to crawl towards the other end. Instantly that also was closed to us and a curtain of shells started dropping behind us. We were trapped. With perfect coolness — a coolness which, whatever I looked, I did not share — we went down on our hands and knees, wriggling our way through the corpses and shell holes in the direction of where our front line ought to be. After what seemed an age, we got back. Later we registered the guns, and one of our officers, who had been laying in wire, was killed in the process. His death, like everything else, was regarded without emotion as being quite ordinary.

Coningsby Dawson

Shelling

Over in the German lines I hear quick, sharp reports. Then the red-tailed comets of the *minenwerfer* sail high in the air, making parabolas of red light as they come towards us. They look pretty, like the fireworks when we left Montreal. The sergeant rushes into the bay of the trench, breathless. "Minnies," he shouts, and dashes on.

In that instant there is a terrific roar directly behind us.

The night whistles and flashes red.

The trench rocks and sways.

Mud and earth leap into the air, come down upon us in heaps.

We throw ourselves upon our faces, clawing our nails into the soft earth in the bottom of the trench.

Another!

This one clashes to splinters about twenty feet in front of the bay.

Part of the parapet caves in.

We try to burrow into the ground like frightened rats.

The shattering explosions splinter the air in a million fragments. I taste salty liquid on my lips. My nose is bleeding from the force of the detonations.

SOS flares go up along our front calling for help from our artillery. The signals sail into the air and explode, giving forth showers of red, white and blue lights held aloft by a silken parachute.

The sky is lit by hundreds of fancy fireworks like a night carnival.

The air shrieks and cat-calls.

Still they come.

I am terrified. I hug the earth, digging my fingers into every crevice, every hole.

A blinding flash and an exploding howl a few feet in front of the trench.

My bowels liquefy.

The concussion of the explosions batters against us.

I am knocked breathless.

I recover and hear the roar of the bombardment.

It screams and rages and boils like an angry sea. I feel a prickly sensation behind my eyeballs.

A shell lands with a monster shriek in the next bay. The concussion rolls me over on my back. I see the stars shining serenely above us. Another lands in the same place. Suddenly the stars revolve. I land on my shoulder. I have been tossed into the air.

I begin to pray.

"God — God — please . . . "

I remember that I do not believe in God.

Acrid smoke bites the throat, parches the mouth. I am

beyond mere fright. I am frozen with an insane fear that keeps me cowering in the bottom of the trench. I lie flat on my belly, waiting. . . .

Suddenly it stops.

I bury my face in the cool, damp earth. I want to weep. But I am too weak and shaken for tears.

We lie still, waiting. . . .

Charles Harrison

No safe place

The shelling continued all that night and the next day. We had dug deep V-shaped pits, connecting some of them, and there we crouched, grey faces under muddy helmets, red-rimmed eyes, staring, dazed, wondering, our brains numbed beyond thinking by the incessant explosions. One of the new men pitched down between our shelter and the next one. He was pierced in a dozen places and one arm had been sheared from his body by shrapnel. Mickey sat beside me shuddering, half-stunned, staring unseeing, his limbs twitching convulsively at each concussion.

A shell flung equipment in the air. A steel helmet struck into the parados. Then a haversack came hurtling into our trench and fell apart. We gazed stupidly at the contents, a pair of socks, a towel, a toothbrush, a razor and a tin of bully. Another new man came sprawling into our shelter. His helmet was gone and he had lost his rifle. He shook as with ague and crouched in the mud, grovelling and making almost animal noises. He had been literally blown out of his pit and his chum was killed. Then Davies came from the other direction, stepping on the armless body in his path. I shouted at him, asking some questions about the battalion, but he never answered. He sat down close beside me and I was wedged there between him and Mickey. There were continuous explosions just behind us. Mud showered down on our legs, buried our Lee-Enfields, but we stayed in our huddle. Then came a tremendous shock and the narrow passage through which Davies had come was blocked by an upheaval and the dead man slid toward us, slithered down until his one arm was outstretched beside our boots. There was a watch on his hairy wrist and, strangely, it was going. I looked at the time. One o'clock. Each hour had grown to be a grim possession, something held precariously.

The new man recovered enough to huddle on the other side of Mickey. Fear had relaxed the muscles of his face and it had become like dough; his mouth dribbled; I could not look at him. All that afternoon we sat there and, oddly, it seemed but a short time. Nothing was clear to me. Explosion succeeded explosion, a concentrated clamour, slamming and pounding, until the noise beat on the brain itself, and when the firing lulled to solitary shells it became the torture of dripping water. I stirred, and found that my arm had been around Mickey all the while and that Davies and I had gripped hands. We got up, freed our rifles from the mud, shook ourselves. We hoped that we would soon be relieved.

Will Bird

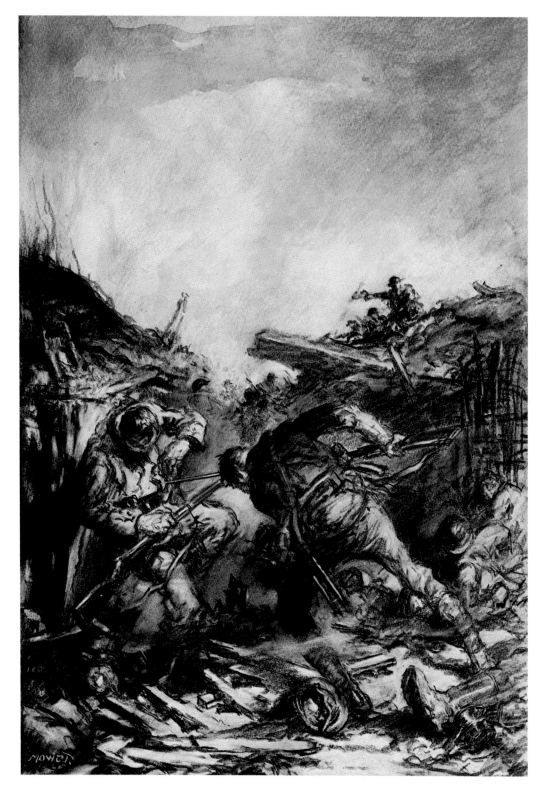

42 H. J. Mowat *Trench Fight*

Face to face

We are lying out in front of our wire, waiting for the signal to leap up. It is quiet. Now and then a white Very light sizzles into the air and illuminates the field as though it were daytime.

We lie perfectly still.

Over in the German lines we hear voices—they are about fifty yards from where we now lie.

I look at the phosphorescent lights on the face of my watch.

Two minutes to go.

MacLeod, the officer in charge of the raiding party, crawls over to where we lie and gives us a last warning.

"Remember," he whispers, "red flares on our parapets is the signal to come back..."

In that instant the sky behind us is stabbed with a thousand flashes of flame.

The earth shakes.

The air hisses, whistles, screams over our heads.

They are firing right into the trenches in front of us.

Clouds of earth leap into the air.

The barrage lasts a minute and then lifts to cut off the enemy's front line from his supports.

In that moment we spring up.

We fire as we run.

The enemy has not had time to get back on his firing steps. There is no reply to our fire.

We race on.

Fifty yards — forty yards — thirty yards!

My brain is unnaturally cool. I think to myself: This is a raid, you ought to be excited and nervous. But I am calm.

Twenty yards!

I can see the neatly piled sandbags on the enemy parapets.

Our guns are still thundering behind us.

Suddenly yellow, blinding bursts of flame shoot up from the ground in front of us.

Above the howl of the artillery I hear a man scream as he is hit.

Hand grenades!

We race on.

We fire our rifles from the hip as we run.

The grenades cease to bark.

Ten yards!

With a yell we plunge towards the parapets and jump, bayonets first, into the trench.

Two men are in the bay into which we leap. Half a dozen of our men fall upon them and stab them down into a corner.

Very lights soar over the trench, lighting the scene for us.

We separate, looking for prisoners and dugouts.

Depth charges are dropped into the underground dwellings and hiding places. The trench shakes with hollow, subterranean detonations.

Somewhere nearby a machine gun comes to life and sweeps over our heads into No Man's Land.

The enemy artillery has sacrificed the front line and is hammering the terrain between their lines and ours.

Green rockets sail into the black sky. It is the German call for help.

The whole front wakes up.

Guns bark, yelp, snarl, roar on all sides of us.

I run down the trench looking for prisoners. Each man is for himself.

I am alone.

I turn the corner of a bay. My bayonet points forward — on guard.

I proceed cautiously.

Something moves in the corner of the bay. It is a German. I recognize the pot-shaped helmet. In that second he twists and reaches for his revolver.

I lunge forward, aiming at his stomach. It is a lightning, instinctive movement.

The thrust jerks my body. Something heavy collides with the point of my weapon.

I become insane.

I want to strike again and again. But I cannot. My bayonet does not come clear. I pull, tug, jerk. It does not come out.

I have caught him between his ribs. The bones grip my blade. I cannot withdraw.

Of a sudden I hear him shriek. It sounds far off as though heard in the moment of waking from a dream.

I have a man at the end of my bayonet, I say to myself.

His shrieks become louder and louder.

We are facing each other — four feet of space separates us.

His eyes are distended; they seem all whites, and look as though they will leap out of their sockets.

There is froth in the corners of his mouth which opens and shuts like that of a fish out of water.

His hands grasp the barrel of my rifle and he joins me in the effort to withdraw. I do not know what to do.

He looks at me piteously.

I put my foot up against his body and try to kick him off. He shrieks into my face.

He will not come off.

I kick him again and again. No use.

His howling unnerves me. I feel I will go insane if I stay in this hole much longer. . . .

Suddenly I remember what I must do.

I turn around and pull my breech-lock back. The click sounds sharp and clear.

He stops his screaming. He looks at me, silently now.

He knows what I am going to do.

A white Very light soars over our heads. His helmet has fallen from his head. I see his boyish face. He looks like a Saxon; he is fair and under the light I see white down against green cheeks.

I pull my trigger. There is a loud report. The blade at the end of my rifle snaps in two. He falls into the corner of the bay and rolls over. He lies still.

I am free.

Charles Harrison

Bayonet

Half-dazed by the bomb explosions, I flourished my bayonet, intending only to bluff the German into surrender — for I had always a dread of such fighting — the fellow drove headlong at me. He tripped over his comrade as he came, but I seemed paralyzed. I could not move to avoid him. I tried to ward his weapon and then instead of tearing steel in my own flesh I felt my bayonet steady as if guided, and was jolted as it brought up on solid bone. My grip tightened as my rifle was twisted by a sudden squirming, as if I had speared a huge fish.

Will Bird

A charmed life

March 3, 1915

Dearest old Mother,

We have made our attack at last and I have led it!

The night we marched off to the trench it was pouring rain. We slopped along in the usual way. The colonel had informed me that an attempt would be made by us at five the next morning to capture and destroy the German trench which had been brought up to within fifteen yards of our No. 21 trench. . . . The night passed more or less uneventfully. The moon was well down but dawn was coming. Then I saw the attacking party coming along to my trench. The moonlight glinted on their fixed bayonets. When the head of the line reached my trench they lay down. The Colonel called me out. He said "There are six snipers who will go ahead of you. Then you will go with three bomb throwers. Lieutenant Crabbe will be behind you with twenty-five men. Then there will be another party with shovels behind him. Alright, lead on." I was pretty scared! My stomach seemed hollow. I called on my men and we fell into line and immediately began creeping forward, flat on our bellies. I had a bomb ready in my hand. We lay for a moment exposed and then suddenly we were up and rushing forward. My legs caught in barbed wire but I stumbled through somehow. I set my fuse and hurled my bomb ahead of me. From that moment hell broke loose. I never thought there could be such noise.

I had my revolver out. A German was silhouetted and I saw the flash of his rifle. I dropped on one knee and fired point blank. He disappeared. I said to myself "I have shot

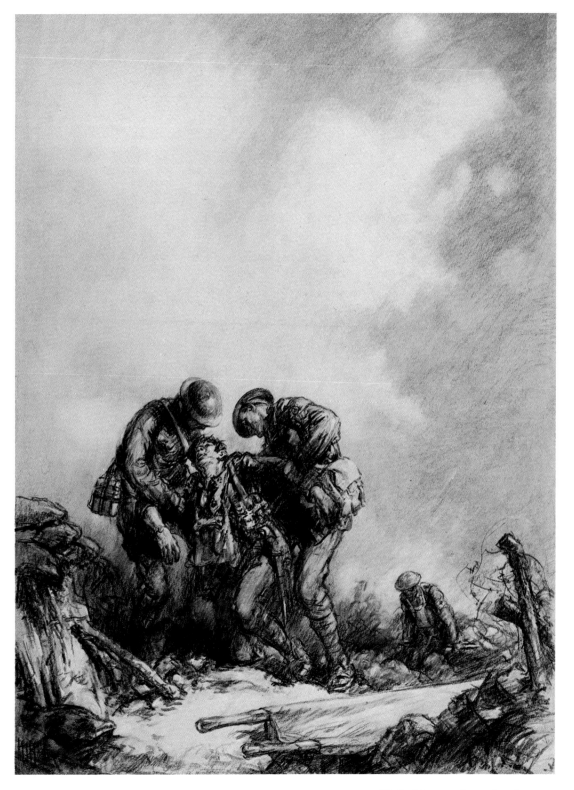

H. J. Mowat *Stretcher Bearers* 45

him." I fired into the trench at whatever I thought was there. Then my revolver stopped. I lay down flat and began to reload. I was against the German parapet. I looked behind me and could see only one man apparently wounded or dead near me. I thought "The attack has failed. I am alone. I will never get out." A machine gun was going and the noise was awful. Then I saw Crabbe coming. He knelt near me and fired over me with a rifle. I had got a cartridge home by this time and Crabbe and I went over the edge into the trench.

It was deep and narrow, beautifully built, dried with a big pump, sides supported by planks, and looked like a mine shaft. A German was lying in front of me. I pushed his head down to see if he was dead. He wasn't. I told a man to watch him. I then began to pull down the parapet sandbags. Three or four men were there too, some with shovels. The German machine guns were going like mad, nipping the top of the trench. It was beginning to grow light. Presently we were told to evacuate the trench. I passed the order, then climbed out and made a run for No. 21. Another man and I went over head first. The man that came after me was shot through the lungs and the next man got it through the stomach. They fell on me in the mud. I could not budge. Then over top of us all came a German! He held up his hands and a couple of our men pulled him off and took him away. One or two of our men came piling over with fixed bayonets and nearly put our eyes out. I was finally pulled from under and out of the mud. It was not quite light. I beat it across the open expecting to get it any minute. I was so exhausted I wobbled from side to side in the mud. However I reached home and dived under cover. I was tired! But mighty glad to be back.

The Germans were now back in the trench we had taken and they began throwing bombs into No. 21. It was awful. We could do nothing to help. Just look on. Out of thirty-five men twenty-one were killed or wounded. At night I went over to the trench again to see them. I could only find one of my bombers. We had no more bombs so I sent him home. The night was very cold and very long. No sleep. The next day No. 21 was bombarded and we had some shrapnel over ourselves. At a quarter to twelve a message for Major Ward came in to help the artillery get range for the German trenches. Great care had to be exercised. Poor Ward was sitting next to me. He jumped up to look and then sank back into my arms. He bled frightfully. He had been shot in the back of the head. I bound his head up as best I could. The brain matter was oozing out. I put on about four field dressings and staunched the blood. I loved old Ward. He is one of the best fellows I know. It was terrible for me to see him like that so suddenly.

I had to leave at once to direct the artillery. They opened up and dropped a shell over us to the left of No. 21. I did what I could to give them the range but it was my first attempt. About four shells had been fired when our wire broke down. I could give no more help. They fired again but it was too risky. They had to stop. I was then cut off. Fortunately I had sent word about Ward and asked for stretchers as soon as it was dark. I made Ward as comfortable as I could. He was now conscious and could recognize me though his mind wandered. He was in great pain and I gave him a good deal of morphine. He would hold my hand sometimes. He said "Talbot, you're an angel." He called for "Alice, where's Alice?" — his wife. A terrific snowstorm blew up. I never saw such darkness and such wind. Flocks of birds flew before it. It was bitterly cold. Later there was thunder and lightning. How long those hours were. Darkness would not come. It was not until 8:30 p.m. that the stretcher-bearer party came. Ward was still alive.

The colonel told me that No. 21 had been evacuated. This left me in a precarious position. No. 21 commanded my rear and if the Germans occupied it they could fire straight into the back of mine. I posted men along the rear, as in a fort. We stayed in the trench until about 10:30 p.m. when we were relieved. This was my third night without sleep. We were kept in dugouts as support while our attack was repeated by another regiment. There was great loss of life. However we were finally marched home and arrived in billets about 6 a.m. I was at my limit.

We are to rest here for two or three days. I am feeling splendidly now dearest, and full of hope and confidence.

This is a time of trial but it will make life worthwhile, which it would not be otherwise. I have faith in your courage, so I tell you what I am doing. Good night now, my loving, lovable little mother.

Talbot Papineau

After the raid

The effect of the rum begins to wear off.

I try to sleep.

I cannot.

I am proud of myself. I have been tested and found not wanting.

I lie on my blanket and think of the raid. I feel quietly sure of myself. I went through all that without breaking down.

I feel colder now that the rum no longer acts.

I begin to shiver. I draw my greatcoat over my head.

I begin to shake.

"Cold," I say to myself, "cold."

My hands shake — my whole body. I am trembling all over.

"Fool," I say to myself, "fool; why are you trembling? The raid is over. You are safe. You will get an M.M. — ten days' leave in London or Paris."

I try to decide where I shall go, to Paris or to London, but the thoughts do not stick.

The shaking becomes worse. The movements are those of one who is palsied.

I begin to sob.

I am alone.

Charles Harrison

Prisoner

We now saw our first PW (prisoner of war) but could not believe what we saw. Not after what we had heard and read. He was not a square-head with a double chin on the back of his neck, a spiked helmet low on his head and a big pipe in his mouth. He was just an average young man, who could have been one of us, was neither arrogant nor cringing, showed us snap shots of what we took to be his wife and child and gave us a subject for discussion until we saw something else.

Unknown Soldier

I Don't Want To Die

I want to go home,
I want to go home,
I don't want to go in the trenches no more,
Where whizz-bangs and shrapnel they whistle and roar.
Take me over the sea
Where the Alleyman can't get at me.
Oh my,
I don't want to die,
I want to go home.

Gitz Rice

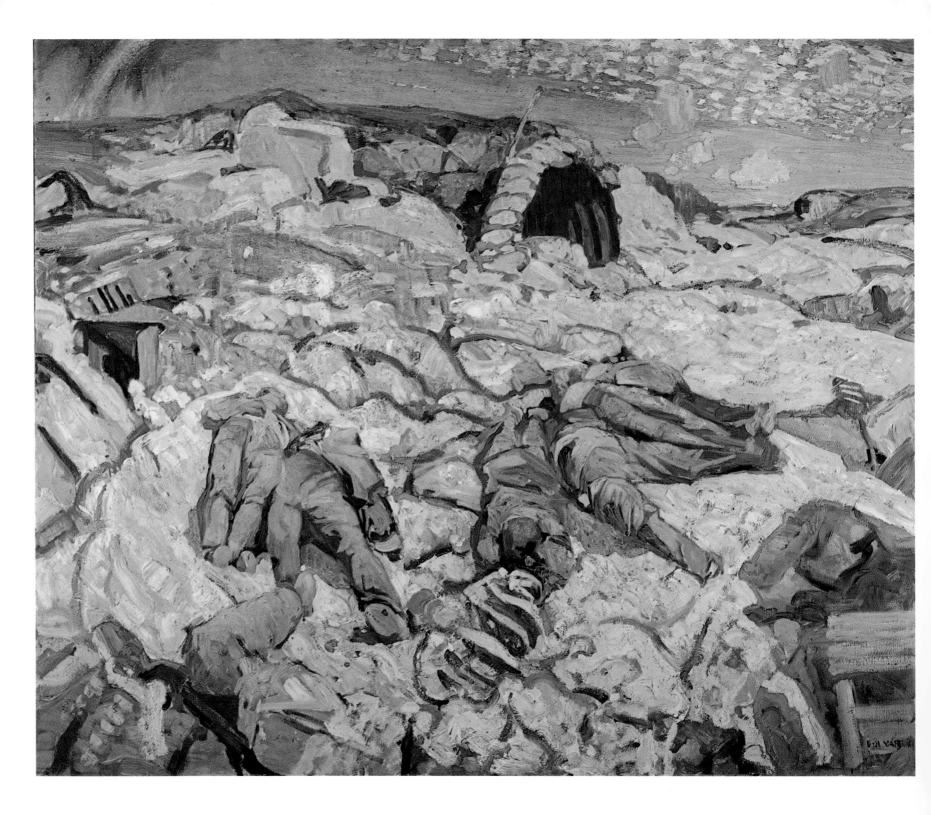

48 F. H. Varley *The Sunken Road*

Sniper

In the morning Harry and I went out, as soon as it was light, to a sniping post on the crater line. A steel plate was placed on a high point, and camouflaged on the enemy side with wire and rubbish. We swung back the small plate that covered our observing slit and watched for a victim.

It was interesting to lie there and scan the German lines through a glass that brought everything to you with startling clearness. I could see their coloured sandbags, spades lying on the parados, tiny curls of smoke from a dugout, and several times a big pot helmet bobbed along the trench, just high enough for us to get occasional glimpses.

I saw a German in full pack rise almost waist-high in a place in their trench. I was so amazed that it took me a moment to discover that during the night our guns had blown in the parapet. The German apparently was a new man to that sector, or else had grown careless of danger. He did not hurry and I tingled all over as I scored my first hit. It was not a great shot, the distance was not one hundred yards, and I had cross-hair sights, but at last I had really killed a Hun.

Harry was tickled. He rubbed his hands and noted down the facts in his book but had not finished when a second German, also in pack, rose in the same place. I shot him as soon as he appeared, as I was excited and taut on the trigger. Hardly had he fallen than a third man stepped on the piled earth, and stared all around. I shot him very carefully, aiming directly at his left breast, and through my telescopic sights could see his buttons. As he pitched down beside the others, two more Germans appeared, but they had thrown off their packs and big helmets and they flung themselves down by the broken parapet and peered toward me. One had an immense head, round, enormous, and he glared like a bull. His mate was very dark and his hair was close cropped. They remained with their chins resting on the bags, as if watching me, and Harry gripped my shoulder, "Shoot, man," he rasped in my ear, "you won't get a chance like this again."

A queer sensation had made me draw back. I handed him the rifle. "Go ahead yourself, if you want," I said, "I've had enough of this bloody game."

He seized the Ross and took quick aim and I saw the dark flush that spurted over the face of the big-headed man. He sank from view, his fingers clawing and tearing at the bags as he went. His companion ducked slowly, just escaping Harry's second shot. Then, over on the left by the wire tangle, a German got up and walked overland and he carried a big dixie. It was a cook, and it clearly proved that a new battalion was in the line. Harry shot him with great satisfaction, and then potted a third man, an officer, who stepped up on the blown-in part and waved to a working party. When he fell he first stepped back, then ahead. No other Germans came in sight, though we could see their shovels as they cleared their trench.

Will Bird

Friends

In the afternoon two of the scouts came along and told me that my chum had been killed. He was out sniping, and took too many chances and got sniped himself. I could not believe it at first, because he had been so full of life, and a big good-natured lad always playing and fooling with someone, yet he had been shot clean through the heart, and it sure made some of us feel blue and sore. I sure miss him here, for when we were here before he slept with me, and we used to go out souvenir hunting together, but he is gone.

John McNab

Philosophy of the trenches

It's all arranged for you, if there's a bit of shell or a bullet with your name on it you'll get it, so you've nothing to worry about. You are a soldier — then be one. This is the philosophy of the trenches.

Louis Keene

Second battle of Ypres

For two days we had been in reserve billets. It was four in the afternoon, and all was still and peaceful. Outside, the men lay basking in the April sunshine or indulging in games of chance and skill. Round the end of the farm building half a dozen men were kicking a football about.

On the ground a group was gathered round the royal and ancient game of crown and anchor. Here and there tattered warriors were repairing the rents in their garments caused by barbed wire, while others stripped to the waist conducted operations of engrossing interest and of a nature reminiscent of the monkey house at the zoo!

Inside, the officers employed the idle afternoon according to their various tastes: the Colonel pursued a scheme of defence; Major Meldrum busied himself with the war diary, and the Adjutant compiled a nominal roll; it was, he said, the twentieth since the formation of the regiment, and showed no signs of being more correct than its predecessors. In a corner, stretched on his blankets, the Medical Officer snored noisily and ungracefully.

The Boches suddenly appeared to have become active, and to be concentrating their attention on the neighbouring village. The football game had ceased, and the men were watching the bombardment. Big crumps were falling round the church, and roofs were being lifted, and walls tottered in a cloud of black smoke and brick dust. The church steeple went, flattened by a direct hit, and already two houses were burning.

Across the fields some men and women were running; they were part of the civilian population. All honour to them; they had stayed by their firesides up to the last moment, hoping against hope that their homes might be spared, and now with a few personal effects they went their way, blown as straws before the devastation that was like to destroy their all. As they fled, puffs of smoke appeared above them in the sky. Two of them, a man and a woman, paused in their flight; they seemed to crumple and collapse, shutting up as does a footrule: they were the first fruits of the German shrapnel. The woman rose and staggered on—evidently she was grievously stricken; the peasant lay where he fell.

Other figures detached themselves from the buildings or appeared over the crest of the hill above it; some were running, others seemed scarce able to walk. As they approached, we recognized they were not civilians: their dusky faces and uniforms were those of the French colonial troops. They came to us across the fields, their faces blue beneath their tan, and breathing hard as though from running. Most of them were wounded, and gasping; struggling for breath, they tried to tell us, in a language which our French scholars could not understand, of some terror that lay behind them.

Brigade Headquarters were on fire, the thatched roof burning merrily and the sparks driving toward us, borne on the light east wind. Something else came to us carried also by the evening breeze. At first a faint, sour pungency, that dried our mouths and set us coughing. Over there to the northeast something was happening, something that we gained a slight suspicion of, from the terror-stricken brown faces of the swarthy soldiers of France, who still continued to arrive in twos and threes.

With a rattle and clash a limber hammered up the road, the horses stretched to a gallop, their drivers bending low and their sergeants urging them on, all heedless of the shrapnel bursting overhead.

Another and another limber followed; this was the food for the guns, and loudly they clamoured for it, calling for more and yet more again. Orderlies rattled along the road on motorcycles, bearing messages through the tornado of flying metal, while here and there signallers, with fine contempt of danger, mended the broken telephone wires.

In the clamour of destruction, amid the wild shriek of the flying shell and the roar of guns, a new sound mingled; it was the sharp rattle of rifle fire.

With our equipment on, we stood waiting, watching the racing limbers, the flying cyclists, and the wounded black men who still staggered by. The rifle fire had increased to a continuous patter, and now the shells began to search for

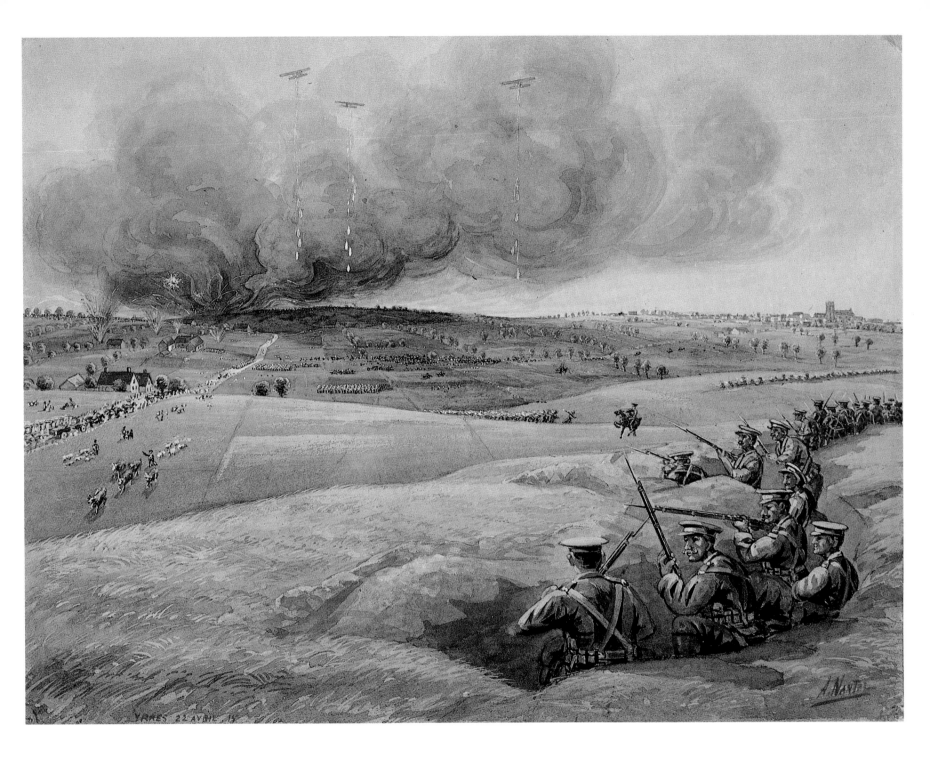

Arthur Nantel *7 A.M., April 22nd, 1915* 51

our farmhouse. Large ones roared overhead, flying on a more distant journey, to fall with a crumping thud on the city behind us. Now the something which had come to us before was wafted to us again, bringing the tears to our eyes, gripping us by the throat, and setting us catching our breaths. And with it came a Highlander, one of our own Canadians, bleeding from a wound in the shoulder, pale and gasping. Never did the bearer of the fiery cross carry tidings so urgent. "The Germans are attacking; they're all over the place; we're being suffocated by gas."

Herbert Rae

To the last man

"Gas? What are they talking about," I ask myself.

Something must have gone wrong up front. This looks like a retreat. We have never been in a retreat before and I wonder what we are supposed to do.

"Fall in, on the double," comes the order.

Extra bandoliers of cartridges are issued and we march away in the darkness, stumbling through fields and across small streams.

We plod on through the night. By dawn we reach a stretch of open country across the Ypres canal and are ordered to dig in.

The shell fire is letting up. Maybe it's all over. I hope so, anyway.

What's this coming toward us? Looks like a panic. They're in uniform, but who are they? Where's their rifles? What's the matter with 'em? They look like ghosts, their skins a grey color and their eyes fairly bulging out of their sockets. What's that they're trying to say? Gas!

"Gas! Gas!" is all we can make out above the hubbub of their terror. "What the hell's the matter?" we jeer at them. "Lost yer nerve?"

"Gas! Gas!"

Damn cowards, we think as they stream past. But gas or no gas, we are told to go on. Orders are passed down the line for us to rush across the open space in dashes of one hundred yards, with one minute intervals of lying flat on our faces. That's going to be tough.

The signal comes and we hop off. We cover about five hundred yards when all hell lets loose. Shells burst over our heads, sending deadly fragments in all directions. We are running into a hail of machine gun and rifle bullets.

"Forward," command our officers ahead of us. We keep on going. Ahead of me I see men running. Suddenly their legs double up and they sink to the ground. Here's a body with the head shot off. I jump over it. Here's a poor devil with both legs gone, but still alive.

My hand feels as if it were hit by a club and there's a burning sensation in my fingers. A bullet has seared them and smashed the grip of my rifle. I drop the useless weapon. There's a dead Tommy. He'll never need his rifle again, so I pick it up without stopping.

My brain is in a whirl as at last we reach the embankment which affords fairly good cover. Here we drop under protection of a ridge and try to collect our scattered senses. We have lost more than half our battalion. Well, I am still alive. It is our first real battle. Orders come to hold the ridge against all further advance of the enemy, to hold it to the last man.

George Bell

German attack

Suddenly the hedge that fronted the trench across three hundred yards of open was alive with grey-blue figures.

"Here they come!" shouted Major Hill. "Rapid independent! Give them hell!"

Across the open space the attack came, not in dense masses as we had been led to expect, but line on line, like waves in an advancing flood. No wild charge of cheering warriors, and without the glorious rush of battle, they came on methodically and silently, as men with a duty to be performed in which they took small delight. It was a magnificent example of their discipline.

Every man had his greatcoat rolled up; we saw their water bottles and their haversacks hanging as if on parade. Across the fields they stumbled forward, running clumsily with their fat legs and ridiculous boots. And behind each line we saw their officers urging them on. From the trench our rifles cracked and machine guns spat; before the hail of bullets the Germans fell. Soon the field was spotted with fallen figures, some lying still, others trying to crawl away. But still they came on. Now we could see their features and count the buttons on their tunics as they lumbered forward. Down the road towards our lines, blowing what, presumably, was the charge, came a German bugler. A platoon must have hit the life out of him with a splash of rifle bullets.

Now the wave lapped against the edge of our trench. Suddenly a fat German, with bulging eyes, recognizing death staring at him across the mud bank, turned to fly. A bullet caught him on the buckle of his waistbelt, causing his equipment to fly apart as it passed onwards on its way. A huge red-headed warrior, his mouth open and breathing hard from running, got it square between the eyebrows; the force of the rush carried him onward to fall against the parapet, where he lay, the back blown out of his head and with a look of mild surprise upon his face. One or two rushed the parapet, but they were not fighters, and fell like sheep on the points of our bayonets.

The attack had failed for the moment, but at any time it might be renewed.

At headquarters the Major waited for news. The signal wires were cut; wiremen, sent out to repair them, never returned. Orderlies despatched with messages turned up days after in base hospitals badly wounded, or died before delivering their missives. The thatched roof of the orderly room was burning; the end of the low house, hit by a salvo, tottered and fell with a crash, and the Major and the Adjutant moved into the medical dressing room in search of healthier quarters.

Outside the building the bullets pattered on the walls like hail. The Germans in a wood to our left had turned a machine gun on the dressing station door, and repeated flights of bullets flicked inside, knocking the plaster from the walls, and rattled on the brick floor.

From the front line came a message from Major Hill: "Evening's infantry attack repulsed. We are now being shelled heavily. Our casualties heavy. We are holding on."

The room was filled with dying and badly wounded men; trampled straw and dirty dressings lay about in pools of blood. The air, rank with the fumes of gas, was thick with the dust of flying plaster and broken brick, and stifling with the smoke from the burning thatch.

Yet in the stench of that foul atmosphere, reeking with a host of horrors, with the earth trembling and the roar of battle all around, the wounded, lying with the dead, made no complaint.

"Any sign of reinforcements?" asked the Major. The Adjutant, watching the highroad leading up from the city, and seeing no sign of help, answered in the negative. The Medical Officer, remembering a nursery story — it is strange how these things come to one — murmured:

"Sister Ann, Sister Ann, do you see anybody coming?"

In the front line the German artillery had again taken up the tune, pounding the flimsy earthwork and bringing death to its occupants. Again the storm lifted, and again the blue-grey uniforms swarmed across the intervening ground to meet the thin but waiting line of khaki.

A wounded man arrived at headquarters, blood streaming from a cut on his forehead. "The Germans are in our trenches." As he delivered the message, the machine gun, waiting in the wood, caught him on its whirring blast and crumpled him up on the threshold. Crash! A shell hit the outside wall with thundering impact. Outside, remnants of our battalion were retiring, taking what cover they could, loading magazines and firing coolly and carefully.

The wounded were got out, as many as could limp and hobble; others were hastily borne away on stretchers; the remainder, who were dying, were placed in dugouts so as to escape the worse death from burning.

The battalion took up a new line, all that was left of them.

Herbert Rae

Resting place

It was a perfect morning, hot enough for summer, but with all the freshness of spring. The whole land was covered with luxuriant growth, for there is not a soul to till the ground. Everywhere was luscious green grass, full of tall buttercups and cuckoo flowers. The ditches contained masses of a large white stellaria, that looked singularly beautiful against the lovely green of the grass. The birds were in full song; all nature was smiling.

While the bearers were getting the patient ready I went into the little garden at the back of the aid post. The place had been converted into an English cemetery; there were fifteen or twenty crosses, several of them bearing the names of friends of mine, and five open graves were standing ready waiting for the dead of the day.

William Boyd

In Flanders Fields

In Flanders fields the poppies blow
 Between the crosses, row on row,
 That mark our place; and in the sky
 The larks, still bravely singing, fly
Scarce heard amid the guns below.

We are the Dead. Short days ago
We lived, felt dawn, saw sunset glow,
 Loved and were loved, and now we lie,
 In Flanders fields.

Take up our quarrel with the foe:
To you from failing hands we throw
 The torch; be yours to hold it high.
 If ye break faith with us who die
We shall not sleep, though poppies grow
 In Flanders fields.

John McCrae

The mouth of hell

It was a perfect night, brilliantly clear, starry, and absolutely still. Not a sound was to be heard save the croaking of the frogs. Suddenly we emerged from the tangled undergrowth onto the bare summit of the hill, and sat down at the foot of the ruined tower. The scene that met our eyes was so solemn, so awe-inspiring that all conversation between us ceased.

For at our feet lay Ypres, burning furiously. The great cloud that hung above it was now glowing as if some vast furnace was burning in its midst, but the cloud itself appeared to be absolutely motionless. Now and then great tongues of flame would leap up from the doomed town, but apart from these the whole impression was one of rest, immobility. We felt that we were looking at some painted scene, or watching a vast stage where some lurid Mephistophelian drama was being enacted. Here and there along the line a star shell would go up and, bursting, light the landscape with a garish flare.

Overhead were the quiet stars. Nothing broke the great silence, save now and then the deep, rich, solemn b-o-o-m of a big gun far away up north, with, perhaps, an occasional crackle of rifles near at hand. But, as we sat, the stillness of the night was broken by the song of a bird, faint and hesitating at first, but gradually gathering volume, till the whole air was throbbing with the melody. It was a nightingale singing in the wood below. We sat on, and on, and on. The whole town was glowing like the mouth of hell. Now and again some roof would apparently fall in, and the great hungry tongues of fire would lick the sky, but at our distance no sound broke the awesome stillness — only the song of the nightingale and the booming of guns.

William Boyd

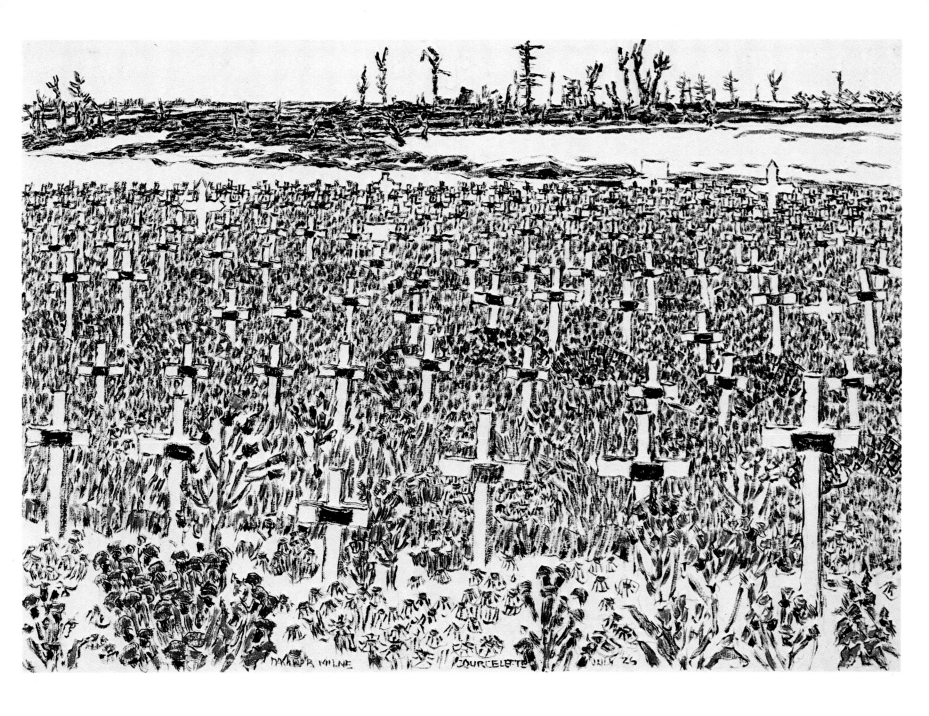

David Milne *Courcelette from the Cemetery* 1919 55

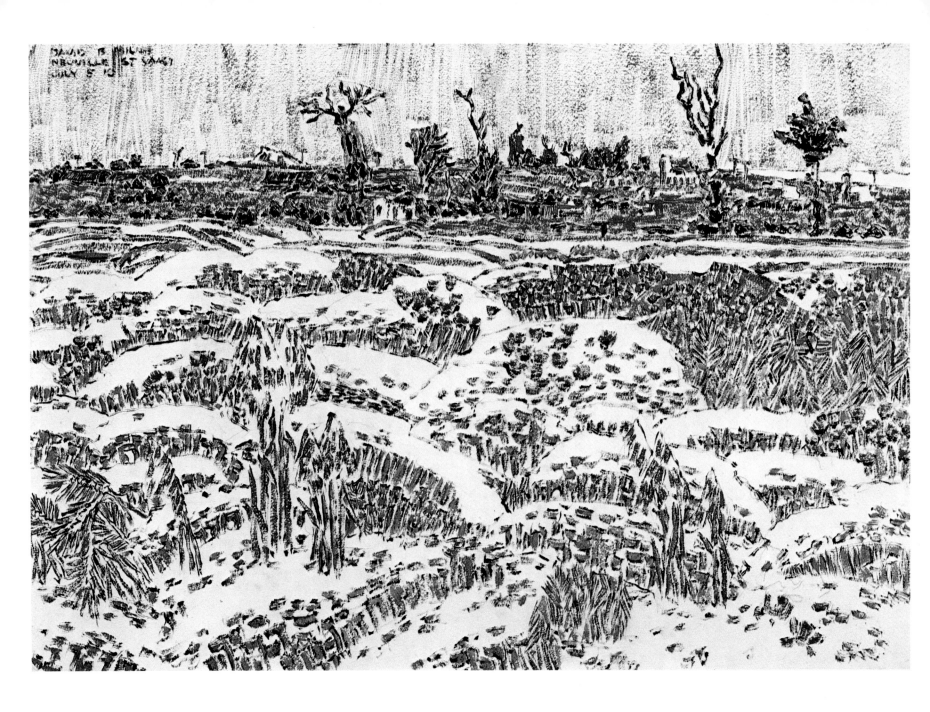

56 David Milne *Neuville-Saint-Vaast from the Poppy Fields* 1919

Lunch party

Though there is a cool wind the sun shines warmly through the trees now and then and there is almost a suggestion of spring in the air. Yesterday we had a lunch party outside. A small table, one chair, one ammunition box, one biscuit box and a pile of pine boughs. We had turtle soup, then toast and potted grouse and cold tongue, then a nice raisin pudding with strawberry preserves and Devonshire cream. After luncheon we played bridge! Stray bullets whistle through the trees but do no harm. As I write a German battery is firing and the shells are shrieking overhead. Our luncheon was twice disturbed by shells and we cut for shelter.

Talbot Papineau

Officers' mess

It was a French home that had escaped damage with the exception of losing one corner of its roof, and was now an officers' mess. They were having lunch. A table was spread with a white cloth. On it were real dishes, a bowl of roses, tall bottles with expensive labels. The officers were in slacks, clean clothed and their batmen hovered about arranging seats for them.

It was too much for us to watch. We went out front and saw the men lined up for their meal. They carried dirty mess tins and were issued with a ladlefull of greasy mulligan in the tin tops, and weak-looking tea. They sat around the ruins and ate wherever they could squat, without speaking, hurriedly, as if they hated the business. Some emptied part of their issue on the ground and scrubbed their mess tins with bits of sandbags as they shambled off to where they slept.

Will Bird

Provisions

All of our provisions came up to the front line in sandbags, a fact easily recognizable when you tasted them. There is supposed to be an intention to segregate the various foods, in transport, but it must be admitted that they taste more or less of each other, and that the characteristic sandbag flavour distinguishes all of them from mere ordinary foods which have not made a venturesome journey. As many of the sandbags have been used originally for containing brown sugar, the flavour is more easily recognized than actually unpleasant.

Alex McClintock

Cuisine

We live mostly on bully beef and hardtack. The first is corned beef and the second is a kind of dog biscuit. We always wondered why they were so particular about a man's teeth in the army. Now I know. It's on account of these biscuits. The chief ingredient is, I think, cement, and they taste that way too. To break them it is necessary to use the handle of your entrenching tool or a stone. We have fried, baked, mashed, boiled, toasted, roasted, poached, hashed, devilled them alone and together with bully beef, and we have still to find a way of making them into interesting food.

Louis Keene

Versatility

Hardtack makes an excellent fuel, burning like coke and giving off no smoke. We usually saved enough hardtack for our jam, and used the rest to boil our tea.

Alex McClintock

Respite

It is warm and Fry has discovered a little stream about three kilometres from the village. We decide to go swimming. About ten of us set off across the fields. It is late afternoon and the sun slants down upon us as we shout and laugh.

We have nearly lost that aged, harassed look which we wear when we are in the line. We are youngsters again. Most of us are under twenty. Anderson is the only matured man among us. He is forty.

We reach the little river. It is lined with tall bushes and here we tear off our uniforms. Broadbent is the first to undress and plunges into the water with a loud splash, the kind known to boys as a bellywopper. His body is fair and lithe.

During the long winter months in the line bodies did not exist for us. We were men in uniform; clumsy, bundled, heavy uniforms. It is amazing now to see that we have slim, hard graceful bodies. Our faces are tanned and weather-beaten and that aged look which the trench gives us still lingers a bit, but our bodies are the bodies of boys.

We plunge naked into the clear water, splashing about and shouting to each other. Only Anderson does not undress fully. He wears his heavy grey regulation underwear. We tease him. He walks gingerly to the water's edge and pokes a toe into the stream. Fry creeps up behind him and shoves him splash into the water. We shout and yell and come to his rescue, dragging him to the bank. Broadbent starts to undo his underwear.

Anderson fumes, sputters and strikes out. His face is red and he shouts deadly threats. We laugh and leap into the water.

We duck one another and throw water into each other's faces. A few lads from the village stand on the bank and look at us in silence. They have the faces of little old men. We motion to them to join us but they shake their heads gravely.

Who can describe the few moments of peace and sunshine in a soldier's life? The animal pleasure in feeling the sun on a naked body. The cool, caressing lapping water. The feeling of security, of deep inward happiness. . . .

In the distance the rumble of the guns is faint but persistent like the subdued throbbing of violins in a symphony. I am still here, it says. You may sleep quietly at night in sweet-smelling hay, you may lie sweating under a tree after drill and marvel at the fine tracings on a trembling leaf over your head, but I am here and you must come back to my howling madness, to my senseless volcanic fury. I am the link that binds you to your future, it mutters.

But the water is cool and inviting and the afternoon grows older. The stream gurgles and swishes against the bank on which we stand. I shake the thought of the guns from my mind.

Charles Harrison

Murderous business

I want to get to bed and just lie there and do nothing and think of nothing. I am the only officer now who has been through the whole show out of forty and I don't suppose there are twenty men out of 1200 who have been through it either. This is just pure wonderful luck so it is no boastfulness to mention it. However it may explain my present feelings.

I hate this murderous business. I have seen so much death — and brains and blood — and marvellous human machines suddenly smashed like Humpty Dumpties. I have had a man in agony bite my finger when I tried to give him morphine. I have bound up a man without a face. I have tied a man's foot to his knee while he told me to save his leg and knew nothing of the few helpless shreds that remained. He afterwards died. I have stood by the body of a man bent backward over a shattered tree while the blood dripped from his gaping head. I have seen a man apparently uninjured die from the shock of explosion as his elbow touched mine. Never shall I shoot duck again or draw a speckled trout to gasp in my basket — I would not wish to see the death of a spider.

Talbot Papineau

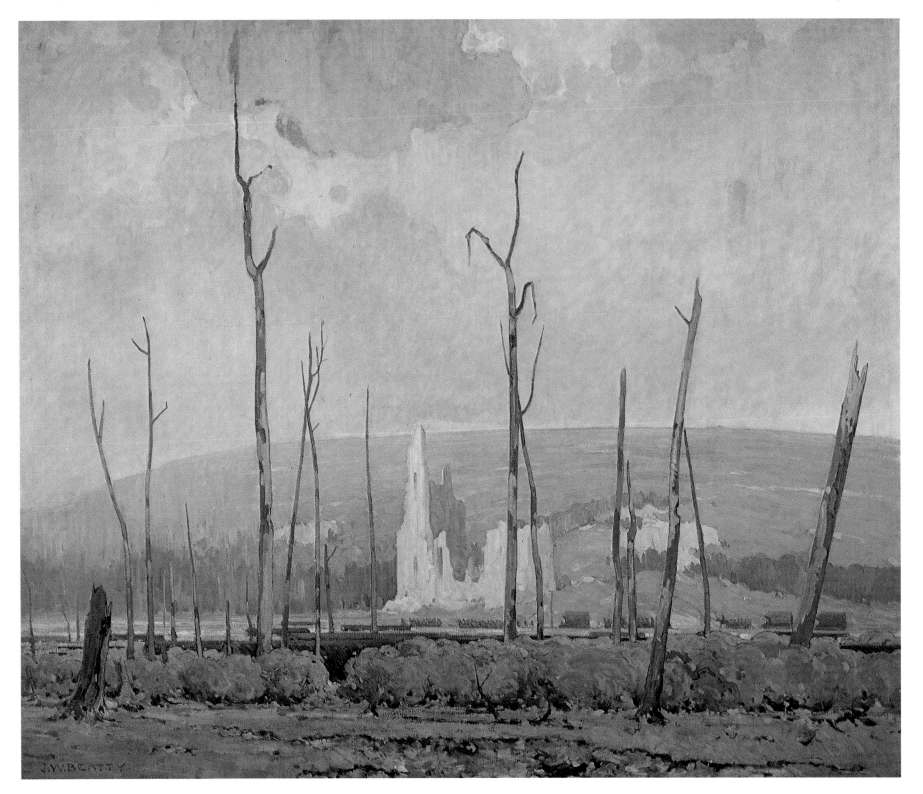

J.W. Beatty *Alblain Saint-Nazaire* 59

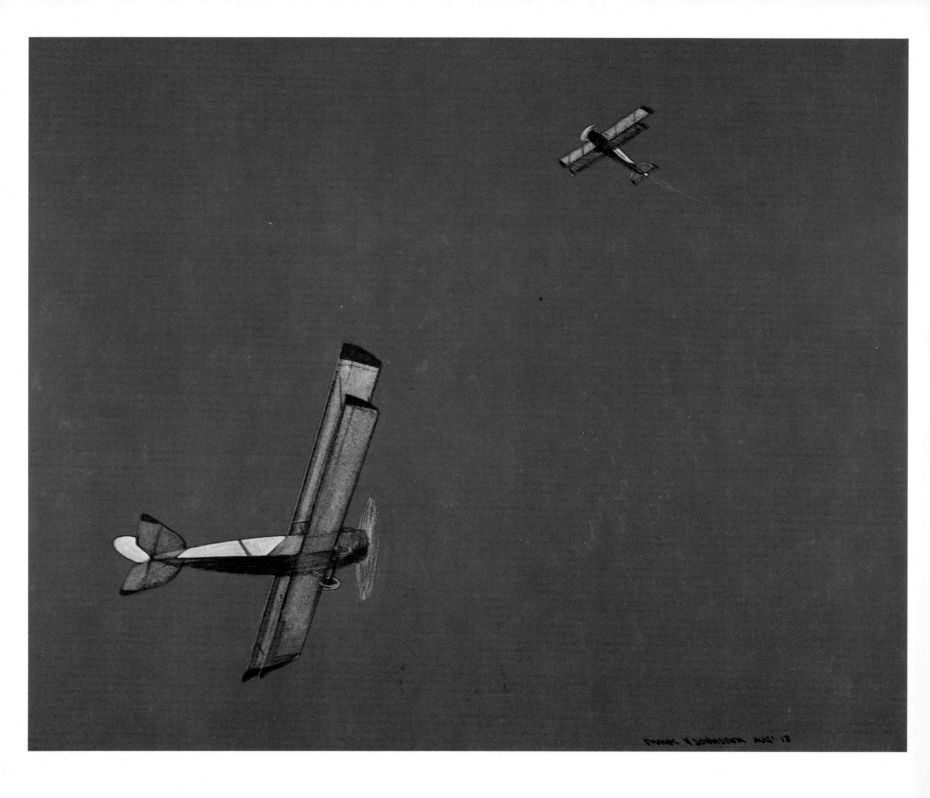

60 Franz Johnston *Looking up into the Blue* 1918

Cavalry in the sky

A German aeroplane has been hovering over our positions looking for my gun, so we have stopped firing and all movement. I know just how the chicken feels when the hawk hovers over it. Few people realize how much aeroplanes figure in this war, for war would be much different without them. They do the work of cavalry, only in the sky. Whenever they come over, the sentries blow three blasts on their whistles and everybody runs for cover or freezes; guns stop firing and are covered up with branches made on frames. If men are caught in the open they stand perfectly still and do not look up, for on the aeroplane photographs faces at certain heights show light; dugouts are covered over with trees, straw or grass. We use aeroplane photographs a great deal; they show trenches distinctly and look very like the canals on Mars.

Later in the evening from a trench we had the satisfaction of seeing another aeroplane set on fire, burn, and drop into the German lines like a shot partridge.

Louis Keene

Clouds

An aeroplane had been coming up behind us, and continued to make for the German lines, soon dwindling to a mere black dot against the brilliant blue of the sky. Suddenly, in a flash, in the twinkling of an eye, a little white ball about the size of your hand appeared against that brilliant blue close to the aeroplane. One moment there was nothing but the immense blue dome, the next, although you heard nothing and saw nothing coming, there was that little fleecy cloud hanging high in mid-air.

The appearance of the first puff of pure white shrapnel smoke against the deep blue of a cloudless sky is one of the most dramatic things you can imagine. The contrast in colours is perfect. You never get the same dazzling absolute white in a cloud, nor do you get a tiny isolated cloud against the great expanse of blue.

The aeroplane was travelling at a good speed, and soon there was a long string of little white clouds to mark its course. Now and then we lost sight of it, and would fear that it had been hit, but on listening intently we could hear the faint drone of the engine coming down from the great height. Suddenly it made an abrupt right-angled turn, thus indicating the position of the hostile battery it had been observing, and a moment later our big guns began to speak. And all around us were hyacinths and speedwells and forget-me-nots, and the red sun sinking in a golden splendour in the west. And still the shrapnel burst around the aeroplane, and still those great columns of black smoke rolled up from burning Ypres.

William Boyd

Ace flyer

One day I saw a single enemy scout flying at a tremendous altitude. I climbed up carefully some distance from him, and got between him and the sun; then, waiting until he was heading in exactly the opposite direction, I came down with tremendous speed and managed to slip underneath him without even being seen. I could make out each mark on the bottom of his machine as I crept closer and closer. My gun was all ready, but I withheld its fire until I came to the range I wanted—inside of twenty yards. It was rather delicate work flying so close under the swift Hun, but he had no idea that I was in existence, much less sitting right below him. I carefully picked out the exact spot where I knew the pilot was sitting, took careful aim, and fired. Twenty tracer bullets went into that spot. The machine immediately lurched to one side and fell.

I had quickly to skid my machine to one side to avoid being hit by the falling Hun. After he had passed me a little way, I saw him smoking. Then he burst into flames. That pilot never knew what happened to him. Death came to him from nowhere.

Billy Bishop

Winter at Vimy ridge

Everything had frozen and no working parties moved anywhere. The ground was like rock. We moved constantly while on our rounds, as it kept us warm, but the sentries huddled in their corners and grew stupid from the cold. Several of them went to sleep on duty.

Our rifles had to be kept clean, and our feet rubbed with whale oil to prevent frost bite, but there was no shining of brass and buttons. At one point we found a Lewis gun crew asleep, every man, and for a joke removed the gun, hid it, and wakened them by throwing bits of chalk. I do not think they went to sleep again when on post.

I saw one of our draft asleep, and wanted to wake him, but the officer making his rounds reached him first. He shook the fellow and then talked with him in a low voice, telling him the usual penalty for such neglect of duty. That man never forgot his lesson, or the kindness of the officer.

We could hear plainly the Germans coughing in their trenches, hear them walking on frozen boards, and hear the creaking of a windlass drawing chalk up from some dugout. The first night passed uneventfully. At daylight we put up small periscopes on slivers stuck in the sand-bagged parapet and watched in them till dark. Several times during the day we heard "fish tails" and "darts," German grenades, going over into our lines, but none came near us.

The next night I saw my first uncaptured German. I had looked at prisoners in the cages back of the lines, and saw their queer top boots and gray uniforms with the two buttons at the back of the tunic, but now I had seen a real enemy. He was only a boy, and he was standing waist high above his trench wall as one of our flares burst directly above him and placed him in dazzling light.

He did not move at first, but his face looked very white and ghostlike, and then I knew that he had seen me for I was standing as high as he on our side. Some wild impulse caused me to wave to him—later I would not have done it—and he waved back.

Will Bird

Tough guys

Marching through the sloughed-up mud, through shell holes filled with putrid water, amongst most depressing conditions, I saw a working party returning to their billets. They were wet through and wrapped up with scarves, wool helmets, and gloves. Over their clothes was a veneer of plastered mud. They marched along at a slow swing and in a mournful way sang —

Left — Left — Left
We — are — the tough Guys!

Apparently there are no more words to this song because after a pause of a few beats they commenced again —

Left — Left — Left —

They looked exactly what they said they were.

Louis Keene

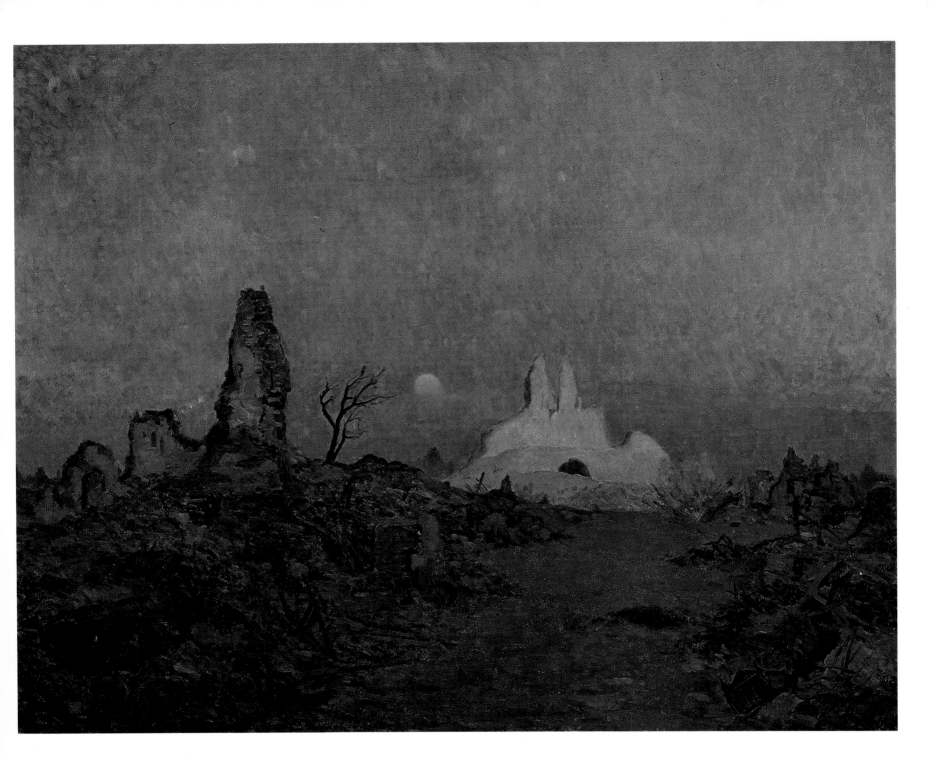

Maurice Cullen *The Sunken Road, Hangard* 1918

64 Arthur Nantel *Christmas Eve in Giessen Camp*

Noël

It was not a cheerful Christmas Eve. The roads were flooded with water, and the transports that were waiting for the relief were continually getting tangled up with one another in the darkness. To make matters worse, I was met by a sergeant who told me he had some men to be buried, and a burial party was waiting on the side of the road. We went into the field which was used as a cemetery, and there laid the bodies to rest.

The Germans had dammed the river Douve, and had flooded some of the fields and old Battalion headquarters. It was hard to find one's way in the dark, and I should never have done so without assistance. The men had acquired the power of seeing in the dark, like cats.

A battalion was coming out and the men were wet and muddy. I stood by the bridge watching them pass and, thinking it was the right and conventional thing to do, wished them all a Merry Christmas. My intentions were of the best, but I was afterwards told that it sounded to the men like the voice of one mocking them in their misery.

I determined to have a service of Holy Communion at midnight, when the men would all have come into the line and settled down. About eleven o'clock I got things ready. The officers and men had been notified of the service and began to assemble. The barn was a fair size and had dark red brick walls. The roof was low and supported by big rafters. The floor was covered with yellow straw about two feet in depth. The men proceeded to search for a box which I could use as an altar. All they could get were three large empty biscuit tins. These we covered with my Union Jack and white linen cloth. A row of candles was stuck against the wall, which I was careful to see were prevented from setting fire to the straw. The dull red tint of the brick walls, the clean yellow straw, and the bright radiance of our glorious Union Jack made a splendid combination of colour. It would have been a fitting setting for a tableau of the Nativity.

The Highlanders assembled in two rows and I handed out hymn books. There were many candles in the building so the men were able to read. It was wonderful to hear in such a place and on such an occasion, the beautiful old hymns, "While Shepherds Watched their Flocks by Night," "Hark, the Herald Angels Sing," and "O Come All Ye Faithful." The men sang them lustily and many and varied were the memories of past Christmases that welled up in their thoughts at that time.

I had a comfortable bunk in one of the dugouts that night, and was up next morning early to spend the day among the men in the line. I was delighted to find that the weather had changed and a most glorious day was lighting up the face of nature. The sky overhead was blue and only a few drifting clouds told of the rain that had gone. The sun was beating down warm and strong, as if anxious to make up for his past neglect. The men, of course, were in high spirits, and the glad handshake and the words "A Merry Christmas" had got back their old time meaning.

The Colonel had given orders to the men not to fire on the enemy that day unless they fired on us. The Germans had evidently come to the same conclusion. Early in the morning some of them had come over to our wire and left two bottles of beer behind as a peace offering. The men were allowed to go back to their trenches unmolested, but the two bottles of beer quite naturally and without any difficulty continued their journey to our lines. When I got up to the front trench, I found our boys standing on the parapet and looking over at the enemy. I climbed up, and there, to my astonishment, I saw the Germans moving about in their trenches apparently quite indifferent to the fact that we were gazing at them. One man was sawing wood. Between us and them lay that mass of wire and iron posts which is known as the mysterious No Man's Land. Further down the hill we saw the trenches of the 13th Battalion, where apparently intermittent strafing was still going on. Where we were, however, there was nothing to disturb our Christmas peace and joy.

Canon F. G. Scott

Religion

There was no greater stupidity shown, no more blind disregard of the soldier's intelligence and right to individualistic feeling, than compulsory church parades. They went because they had to go, and carried with them an instinctive defiance that no fine words of the padre could overcome. They would not and did not join in the singing. The padre himself and a few of his officers would usually struggle through "O God Our Help in Ages Past" and "Fight the Good Fight with All Thy Might." It seemed as if they did not think the soldier could possibly know any other hymns. But in the evenings, when there was opportunity, those same dumb-lipped men would go, voluntarily, to a Y.M.C.A. hut, and there fairly bring down the roof with singing that throbbed with fervour.

In their billets when in the humour they would sing rollicking songs, sentimental ditties. "K-k-k-katy," "My Little Grey Home in the West," "When You Come Home, Dear," and "Hello My Dearie, I'm Lonesome for You." And "Mademoiselle from Armentières" was always remembered, and the regimental march pasts were encores. *"Oh, Jock, are ye glad ye enlisted; Oh, Jock is your belly full?"* When near the "shino" boys the "forty-twas" would gently chant the rather vulgar old number about the R.C.R.s sailing away and leaving things not as they ought to be, *". . . and when they get home there'll be . . . to pay in the good old R.C.R.s."*

Yet those same singers, many a night in a cold, draughty billet, joined in hymns and sang then with all the feeling of any church choir. Padres, as a rule, were scorned, for only sincerity could live with the "other ranks," and they knew, whatever the showing, that he was not one of them. Our own padre was not disliked. Sometimes on the crater line he came at night with cigarettes and warm drinks and talked with a private, but he was apart from the men, and usually with, perhaps through circumstances, an officer whom the majority cordially hated.

Will Bird

Benediction

The main dressing station was the school house. It was a good sized building and there were several large rooms in it. Many is the night that I have passed there. In the largest room, there were the tables neatly prepared, white and clean, for the hours of active work which began towards midnight when the ambulances brought back the wounded from the front. The orderlies would be lying about taking a rest until their services were needed, and the doctors with their white aprons on would be sitting in the room or in their mess near by. The windows were entirely darkened, but in the building was the bright light and the persistent smell of acetylene gas. Innumerable bandages and various instruments were piled neatly on the white-covered table; and in the outer room, which was used as the office, were the record books and tags with which the wounded were labelled as they were sent off to the base. Far off we could hear the noise of shells, and occasionally one would fall in the town.

When the ambulances arrived every one would be on the alert. I used to go out and stand in the darkness, and see the stretchers carried in gently and tenderly by the bearers, who laid them on the floor of the outer room. Torn and broken forms, racked with suffering, cold and wet with rain and mud, hidden under muddy blankets, lay there in rows upon the brick floor. Sometimes the heads were entirely covered; sometimes the eyes were bandaged; sometimes the pale faces, crowned with matted, muddy hair, turned restlessly from side to side, and parched lips asked for a sip of water. Then one by one the stretchers with their human burden would be carried to the tables in the dressing room. Long before these cases could be disposed of, other ambulances had arrived, and the floor of the outer room once more became covered with stretchers. Now and then the sufferers could not repress their groans.

One night a man was brought in who looked very pale and asked me piteously to get him some water. I told him I could not do so until the doctor had seen his wound. I got

him taken into the dressing room, and turned away for a moment to look after some fresh arrivals. Then I went back towards the table whereon the poor fellow was lying. They had uncovered him and, from the look on the faces of the attendants round about, I saw that some specially ghastly wound was disclosed. I went over to the table, and there I saw a sight too horrible to be described. A shell had burst at his feet, and his body from the waist down was shattered. Beyond this awful sight I saw the white face turning from side to side, and the parched lips asking for water. The man, thank God, did not suffer very acutely, as the shock had been so great, but he was perfectly conscious. The case was hopeless, so they kindly and tenderly covered him up, and he was carried out into the room set apart for the dying. When he was left alone, I knelt down beside him and talked to him. He was a French Canadian, and a Roman Catholic, and, as there happened to be no Roman Catholic chaplain present at the moment, I got him to repeat the "'Lord's Prayer" and the "Hail Mary", and gave him the benediction. He died about half an hour afterwards.

When the sergeant came in to have the body removed to the morgue, he drew the man's paybook from his pocket, and there we found that for some offence he had been given a long period of field punishment, and his pay was cut down to seventy cents a day. For seventy cents a day he came as a voluntary soldier to fight in the Great War, and for seventy cents a day he had died this horrible death. I told the sergeant that I felt like dipping that page of the man's paybook in his blood to blot out the memory of the past.

Canon F. G. Scott

Quarters

All grousing was reserved for the higher-ups, the "brass-hats" and the "big bugs" responsible for everything. The men were unselfish among themselves, instinctively helping each other, knowing each other, each with a balance and discipline of his own. We endured much. The dugout reeked with odours of stale perspiration and the sour, saline smell of clothing. There was not enough water to permit frequent washing. The warmth of the men thawed the earthy walls enough to cause them to ooze water. Rats were everywhere, great, podgy brutes with fiendish, ghoulishly gleaming eyes. They came at night on the parapets and startled one so that he thrust at them with his bayonet, or crawled over him as he lay under his blanket in his bunk trying to "shiver himself warm."

Will Bird

Rats

About the only amusement we had during our long stay in the front trenches was to sit with our backs against the rear wall and shoot at the rats running along the parapet. They used to run over our faces when we were sleeping in our dugouts, and I've seen them in ravenous swarms, burrowing into the shallow graves of the dead. Many soldiers' legs are scarred to the knees with bites.

Alex McClintock

Vimy before the battle

April 8, 1917

It was very cold. The men did something perhaps they shouldn't do. They lit little fires. They had all these little wee fires but the wood was thick enough to shield us. And I saw that night Henry V at Agincourt wandering around from little fire to little fire: "And gentlemen of England now abed will curse the day they were not here." It was exactly that. That exact scene.

H.R.H. Clyne

Battle prayer

April 9, 1917

We climbed the hill, and there on the top of it waited for the attack to begin. The sky was overcast, but towards the east the grey light of approaching dawn was beginning to appear.

Far over the dark fields, I looked towards the German lines, and, now and then, in the distance I saw a flare light appear for a moment and then die away. Now and again along our nine mile front I saw the flash of a gun and heard the distant report of a shell. It looked as if the war had gone to sleep, but we knew that all along the line our trenches were bristling with energy and filled with men animated with one resolve, with one fierce determination.

I went over to a place by myself where I could not hear the other men talking, and there I waited. I watched the luminous hands of my watch get nearer and nearer to the fateful moment, for the barrage was to open at five-thirty. At five-fifteen the sky was getting lighter and already one could make out objects distinctly in the fields below. The long hand of my watch was five-twenty-five. The fields, the roads, and the hedges were beginning to show the difference of colour in the early light. Five-twenty-seven! In three minutes the rain of death was to begin. In the awful silence around it seemed as if Nature were holding her breath in expectation of the staggering moment. Five-twenty-nine! God help our men! Five-thirty!

With crisp sharp reports the iron throats of a battery nearby crashed forth their message of death to the Germans, and from three thousand guns at that moment the tempest of death swept through the air. The flashes of guns in all directions made lightnings in the dawn. The swish of shells through the air was continuous, and far over on the German trenches I saw the burst of flame and smoke in a long continuous line, and above the smoke, the white, red and green lights, which were the SOS signals from the terrified enemy. In an instant his artillery replied, and against the morning clouds the bursting shrapnel flashed. Now and then our shells would hit a German ammunition dump, and, for a moment, a dull red light behind the clouds of smoke added to the grandeur of the scene. I knelt on the ground and prayed to the God of Battles to guard our noble men in that awful line of death and destruction, and to give them victory, and I am not ashamed to confess that it was with the greatest difficulty I kept back my tears.

Canon F.G. Scott

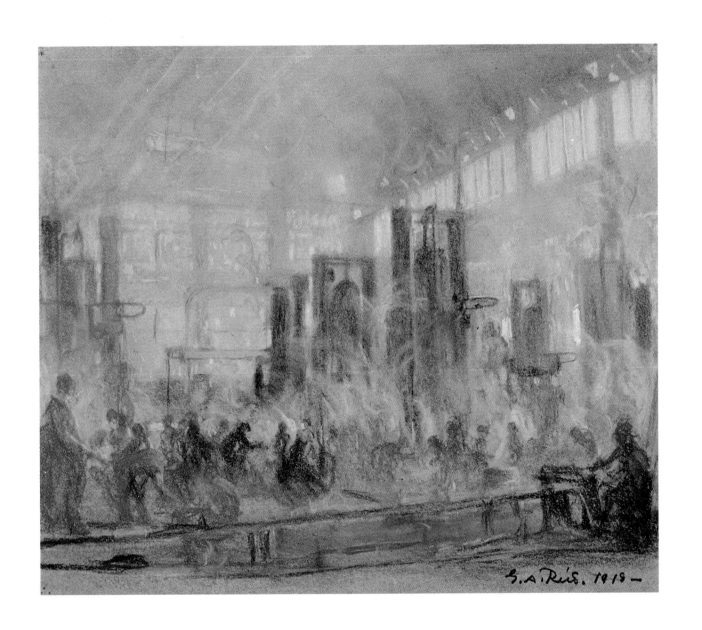

G. A. Reid *Forging 4-inch Shells* 1918　69

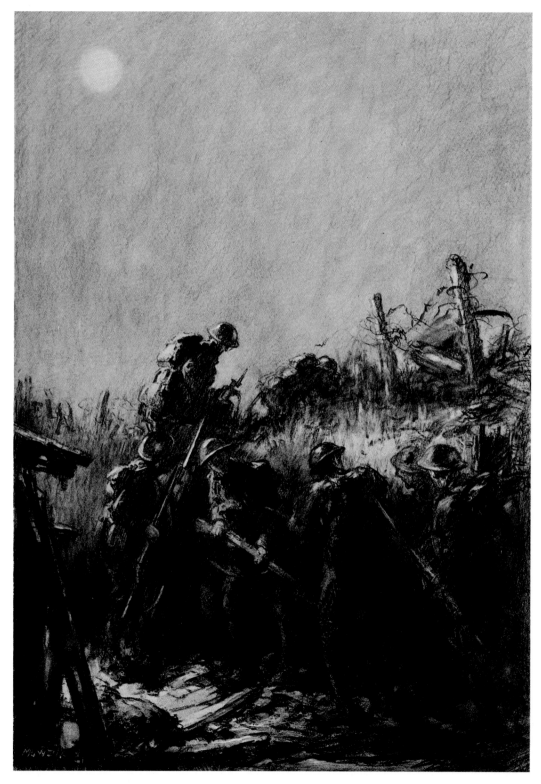

70 H. J. Mowat *A Night Raid*

Hell with the lid off

You see two walls of flame in front of you, one where your own barrage is playing, and one where the enemy guns are firing, and you see two more walls of flame behind you, one where the enemy barrage is playing, and one where your own guns are firing. And amid it all you are deafened by titanic explosions which have merged into one roar of thunderous sound, while acrid fumes choke and blind you. To use a fitting, if not original phrase, it's just "Hell with the lid off."

Going over, I was struck by shell fragments on the hand and leg, but the wounds were not severe enough to stop me. In fact, I did not know that I had been wounded until I felt blood running into my shoe. Then I discovered the cut in my leg, but saw that it was quite shallow, and that no artery of importance had been damaged. So I went on.

I had the familiar feeling of nervousness and physical shrinking and nausea at the beginning of this fight, but, by the time we were half way across No Man's Land, I had my nerve back. After I had been hit, I remember feeling relieved that I hadn't been hurt enough to keep me from going on with the men.

When we had got into the German trench and were holding it against the most vigorous counter attacks, the thought which was persistently uppermost in my mind was that I had lost the address of a girl in London along with some papers which I had thrown away, just before we started over, and which I should certainly never be able to find again.

Alex McClintock

Over the top

Once over the top and smelling the mingled odour of blood, iodine, cordite, burnt flares, powder and recently upheaved earth, the spirit of the thing seized one and in the relief at being alive and doing something, most men laughed.

Unknown Soldier

In the enemy trench

I turn a corner quickly—two grey Germans stand straight in front of me. . . . Two red flashes straight into my face—done for already!—but they haven't hit me, so now it is my turn. A snap shot at one of the two, and the other disappears round a corner. The road is free! "Come on boys, give them hell!" At the next corner a shower of rifle bullets and "sticks" whizz past my head from a machine gun post. . . . I fire away madly till my magazine is empty; then I fling down the rifle and hurl my bombs at them—the trench is chockfull of dust and smoke. Mac has come up close behind me, his shots thunder right into my ears. . . . From behind they are throwing bombs by the dozen, without minding in the least who and what they are hitting. They shout and yell: "Give them hell, boys!" The German dynamite bombs are bursting everywhere, in the trench and on the parapet. We throw ourselves flat at the bottom of the trench and are not even hit by an explosion three yards away, though a cartload of rubbish descends on our backs. Jack comes up from behind with a fresh supply of Mills' bombs. . . . "Here you are, Fritzie boy, damn you! . . . and here is another!" Ah, they have had enough, they are done for, the bastards! A couple of survivors dash off from the post, and we rush after them, tear our hands and kilts on the wire, jumping across the overturned machine gun and the dead or dying gunners, running panting and perspiring along the dry, hard trench, corner by corner . . . and then we reach the next machine gun post and throw ourselves against it, yelling and roaring, with bombs and bayonets, battle-mad —regardless of everything in the world, our whole being intent on one thing alone: to force our way ahead and kill!

Thomas Dinesen

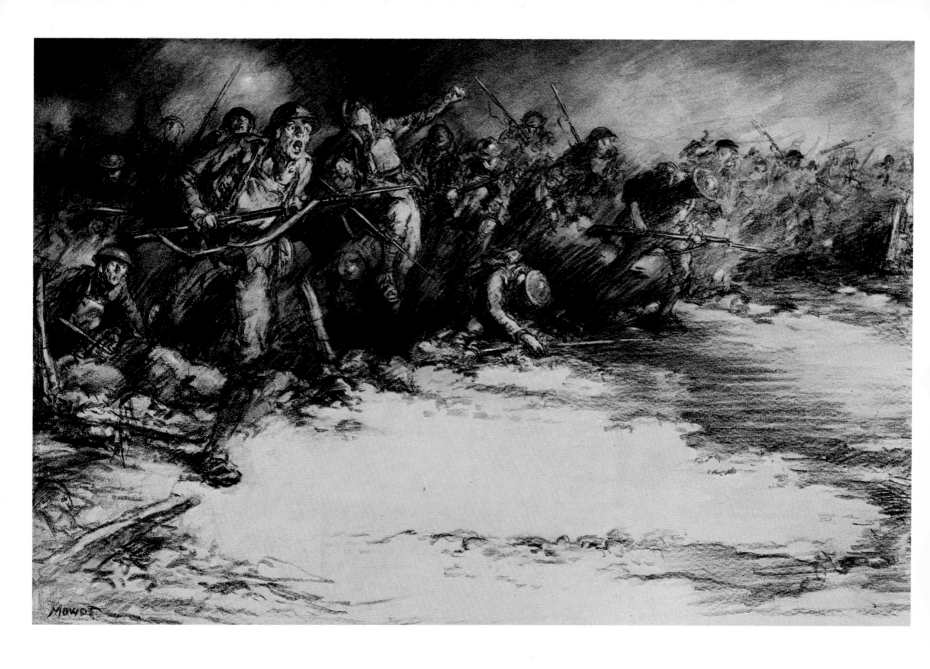

H. J. Mowat *Counter Attack*

Aftermath

We went over the Ridge just at dusk and found it a jungle of old wire and powdered brick and muddy burrows and remnants of trenches. We went off the main track that was being used and sat in a big crater to rest. Three dead men were reclining in the place, lolled back to the muddy wall, gazing incuriously before them, their faces turned black. We rose and climbed away from the place and almost stumbled over another dead man crouched in a shell hole, his rifle in his hands, squatted as if he were ready to spring.

In the twilight, just before darkness, we stood and looked down over the Ridge on the enemy side. The first flares rose, in scattered places, and we could not distinguish the lines. The air was damp and chilling, an unearthly feeling predominated. The dead man, the solitary flares, the captured ground, gave me a sense of ghosts about, and one realized the tragedy of the stricken hill. Many, many men had died on that tortured, cratered slope.

We found the platoon, and hardly recognized it. The sergeant was there, and MacDonald, but the rest were strangers. They told me that the 73rd, of the Fourth Division, had been so cut up that they had been withdrawn and the 85th Nova Scotia Highlanders had taken their place. The remnant of the 73rd had been divided between us and the 13th.

They sat in the dugout that night, after a hard day of rebuilding roads, each man suffering from bodily fatigue, and crawling vermin, and the clammy chill of mud-caked clothing, their faces brooding, enigmatic, only their eyes moving. They would not talk about the fighting and seemed utterly worn. Six months ago we had marched to Mount St. Eloi, eagerly, bravely, our tin hats askew and with a cheeky retort for every comment, hiding whatever secret apprehensions we had, not knowing the heavy ominous silence that follows the burst of big shells — and the cries of the wounded; not knowing what it is to scrape a hasty grave at night and there bury a man who has worked with you and slept with you since you enlisted.

Will Bird

To hell with tradition

In the early days we sometimes discussed death. The men of some nations are fatalists — willing to die — accept death as the will of some supreme being. The French were proud of the graduates of their military school; they advanced in line until they fell. The Guards had wavered in No Man's Land at the Somme but their officers placed stakes in the ground and formed a new line which advanced. We thought this to be perfect for opera but not for war. Our soldiers were unwilling to die like that. Go in overloaded with cigarettes, food and water — never say die — to hell with tradition — look for an opening in the barrage and go through it, in single file if need be — crawl behind a machine gun; don't wade into it — drop when a machine gun starts to traverse — if anyone is to die, let it be the enemy — go into an attack like prospectors in a gold rush, one's only thought being to get there, and stay there, living. We had two avowed fatalists; they were killed.

Unknown Soldier

Are we winning?

One question which was asked me again and again in trenches and dugouts and billets was: "Are we winning the war?" It may be hard for people at home to realize how little our men knew of what was happening. The majority of them never saw the newspapers, and, of course, the monotony of our life and the apparent hopelessness of making any great advance was a puzzle to them.

Canon F.G. Scott

Nothing matters

We march towards the city singing our smutty marching songs. Songs laden with humour — gallows humour, the Germans call it. There is something terrifying in the eagerness with which we sing these songs.

A song to forget the horror of the trenches!
A song to forget our dead!
A song to forget the unforgettable!

Our bellies are full. We have rested for a night. It is late afternoon and now we are marching towards Béthune with its wine shops, gambling dives, its safe streets — its *bordels*.

Let the thunder of the artillery boom behind us. We are marching away from it.

Seven hundred men, hard, tough, and war-bitten.
Our feet beat the rhythm for the songs.

> *Oh, madam, have you a daughter fine?*
> *parley voo.*
> *Oh, madam, have you a daughter fine?*
> *parley voo.*
> *Oh, madam, have you a daughter fine,*
> *Fit for a soldier up the line?*
> *Hinky, dinky, parley voo.*

And then the answer:

> *Oh, yes, I have a daughter fine,*
> *Fit for a soldier up the line,*
> *Hinky, dinky, parley voo.*

Mile after mile the verses are roared out with a half-terrified, half-Rabelaisian boisterousness.

Then the concluding verses.

> *So the little black bastard he grew and he*
> *grew, parley voo.*
> *The little black bastard he grew and he*
> *grew, parley voo.*
> *The little black bastard he grew and he*
> *grew,*

> *And he learned to love the ladies too,*
> *Hinky, dinky, parley voo.*

And a word for the generals:

> *Oh, the generals have a bloody good time*
> *Fifty miles behind the line.*
> *Hinky, dinky, parley voo.*

Left, right, left, right, roar the dirty marching songs:

> *Oh, wash me in the water*
> *That you washed your dirty daughter,*
> *And I shall be whiter*
> *Than the whitewash on the wall. . . .*

Left, right, left — roar the dirty marching songs.

Tomorrow we may be dead. The world is shot to pieces. Nothing matters. There are no ten commandments. Let'er go!

Charles Harrison

Women

With the girls you may use any trick, however mean and shabby — the only thing is to get what you want from them and then beat it. They tell you proudly of how cunningly they managed to hide every trace of number and name from her when leaving, so that they themselves are quite on the safe side should some consequence or other ensue from their actions. Or they come home from leave and depict how they were strolling along the Strand without a penny in their pockets, when they fell in with a woman from the streets and were helped and assisted by her in every way; and how, when a couple of days afterwards, they had spent every bit of money she had, they left her with a curse. "Oh, hell, she was only a whore, anyway!"

Thomas Dinesen

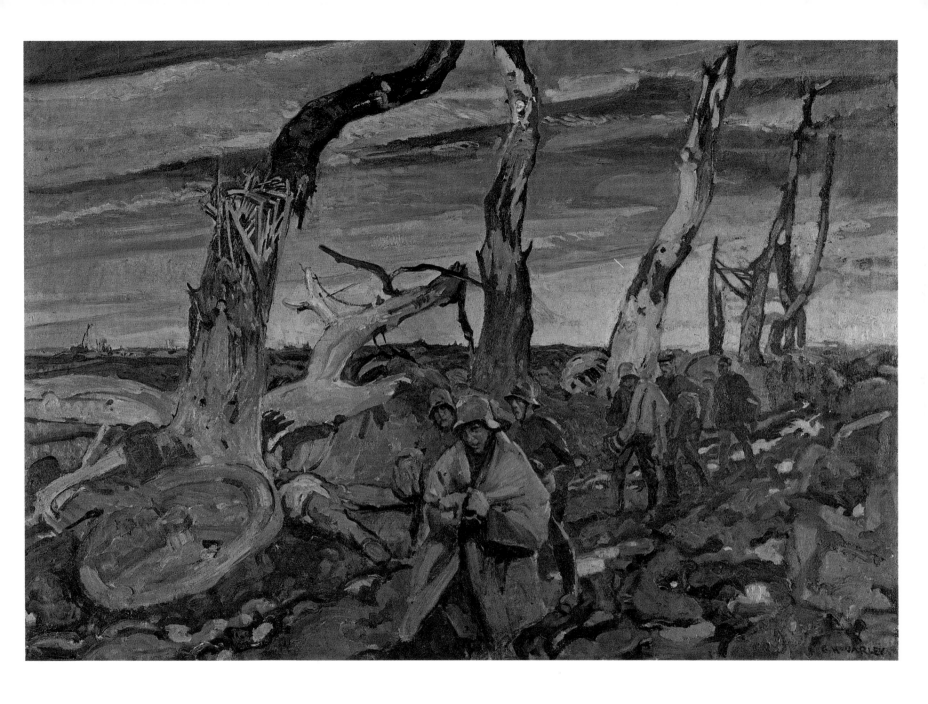

F. H. Varley *German Prisoners* 75

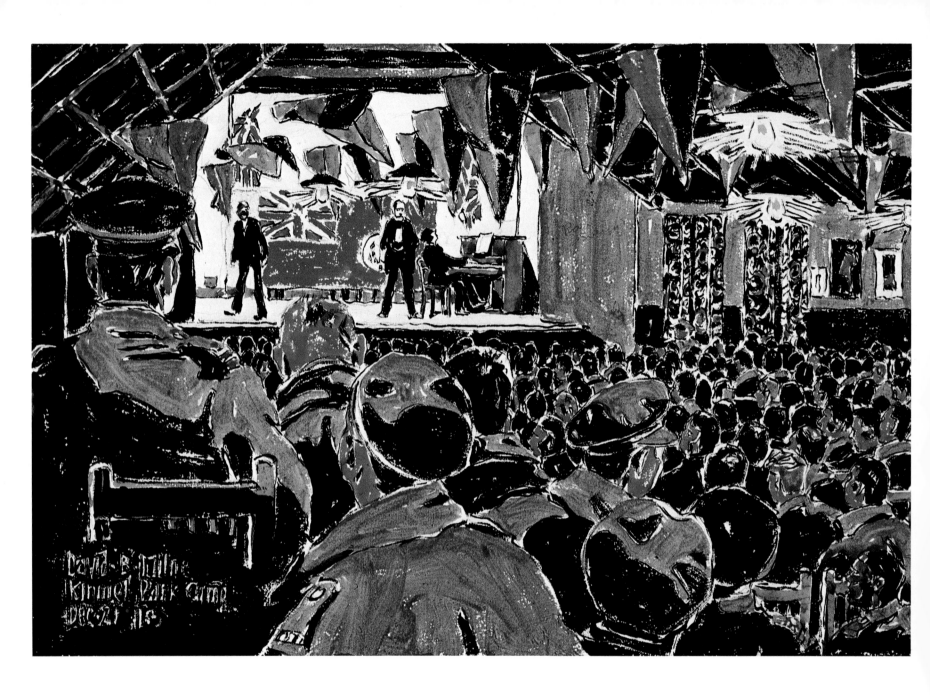

76 David Milne *Concert at the 'Y', Concentration Camp, Kinmel* 1918

Mademoiselle from Armentières

We marched to a vacant school in Armentières, fourteen miles in six hours on a cobbled road and sleet falling. My equipment and arms weighed ninety-eight pounds and I only one hundred thirty-seven. The city gave us a royal welcome — bowls of coffee, flowers, hugs, kisses and smokes. As the firing line almost surrounded the city, we had to carry a rifle and bandolier of ammunition when going for a walk or to the latrine. For thirty cents we could have seven fresh eggs, a beefsteak, a quart of fried potatoes, a pint of white wine and look at two comely wenches. I did not meet Mademoiselle from Armentières who had not been something for forty years but I was called to the Black Cat one eve to act as interpreter between a young Jock and a very attractive young thing arguing about the price (ten cents). She told me she had just saved a battalion from dying of sexual starvation. "You know," she said, "I just put it between my legs, give it a squeeze and yell 'next.'"

Unknown Soldier

The old Adam

It is rather fun sampling French cooking and drinking the excellent *vin blanc* in one of the small *estaminets*; and we are always dreaming of the sweet, pretty and kind-hearted French girl we three will meet one of these days—though I have had nothing but disappointment on this score so far! Perhaps they don't trouble themselves about a mere *poilu* like me.

When living in the trenches and amongst the ruined houses there, we take no interest in women and love beyond the usual jokes and funny stories — such is my impression, at any rate. We do not talk or think much about love-making. Life is so hard, and so full of exertion and intense excitement that all such thoughts and desires are quite imperceptibly put aside. But here, in these peaceful surroundings, with so much spare time on your hands, the old Adam of the flesh again comes to life. . . .

Most of my comrades here take every opportunity of this kind and rather make fun of those of us who are a bit more particular. Each Sunday afternoon, a long queue is formed in front of a certain house. One by one the soldiers are admitted, inflamed by the jokes and jests shouted out by the men behind them in the line, and each one is given ten minutes for the whole business.

Thomas Dinesen

Our splendid Canadians

My Very Dearest Lal:

No one wants to go into the trenches, yet no one (who is anyone) would dodge out of it. Everyone wants a soft blighty wound, with the chance of getting to where there are no whizz bangs, and you go to bed every night. Every man I have spoken to: German, French, English, Canuck, are sick to death of it; yet to quit without a definite decision is out of the question, and no one would think of it. And how on earth am I to tell you not to worry and all that; how on earth is a husband (like me) to write to a wife (like you) about his feelings on and before going into the front line of a war like this? None of us are heroes. To read of "Our Splendid Canadians" makes us ill. We are just fed up, longing for the end, but seldom mentioning it, and hoping —when we think of it—that when we do get it—it will be an easy one, or something final. Our main effort is to think and talk as little of the war as possible. The mail is far the most important thing; the next, "What's the rations to-day?" the next, "What's the job today?"

Stretcher-Bearer

An abhorrent duty

My Dear Miss Fox:

It is over a year now since I volunteered and since then life has seemed like the ball in a game of roulette trembling uncertain upon the edge of either Beginning or End. For in effect Life will be again at the Beginning if I survive — all opinions, decisions, ambitions hang suspended awaiting the verdict of chance. In the meantime I have moments of gaiety with companions — moments of sadness when I think of home—moments of terrific anxiety and responsibility—and blank black moments when I question myself, my courage and even the final success of our cause.

For awhile I thought too vividly — I pictured the home-coming — the glad celebrations which you too promise — the widened fields of action — the possible realization of some ambition—and then the wish to live became maddeningly dear—the wider my horizon—the keener my perception of self and the possibilities of Life—the more horrible appeared Death—the less I wished to put my head above the parapet and the more acute the inner throb when a machine gun barked menacingly and I thought of the time to come when I should have to charge into that rain of bullets—and then suddenly cease to be—or slowly in pain realize the the coming end of all things.

It is a great mistake for a soldier to have too keen an imagination or to allow his thoughts to dwell morbidly on his dangers. I now cultivate a sort of dare-devil careless-ness. I am not by nature intrepid, not even quarrelsome enough to make fighting enjoyable. On the contrary I shrink from the naked disclosures of human passions—I dislike intensely loss of control—drunkenness, insanity, hatred, anger—they fill me with a cold horror and dread. But to see a man afraid would be worse than all. To have to kill a man in whose eyes I saw the wild fear of death would be awful. I almost think I should stop and let the fellow kill me instead. There should be no heroism in war. No glorifi-cation—no reward. For us it should be the simple execution of an abhorrent duty —a thing almost to be ashamed of.

Talbot Papineau

Lifeline

One thing I have learned out here is how little anything that we used to think of such importance really matters. This saves a lot of heart-burning, and here, continuously face to face with death, I've come to *know* it's true. Like you, Mother dear, I think I'm coming back to you, but just now everything else in the world seems to have ceased to exist. Life, as I used to live it, is a thing of the past and just one thing has remained unchanged in this wreck of a world gone insane and that thing, the only thing that matters, the only thing that makes living possible, is love. Out of my old world there appears to be little left but you, Dad and me. Everything else seems incidental, but we are one and live in and for each other.

Armine Norris

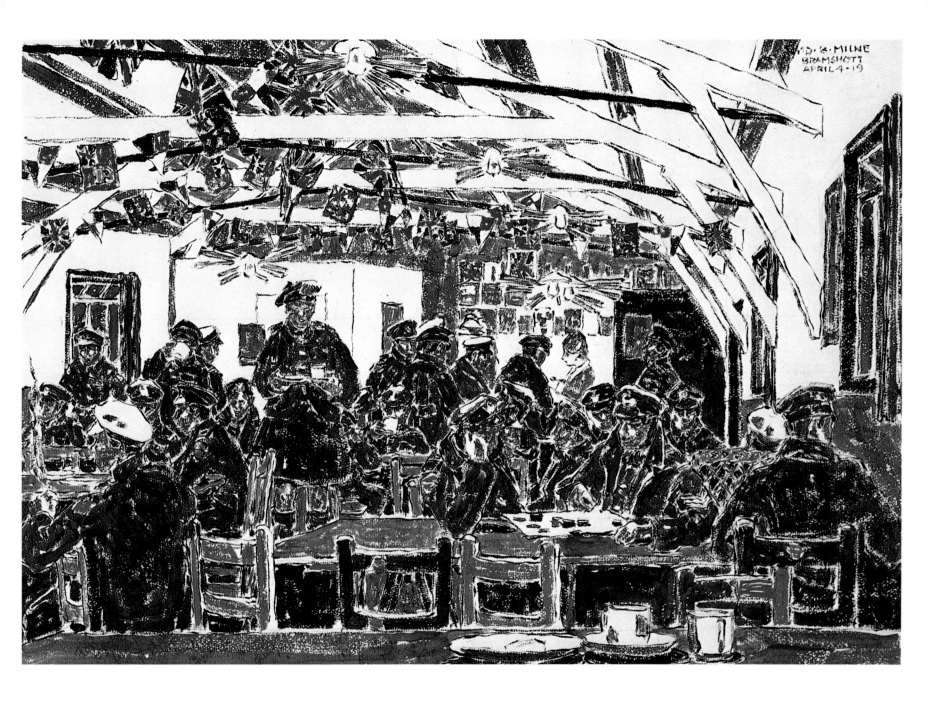

David Milne *Bramshott, Interior of the Wesleyan Hut* 1919

Virtue

The dangers and hardships roused a strong sympathy for each other. A soldier would share his last rations with a comrade, even a stranger, who was in need of them; he would always make room in a dugout for those who wanted shelter; he considered the uniform was a passport for immediate sympathy and assistance. To help a wounded man was a most sacred obligation. What caused us most distress was not the sight of corpses but that of a wounded man for whom nothing could be done. It was a prime virtue to share good things with others; a prime vice, to try to keep them for yourself. Frequently, a man would insist on sharing a dangerous mission with another, to give him what help he could. This spirit of comradeship was one of the most beautiful things in life on service.

Curiously enough, however, this virtue flourished side by side with a rather free habit of helping yourself to things which you needed, or thought you needed. To abstract equipment or articles of army issue was considered quite permissible, provided that the other man was not a member of your own group and that he suffered no serious consequences thereby. It was argued that as all the equipment was the property of the government, there was no stealing involved, but only transfer of the government's property from one person to another. Interference with purely private and personal property, however, was frowned on by public opinion; it took place sometimes, nevertheless.

It was very difficult to practise truth-telling in the army. There were infinite petty regulations, each with a penalty attached, which one could not avoid breaking frequently; and if one were caught, and the officers were small minded, one was almost forced to attenuate the truth. Again, if it were necessary to rebuke a non-com, and he made trouble over it, the only way to avoid a serious penalty was to lie out of it. Instances were known where half a dozen men stolidly perjured themselves to avoid inculpating a comrade who had discussed a non-com's deficiencies with him in the friendliest spirit. The severe penalties for trifling matters compelled a liberal disguising of the truth.

Wilfred Kerr

Inspection

You were herded like cattle into fields or yards and there stood to await the pleasure of some be-ribboned personage who gazed at one as if he were really lower in worth than a good horse. You look straight in front and the steps come closer and closer as the mighty one and his retinue go down the line, and then a cold, supercilious face is before yours, and with creaking, shining leather and immaculate khaki they pass as you try to thrust back at them a gaze of impenetrable indifference.

Will Bird

Silence

As it was forbidden to talk on parade, we whispered out of the corner of our mouths.

A platoon officer could hear a dozen men behind him whistling, but if he turned to see who it was, he would see nothing, but the whistling continued!

Unknown Soldier

Discipline

We talked about discipline, the cruelty of cartwheel crucifixion, which I had seen on the parade grounds of the R.C.R.s below Mount St. Eloi. Men, volunteers, spread-

eagled to cart wheels, tied there for hours in a biting, bone-chilling wind, all because the fellow had not shined a button or given some snobby officer a proper deference. I had seen men laden with their packs and rifles, overcoats and all, marched back and forth, twenty feet each way, to the barking of a bristled non-com, a sheer process of fatiguing the man until he was almost a wreck; and these men who had left good jobs and homes and had come, as the orators said, to fight for right and loved ones.

We were all at the mercy of authority-crazed, overfed, routine-bound staffs, old fogies with a tragic lack of imagination and a criminal ignorance of actual warfare.

Will Bird

Drunk

My servant Hinton got drunk again the other day and I had to give him twenty-eight days field punishment No. 1. At present he is out in the sun tied up with his back to a cart wheel. He gets this for two hours each day during the period of his punishment. My usual custom is to give fourteen days for the first drunk, twenty-eight for the second and any further cases are referred to court.

John Creelman

What makes a soldier?

There was a chap with us from a little town in Northern Ontario. While in Canada and England he was utterly worthless; always in trouble for being absent without leave, drunk, late on parade, or something else. I think he must, at one time or another, have been charged with every offense possible under the K.R.&O. (King's Regulations and Orders). On route marches he was constantly "falling out." I told him, one day when I was in command of a platoon, that he ought to join the Royal Flying Corps. Then he would only have to fall out once. He said that he considered this a very good joke and asked me if I could think of anything funny in connection with being absent without leave — which he was, that night.

In France, this chap was worth ten ordinary men. He was always cheerful, always willing and prompt in obeying orders, ready to tackle unhesitatingly the most unpleasant or the most risky duty, and the hotter it was the better he liked it. He came out laughing and unscathed from a dozen tight places where it didn't seem possible for him to escape.

Then there was a certain sergeant who was the best instructor in physical training and bayonet fighting in our brigade and who was as fine and dashing a soldier in physique and carriage as you ever could see. When he got under fire he simply went to pieces. On our first bombing raid he turned and ran back into our barbed wire, and when he was caught there acted like a madman. Now he is back of the lines, instructing, and will never be sent to the trenches again. We had an officer, also, who was a man of the greatest courage, so far as sticking where he belonged and keeping his men going ahead might be concerned, but every time he heard a big shell coming over he was seized with a violent fit of vomiting.

Alex McClintock

Decorations

This morning Mr. McIntosh congratulated me and I asked him what was the matter now, for I fancied something must be wrong. I had always as little as possible to do with officers and never spoke unless spoken to. He told me I had come through orders for a Military Medal. All the medals I want is a consciousness of duty done and my only souvenir, a whole skin.

Albert West

The iron hand

There is nothing which brings home to the heart with such force the iron discipline of war as the execution of men who desert from the front line. One evening I was informed that a man in one of our brigades was to be shot the next morning, and I was asked to go and see him and prepare him for death.

I went in to the prisoner, who was walking up and down in his cell. He stopped and turned to me and said, "Sir, is there any hope?" I said, "No, I am afraid there is not. Everyone is longing just as much as I am to save you, but the matter has been gone into so carefully and has gone so far, and so much depends upon every man doing his duty to the uttermost, that the sentence must be carried out." He took the matter very quietly, and I told him to try to look beyond the present to the great hope which lay before us in another life. I pointed out that he had just one chance left to prove his courage and set himself right before the world. I urged him to go out and meet death bravely with senses unclouded, and advised him not to take any brandy. He shook hands with me and said, "I will do it." Then he called the guard and asked him to bring me a cup of tea. While I was drinking it, he looked at his watch, which was lying on the table, and asked me if I knew what time "IT" was to take place. I told him I did not. He said, "I think my watch is a little bit fast." The big hand was pointing to ten minutes to six.

A few moments later the guards entered and put a gas helmet over his head with the two eye-pieces behind so that he was completely blindfolded. Then they handcuffed him behind his back, and we started off in an ambulance to a crossroad which went up the side of a hill. There we got out, and the prisoner was led over to a box behind which a post had been driven into the ground. Beyond this a piece of canvas was stretched as a screen. The firing party stood at a little distance in front with their backs towards us. It was just daylight. A drizzling rain was falling and the country looked chilly and drear. The prisoner was seated on the box and his hands were handcuffed behind the post. He asked the A.P.M. if the helmet could be taken off, but this was mercifully refused him. A round piece of white paper was pinned over his heart by the doctor as a guide for the men's aim. I went over and pronounced the Benediction. He added, "And may God have mercy upon my soul." The doctor and I went into the road on the other side of the hedge and blocked up our ears, but of course we heard the shots fired. It was sickening. We went back to the prisoner who was leaning forward and the doctor felt his pulse and pronounced him dead.

The effect of the scene was something quite unutterable. The firing party marched off and drew up in the courtyard of the prison. I told them how deeply all ranks felt the occasion, and that nothing but the dire necessity of guarding the lives of the men in the front line from the panic and rout that might result through the failure of one individual, compelled the taking of such measures of punishment. A young lad in the firing party utterly broke down, but as one rifle on such occasions is always loaded with a blank cartridge, no man can be absolutely sure that he has had a part in the shooting. The body was then placed in a coffin, and taken in the ambulance to the military cemetery, where I held the service. The usual cross was erected with no mention upon it of the manner of the death. That was now forgotten. The man had mastered himself and had died bravely.

I have seen many ghastly sights in the war, and hideous forms of death. I have heard heart-rending tales of what men have suffered, but nothing ever brought home to me so deeply, and with such cutting force, the hideous nature of war and the iron hand of discipline, as did that lonely death on the misty hillside in the early morning.

Canon F.G. Scott

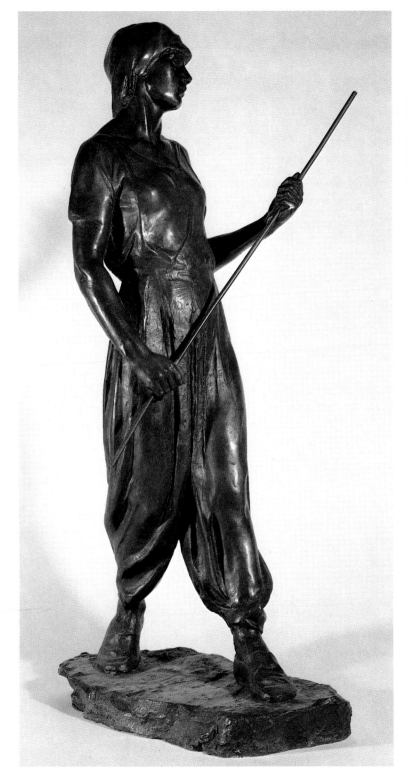

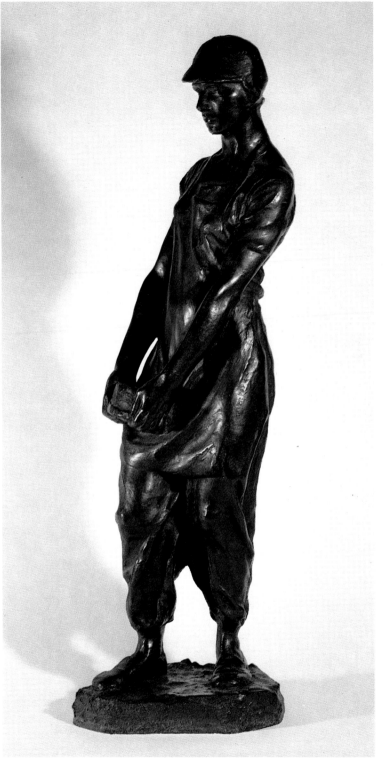

Frances Loring *The Rod Turner* Florence Wyle *Munitions Worker* 83

A Song of Winter Weather

It isn't the foe that we fear;
　It isn't the bullets that whine;
It isn't the business career
　Of a shell, or the bust of a mine.
It isn't the snipers who seek
　To nip our young hopes in the bud:
No, it isn't the guns,
And it isn't the Huns, —
　It's the MUD,
　　　MUD,
　　　　MUD.

It isn't the *mêlée* we mind.
　That often is rather good fun.
It isn't the shrapnel we find
　Obtrusive when rained by the ton.
It isn't the bounce of the bombs
　That gives us a positive pain:
It's the strafing we get
When the weather is wet, —
　It's the RAIN,
　　　RAIN,
　　　　RAIN.

It isn't because we lack grit
　We shrink from the horrors of war.
We don't mind the battle a bit;
　In fact that is what we are for.
It isn't the rum-jars and things
　Make us wish we were back in the fold:
It's the fingers that freeze
In the boreal breeze, —
　It's the COLD,
　　　COLD,
　　　　COLD.

Oh the rain, the mud and the cold,
　The cold, the mud and the rain;
With weather at zero it's hard for a hero
　From language that's rude to refrain.
With porridgy muck to the knees,
　With sky that's a-pouring a flood,
Sure the worst of our foes
Are the pains and the woes
　Of the RAIN,
　　　THE COLD,
　　　　AND THE MUD.

Robert Service

Auld Lang Syne

We're here because
We're here because
We're here because
We're here.
We're here because
We're here because
We're here because
We're here.

Nightmare

It was still raining and we were taken through the mud to battery positions. Horses and mules had drowned there as they tried to move the guns, and so ropes were used, and thirty men tugged on each one. We could not pull the guns in the usual fashion as the mud gripped the wheels, so we turned them over and over until they were in new emplacements. It was tremendous labour. We wallowed often to our armpits in mud and water mixed to porridge thickness and the only thing solid underfoot was a dead man or his equipment. As we got the guns in their new places big, black-winged Gothas came overhead and dropped bombs on us, or on the track that was some hundred yards away. There ammunition-laden mules were packed in line and I saw direct hits made on broad rumps or on the shaky planks of the "board road." More carcasses were piled beside the way, more legs to stiffen toward the skies, more bodies to distend and afford footholds for rats. Shambles of heads and heels and entrails were shovelled into the mire and the procession kept on. None of our airmen were in sight.

Then the Hun shelled us. The battery had not loosed a round before one gun was wrecked by a direct hit and two gunners killed. We went away, back to our tents, sodden, shaking with cold and exhaustion, and were cheered by steaming hot tea and mulligan. But we sat at night in the rain-soaked tents, huddled in sitting positions on floors that were pooled with icy water and the shelling kept on. We sat there in the dark, unmoving, without speaking, our brains numbed by the awfulness of everything, trying to reach a comatose state that answered for sleep. Again we moved on, this time to an area dotted with derelict rusting tanks, and on the way met remnants of relieved battalions, men who looked like grisly discards of the battlefield, long unburied, who had risen and were in search of graves in which to rest. A German airman came over, flying deliberately, one of those hawks of the Black Cross, swooped down and sprayed bullets at one of the sausage balloons above Ypres. There were forked flames, billowing smoke, a meteor of fiery fabric, charred fragments, and two swaying figures attached to parachutes. They dangled a moment and then sank from sight.

Some of the men slept in tanks. We went to one, Melville, Tommy and I, and could tip it with our weight. Water was underneath and as we rocked the monster, a head squeezed out in the muck, a face without eyes, the skin peeled as though from lard, a corpse long dead and frightful. We left the place and found a mound of solid earth, enough to make our bed, and there we stayed, between sandbagged walls, with a roof of salvaged corrugated iron.

At night we were called forth and led to a dump and there laden with sections of new-made "bath mats." All around the giant horseshoe of the Salient there were red flashes and winking glows and the misty light of flares.

We went toward the front line, past water-logged trenches, a nightmare of scummy holes, an indescribable desolation, on and on. They sky was illumined by strange flickering lights, the reflection of a thousand gun flashes, and quivered with the passage of shells. As we neared the end of our duckwalk a few flares soared up ahead of us, alarmingly near, and their fitful gleams cast strange moving shadows over the swamp. A machine gun fired nervously and bullets buried themselves with vicious thuds in jagged, fanglike stubs nearby. We hurried, then met the foremost carriers without their loads. Each man, as he came to the end of the narrow "bath mats," threw down the one he carried, butting it to that one on which he stood. Thus the path went on with amazing speed. But the boards were new and their whiteness was detected. Suddenly a hurricane of shell fire was all about us. Fortunately I was just at the end and I threw my load down, jumped around and ran. Others heaved their sections wildly and all was confusion. High explosive rained all around us—stunning, stifling, ear-splitting; everywhere there was a dead smell of gas and mud and blood.

Will Bird

The Gun

A sharp command from the misty dark,
And we brace ourselves for the big gun's bark,
For the echoing bang that splits the night,
And the sudden flash of the blinding light
That etches clear, for a moment's space
The tense, hard lines on each straining face,
Then the darkness folds like a robe again,
And the squeaking scotches groan and strain,
And we hark once more, as the orders come,
To the quivering "plunk" as the shell drives home,
To the leathery squeal as the wheel brakes jam,
To the thudding clang of the breech block's slam,
Then our palms fly up to our mud-stained cheeks,
And we close our ears as the big gun speaks.

O, the enemy search for her night and day,
And they blow up an odd estaminet
Or a couple of churches, just for fun,
But they never come nigh to the crouching gun,
For she sits secure by the battered wall,
And she bides her time while the stray shells fall,
Yes, she waits and waits till the last one rips,
With a sneering laugh on her cruel lips,
Then she wakes to life with a shattering roar,
And we feed her the shells, and she calls for more,
And she hurls them North and East and South
Like bitter oaths from her blackened mouth —
Oh, well do the enemy know their path,
And they fear our gun when she roars her wrath.

So she works for us, and we work for her,
And together we swing from ridge to spur,
And our trail lies plain to the shuddering skies
In the sanguine stream of our sacrifice;
For we stride the length of the lonely land,
And we scatter death with an open hand
To the foe as they crouch in their dugouts deep —

Be they wide awake, be they fast asleep,
Still we search them out and we mark them well
And we leave their fate to the screaming shell
That our big gun speeds on its hellish way —
Till over the town the dawn breaks grey,
And the darkness drives from the far hill crest;
Then we leave the gun for a well-earned rest.

Edgar McInnis

Fire away

We opened fire here at dawn and fired continually until night. We estimated we fired a thousand rounds per gun on this barrage. The guns got so hot that every hour they had to be stopped, one at a time for ten minutes, while we put an empty shell case in the breech, elevated the gun and poured water to cool the gun off, swabbed it out and started firing again. This kept up until morning when we got to stand down. By then we were deaf and had to have orders written. We had splitting headaches. Every time the gun fired it felt like being hit on the side of the head with a board.

Gordon Howard

No more fatigues

I stumble and fall. I jump to my feet and run a few steps. I fall again. I try to get on my feet but my right leg gives way.

My right foot feels numb. I look at it; it is spurting a ruby fountain. The top of the bubbling stream glistens in the sun.

I feel empty inside, nauseous.

I am frightened.

As though speaking to a stranger, I say:

"My God, I am wounded." I look at the blood with surprise.

I roll into a shell hole for safety.

Our guns are hammering into the valley below. They

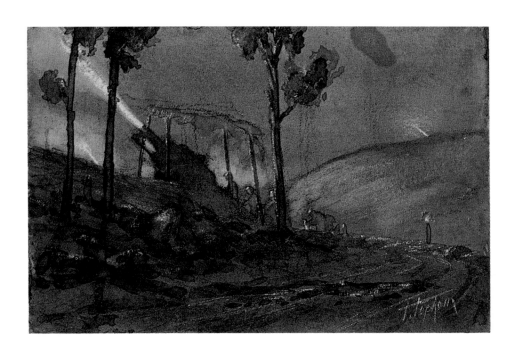

Thurston Topham *9.2-inch Howitzers, A Night Shoot*

begin to move forward. I lie where I am. The sound of the fighting moves away from me, farther, farther. . . . The enemy is falling back.

I look at my foot. It is still spurting blood—an artery must be cut. Something must be done. I make my handkerchief into a tourniquet and tie it tightly above my ankle. I twist it until my foot feels colds. The blood ceases to spurt and drips now; drip, drip. . . .

I am weak. My mouth is dry and my throat cries for water. I look into my water bottle—it is empty. I remember that I emptied it coming through the biting smoke of the barrage.

I lean against the side of the cone-shaped shell hole and watch the dark red blood ooze out of the hole in my boot on to the yellow earth and sink in.

The noise of the battle sounds fainter and fainter. . . .

I am alone in the hole. Nearby I hear men groaning and howling—I forgot all about the others when I saw the blood leaping from my heavy, dirty boot.

An hour passes. The boot is covered with nearly black hardened blood. I am wearing a boot of congealed blood, it seems.

Wounded, I say to myself again and again. Wounded—home—no more war now—no more lice—a bed.

I am glad. I look gratefully at the torn boot, at the blood-soaked piece of earth on which it limply rests. I am glad—glad—soon I will see lights coming from houses and hear the voices of women and feel their cool hands on my face.

Yes . . . I am happy.

I begin to cry.

A sharp pain shoots up my leg.

I feel in my pockets for a cigarette. Fortunately I have one. I light up and fill my lungs with the soothing smoke. I exhale with a sigh of happy relief. My pain seems less. . . .

I am thirsty. My mouth is gummy for the lack of saliva. I crawl out of the shell hole, dragging my wounded foot after me. I will find one of the killed and take his water bottle.

I slide into a large shell crater. A man lies huddled at the bottom.

It is Broadbent.

One of his legs hangs by a mere strip of skin and flesh to his thigh. He opens his eyes and smiles weakly. His face is bathed in sweat and pain. His lips move slightly. He is speaking. I put my head close to his and listen.

"I can't look at it — tell me is it off?" he whispers.

I lift his head up and give him a drink of the water I have found. It is lukewarm. He drinks.

His face is a dirty white—it is turning green. His eyes are half closed. His breathing becomes heavier. The deep whistling intakes sound above all the other sounds of the field.

I move to alter my position. His eyes follow me, beseeching me not to forsake him. I reassure him.

He looks at my foot and smiles faintly.

"You're lucky. A blighty. No more fatigues — "

The heavy blistering August sun drags itself higher into the sky. The noise of the battle is a dull rumble now. Midday insects drone sleepily. In the side of the shell hole there is an opening of an ant hill. I watch the beady insects scurrying in and out. Two of them struggle to carry a little ball of ordure uphill. Again and again it topples them over. They try again, others come to their aid, and finally it is taken into the dark little hole.

After a long while he speaks again.

"I know it isn't off—I can feel my toe when I wriggle it—it can't be off."

His breath comes faster. He looks up to the globe of fire which seems to hang motionless in the sky. Tears roll down his dirty green cheeks.

"I know it — I'm dying — God — and I'm glad. I don't want to go back — like this. . . . " He moves his hand listlessly towards his thigh. His face glistens in the sun. "Mother," he whimpers like a child, "mother. . . . "

Like the hundreds of other men I had seen die, Broadbent dies like a little boy too — weeping, calling for his mother.

Tears cease to stream down his face. He lies perfectly still.

In the rear I hear the stretcher-bearers calling to each other.

Charles Harrison

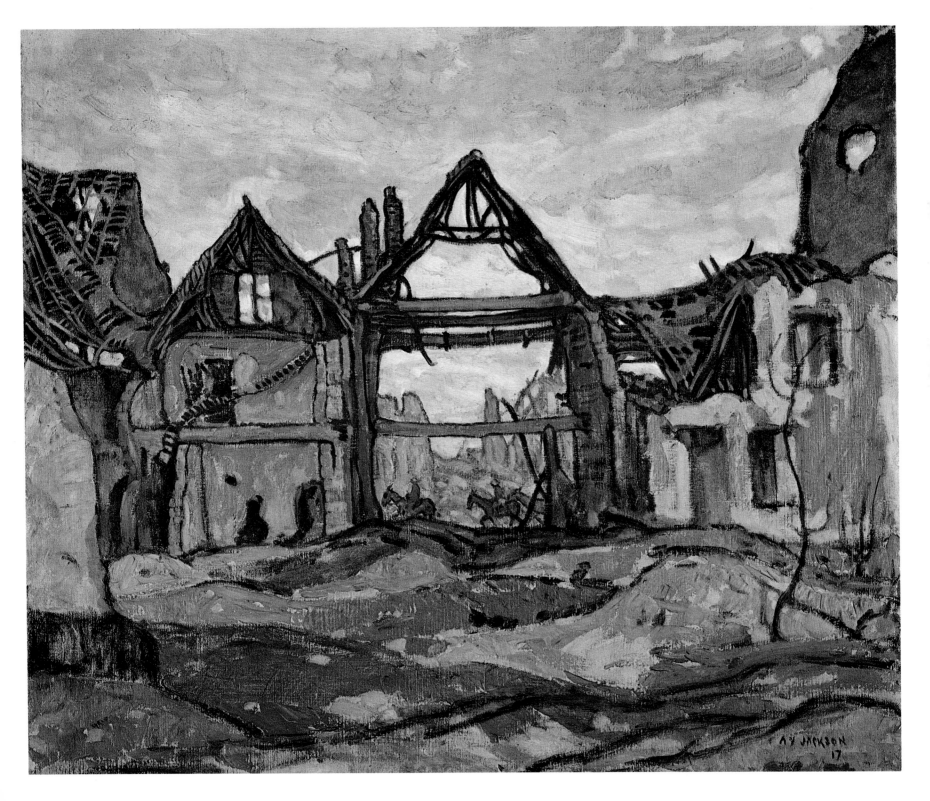

A. Y. Jackson *Houses of Ypres* 1917　89

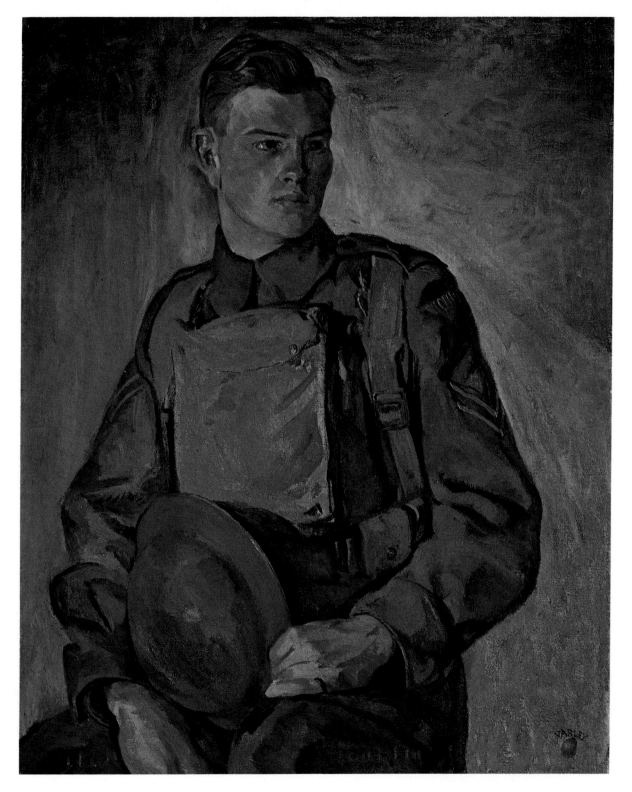

F. H. Varley *Canadian Soldier*

Testament

A notebook was picked up in a shell hole on the Somme and handed to me. Its pages were thick with the life blood of the owner. Through the blood and the mud I deciphered his last message. "Got it in the neck — Find paybook and will at record office." Then, in a hurried and wavering hand he wrote his great confession of faith — "God is good. God is love. God bless Moth. . . . "

Chaplain

Hope

October 27, 1917

Dearest Mother,

Just a hurried line, my last, I'm afraid, for a few days. By the time you receive it I shall be all right, or you will have news to the contrary, so you need have no anxiety. I am enjoying the whole thing enormously so far and have as yet not the least nervousness. I have issued most minute and careful orders and I hope foreseen every eventuality. My men and officers are splendid. I have every confidence in them. We are all in fine spirits.

I always know that if I do get killed I was completely happy and content to the last minute and that my only regret is due to the sorrow it will cause you. It is all worthwhile and as time goes by you will realize this feeling too. Remember dearest that if I can, my spirit will always be with you to comfort you and that my only unhappiness will be yours. I say this just in case, in order that you may know what my last thoughts were. I have a sensible feeling, however, that my chances are good and that I can still write you gallant tales! I have already missed a number of shells today and the auguries are good.

My mind is concentrated in the effort here and my heart is always full of love and gratitude for you, dearest and sweetest of mothers.

Talbot Papineau

Last letter

October 29, 1917

Dearest Mother,

After all I have been able to write you again before going over. We have been fortunate so far and all things are cheerful. I have even shaved this morning in a little dirty water. I was delighted last night to get two letters from you and a box of candy which I have actually carried with me and have enjoyed. It was a cold night and I slept only about one hour. Also a noisy night, I can assure you, and the earth full of vibrations.

I hope by the same mail you receive another letter from me to say all is successfully over. But of course it may be difficult or impossible to write for a few days so don't worry.

There seems so little to say when if only I knew what was to happen I might want to say so much. These would be poor letters to have as last ones but you must know with what a world of love they are written. Always remember that I could not love thee so well, or you love me, did I not love honour more. You have given me courage and strength to go very happily and cheerfully into the good fight. Love to all, and a big hug for thee, my dear brave little mother.

Talbot Papineau

Official regrets

Nov. 5, 1917

Mrs. L. J. Papineau,
Dear Madam:

In confirmation of my telegram to you of yesterday's date I regret exceedingly to inform you that an official report has been received to the effect that Capt. A/Major T.M. Papineau, M.C., P.P.C.L.I. was killed in action on October 30, 1917.

Yours truly,
J.M. Knowles, Lieut.

Statue

The whole region was unspeakably horrible. Rain was falling, the dreary waste of shell-ploughed mud, yellow and clinging, stretched off into the distance as far as the eye could see. Bearer parties, tired and pale, were carrying out the wounded on stretchers, making a journey of several miles in doing so. The bodies of dead men lay here and there where they had fallen in the advance. I came across one poor boy who had been killed that morning. His body was covered with a shiny coating of yellow mud, and looked like a statue made of bronze. He had a beautiful face, with finely shaped head covered with close, curling hair, and looked more like some work of art than a human being.

Canon F.G. Scott

Desolation

Dear Will,

We take pride in the way we fix up our dead. Some battalions just pin the blanket around the corpse and send it in a shapeless parcel. Whenever possible we tie their arms folded across their breast, tie their feet together and then pin the blanket around with the seam running down the centre of the body forming a cross with the seam running across the chest. Then we stitch it up and make a very neat job. The corpse is taken out at night to a cemetery about four miles behind the line.

I'm afraid I shall give you the horrors but this is war. There is no glory in it. Just scientific murder. I am used to these sights. They don't have to prime me with rum. I have and usually do drink it on those jobs but usually afterwards, to take the taste of dead men out of my mouth. I don't worry much over it now but there were times when I would figure it out that that shapeless mass was some mother's son, somebody's husband maybe. I have looked through some of the letters in their pockets, letters full of hopes and plans for the future and above all someone longing for the time when they shall come home again. I receive similar letters myself and do you wonder that sometimes I get a little miserable and wonder if someone will have the privilege of performing the last rites for me as I have done for so many others. Death has no horrors for me. It's the little things one leaves behind that worries. Perhaps I shall yet learn to thank God for putting me into khaki but when you are passing through the valleys you cannot see the glories which lie behind yonder ridge, especially when the mud of the valley is stained red with blood of heroes murdered by those demons, greed and covetousness. Great good may be the outcome of this war but to me the price is far too heavy.

I stand sometimes on a lovely spring morning with my back to the trenches and I look back over the country behind our lines. The sun shines, the birds are flying, the fields are turning a delicate green, on every hand there are signs of new life. God is again doing his part. He has sent the snow and the rain and we are beginning to see the wisdom of it. But yonder is a ruined village, once the quiet happy home of peace-loving peasant farmers. Now it is left desolate, hardly a wall left standing. My eyes fall to the ground. To my left on stretchers covered with blankets lie two silent figures. Suddenly with a noise like a freight train a big shell soars overhead and bursts on the road scaring the birds and bringing me to earth with a suddenness that is painful.

E.J. Spillett

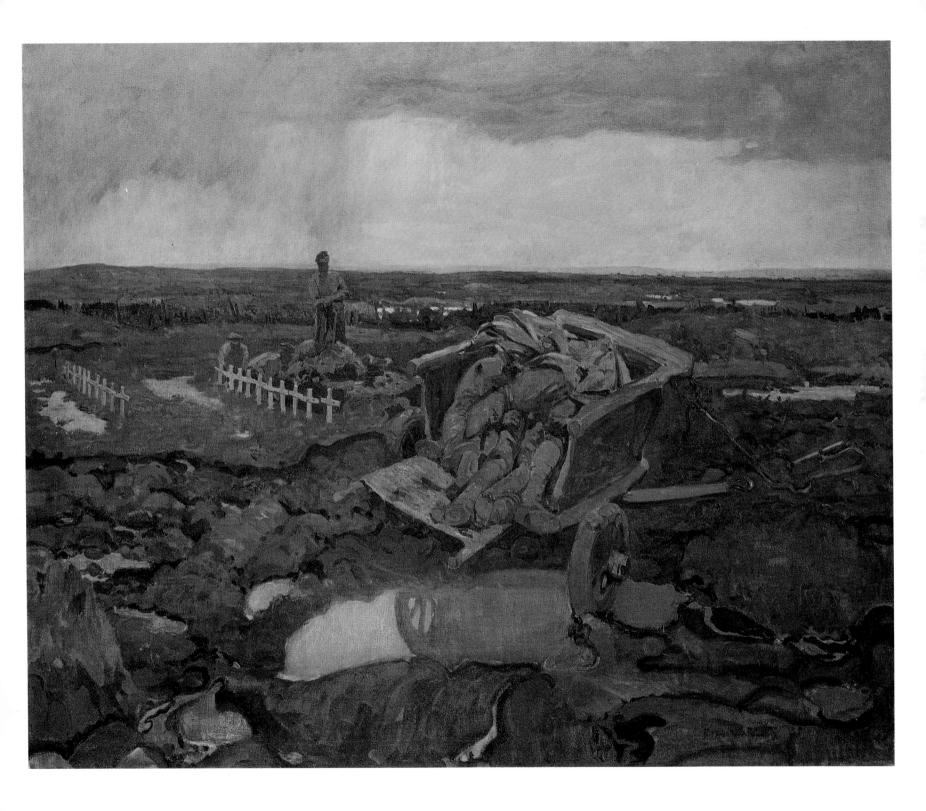

Burial

An old chaplain of the Canadian forces came to our trench section seeking the grave of his son, which had been marked for him on a rude map by an officer who had seen the young man's burial. We managed to find the spot, and, at the old chaplain's request, we exhumed the body. Some of us suggested to him that he give us the identification marks and retire out of range of the shells which were bursting all around us. We argued that it was unwise for him to remain unnecessarily in danger, but what we really intended was that he should be saved the horror of seeing the pitiful thing which our spades were about to uncover.

"I shall remain," was all he said. "He was my boy."

It proved that we had found the right body. One of our men tried to clear the features with his handkerchief, but ended by spreading the handkerchief over the face. The old chaplain stood beside the body and removed his trench helmet, baring his grey locks to the drizzle of rain that was falling. Then, while we stood by with bowed heads, his voice rose amid the noise of bursting shells, repeating the burial service of the Church of England. I have never been so impressed by anything in my life as by that scene.

Alex McClintock

Grim mission

My only chance of finding my son's body lay in my making a journey before his battalion moved away. I started at 6:00 a.m. for Death Valley. A runner volunteered to come with me. He brought a spade, and we started down the trench to the front line. When I got into Regina Trench, I found that it was impossible to pass along it, as one sank down so deeply into the heavy mud.

I looked over the trenches, and on all sides spread a waste of brown mud, made more desolate by the morning mist which clung over everything. I was determined, however, not to be baffled in my search, and told the runner who was with me that, if I stayed there six months, I was not going to leave till I had found that grave. We walked back along the communication trench peering over the top every now and then to see if we could recognize anything. Suddenly the runner pointed far away to a lonely white cross that stood at a point where the ground sloped down through the mist towards Regina Trench. At once we climbed out of the trench and made our way over the slippery ground and past the deep shell holes to where the white cross stood out in the solitude. We passed many bodies which were still unburied, and here and there were bits of accoutrement which had been lost during the advance.

When we came up to the cross I read my son's name upon it, and knew that I had reached the object I had in view. As the corporal who had placed the cross there had not been quite sure that it was actually on the place of burial, I got the runner to dig the ground in front of it. He did so, but we discovered nothing but a large piece of a shell. Then I got him to try in another place, and still we could find nothing. I tried once again, and after he had dug a little while he came upon something white. It was my son's left hand, with his signet ring upon it. They had removed his identification disc, revolver and pocketbook, so the signet ring was the only thing which could have led to his identification. It was really quite miraculous that we should have made the discovery.

The mist was lifting now, and the sun to the east was beginning to light up the ground. We heard the crack of bullets, for the Germans were sniping us. I had the runner go down into a shell hole, while I read the burial service, and then took off the ring. I looked over the ground where the charge had been made. There lay Regina Trench, and far beyond it, standing out against the morning light, I saw the villages of Pys and Miraumont which were our objective. It was a strange scene of desolation, for the November rains had made the battle fields a dreary, sodden waste. We made a small mound where the body lay, and then by quick dashes from shell hole to shell hole we got back at last to the communication trench, and I was indeed thankful to feel that my mission had been successful.

Canon F.G. Scott

Lazarus

I am in hospital in London, lying between clean white sheets and feeling, for the first time in months, clean all over. At the end of the ward there is a swinging door; if I listen intently in the intervals when the gramophone isn't playing, I can hear the sound of bath water running — running in a reckless kind of fashion as if it didn't care how much was wasted. To me so recently out of the fighting it seems the finest music in the world.

Out there in France we used to tell one another fairy tales of how we would spend the first year of life when war was ended. One man had a baby whom he'd never seen; another a girl whom he was anxious to marry. My dream was more prosaic, but no less ecstatic—it began and ended with a large white bed and a large white bath. For the first three hundred and sixty-five mornings after peace had been declared I was to be wakened by the sound of my bath being filled; water was to be so plentiful that I could tumble off to sleep again without even troubling to turn off the tap.

And here, most marvellously, with my dream come true, I lie in the whitest of white beds. The sunlight filters through trees outside the window and weaves patterns on the floor. Most wonderful of all is the sound of the water so luxuriously running. Someone hops out of bed and restarts the gramophone. The music of the bathroom tap is lost.

Up and down the ward, with swift precision, nurses move softly. They have the unanxious eyes of those whose days are mapped out with duties. They rarely notice us as individuals. They ask no questions, show no curiosity. Their deeds of persistent kindness are all performed impersonally. It's the same with the doctors. But we follow them with our eyes, and we wish that they would allow themselves to guess. For so many months we have not seen a woman; there have been so many hours when we expected never again to see a woman. We're Lazaruses exhumed and restored to normal ways of life by the fluke of having collected a bit of shrapnel — we haven't yet got used to normal ways. The mere rustle of a woman's skirt fills us with unreasonable delight and makes the eyes smart with memories of old longings. Those childish longings of the trenches! No one can understand them who has not been there, where all personal aims are a wash-out and the courage to endure remains one's sole possession.

Coningsby Dawson

Kiss of life

It was just one of London's flower girls, one of the women who religiously meet the hospital trains and shower on the wounded soldiers the flowers they have not sold—flowers, no doubt, held back from sale in most cases for this charitable purpose. When the attendants were moving me from the train and placing me on a stretcher, I was gently touched, and a large bunch of roses placed in my hand. The act was accompanied by the words: "'Ere ye are, Tommy. These 'ere roses will 'elp to liven things up a bit when yer gets in the 'ospital. Good luck to you, matey; and may yer soon get better." The voice was harsh and unmusical. Grammar and accent showed that it had been trained in the slums; but the kindly act, the sympathetic words, touched my soul.

The act was much to me, but the flowers were nothing. In answer to the girl's good wishes, I replied that I did not see as well as I used to, and that my power of enjoying the perfume of flowers had also been taken from me; perhaps there were some other wounded boys who could appreciate the beauty and scent of the flowers better than I could, and she had better put them on one of their stretchers. But she left them with me, and, in a voice in which I could detect a tear, said: —

"Well, matey, if yer can't see, yer can feel. Let's give yer a kiss."

I nodded assent, and then I received the first kiss from a woman's lips that I had had since I left home—and then she passed away, but the memory of that kiss remains, and will remain while life lasts.

James Rawlinson

Liberation!

We marched through villages with inhabitants almost delirious. They shouted at us and the children ran alongside yelling "Bon Canadaw." At one place an old peasant beckoned to us to watch him. He hurried to an outbuilding and worked with a long-handled rake until he pulled from under the floor the badly-hacked body of a German officer. The Frenchman stamped on the battered face with his boots until we spoke sharply to him and walked away. Again we saw a more pitiful sight, escaped prisoners, who had lain hidden for two days in a wood. It was hard to recognize them as British soldiers. They were walking skeletons, with matted hair and beards, rags on their feet in lieu of boots, their tattered clothing crawling with vermin.

We saw refugees with great, sweat-dried Percherons drawing farm carts heaped with mattresses and furniture, with lean cows tethered to the rear, and old men following with barrows and push carts piled with other possessions, nearly everyone dressed in his or her Sunday best, usually black, and very tired, footsore and pathetic. Some hissed their hatred in vitriolic language, some were dull and would not talk, poor creatures too beaten by life's ironies for even the joy of deliverance. At one place a pig was eating a dead horse by the roadside and was driven away with shrill cries as women attacked the carcass with knives and stripped every shred of meat for their own consumption. We gave most of our rations to children.

One night as we were going past the outskirts of a village a Red Cross sergeant called me to a building, a doorless stable that had sheltered a few of the fugitives. Shells were dropping near, the village had been strafed all the afternoon, and all the rest had fled and left him with a woman who lay on blankets in one corner.

"Help me, corporal," he said. "I'm alone for the time but my men will soon be here with an ambulance. This woman has been deserted by everybody and is going to have a child."

He had only a lantern he had salvaged and a pair of sheets taken from a farmhouse. The house was a wreck as a shell had hit it but the stove was still in order and I made a fire in it to heat water. I worked there with the sergeant, a man with three years at a medical college, until the ambulance came and took away the mother and baby, both, the sergeant said, doing far better than he had expected.

Will Bird

November 11, 1918

At five in the morning of the 11th—it was very dark—I saw the shadow of a man and the gleam of a bayonet advancing stealthily along that farther wall, near the Café des Princes. Then another shadow, and another. They crept across the square, keeping very low, and dashed north toward the German lines.

I knew this was liberation. Then, above the roar of artillery, I heard music, beautiful music. It was as though the Angels of Mons were playing. And then I recognized the song and the musician. Our carilloneur was playing "O Canada" by candlelight.

This was the signal. The whole population rushed into the square, singing and dancing, although the battle still sounded half a mile away.

In the city hall at six in the morning I first met some Canadians and we drank a bottle of champagne together. We did not know at the time that this was the end of the war.

The dawn revealed a strange sight in the square. The Canadian troops, exhausted from their long offensive, lay sleeping on the cobblestones of the square while all Mons danced around them.

At two o'clock in the afternoon it was officially announced that the war ended that morning at eleven. Our joy will never be forgotten.

Victor Maistrau,
Burgomaster of Mons

Gerard de Witt *Canadian Troops Entering Cambrai* 97

98 J. Ernest Sampson *Armistice Day, Toronto* ca. 1918

Armistice

Armistice Day dawned clear and crisp. No one was very happy. Now that we were out in the open and winning, it had to stop. "Berlin or bust" now seemed ridiculous. The armistice was officially announced in the Grande Place and the brigade bands played some airs. We had waited four years for this day but no one laughed, no one cheered, no one got drunk!

The signing of the Armistice was the signal for many tremendous celebrations in the larger cities, particularly those farthest from the danger zone. But for the men under arms, it meant only that war-weary veterans would be under strict discipline and denied the campaign of movement to which we had looked forward. What to do? No war, no train for home and so quiet one could hear one's hair growing. The change was too sudden.

There were sitdown strikes, not really mutinies. There was so little to do now. One day, I stood in front of my platoon and the sergeant stood behind it but the platoon sat in a railway cutting under a bridge and decided that since the war had been fought and won there was no further need for clean rifles, parades, polished brass and squad drill. Battalions refused to parade. The men were unstrung by the peace — the reaction to life in a machine.

Unknown Soldier

Going home

We got on the boat at Liverpool. The *Adriatic* was a clean-looking vessel and I wandered slowly to the first deck. A white-painted cabin had no name on the door. I seized a chalk and wrote "Occupied," and went in.

There were a number of nurses and passengers on board and the ambitious Sam Browners got some of the men lined up and tried to make them do monkey tricks, but the older heads left us alone. Several of the lady passengers were loud in their talk and we heard them exclaiming as they saw the "real kilties: they're famous, you know, for their bayonet fighting." And they eyed us as if we were wolves, on chains, being exhibited.

At night I stayed on deck for hours. It was clear and calm and the stars were wonderful. I watched them, studied them. Back in boyhood days they had been to me the greatest marvel of all creation, and it was my fantasy that they sprinkled the "roof" of our world. Many and many a night when relaxed on outpost duty I had turned on my back for the moment and rested my eyes on the great starlit spaces overhead until I felt lifted away from all the foul and cruel existence that we knew. It came to me as I watched them that even the war, the greatest catastrophe this world knew, was but a momentary episode, that Time and Space were limitless. And we go on. Where?

On the evening of the last night out our emotions ruled us, turned us to a riot of horseplay. We scuffled and wrestled and dragged each other about and made mock speeches. Then, gradually, we quieted, each with his own thoughts. And when all was still I went on deck and stared over the dark waters ahead.

Darkness. The rush of the ship. I felt my way again into a stifling dugout, into an atmosphere rancid with stale sweat and breathing, earth mould, and the hot grease of candles . . . I saw faces, cheeks resting on tunics, mud-streaked, unshaven, dirty faces, some with teeth clenched in sudden hate, some livid with pulse-stopping fear — I saw men turning on their wire bunks, quivering as if on some red-

hot grill . . . I heard them gasp and sob and cry out in agony, and mutter as they tossed again. Then, a machine gun's note, louder, higher, sharper, crack-crack-crack as it sweeps over you in a shell hole where you hug earth . . . the growl of guttural voices, heavy steps, in an unseen trench just the other side of the black mass of tangled, barbed barricade beside which you cower . . . the long-drawn whine of a shell . . . its heart-gripping explosion . . . the terrible oppressive silence that follows, then the first low wail of the man who is down with a gaping blood-spurting wound. . . .

I moved about, shook myself, sniffed the salt air, tried to rid myself of my dreams, and as I stood there came a sudden chill. I grew cold as if I had entered a clammy cavern. I could not understand but went and got my great-coat. A dim figure passed me as I returned to the deck and a voice said "We're getting nearer home. I can feel the change."

Ah—I knew. We had left the warm current and were into the icy waters — nearer home. We had left behind the comradeship of long hours on trench post and patrols, long days under blazing suns and cruel marches on cobbled roads—the brotherhood of the line; and we were entering a cold sea, facing the dark, the unknown we could not escape.

Dark figures came and stood beside me. I had not thought that anyone save myself would come on deck and here they were, ten, a dozen, still more, all hunched in greatcoats, silent, staring. I looked at my watch. It was three o'clock in the morning. These men could not sleep; they were come to see the first lights of Halifax. I moved quietly among them, scanning each blurred face. It was as I thought. They were all "oldtimers," the men of the trenches. We went on and on and on, and no one spoke though we touched shoulders. I tried to think of a comparison. Ah—we were like prisoners. I had seen them standing like that, without speaking, staring, thinking.

Prisoners! We were prisoners, prisoners who could never escape. I had been trying to imagine how I would express my feelings when I got home, and now I knew I never could, none of us could. We could no more make ourselves articulate than could those who would not return; we were in a world apart, prisoners, in chains that would never loosen till death freed us.

And I knew that those at home would never understand. They would be impatient, wondering why we were so dumb, unable to put our experiences into words; and there would be many of the boys who would be surly, taciturn, moody, resenting good intentions, perhaps taking to hard liquor and aimless drifting. We, of the brotherhood, could understand the soldier, but never explain him. All of us would remain a separate, definite people, as if branded by a monstrous despotism.

But I warmed as I thought of all that the brotherhood had meant, the sharing of blankets and bread and hardships, the binding of each other's wounds, the talks we had had of intimate things, of the dogged simple faith that men had shown, flashes of their inner selves that strengthened one's own soul. Perhaps when my bitterness had passed, when I had got back to normal self, to loved ones tried by hard years of waiting, I would find that despite that horror which I could never forget I had equalizing treasure in memories I could use, like Jacob's ladder, to get high enough to see that even war itself could never be the whole of life.

The watchers stirred. I tingled. My throat tightened. Waves of emotions seized me, held me. I grew hot and cold, had queer sensations. Every man had tensed, craned forward, yet no one spoke. It was the moment for which we had lived, which we had dreamed, visioned, pictured a thousand times. It held us now so enthralled, so full of feeling that we could not find utterance. A million thrills ran through me.

Far ahead, faint, but growing brighter, we had glimpsed the first lights of *Home*.

Will Bird

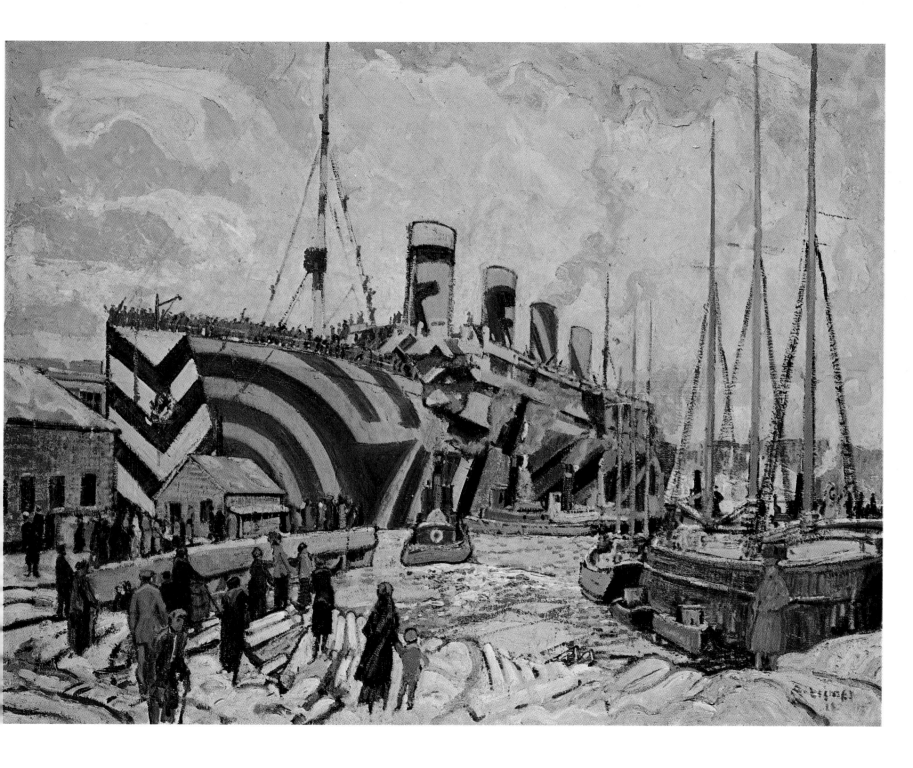

Arthur Lismer *'Olympic' with Returned Soldiers* 1919 101

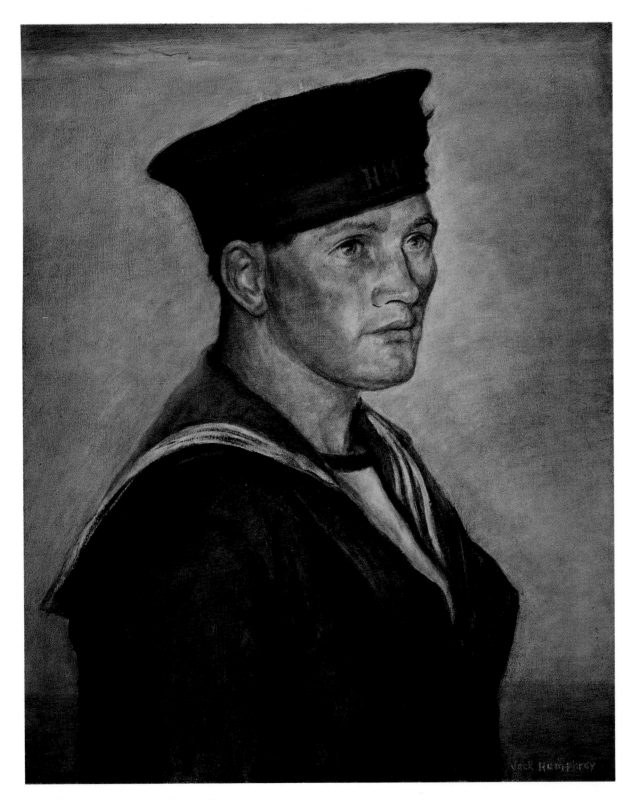

Jack Humphrey *A Canadian Sailor*

The Second World War 1939–1945

Old soldiers never die —
they live on to send their sons off
to other wars.

Raymond Souster

Join Up

Why don't you join up?
Why don't you join up?
Why don't you join old Ralston's army.
Two bucks a week; — all to eat.
Great big boots and blisters on your feet.
Why don't you join up?

Breaking in

The harsh brassy notes of Reveille echoing through the chilly morning air in the sheep pen, signalled the beginning. The sheep pen, so-called from its peacetime role at the Canadian National Exhibition, was otherwise known as the Reception Wing, No. 1 Manning Depot, R.C.A.F., Toronto. Here, in one gigantic building, stood symmetrical tiers of bunks, enough to accommodate a thousand men. Here thousands of homesick, dejected recruits spent their first ten days "working for George."

Before the last notes of the bugle had died away, the lights blazed on fiercely, seeking us out in our bunks, and the air was filled with the sound of water splashing into a hundred wash basins at once. Service issue razors rattled and scraped over stubbly chins, dampened only with cold water.

At the end of every second row of bunks was a special bunk occupied by one of those imperious individuals, the corporals. These awe-inspiring personages demanded as much deference from the lowly recruits as a Nazi S.S. colonel. Usually they got it too.

"Everybody up!" the corporals roared. We hesitated on the upper edge of the double bunk contemplating the distance to the floor.

"Smarten up there! Hit the deck!"

The walk to breakfast turned out to be the longest I ever took in my life, all under one roof. The C.N.E.'s Coliseum had been remodelled into a barrack so large that 10,000 men at one time were quartered in one gigantic sprawling structure. The whole atmosphere of the place was calculated to knock the "civilian" out of the recruit and press him into service mould. In highly concentrated doses, R.C.A.F. service tradition and esprit de corps were administered to the recruits by a staff of swashbuckling, heel-clicking, drill-and-polish experts.

Morning parade was the first in a series of ordeals that followed one another in rapid succession. Arraigned in the arena in huddling groups, we faced the formidable sergeant-major; to me he looked like a cross between an ape

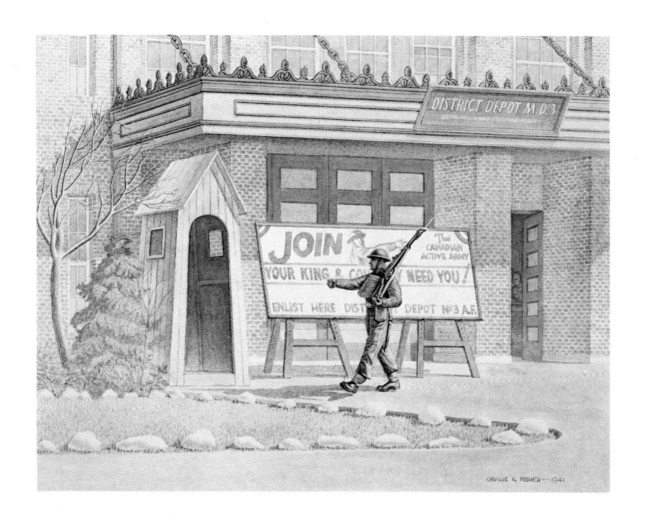

Orville N. Fisher *Recruits Wanted* 1941

and a dictator. And, enthroned on a small balcony overlooking the arena, armed with a powerful microphone and a vitriolic vocabulary, the lordly flight-sergeant presided. Miscreants were publicly lashed with some well-chosen phrases from the flight's razor-edged tongue. Such crimes as drying socks in the shower room or failing to polish shoes were severely and speedily dealt with in this military tribunal known as morning parade.

Having survived this monkey business, my pals and I faced the photographers, the fingerprint bureau and the stores depot. Like a chassis rolling down the assembly line at General Motors, I emerged at the other end, loaded to the springs with the accessories of an airman, from winter underwear to toothbrush.

The next stage in the treatment was the barber shop. A squad of unscrupulous barbers mowed off the shiny waves from many a boyfriend's handsome head. In their place they left a prisonlike haircut resembling a scrub brush. Minutes later, still out of breath and stripped stark naked, we faced the medical officer.

Bedtime came early and our jealous chaperones, the corporals, conducted a meticulous "bunk check." As the lights went out, darkness enveloped the sheep pen except for the eerie glow of two or three dim blue guide lights. The orders were for strict and complete silence after "lights out." But from somewhere out of the gloom came the voice of a wag, pitched high and shrill, in a striking imitation of a child.

"I want my mama!"

"Shut up!" The imperious voice of a corporal cut the air like a meat cleaver. Muffled but irrepressible snorts of laughter shook every bunk.

"I said shut up!" The corporal's voice was fierce and threatening. More muffled sounds of laughter filled the room.

"I want to go home!" From a different part of the room came the plaintive, childlike tone of a different wag. This time the sounds of amusement were louder. The corporals, all in a towering rage, hurled threats of severe punishment and reprisal in every direction. Of course, the wags were never located, but the boys dropped off to sleep at last, their sides sore from laughing.

Gerald Wright

Kiss Me Goodnight, Sergeant-Major

Kiss me goodnight, Sergeant-Major,
Tuck me in my little wooden bed,
We all love you, Sergeant-Major
When we hear you bawling "Show a leg!"

Don't forget to wake me in the morning,
And bring around a nice hot cup of tea,
Kiss me goodnight, Sergeant-Major,
Sergeant-Major be a Mother to me!

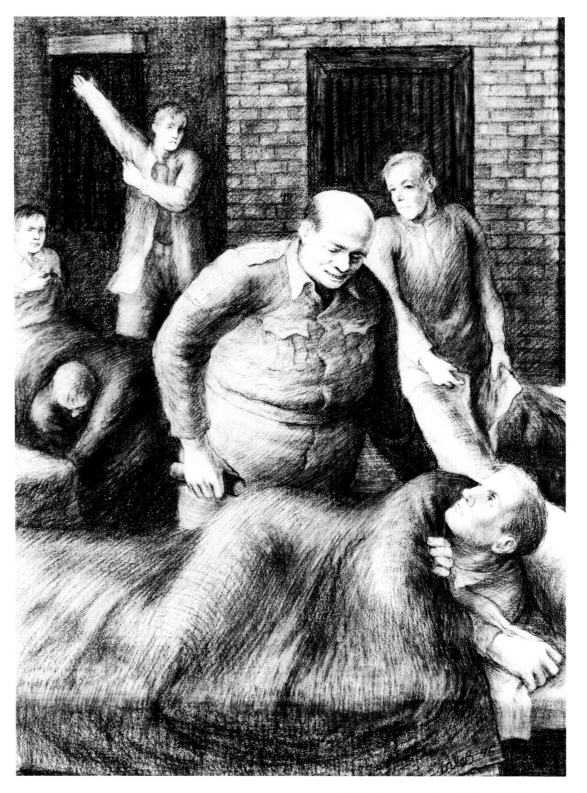

Miller Brittain *Sam Wakes Us Up* 1945 107

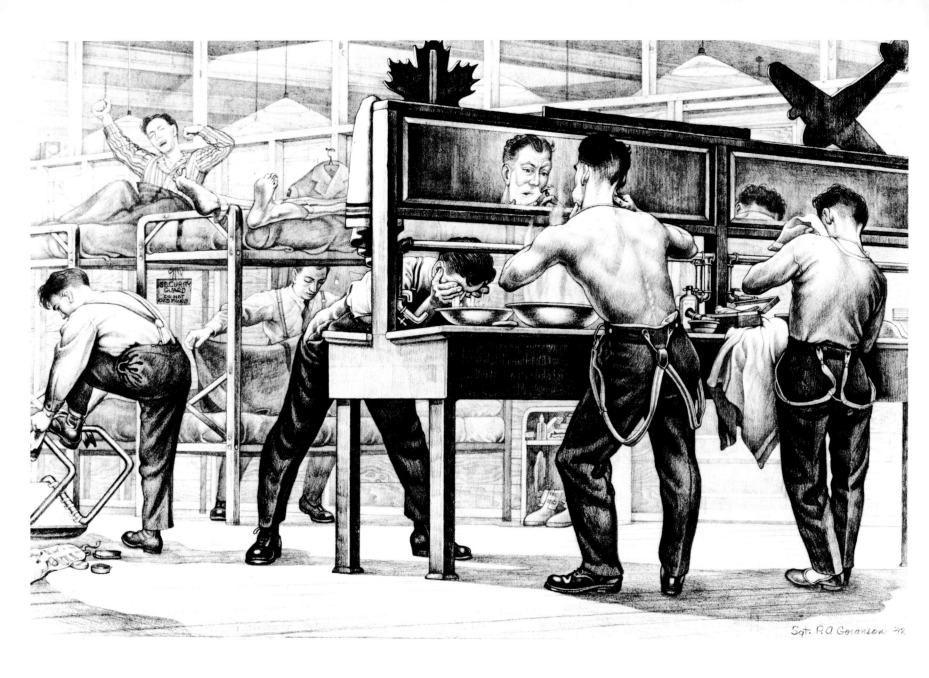

108 Paul Goranson *Oh Reveille* 1942

Fall of Hong Kong

December 6th, 1941 We had a gruelling session of squad drill under the lashing tongue of a lieutenant. Went out in the evening with Vic and saw a show called "The Long Voyage Home."

December 7th Confined to barracks, all ranks, moving stores, loading amm'n. Erected tents, then the brigadier ordered that the big marquees we had worked so hard to put up must come down. We could sleep in pup tents but there were not enough, so most of us slept under the stars. We heard distant rumbles of artillery during the night.

December 8th We are at war with Japan. Just after breakfast the siren started to wail a warning, then we heard planes but could not see them, then great water spouts four in a row in the harbour close to a big freighter. Our ack-ack opened up. On a wiring party last night and all day today.

December 9th Worked all night moving stores from mainland across by ferry and up into hills, then no place to put them out of the rain. Great quantities thrown on the ground, this continued throughout the day. Our old parade square bombed and the Jubilee building was hit. Some Chinese killed and several Rifles wounded.

December 11th While on night shift we heard a whistle and scream as the first heavy artillery shell from the mainland reached our island. Counted eight separate ones. An artillery duel going on now. Six Jap bombers flew over at 3:35 and dropped bombs. Kowloon has been bombed, some parts are burning. The echoes of the report of our big guns rock and roll around these peaks like thunder. The air raid siren has been sounding almost constantly these days. Some of the boys have been raiding our stores piled in the open and we tasted our Xmas puddings a little earlier than usual.

December 14th Quiet night. Heavy artillery this fore-noon. A hit made on gasoline dump at crossroads. It did not take fire but is running away rapidly. Some of the boys have young beards. Heavy shelling this afternoon. Shrapnel dropping around us. The fragments are quite hot, ugly jagged pieces of metal. Quite a number of planes going over dropping bombs and propaganda leaflets at the same time.

December 15th Our water supply very inadequate. We are lucky when we get two meals a day. A lot of Jap planes over. Moved into a lovely house, the owner is gone, but his coat of arms is emblazoned over the mantelpiece. But we had no chance to sleep, we worked all night filling sand bags and carrying them to build a barricade around the officers' orderly room.

December 16th Food seems harder to get all the time. We have drawn our emergency iron rations, but were ordered not to touch them till we had been without food for two days. There is a small radio in this house, and we heard some Christmas carols. Went out this evening, filled sandbags till one o'clock.

December 18th A huge fire down on the edge of Victoria City. An oil dump has been hit by Jap bombs. A vast cloud of black smoke covering most of the sky and bellowing ever upward.

I cannot bring myself to write what happened between the 18th and the 25th. All I can say is I saw too many brave men die, some were my best friends and died beside me.

When we heard the Governor of the Colony had surrendered to the enemy (on Xmas day), I saw some men break down and cry like children. "What, surrender now?" they sobbed "After all the good men we've lost?" (We had 137 men killed). Others cursed and raved as though delirious. Others like myself were stunned, dazed, apathetic. I had never dreamed it could happen, up to the last moment, until Lieut. Corrigan ordered us to lay down our arms. I had hoped, prayed and, yes, believed, a miracle would happen. Surely there must be aid for us not so far away, what about all the rumours of Chiang-Kai-Chek leading a Chinese army down thru the new territories? What about . . . ? Ah, well, here's one Lee-Enfield that no Jap will ever use against us. I released the bolt, slipped it out and flung it into a deep rocky ravine 200 feet below.

Tom Forsyth

Hong Kong, 1941

"You bastards are going with me
right to the top and we'll kill
every one of those bloody Japs,"
Sergeant-Major John Robert Osborn
told his sixty-five men,

(all that was left of "B" Company,
Winnipeg Grenadiers, a regiment
"Not recommended for operational training,"
on December 19, 1941):

and a half-hour later
with thirty men left
he stormed to the top
of Mount Butler, then stayed there
for eight hours and a half.

(Able seaman at Jutland,
a farmer in Saskatchewan,
Manitoba railway worker,
now at forty-two
a soldier at Hong Kong)

"Dig, you sons-of-bitches,
dig like you've never dug before,
they'll be back for us soon,"
he told them with a grin.

(Mr. Ralston,
Canadian Minister of Defence:
"The garrison's position is undoubtedly,
for the time being, a very trying
and difficult one":
John Osborn,
his bayonet thick with blood,
an ugly gash on his forearm,
would have damn well agreed with him. . . .)

And the Japs came back,
slinging grenades by the dozen,
and soon there were twelve
then only six Grenadiers;
finally five as Osborn
threw himself on a grenade
he couldn't reach in time. . . .

Is there still a Mount Butler
in Hong Kong today?
If there is it should be called
John Osborn's Hill.

Raymond Souster

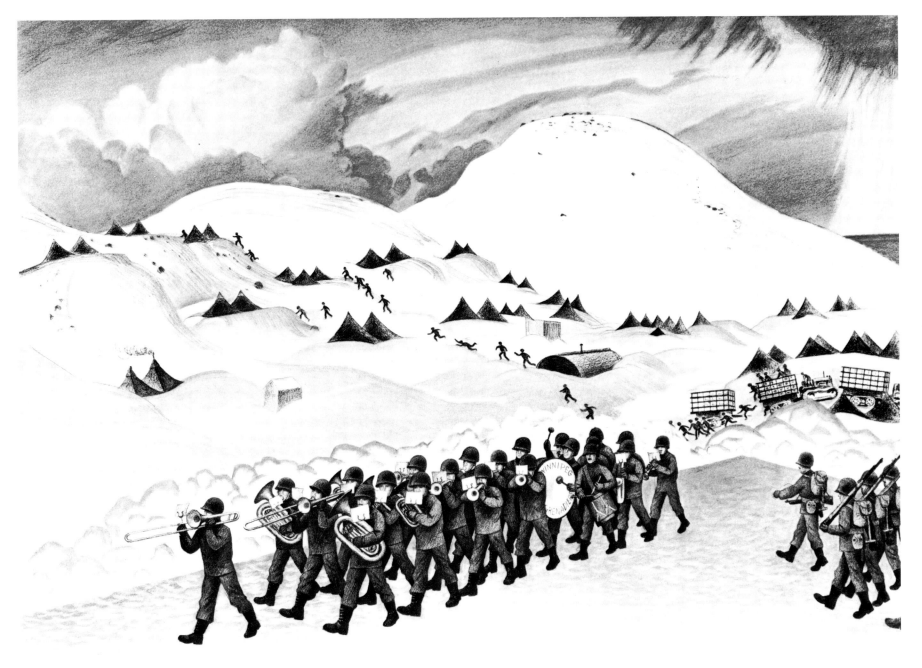

E. J. Hughes *Parade Ground on Kiska* 1944 111

Bucking the odds

Early the morning of December 20th a large body of us were sent out with the purpose of breaking up an ambush to allow a body of Canadian infantrymen to get through to Repulse Bay. During the fracas we became badly disorganized but repulsed the ambushers. We were told to put up overnight in a house on the Heights. The Japs had watched our actions and almost immediately opened fire on the house from three sides.

We decided the best thing for us to do was to leave as soon as possible for Repulse Bay, but an interpreter had announced that only wounded men were left in the house and we were prepared to surrender. Very few men agreed to lay down arms and surrender. Most of us were all for picking up our rifles and taking a chance on getting through but were ordered to pile our arms in one room and help prepare stretchers for the wounded.

In the early morning of the 21st the Japs stormed the house using hand grenades and a small portable type of machine gun. The wounded men downstairs were literally murdered in cold blood. Our white flag was torn down and our interpreter was bayoneted and pinned to a door to die. On hearing the noise downstairs a few of us went for our rifles and grenades. The Japs came upstairs and kicked open the door of the room we were in. First they sprayed the room with machine gun fire, following it up with a heavy barrage of grenades. These were very slow in going off and we were all busy tossing them out the windows as fast as we could. During this grenade barrage I received a good-sized piece of shrapnel in the jaw. Many of the men were seriously wounded and many killed. Two of us opened fire on the Japs with our rifles and managed to get three of them.

The next thing they did was to pour kerosene on the ground floor and set fire to the house. We got as many of the wounded out the windows as possible and then jumped out ourselves. Many headed down the Repulse Bay road but were immediately met with heavy machine gun fire, so we headed for the water. Eight of us started out to swim; four of us reached the other side.

When I reached the shore I was almost completely exhausted. I decided to sit down and await the arrival of the others. When they arrived we started out over the hills towards Stanley but were too utterly exhausted to force through the underbrush, having found no signs of a path anywhere.

From here on I cannot recollect much as the crack in the jaw seemed to daze me pretty badly. I remember coming to, halfway up the hillside and was told that the Japs had been chasing us for three or four days. There was a deadly silence in the air and we thought that another Armistice was on. That evening some Chinese boys brought some more bully and beer and said it was Christmas Day. They told us to get over to Stanley as soon as possible. The climb was hard and took us the best part of a day and a half. We had just reached the top when a party of six Japs surprised us and took us captives.

They tied us up together and made us march back down to the road. On reaching the road they seemed undecided as to what to do with us but eventually turned our heads towards Repulse Bay. We had marched about half a mile further when a car drove up with some N.C.O.s (or at least they all had swords), and one of our captors went forward to speak to them. When he returned we were turned about and marched back the way we had come. Eventually we were made to crawl in a ditch and we knew that the end had arrived for us. We said goodbye to each other and the staff-sergeant said a prayer for us. Then the noise started. It seemed to me that the rifles and revolvers used were placed at my ears, the noise was so great.

I was first to be hit. It got me in the left shoulder and sent me over on my face where I lay very quiet waiting and hoping that the next one would be a clean shot and have it finished. I heard the "death rattle" three times that day as my comrades died miserable deaths. I was hit three times again after that, in the left elbow, the left hip and through

the second finger of my right hand. The Japs didn't bother to inspect their handiwork, as there was enough blood around to convince almost anybody.

I lay very quietly and when the Chinese came along to loot our bodies I scared them very badly by suddenly sitting up and talking. After they had completely looted all of us of our rings, watches and money, they untied me and told me to go before the Japs came back. I had gone along the road about three or four hundred yards when I started to lose consciousness. When I came to again I felt very weak, hungry and thirsty, I hadn't eaten since the 19th and I didn't know what the date was by now but it seemed a long time back to the last meal.

Eventually I got over the hill and found myself on the bluff above Stanley. Many Chinese were coming along the road, with all their personal belongings. One look at me and they started to scream and run away. The maggots were falling quite freely from the hole in my jaw by this time and the sight wasn't pretty. I found out all the British troops were in Hong Kong and started my walk.

Then came my change of luck. Along the road came a truck. After much haggling and arguing they allowed me to climb on the lorry and I was taken to St. Albans Convent which was being used as an emergency hospital. I was told it was New Year's Day, 1942 and was so happy that I cried myself back into unconsciousness.

Canadian soldier

Prison rations

January 1st, 1942 Quite cold in our windowless, doorless hut, very windy. Dust and ashes are swirling around from the remains of the rubbish fires which were burning all day yesterday around our huts. Men are grouped around little cooking fires trying to boil water to make tea. A chill cheerlessness pervades the camp. Some peddlers are trying to sell some native food thru the wire, the sentry chased them away. The sun is shining but it has no warmth. Cpl. Fox has dysentery. Roll call at 9.30. Breakfast a cup of half-cooked rice without any salt. No dinner. My worldly goods are indeed few. I have the clothes I stand up in, one change of cotton underwear, one haversack and water bottle and my steel helmet. Our rice tonight was only half-cooked and yet it was burnt! Strange, today every man was asked his age and previous occupation. Chilly this evening.

January 2nd A very cold, miserable night. Wrapped up in one blanket and oilskin gas cape, but shivered all night. Everyone trying to find something to cover our windows.

January 3rd Another shivery night. Major Baird gave us a pep talk, telling us not to get downhearted, this morning. A Middlesex team beat the Royal Signals 4−0 at football. They must be eating better than we are.

January 4th Sunday. Roll call at 8.30 and Church Parade at 12:00. The main topic of conversation is food, and once Jenkins struck an attitude and declaimed:

> *You may live without books —*
> *What is knowledge but grieving?*
> *You may live without hope —*
> *What is hope but deceiving?*
> *You may live without love —*
> *What is passion but pining?*
> *But where is the man who can live without dining?*

At the Church parade the Royal Scots padre took the service. His text was, "Ye are they who came out of great tribulation."

Tom Forsyth

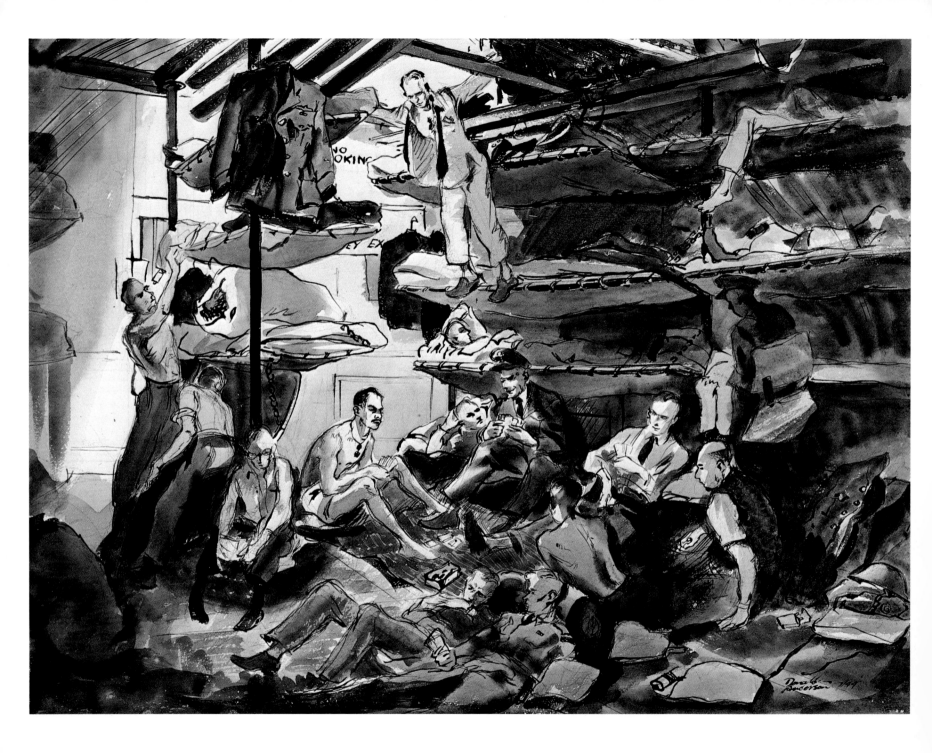

114 Donald Anderson *Officer's Quarters Aboard Troopship* 1944

Roll Along Wavy Navy

Roll along, wavy navy, roll along,
Roll along, wavy navy, roll along
When they say "Oh, there they are!"
It's the R.C.N.V.R.!
Roll along, wavy navy, roll along.

Oh, we joined up for the glory of it all,
Yes, we joined up for the glory of it all,
But the good old R.C.N.
Made us change our minds again!
Roll along wavy navy, roll along.

Oh we joined up for the chance to go to sea,
Yes, we joined up for the chance to go to sea,
But the first two years or more,
We spent marching 'round the shore!
Roll along, wavy navy, roll along.

Ocean choir

Ships are wonderful and lovely things. They seem to live under your feet, rising and falling, throbbing and shuddering as they breast the long, rolling swells. Ships seem to have feelings as well, for when the sea is rough a thousand little voices all begin to speak out of turn, all jabbering, chattering, moaning and screeching. They keep this up until speed is slackened and the strain on the tortured hull is released.

Don Wilson

U-Boat Alley

The first couple of days I spent mainly by the rail staring out at the sea, listening to the sound of the waves as they break on each other and rush past the side of the ship. Salt water seethes, boils, and hisses. Very different from fresh water in this respect. Sometimes the sea has looked quite blue; but mostly it has been black, flecked with creamy streaks and blobs of foam. The *absolute depths* that lie below that dark marble surface fascinate me. I stare at it by the hour.

There were about fifty ships, all the same ghostly grey, in our original convoy. Then, just past Newfoundland, we joined a monster convoy of around 400 vessels; and then, after a couple of hours of messaging back and forth with flags and signal lamps, the whole fleet, which now reached to the horizon in all directions, began to move off as one formation at about eight knots in the gathering twilight, and I knew we were headed out and the next land I would see would be England. If we make it. We're in U-Boat Alley right now, and just about as vulnerable as you can get. Several times in the last day or two we've heard depth charges whamming at different distances from our ship. The captain keeps saying it's just navy escorts dispersing stray herds of whales that might prove hazardous to the convoy. I believed him at first.

Donald Pearce

Torpedo

Suddenly, like lightning, a colossal flash leapt from the convoy. In a moment it resolved itself into a tremendous flame which shot upwards from the water, accompanied by a roar like the passing of an express train. The great column of fire, whose diameter might have been equal to the length of the ship from whose tanks it sprang, seemed almost to reach the cloud base. The whole convoy was lit up by its brilliance: I caught a murmur around me, as of the letting out of breath from many throats.

Then, with equal suddenness, the light went out as though consumed by some fire-eating monster, leaving utter blackness.

But as our eyes became once more accustomed to the darkness, we saw a great black cloud of smoke, like a dense thunderhead, rolling across the sky to leeward — all that was left of a cargo which had until now been destined for the machinery of war on land or in the air.

There remained in my mind's eye a picture of the greater part of the convoy as it had presented itself for the brief moment of the illumination; some ships in clear profile, some in silhouette, poised as though, while in the act of forging their way through the water, they had paused to watch the destruction of a friend.

No one aboard could have survived.

I turned away to the westward with a sickening feeling which must have been shared by all who witnessed the attack, except the U-boat commander who fired the torpedoes.

Alan Easton

Seascape 1940−1941

Here went a ship: a dead man clinging to a raft,
splintered debris, brown scabby scum
of burned-out fuel oil. That by the way.
8000-tonner still burning from the bombing,
wounded rolling idly in an oily sea;
grey cold afternoon. The eighty-four
survivors forlorn and silent in the boats
(why do survivors smell the way they do?)
The captain's arm raised but no word;
he seems to calculate some sad decision.
The shadow of the ship was ultramarine, her flanks
were cherry red and the waves spat and steamed
against her sides in languid futility.

George Whalley
from Seascape

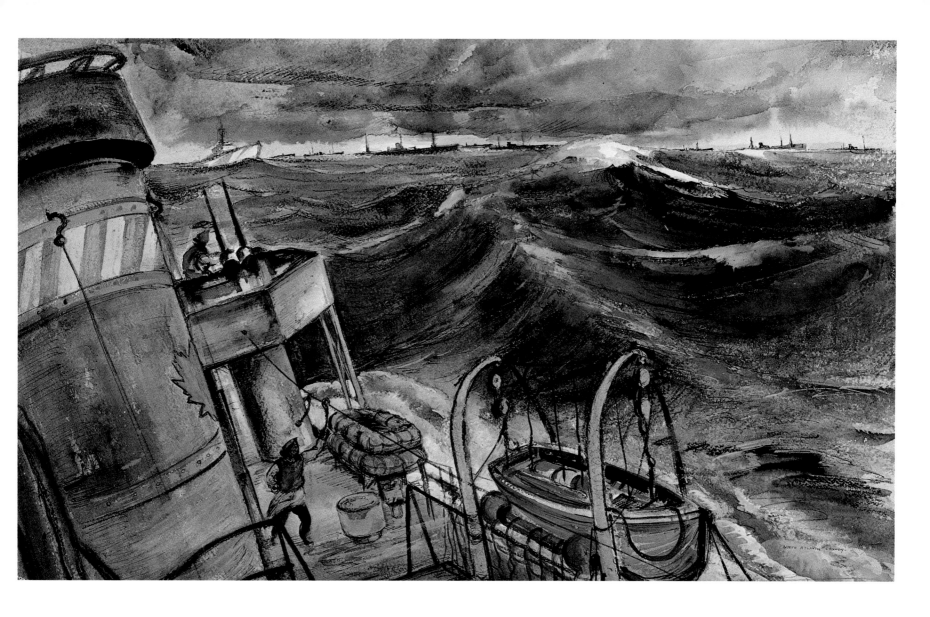

Leonard Brooks *Atlantic Convoy* 117

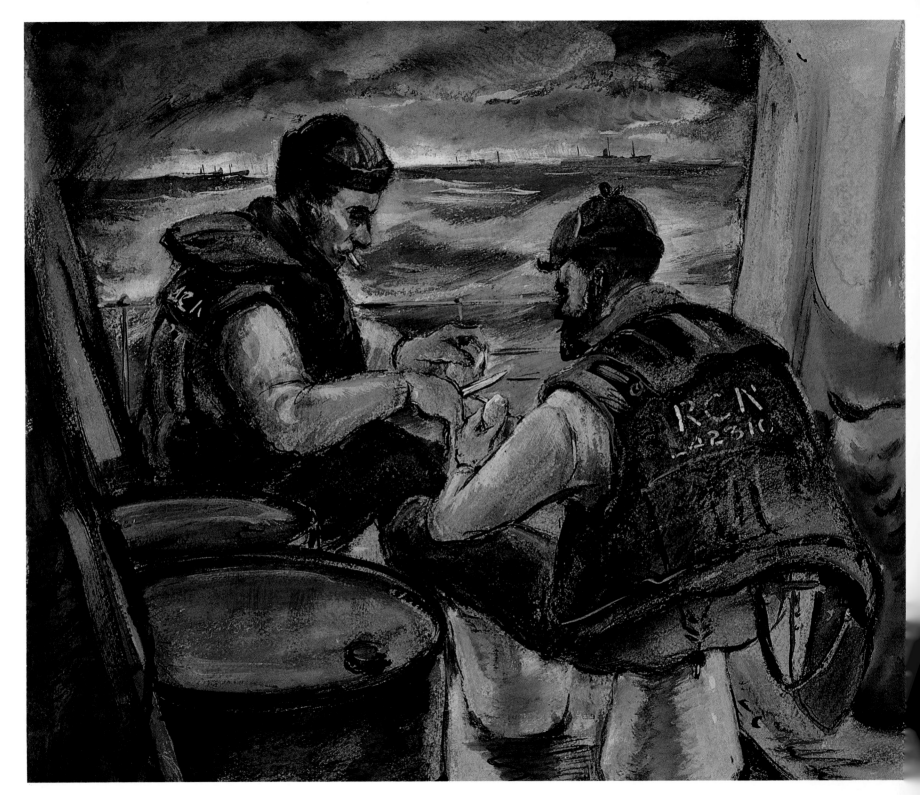

Leonard Brooks *Potato Peelers*

Adrift

In half an hour we had reached the scene of the wreck. Wreckage was strewn over an area of about half a mile, floating in widely separated patches. We passed slowly through it. Lumber there was, many small wooden hatch covers, gratings, doors, sides of deck houses ripped in jagged patterns, ladders and cargo — light stuff which would have floated up as the ship sank, which she probably did quickly. It was our first sight of the devastation of attack.

After an hour it seemed that we had examined practically all of it. The lifeboat from which the men had been taken was abandoned and we saw the one that had capsized. They were a forlorn sight, bobbing gently on the water. I looked down into the boat that had saved the crew. The brass linings of the rowlocks were bright where the oars had polished them. A grey blanket had been thrown on the bottom boards and a pair of mitts lay on the 'midship thwart where they had been dropped; their owner had not wanted his hands encumbered when boarding the rescue vessel.

All this mass of wreckage had to be scanned carefully, for one can so easily miss things unless the sea is glassy calm. In this weather — just a slight sea — a lifeboat could be overlooked and never seen at a distance of a quarter of a mile. Then we came upon a man alone in the water.

As we passed within twenty yards of him I saw that his final struggle to make himself more secure had brought about his end. He was wearing a large waistcoat type of life belt but had evidently come across a life buoy — a ring — and decided to get into it. He had ducked his head down into the water and at the same time passed one hand up through the buoy and grasped the opposite side to help pull himself up into the ring. But he had not fully taken into account the buoyancy of his life belt. He had not been able to submerge it enough to get it under the ring and up through the centre. In his struggle and determination, his strength had obviously failed him and he had not even withdrawn his arm or taken his head from under the buoy.

On the buoy was painted *S.S. Silvercedar*.

The poor chap was clad only in a short shirt and I reckoned he had been in the water for five hours. The temperature of the water was around sixty degrees. With the movement of the buoy on the little waves the man's legs moved and made it appear as though he were feebly trying to swim.

Alan Easton

The kill

I heard the navigator acknowledge a report from the radar operator.

"Radar contact red four-oh, mile and a quarter, sir."

His voice came with a note of urgency in it.

A few paces took me to the port side. The first lieutenant followed.

"Tell him to hold it and we'll put it ahead," I called over my shoulder to the navigator, and to the rating at the wheelhouse voicepipe, "How's her head?"

I had my glasses on the smooth, dark water beyond the port bow. Almost immediately the answer came back:

"Oh-seven-five, sir."

"Port fifteen. . . . Steady on oh-three-five."

I turned my head subconsciously to the right to compensate for the quick swing of the ship to port so that I could keep my eye on the compass bearing of the reported object. Once or twice I looked over the top of my binoculars to glance at the bow of the ship to make sure I was directing my gaze ahead.

"Red one-oh, one mile" came the report from the radar. Ten degrees on the port bow.

"Steer oh-two-five."

"Object's small but getting larger," called the navigator, repeating the radar operator's report.

"Can you see anything, Number One?" I asked.

"Not yet, sir."

"Ought to be showing soon. Stand by for star shell."

He passed the order and had his binoculars back to his eyes in seconds.

"Radar says about ahead now, sir, three-quarters of a mile. Going into the ground wave."

Curse these glasses, I thought, why can't I see through them? But it was like looking for a black spider on a dark wall.

"There it is! A bit to starboard!"

I took a quick glance at the first lieutenant to see exactly which way his glasses were pointing. Then I looked again and this time I saw it.

"Submarine, I think, sir," Black said slowly, quite steadily.

I looked hard.

"Looks more like a fishing trawler to me."

Surely, I thought, that's a trawler. High in the bow and high aft. We're on the edge of the Banks, too. No. That's not her stern, she's high amidships. It's her bridge, her conning tower! Now I can see her stern. It's low. It's a submarine! Beam on.

"Full ahead."

The order was instantly passed. Tenseness reigned. The engine room would be tense, too. Full speed meant an emergency.

"Fire, Number One."

A shrill whistle sounded and I shut my eyes. Then the gun went off and I opened them again. After what seemed like a long wait the star shell burst. There she was! A U-boat silhouetted against the falling ball of light.

I had no need of my binoculars now. The U-boat lay broadside on, about fifteen degrees on the starboard bow, less than four hundred yards away. Her bow was pointing directly across our course and I saw a short boiling wake at her stern—she had obviously just got underway and was working her propellers at full speed.

I altered course five degrees to starboard. Was that enough? Was it too much? Was she diving? Yes.

"Fire again."

I gripped the rail and watched the U-boat. Then a blinding flash came before my eyes. I had failed to obey my own orders. When the gunlayer blew his whistle before he pressed the trigger all eyes were to be shut. So intent had I been that I did not hear the whistle and the gunflash momentarily blinded me. I had to give up temporarily and hope that my vision would be restored quickly.

"Take over, Pilot, I can't see. She needs to come a little more to starboard, I think."

I felt for him with my left hand and touched his sleeve. He made a small alteration of course to starboard. I stared and blinked alternately and felt desperate.

"Is she going down?" I asked the navigator.

"Yes," he replied.

Then came Burley's voice close by me.

"Shall I fire a snowflake now, sir?"

"Yes," I answered.

God bless that man, I thought; he never forgets!

A moment later there was a swoosh and up went the rocket. Five seconds elapsed, then it was as though a great arc lamp had been switched on. The rocket had exploded ejecting its brilliant flare a thousand feet above.

I saw again. The U-boat was still before us, fine on the starboard bow, barely a ship's length away. But the upper part of her conning tower only was showing now.

"Stand by to ram!"

Then, hardly dropping my voice, "Set pattern A."

The asdic officer heard and passed the order on.

Would we make it? Would we reach her in time? We were desperately close.

In the pool of light shed by the flare we saw the U-boat's conning tower disappear. Our bow was almost on her, almost in the luminous whirlpool where her conning tower had been, the great white wake showing the short straight course she had steered—she had had no time to turn before she dived and she could not dive and turn as well.

In three seconds the bow cut the disturbed water. I waited for the crash. Another thirty feet . . . it did not come. The streak of foaming, whirling water was beneath the gun deck now. I heard no grind of steel nor felt the keel touch. Now it was beneath the foremast.

"Fire."

Collins caught my shouted word. "Fire one—Fire two—Fire three," he intoned as he pressed the buzzers. Neil and his men aft would respond instantly to the ringing bells.

I looked over the port side. The disturbed water did not extend beyond the ship on that side. The flare fell into the water astern and all was blackness.

I jumped to the starboard wing of the bridge. The streak was abreast of the after gun platform, its phosphorescence making it as clear as a white line on a highway. Then there were simultaneous explosions.

Four seconds later there were two more. The ship shook violently.

I turned and looked ahead but I would not have seen anything if there had been something there. I was shaking badly and I felt rather weak and my mouth was dry. I wanted a smoke of my pipe. I had failed to ram him—even to hit him. If we had touched him we would surely have felt it; and to scrape him would have done more damage to us than to the vessel below. The only way was to hit him squarely with the stem, and that I did not do. I felt disappointed. But mostly I felt relief.

"How far have we gone since firing?" I asked the plotting rating, speaking through the asdic house window.

"A thousand yards," he replied after a moment.

"I'll turn now and see if you can pick him up," I said to Collins.

We turned and steamed back on a more or less reciprocal course but allowing for the movement of the submarine in the direction we had last seen him going. In a minute or so the asdic officer reported he had contact. He and the operator held it and we ran in and fired five charges. We thought it was a pretty accurate attack.

But something else was more intriguing. A strong smell of diesel oil came to us. We all remarked about it at once and looked over the side to see if any oil was visible on the water. It was too dark to see anything and we soon ran out of it. This immediately started conjecture on the bridge. Obviously it was from the U-boat.

Presently we came back again and regained underwater contact. Although it was fading and uncertain we let go ten charges set to explode deep. The sweet odour of diesel oil was heavy in the air on this run in, and by the length of time we took to pass through it, it was evident that it had spread over a much wider area.

A few minutes later Neil, the torpedo officer, appeared on the bridge. He was breathing fast.

"What are you doing here?" I asked, wondering why he had left his post when we were using depth charges.

"It was the finest thing I ever saw, sir! Think we are wasting ammunition now."

The depth charge from the starboard thrower sank fifty feet and then exploded, as did the others. It must have touched the U-boat's after deck as it went off, for a moment later the bow of the U-boat broke surface a few feet astern. She rose up out of the water to an angle of about forty degrees exposing one-third of her long slender hull. Her momentum was still carrying her forward at right angles to our course. As she hung for an instant poised in this precarious position, a depth charge which had been dropped over the stern rail exploded immediately beneath her and she disappeared in the huge column of water.

"She'll never surface again, sir," Neil concluded.

I was dumbfounded.

Alan Easton

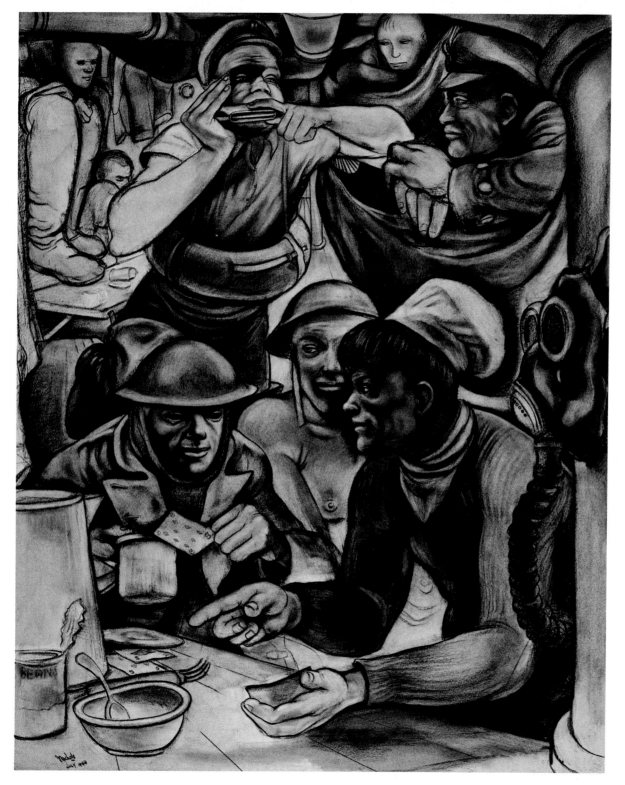

Jack Nichols *Atlantic Crossing* 1944

H.M.C.S. Athabaskan

It was a beautiful day. The sun blazed down in all its glory; the water, a magnificent colour of blue, was like a pane of glass. Most of the crew off watch lay on the upper deck doing their best to get a nice suntan. All was serene and quiet. Only the rush of water as it slid by and the steady throb of the engines broke through our half-sleep. We were in a world of our own for about half an hour, but suddenly revived to a world of reality and war. The shuffle of many feet on the iron deck, the dull ringing of the "action stations" bell from the engine room, a rough shake along with the excited cry "Action stations!" turned the once-peaceful surroundings into a bee-hive of activity.

Over came twenty enemy aircraft, Junkers and Focke Wulf "Condors" and immediately we heard the angry roar of the 4.7" and 4" guns of our own ship. The time was approximately 1255 when the action began, and at 1305 it was all over for us. Jerry got one of his flying bombs to work. It struck us on the port side just aft of the bridge, passed through the chart house, the chief and petty officers' mess, down through the starboard flats, out through the starboard side and exploded in all its fury about twenty feet clear of the ship. All the starboard side of the ship from the bow back to the break of the foc'sle was completely stove in, "A" and "B" guns were put completely out of action, the barrel of starboard Oerlikon gun Number 1 was twisted like a piece of wet rag. All communications from the bridge were shattered, the lights all over the ship were out, and confusion reigned for a few minutes. Fire broke out in the stokers' mess, and the ship was doing everything but sinking. We were given the order to get out on the upper deck, and no time was lost in carrying this out. The ship by this time had a terrible list to starboard and everyone was ordered over to the port side to try to counteract this, but it had little effect. Meanwhile, everyone kept anxious eyes scanned for enemy air-craft which might come back and try to finish us off.

The fire in the stokers' mess was finally squelched, but the biggest job was still ahead. Volunteers were asked for, to go down into the torpedomen's mess and shore up the ship's side so that we could try to get back to port.

From down there the damage looked much more severe than could be seen from the upper deck. She just looked like one huge hole, and this had to be plugged in order to keep the ship afloat. Anything we could get our hands on was jammed in the holes; hammocks, overcoats, underwear, boots, broken lockers, splinters off the mess tables, hats, socks, and everything was soaked with oil. As you got down to plug a hole, the ship would take a slow, weary roll, and a shower of cold salt water would hit you, almost taking your breath away, but you couldn't quit, you had to go on in order to get back to port. You worked until you were ready to give up. Reach for something, lose your balance and down you go. Get up, wipe the oil off your face and the salty taste off your lips and try again. It seemed so hopeless you felt like crying. Officers worked with men, for it was a case of all or nothing, and it is at times like this when the officers really forget their ranks and get to know the worth of the men.

As others came down to help, you finally got a chance to get a welcome rest. On reaching the upper deck, you asked for a cigarette, and someone else offered you a cup of tea to try and steady you down.

At last, after about one-and-a-quarter hours, we finally got under way at a very slow speed. Everyone had a dose of nerves, some swore at our helplessness, others moved about as though in a trance.

The inside of the ship looked as though a miniature tornado had struck; you couldn't move without stepping or tripping over something. Emergency lanterns swung from the deckhead, casting eerie shadows about. Occasionally the narrow beam of a flashlight could be seen as the doctor or his assistant moved around through the wounded, eighteen in all. Some were lying on tables, some more were on benches, others littered the upper deck by the Sick Bay. The stench of antiseptics, blood and oil mingled together.

The injured showed badly torn flesh, deep gaping wounds from flying shrapnel, broken legs, limbs blown off.

Some had teeth blown out by the concussion, others suffered abdominal wounds. Minor injuries consisted of bad bruises, punctured eardrums or nerves.

The trip back was heartbreaking. Our water supply was gone, therefore no washing, no shaving. The only food on board was that in the officers' galley. Our meals consisted of nothing more than a sandwich and, if we were lucky, a cup of tea to wash it down. On orders from the doctor, any of us who had been down in the torpedomens' mess shoring up the ship's side had to discard our shoes, socks, and cut our trousers off at the knees. This was a precaution against oil burns.

For a little over four days we had no sleep. Those of us who were still on our feet gave what assistance we could to the doctor in looking after the wounded.

During our return voyage, five of the crew were buried at sea. It is a lonesome and sad picture. Chaps you have worked with, slept with, eaten with, kidded and fooled around with, have died in defence of those they love. A spare hammock, just a rough piece of ordinary canvas is located. The body is laid in the hammock and a number of empty shell cases are placed around it. The hammock is lashed around the body, and if a White Ensign is available, that too is placed around the body. The body is carried to the rail of the ship. There the captain reads a short piece from the bible, says a short prayer, and the body is dropped over the side.

Stuart Kettles

Customs

At 1900 today, in accordance with Service custom, an Auction was held aboard of the effects of Davies, the rating who was accidentally killed in Portsmouth. Like most of us, who have been unable to replace lost or worn-out items of kit, he had little of value. As usual, an officer conducted the sale. Few bids are made because the item bid on is really desired by the bidder; in most instances when a sale is made the article is thrown in and auctioned again, the object being to raise as much money as possible. Over £110 was made on Davies' kit, and it will be sent to his kin.

I.J. Gillen

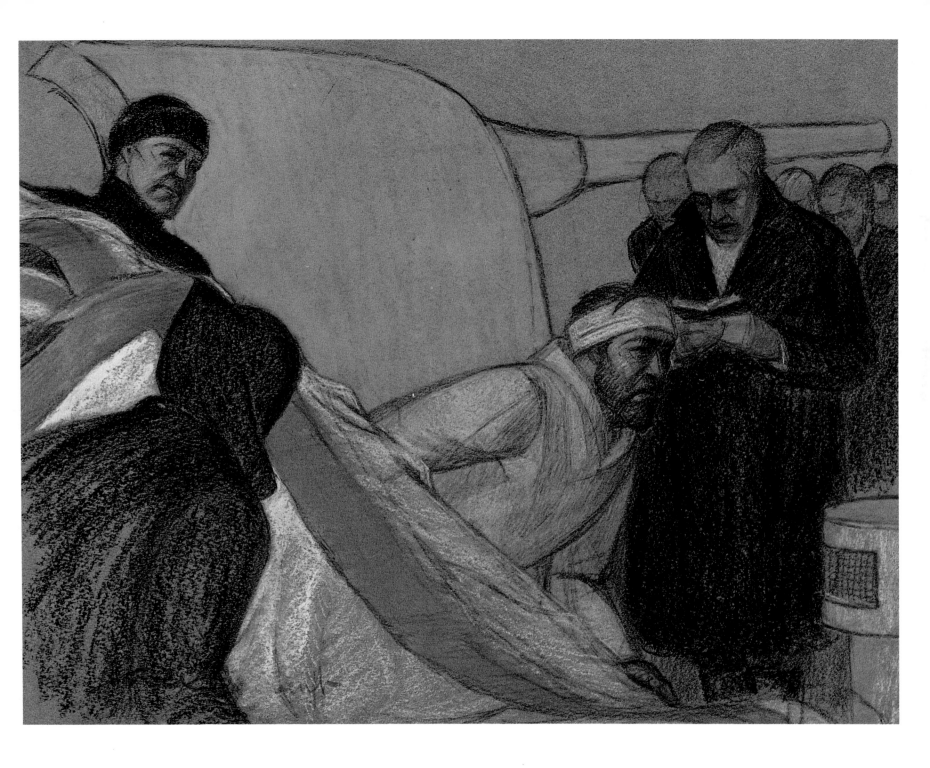

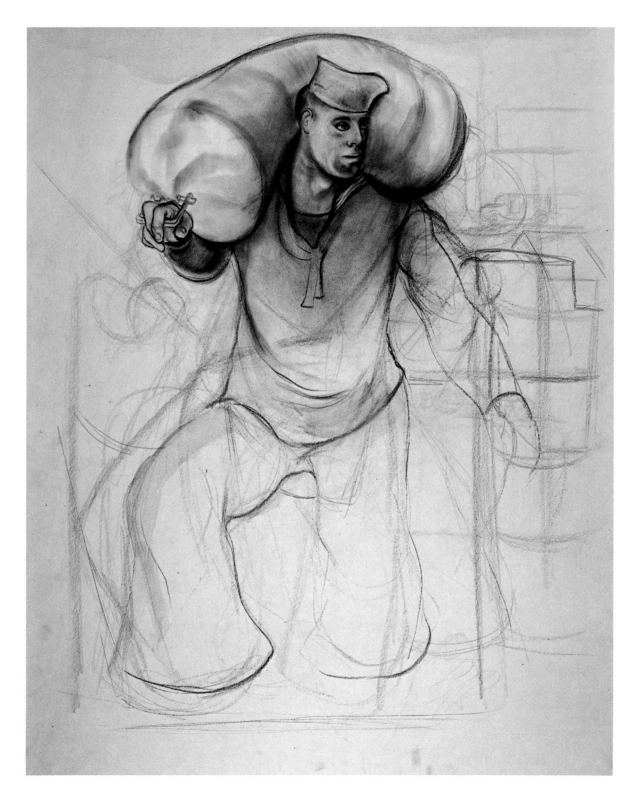

126 Jack Nichols *Joining Ship* (formerly 'Shore Leave')

North Atlantic

We had two enemies; the U-boats and the weather. I often wondered which was the worst. The submarines had been very trying. There had been short periods of fairish weather but there had been a great many gales.

There was that dark night when we had been running in the Western Approaches before a high quarterly sea, four of us together in line abreast making for port after leaving the convoy. The ship was pitching and rolling deeply, slowly; too slowly — the speed of the waves rushing up behind almost synchronized with the speed of the ship. At times she rode like a surf boat before the rollers with her nose pointing down.

At 2000 the leading hand of the blue watch which was coming on deck found he was short of a man, a rating who had been taken ill, and requested a replacement. He was offered a radar rating and chose the one he knew could steer best. The man's first duty was after lookout.

At 2045 the stern rose high in the air and the ship rolled over fifty degrees to port and hung there for an interminable time until the great sea relented and ploughed its way forward along the keel. When the leading hand, making his rounds in the darkness, was able to get aft several minutes later, the lookout man was not on the high gun platform. He made a quick search and discovered the bulwarks on the starboard quarter bent inboard. Going up to the gun platform above the boat deck again he found the protective plating around it almost flattened to the deck and the large raft on the port side gone. He struggled forward and reported to the bridge.

There was a grim search of the upper deck by all available hands, but the mute evidence of damage told that the lookout man had been swept overboard. The great sea rushing obliquely at the stern must have buried the whole after end of the ship. She had been pooped with a vengeance. The boy, hardly nineteen, may have been knocked senseless as the tide of water hit him and bore him through the obstructing spars.

We turned, all four ships, to search but realized the hopelessness of it. As we rose and dived into the steep seas we knew we could never find him. His close friend and shipmate cried for days and nights afterwards.

Alan Easton

Sinking of the Athabaskan

April 28th was a beautiful spring day. The sun shone in all its glory as though it too were celebrating our recent victory. The day slid by, evening came, and with it the best part of any sailor's existence — time to eat. Just the same monotonous meal, but it certainly was good. At that time it was not known what we were liable to have to do for another night's fun, but the whole crew was all for going and grabbing off another Jerry destroyer just for the fun of it. Finally, we were no longer in doubt, for the shrill blast of the Quartermaster's pipe told us all too plainly that our nights of relaxation were over. "Foc'sle party to muster on the foc'sle."

Yes, once again we were going to F.A.F.C. In sailors' language, it wouldn't be polite to say, but to give you a general idea, F.A.F.C. means "fooling around the French Coast," and that is just what we had been doing then for about six weeks. We usually went out to screen mine-laying motor torpedo boats or cruisers, and believe me, it was no joke. We had not been getting any more than seven hours sleep a week for the past six weeks.

2000 hours. We slipped our anchorage in Plymouth stream along with our sister ship, the *Haida*, and proceeded to sea to cover mine-laying motor torpedo boats and a mine-laying cruiser, which were going to do a little job along the coastal waters of France. It was a lovely night, the cool spring air was a treat from the heat of the day, and everyone felt good to be alive and full of health.

We arrived at our predetermined position and immediately set about to watch for any signs of enemy ships which

might show up and spoil the work of the boys closer in towards shore. Up and down we cruised, ever on the alert. The whole ship's company was closed up at "Action Stations" ready for the first sign of Jerry. Gee, it was quiet. What's the time? 0345. Thanks. It won't be long. Just another fifteen minutes and then we turn back.

"Enemy shipping ahead. Stand by." What a break. Almost time to head back and what happens? Oh, well, perhaps it won't amount to anything. Say, we may even be lucky enough to grab off another of Adolf's prized fleet. A terrific roar breaks through our musings and we realize that "A" gun has fired a couple of rounds of 4.7" star shell to illuminate the enemy. It takes no more to snap us around. The ammunition hoist under your control begins to hum and deadly missiles pass from your hands to the hands of a stoker. Into the hand hoist they go and on up to the gun. Keep 'em coming, boy, we're going to need them.

There is a moment of silence while the gunnery officer spots the target, then we're off once more. The continual roar of the 4.7s is like a lullaby, but like all good things, they must come to an end. There is a muffled roar, a glimpse of a dull red flash, the ship lurches. It suddenly drops away from under your feet so quickly that you can feel your feet free of the deck. What was it? Through my own mind flashed the thought "torpedo." Rather than cause confusion among the supply lads, I kept my own thoughts to myself.

From out of the passageway comes the talk and excitement that indicates something unusual has happened. Giving orders to keep the shells rolling to the guns, I went to find out the cause of it all and got the short and snappy answer "We've been hit. Keep the shells going to the guns." Back we go to "Praise the Lord and pass the ammunition," but it is only a matter of a couple of minutes before we get the order from our captain on the bridge, Lieutenant-Commander John H. Stubbs, to "Stand by to abandon ship, *but don't abandon yet.*"

The hatch covers over the magazines are lifted. "Come on up and make it fast. We've been fished." As the boys come up we pass along the captain's verbal orders, and then make for our "abandon ship" stations. Out through the long passageway we make our way. There is no undue excitement, but believe me, our feet sure move fast. At the break of the foc'sle we take a snap look around and find the ship is on fire right at the torpedo tubes. Everyone is moving to a prearranged spot.

I made my way to my abandon ship station on the foc'sle, almost directly under "B" gun turret. Someone shouts down, "We better cut this floatanet loose, then if we have to go over we can scramble down and won't have so far to jump." "Let 'er come", I called and waited till the job was done. It almost fell on top of me. It had just hit the deck at my feet when an ungodly roar and flash filled the air. The second Jerry fish had found a resting place in No. 1 boiler room, and along with the torpedo exploding, No. 1 boiler room also exploded. Boiling hot oil, red-hot pieces of shrapnel, flying timbers and anything that had been torn loose by the explosion filled the air. I covered the back of my neck with my arm, and crouched on the open deck, at the same time wondering if my number was up. When things had quietened down, I ventured a quick look around, particularly over the side. Everywhere I looked there was someone going over the side. No one needed to pass the order to "abandon ship." Every man for himself, and God help the last one.

It was now about 0430 April 29th, 1944. I looked over the side at the cold, uninviting water of the English Channel, by now covered with thick, dirty, fuel oil. My first thought was, "Gee, I can't jump into that," but when I turned around and looked at the burning ship, which was beginning to settle to her watery grave, I suddenly decided, "Hell, I can't stay here neither." Taking off my steel helmet, which I laid carefully to one side, I gave my life jacket a quick pull to make it fit a bit more snugly, stepped over the guard rail, looked to see if anyone was floating around underneath, and then quite unvoluntarily, and without ceremony, joined the Paratroop Battalion. Yes, I bailed out. There was no shock as I hit the water, but it wasn't very doggone long until I realized that it was no Turkish bath.

I looked around after coming to the top, also after wiping the oil out of my eyes, and spitting the English Channel back where it belonged, to see just where the ship was by

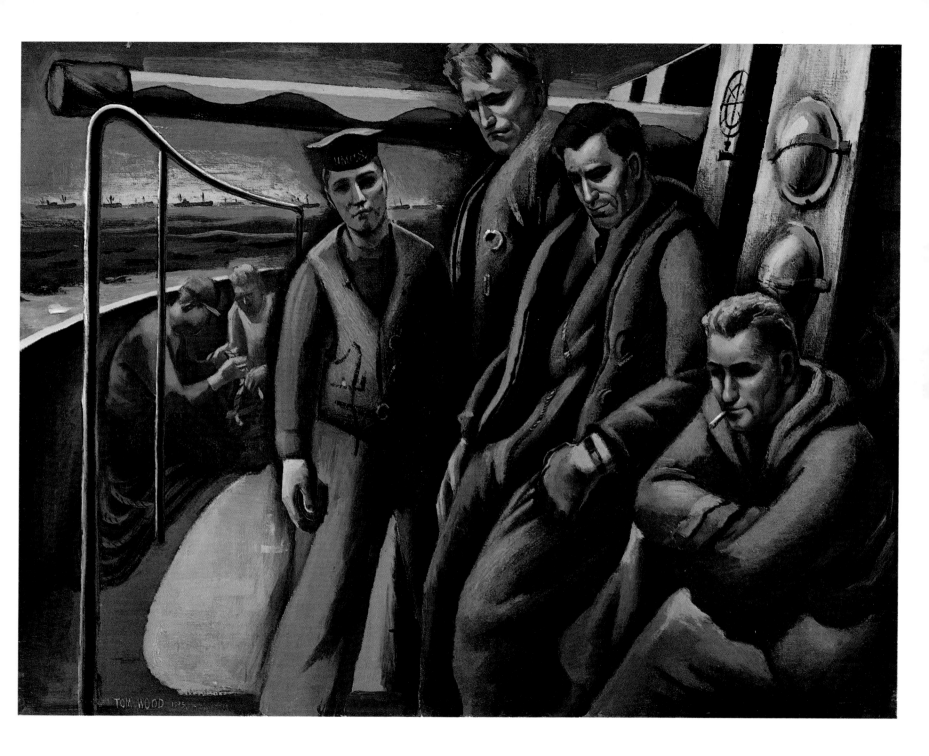

Tom Wood *Gun's Crew* 1945 129

this time. To my surprise, she was beginning to take a very bad list to port, so it struck me that the best thing to do was to get as far away from it as possible. While I was swimming away from it, one of the boys near called out, "Who is it?" I told him and also recognized him by his voice to be George Parsons, the captain of "A" Gun. "Come on over", he called, "Glen Newlove is here with me. We might just as well stay all together. It won't be so tough going that way." I swam to where George and Glen (a cook) were and it was quite a wet reunion. However, it certainly didn't lack any enthusiasm.

It was just a short time after when George said, "Roll me on my back and hold me there 'till I see if I can get this damn light going." The light he referred to was attached to a small hat which was part of the new type life jackets we had just recently been issued. We had a go at it, but the long slow rollers, coming out with the tide, kept throwing George over on his face, until I got tired of rolling him back onto his back. Then I wrapped my legs around him and the two of us floated that way until he got the small light in operation. His only remark was, "Well, I'll be doggoned, the darned thing works." We got a laugh out of this, in spite of the grim situation we were in, just about three-and-a-half miles from the French coast, or in other words, Jerry's back door.

After floating around for awhile, to conserve our strength, all the while inquiring if any of the other lads around us were injured or needed help, we suddenly spotted a ghostlike form approaching us from out of the false dawn. She crept up on us and finally stopped. It took us a minute to realize just what was coming off, but when it did sink home there were cries of "Good old *Haida*," "Wait for us *Haida*." Yes, back into a very uncomfortable spot had come our sister ship to drop all her life-saving equipment and pick up what survivors she could while carrying out this move.

The first thought to enter our minds was to swim for the *Haida* and if at all possible get aboard her and back to England. George, Glen and I started a three-man race for the *Haida*.

On our own ship the *Athabaskan*, we kept a scramble net right at the break of the foc'sle and hoped that the *Haida*,

exactly the same ship as ourselves, might have one there also. However, as I reached the *Haida*, and, in fact, was bobbing up and down in the water and actually touching her, one of the crew off the *Haida* shouted down to me to go back to the break of the foc'sle. I insisted that he throw me a line and I would climb up, but he still kept telling me to go back to the break of the foc'sle. Grabbing onto the boat rope of the *Haida*, which was greasy from the oil of the *Athabaskan*, I started to swim to the directed place. I had just about twelve more feet to go when the *Haida* threw her engines into reverse, a warning to those swimming around in the water that she was shoving off. The force of the water from her propellers washed me away from her side out about a quarter of a mile from the bow.

I now found myself entirely alone, and my legs and arms growing more numb as the minutes passed. The tide, which was going out at the time, came in long slow-rolling waves. This caused a very nice sensation, like rocking a child to sleep in a cradle, and it wasn't very long before this motion began to make me very sleepy. There were none of the other lads around to talk to, to help stay awake. I felt myself going to sleep, and knowing I couldn't stay awake much longer, pulled up the head rest on my life jacket, and was quite prepared to take whatever lay ahead of me, even though I should fall asleep, which was exactly what happened.

The next time I saw the welcome rays of sun, I lay on a wooden table naked as the day I was born, shivering from the cold immersion. A crude bandage was around my right leg, and one of the boys off the ship was sitting beside me wiping the oil out of my mouth, eyes, nose and ears. I asked him where we were and his only answer was "On a German destroyer. They picked us up about nine o'clock this morning." Looking around, it wasn't hard to see that he wasn't fooling. German naval uniforms were all around us. Some of the Jerrys stood with sten guns, rifles and revolvers. We took count and found there about thirty-two of our boys on the first leg of a trip which was to end in Germany.

Stuart Kettles

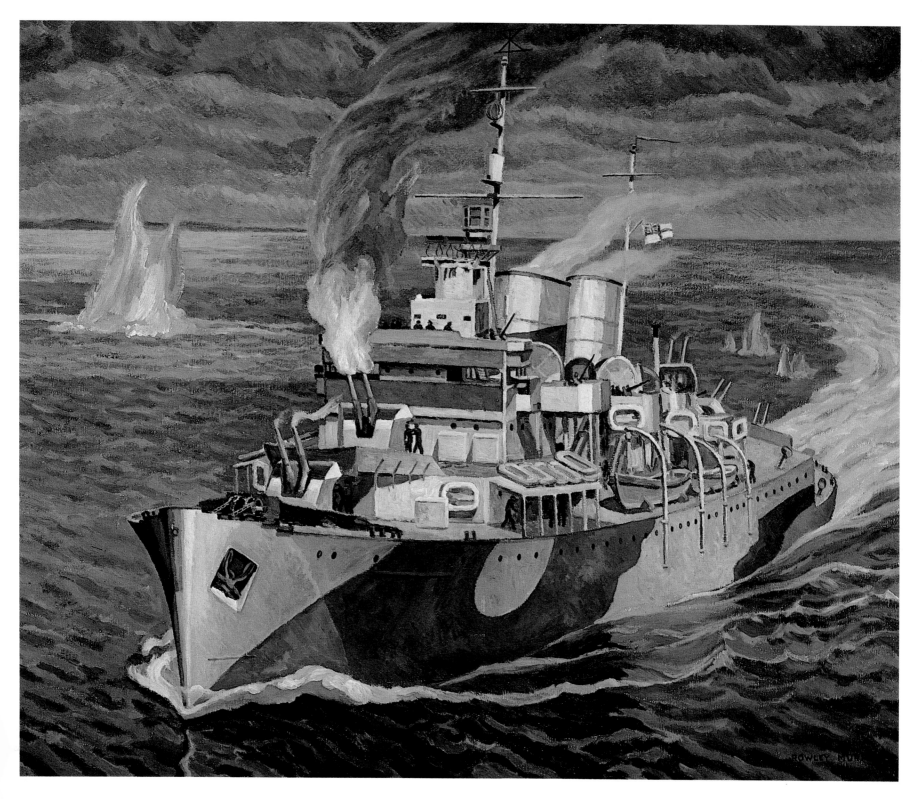

Rowley W. Murphy *'Prince Ship' Under Air Attack* 1943

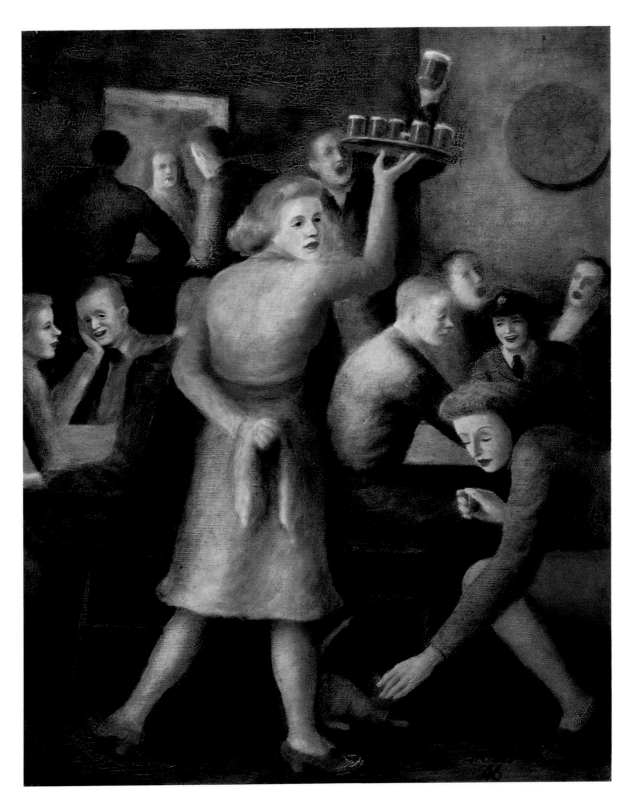

132 Miller Brittain *Airmen in a Village Pub – Yorkshire* 1946

Night off

It was the Flotilla's night off and we were all invited to a birthday party for Pat (a WREN) which was to be held at the Wheat Sheaf Inn. We were no longer on our dignity, and the English officers were highly amused by our antics and the Canadian lingo. Before many minutes had passed, a sedate and elderly gentleman, clad in a gray Scotch tweed suit, quietly appeared and enquired "Pardon me, Sir, which gentleman ordered a taxi?" The types screamed, "We did," and there was a mad scramble out of the bar down the steps and into the taxi. The vehicle closely resembled a royal limousine of about the 1921 vintage. When we were all aboard it set out cautiously through the darkened streets of Ramsgate but when we reached the highway it speeded up to its maximum of fifteen miles an hour, although when it came to an incline it would shift to low and creep up. The voices inside, raised in song, kept time with the racing engine, and clouds of oil fumes spouted forth on every hill. Eventually, the taxi drew up with dignity in front of the Inn and we fell out in all directions. The old driver asked us what time he should return and thanking him profusely, I replied, "10:30 please."

Pat and her party had arrived before us and the celebration was well under way. It was my first visit to the Wheat Sheaf Inn and I was pleasantly surprised at the cheerful, homey atmosphere. In the centre of the room was a large table surmounted by an ornate floral arrangement, oriental rugs covered the floor, and big comfortable easy chairs were scattered about. The oak-panelled walls, covered with Henry VIII prints and brass tallyho bugles, were surmounted by a plate rack filled with fine examples of Crown Derby.

Pat was a pretty little thing with fair hair and a golden suntan and she looked very smart in her WREN uniform. Mind you, there were many other "Pats" — the girls all seemed to have that name—but she was *the* Pat. "Cardinal Puff-Puff" and "Chug-a-Lug" were soon in full progress, priming the party for a good sing-song, and by this time everyone in the pub, including the barmaids, had joined in. The singing was something out of this world. Bobby was at the peak of his story-telling and a young English lad was doing a good job of reciting "Eskimo Nell" when we heard the restrained voice of our taxi driver through the gaiety and laughter. Regretfully, we bade adieu to the barmaids, the Army and the Air Force, and to all who had joined in the friendly little party. The manager of the pub and the barmaids thanked us for coming with our songs and laughter and hoped that we would come again. Having staggered into the limousine, we were off in a cloud of smoke.

Anthony Law

In England waiting

Weekends were invariably busy, because all the girls had friends and relations of all ranks in the different services. There were thousands of Canadian troops in England that winter, who came up to London whenever possible, or asked us to meet them somewhere. While Red Cross girls had officers' privileges, our rank was only a courtesy and we could go out with anybody from privates up, unlike female officers in the armed services. Later those of us attached to the Medical Corps had to observe the same rules as nursing sisters and have dates only with officers, but that was after we left London. All Canadian boys in England were dying to see somebody from home, so as a result we were deluged with invitations. Usually the men were in some weird spot and few could say where, for security reasons. This meant we couldn't go to their towns to visit because nobody was supposed to know the location of their units. Often it was too far for them to come up to London so they would arrange a meeting place, suggesting a rendezvous at some village hotel, all under correct circumstances. At first this custom seemed peculiar and dubious, but it was evidently being done.

Whenever the telephone rang at Corps House there was excitement. It might be from anybody, in any part of England, and a terrific amount of yelling went on in efforts to get a girl to the phone as quickly as possible. It was known, first of all, that some lad had probably waited an hour and a half for his "trunk call" to get through, and was paying two or three shillings for it. He shouldn't be kept waiting. Neither should the half-dozen girls who were sitting around chewing their nails, waiting for other calls. So the person on duty would scream out the name of the girl wanted — and shrieking, "Jean Ellis, telephone!" up four flights of stairs was a feat a Swiss yodeler might have envied.

The girl called would drop whatever she was doing and rush for the phone, regardless of garb or condition. Never have I seen anything funnier than some of those flying rushes. One girl might have her hair all soaped ready for rinsing; another had just stepped out of the tub and grabbed a bath towel; a third would have hair-removing goo all over her legs. But down she would come, on the double.

The operator would intone the usual warnings, then a breathless man's voice would say "Will you and Mary get on the 2:53 Saturday from Waterloo for Whosit. At the station, walk to the top of the road, bear left at the church, walk 250 yards to a large haystack, then sharp right down the road past a pub to a house with green shutters. I have a room reserved for you there. Can you make it?"

Jean Ellis

Inspection

Dear Joan:

Every Monday night we are confined to barracks for some infraction of the regulation: hair on collars, buttons not shined, shoes not shined, skirts too long, skirts too short, beds not made properly and rooms untidy and of course too many people coming in late. We have a great many inspections. Every morning before going to work we are lined up neatly in the lobby of a South Street home for a most thorough inspection. Then, after that, some girls have another one (inspection) when they get to work at their respective buildings.

Kathleen Robson Roe

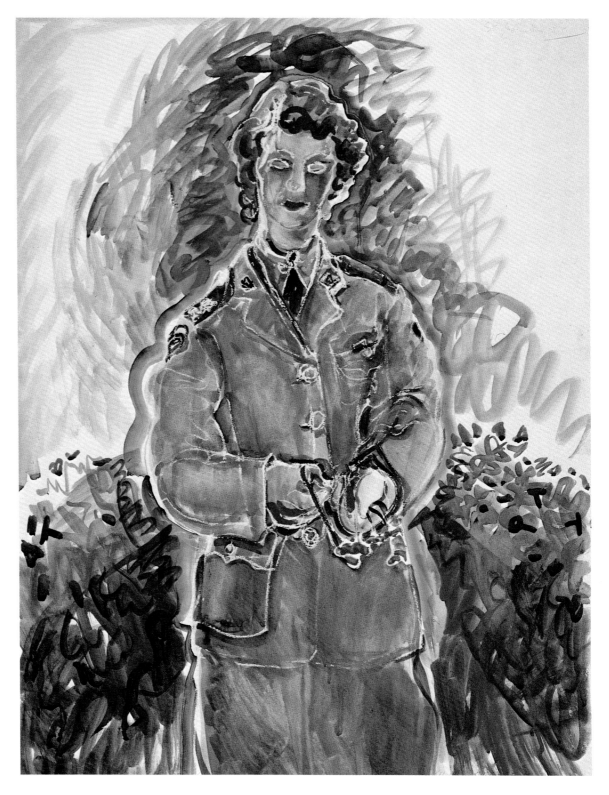

Pegi Nicol MacLeod *C.W.A.C. Officer* 1944

On parade

There were three to five girls in a room. Leaping out of bed the first morning, I grabbed bathrobe, towel and soap, thinking I'd be dressed in five minutes. To my dismay, fourteen girls were lined up between me and the bathroom. They were in all stages of disarray and disrepair and I learned a lot about curlers, face creams and styles in negligées.

Our bathroom was right beside the "lift," so of course the queue went past it. When I had moved up a few places, the lift door suddenly opened, and out stepped three men in uniform. They looked *so* surprised, said "Oh, pardon us, we thought this was the fourth floor," took a good look, grinned, and went down again. I clutched my bathrobe, wondering what was showing, and said "Weren't they stupid?"

"Stupid my eye!" said the girl ahead of me. "They knew perfectly well this was the fifth floor—it isn't the first time this has happened. If any more come up, I'll tell them a thing or two!"

This girl had her own peculiar technique about dressing in the morning. Before going to the bathroom, she got herself completely turned out from the waist up—cuff links in place, tie tied, and all the rest of it. From the waist down she was unclad except for a girdle, with garters dangling, and bedroom slippers. She didn't wear a slip and never bothered with a bathrobe.

Five minutes later, while we were still in line, the lift clicked again and out stepped three more boys who gave us the old "fourth floor" routine. Quite forgetting how unfinished her toilet was, my pal stepped forward, assumed her haughtiest tone, and said "You have made a mistake. This is the fifth floor, not the fourth. Go back in the elevator, push the button marked 4, and you will get where you belong. I thought you had to be able to read to get in the Air Force!" The boys thanked her meekly and went off.

"That should hold them," she remarked smugly. "Of all the nerve, coming up here expecting to see something—"

Looking down, she caught sight of her girdle, realized what they had seen, and was simply shattered. Her mouth hung open, and not a sound came forth. But the rest of us, who had been killing ourselves over the picture she made, howled with glee.

Jean Ellis

The General

The ubiquitous atmosphere of sex seems to hang over this city like a pea soup fog. They tell me it is always thus in times of war and great troop concentrations and I suppose that is so, what with the blackout etc.

A friend of mine was coming home the other day and it was really black and foggy. She had her torch, as they call flashlights over here, with her and was flicking it on and off to get her bearings and find her way to South Street. Sometimes there is a chink of light showing when someone lifts a blackout curtain to go into restaurant or pub and you get to know these various landmarks of light but in a pea-souper it is so dark you literally can't see your hand in front of you. She shone her torch and it showed the figure of an American soldier busily making love to what we call "a Piccadilly commando." She turned it off fast but as she did she noticed the girl's hand slowly withdrawing the soldier's wallet! These commandoes are really bold and sometimes they try to take our escorts away in broad daylight. Around Waterloo Station at night reminds me of Dante's Inferno. I forgot to mention the commando who seems to work the Shepherd's Market vicinity. She wears a tight black satin dress and we have nicknamed her "The General" and usually everyone returning to the barracks reports on her activities.

Kathleen Robson Roe

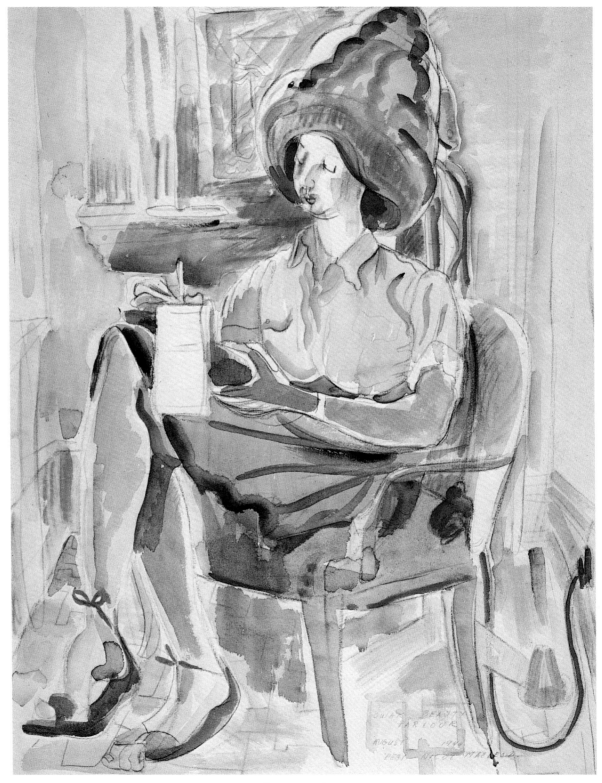

Pegi Nicol MacLeod *C.W.A.C. Beauty Parlour No.1* 1944 137

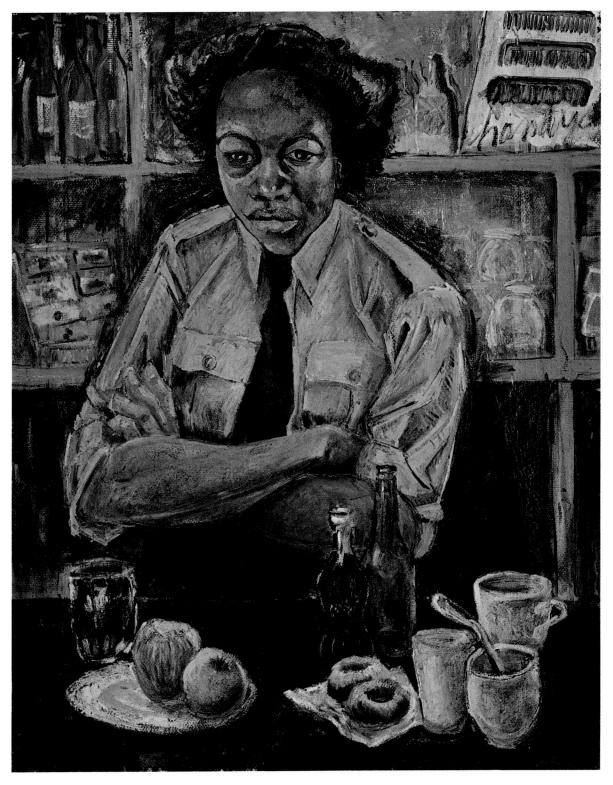

138 Molly Lamb Bobak *Private Roy, Canadian Women's Army Corps* 1946

Hedy Lamarr

The outfits were not thrilling — heavy khaki material cut like an officer's uniform with Sam Browne belt and awful peaked cap; tailored shirts, cotton stockings, sensible shoes. There wasn't an ounce of glamour in a carload. Even Hedy Lamarr would have looked like a drayhorse in the ensemble.

Jean Ellis

I was leaning against a lamppost when one woman anchored alongside and invited me home with her; she noticed my Canadian shoulder-flash, however, and broke off astonishingly with, "I'm sorry, Canada, I thought you was a Yank." I think she really meant it — I mean as an apology—because she patted my arm as she turned away. What was it? Empire feeling? Family relations? Or just no business? The "Yanks" do, of course, carry more money than we do.

Donald Pearce

Family feeling

At blackout we went down to Piccadilly Circus. Almost all the streets were deserted by now, for public London retires early in wartime. But Piccadilly was just starting to get under way for the night. During the day, it is caught in the general rush of London traffic and is only another busy intersection; but at evening it begins to move on its own, like a growing whirlpool sucking in driftwood, circling round and round in the shadows, under arches and in dark alleys, stopping here and there in broken groups, never for very long, moving round and round the pedestal of the statue of Eros at the hub of the whole system. As it moves, it *mutters*, the muttering now and then punctuated by sudden laughs, or shouts; and there is the strong, incessant thud or shuffle of feet underneath the other sounds, like orchestral basses. The people move in pairs usually, or in groups, nudging, brushing, stopping each other, coming back, going away, driven around hour after hour, caught in that fantastic flow.

The prostitutes ("Picadilly commandoes," as the Americans call them) carry flashlights, little ones, and flick them on and off occasionally or make a circle of yellow light over their feet. Frequently they are quite classy-looking women, carefully groomed; but their prices are laughable, £5, £6, £7. "But do you know what you are saying? That's a fortune." "Take it or leave it, brother; it's for all night."

Personal Friend of Mine

It's easy to see she's not my mother, cause my mother's forty-nine
It's easy to see she's not my sister, cause I wouldn't show my sister such a wonderful time

It's easy to see she's not my sweetie cause my sweetie's too refined
She's just the kind of a kid who wouldn't tell what you did
She's just a personal friend of mine.

Veedee

Venereal disease, an inevitable and constant concomitant of wars the world over and throughout the centuries, invoked the display of a plague of signs, posters, brochures and even sermons. In time these monotonous admonitions came to lose whatever salubrious effect they may once have had, owing to their dull repetition. Certainly they did nothing to lower the V.D. rate even after the advent of sulpha drugs, and, latterly, penicillin.

The army went to considerable pains to establish prophylactic treatment centers where, following intercourse, a "hosing" was given, together with a certificate attesting the dutiful soldier had, in fact, submitted to preventative treatment. The centers, which operated around the clock, were located in areas where V.D. was most likely to be acquired (and where was it not?). There, the familiar large blue sign, together with a blue electric light bulb, when available, blatantly proclaimed,

BLUE LIGHT
TREATMENT CENTER

To the average soldier, such an interruption of his love life was not only an annoyance, but a waste of his precious leave time. Hence he quickly came to devise a most convenient solution. The very *first* thing he did on arrival from the line at a rest camp was to visit the "blue light torture chamber" and submit to a treatment, and thereby obtain a certificate of clearance. From then on he pursued his amorous indulgence without further interruption!

Perhaps the greatest goof ever perpetrated in the pictorial campaign against the acquisition of V.D. was that demonstrated by an elaborately printed poster, which was displayed by the hundreds in the rest areas. The highlight was an illustration designed to be an eye-catcher—and it most certainly was. It consisted of a well executed drawing of a curvaceous young woman in a most seductive pose of deshabille, whose every anatomical charm displayed appropriate yearning. It had meant to deter, but the artist had outdone his purpose with the result proving contrary to his aim!

But the crowning bit of hoopla in the anti-venereal campaign consisted of a paraphrasing of that famous pronouncement by one of history's greatest generals, himself a Roman of old, who once wrote, "Veni, Vidi, Vici." The degrading sign, plastered widely about, read,

VINO + VENUS = VEEDEE

Edward Corrigan

Loving Song

I took the legs from off the table, I took the arms from off a
 chair
I took the back from off the sofa, and from the mattress,
 dear, I got a little hair

I took the hands and face from off the clock
And when I'd stuck them all with glue
I got a hell-of-a-lot more lovin', dear, from that damn
 dummy
Than I'll ever get from you.

You take the legs from off a table, you take the arms from off
 a chair
You take the neck from off a bottle and from a horse you get
 the hair
You put the whole damn thing together with bits of string
 and lots of glue
And you'll get a lot more lovin', dear, from that damn
 dummy
Than I ever got from you
Without a struggle, than I ever got from you.

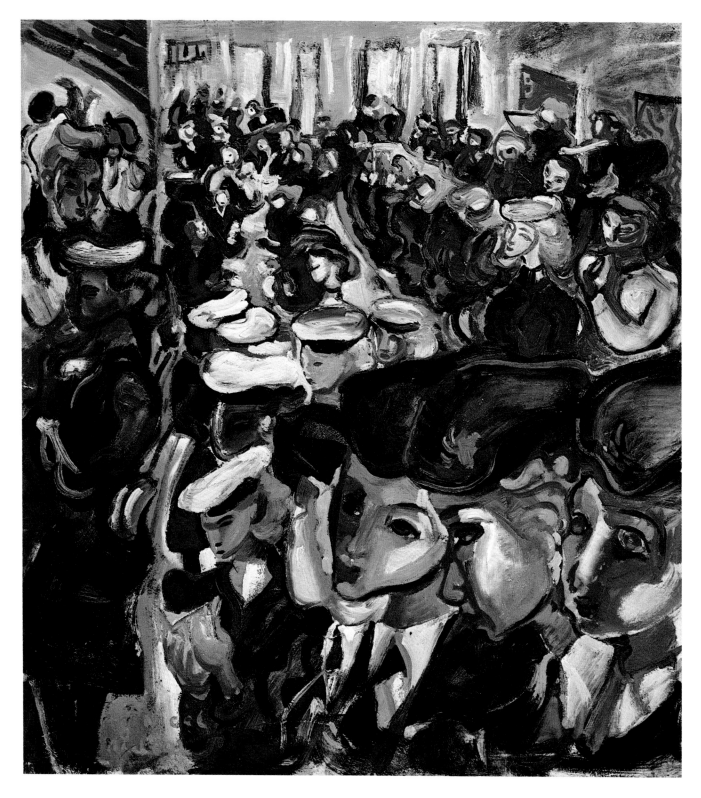

Pegi Nicol MacLeod *Untitled (WRCNs in Dining Room)* 141

142 Molly Lamb Bobak *C.W.A.C. Wedding in the Seminary's Chapel* 1945

Bridal party

Quite a few lovely romances blossomed, and dozens of Red Cross girls became engaged to men they met overseas. Many a beautiful wedding was held at Corps House, because of the generosity of the Robert Simpson Company Limited of Toronto, who sent three wedding ensembles to the Overseas Red Cross girls. With each wedding dress came a veil, gloves and all the rest of the "doings" for a bride, and two bridesmaid's dresses with hats, gloves and accessories. The brides frequently chose their attendants to suit the costumes, instead of following the time-honoured custom of choosing costumes to suit the bridesmaids. After each ceremony the frocks were cleaned and left ready for their next wearers.

Jean Ellis

Airman's Girlfriend

Around her neck she wore a silver locket
She wore it in the springtime and in the month of May
And if you asked her why the hell she wore it
She wore it for an airman who was far far away.

CHORUS:
 Far away (far away), far away (far away)
 She wore it for an airman who was far far away.

Around her leg she wore a purple garter
She wore it in the springtime and in the month of May
And if you asked her why the hell she wore it
She wore it for an airman who was far far away.
CHORUS

Around her waist she wore a dirty girdle
She wore it in the springtime and in the month of May
And if you asked her why the hell she wore it
She wore it for an airman who was far far away.
CHORUS

Around the park she pushed a baby carriage
She pushed it in the springtime and in the month of May
And if you asked her why the hell she pushed it
She pushed it for an airman who was far far away.
CHORUS

Behind the door her father kept a shot gun
He kept it in the springtime and in the month of May
And if you asked him why the hell he kept it
He kept it for an airman who was far far away.
CHORUS

Upon a grave she placed a bunch of posies
She placed them in the springtime and in the month of May
And if you asked her why the hell she placed them
She placed them for an airman who was six feet down.
 Six feet down (six feet down), six feet down (six feet
 down)
 She placed them for an airman who was six feet down.

Distinction

The First Division is the only formation in the history of war in which the birthrate is higher than the deathrate.

Lionel Shapiro

His name was Joe

Servicemen's babies, whether legitimate or not, were each entitled to a layette, as long as paternity could be proved. It was very simple when a girl came in with her own marriage licence and the child's birth certificate, as happened in the majority of applications. It was even simple enough when a girl admitted she wasn't married, but some serviceman had written us a letter acknowledging that he was her child's father. Complications arose when there was no such letter and not always positive identification of the man. If she knew his name and regiment, we sent a routine letter to the padre or O.C. of the unit, asking him to interview the man and report to us. But when she didn't know all the important facts, considerable sleuthing was necessary.

"I think his first name was Joe," said a girl with lovely blonde hair and bad teeth. "At least, I heard other boys call him that. He said one time his last name was Brown and another time it was Jones, but he signed this letter Joe." She gave me the letter to read and I began to blush furiously. Such passionate purple passages — no wonder the girl's head had been turned!

"What regiment was he in?" drew a blank. So did "What sort of badge was he wearing?" But when I drew sketches of various badges, and described others, we finally decided he must have belonged to the XY regiment.

"What colour was his hair?"

"Well, I don't exactly know — you see, I never saw him with his hat off!" But she was sure he was of medium height and on the stout side, and we concluded he was a private as she couldn't remember any stripes on his sleeve or pips on his shoulder. Next step was writing a letter to the padre or officer commanding the XY regiment, saying we had a layette application from a girl with a child two months old who claimed that a man named Joe in the regiment was its father. Since the XY's had been within hailing distance of where she lived eleven months ago, it was possible she was telling the truth, and we would appreciate any assistance in trying to locate the man, who was a private of medium height and fairly heavy. In due time a letter came back saying that Joe had admitted his responsibility, the girl was notified, and she came down for her layette with the baby in her arms. He was a beautiful child and I was glad to see him outfitted.

Jean Ellis

Already

Already we've watched float away
our last gulped-down
one-minute-to-ten pint
of mild and bitter.

Already we've roamed the streets
noisy with election sound trucks,
looking for something
we're not very liable to find.

Already met
the two Land Army girls
as the Fun Fair closed,
the ones who gave us each
a pull from the bottles of beer
they carried in the pockets
of their loose-fitting coats.

Already we've felt the chill
of night coming on,
already watched the darkness
shutting us slowly off
from a living world.

Already known the full curse
of being in uniform,
of being far from home
of being very young.

Already we've lived a lifetime
with midnight still half an hour away.

Raymond Souster

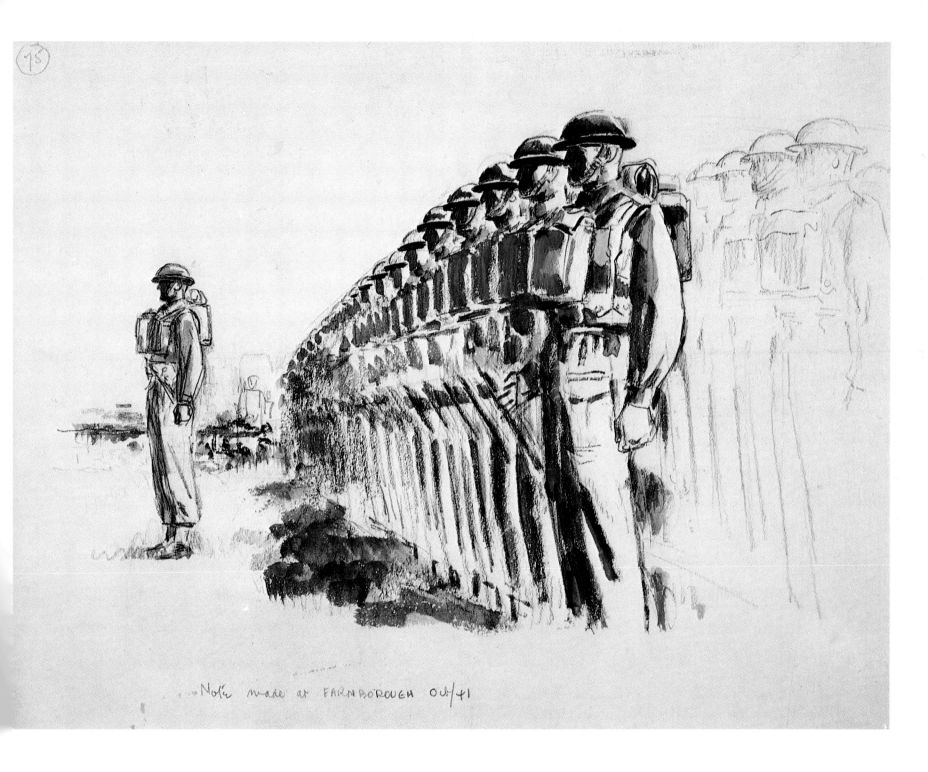

Will Ogilvie *Parade* 1941 145

Dieppe: August 19, 1942

When I woke up it was 0400 and our landing craft was gliding over a calm sea. The sky was clear and sprinkled with stars that shone like jewels on a background of blue velvet. A very light breeze brought us the coolness and perfume of the sea and the night.

The men were sleeping like children, without a care. As I looked at them before going into action for the first time, I wondered which ones would be killed. In a raid of this sort, even if things went well, we were bound to have casualties; I only hoped they would not be too heavy.

In a few hours we should be landing in France; this arrival would be very different from the arrival I had dreamed of as a young man. Many times I had imagined it all — the planning, the packing, the excitement of life aboard a big passenger ship, and the arrival at docks crowded with people waving a welcome. Then, of course, there would be Paris! We French-speaking Canadians loved France as the land of our forefathers.

The men were waking up now, and climbing to the narrow side decks, which were about twenty-four inches wide and just right to sit on.

The eastern sky was beginning to lighten. Dawn was coming up, a brilliant pink, and a slight haze rose from the sea, the prelude to a fine summer's day. Wherever we looked now, there were ships; the Channel seemed full of assault landing craft, fat troop transports, sleek destroyers bristling with guns, tank landing craft: a vast flotilla. All was calm and undisturbed, like some great peacetime review.

Then we heard the first shots of the raid. This was the first time any of us had been under fire and we all ducked. We awaited the arrival of the shells—twenty, twenty-five, thirty seconds; they were not for us.

I pulled myself together and began to get everyone busy. We had to shave and wash in sea water; I tried to convince the men that sea water was very good for the gums! In the best tradition, we could not die without a shave and shiny boots. Nobody had a brush, so we had to borrow a rag from one of the sailors.

We had a little food with us, but not nearly enough. I was lucky enough to find some extra emergency rations, and I shared these out. We had never tasted them before, although all of us had been carrying some in our bags. They come in a tin just like sardines, with a key to roll back the cover. Inside was a sort of chocolate marked off in squares. Its taste was very pleasant, just like chocolate, and I was sorry we had so little as there was not going to be enough to go round. It was not long before I discovered my mistake; it was as much as I could do to eat a second square. We all had more than we could eat, and no one would die hungry.

A destroyer on our right suddenly opened up with its heavy guns; we felt at last that that pleasant sea voyage of ours had come to an end. The dreamy haze of that August morning had been finally and firmly dispelled; the fighting we had been preparing for for three years was on us. It was the first time that Canadian troops had been in action in the war. It would be the first time the name of our regiment was mentioned in a battle, and we had to uphold the tradition that the veterans of the last war had handed down to us.

From our rear, we could hear the sound of aircraft: the Allies coming from England. As they passed overhead, we could see they were fighters making for Dieppe. There were quite a few of them and our men cheered.

Our landing craft had slowed down again and we were barely moving. Now we could hear the roar of guns from the sea: there was a steady firing from the ships near us, pouring shells into Dieppe. We had no means of knowing what was going on; the early morning haze had become thicker with the gun smoke, and judging by the sound of exploding shells, we were too far from land to see anything anyway.

Next, waves of light bombers came roaring in from the sea. This was just about the time the first Canadian landing was due. The British should have landed about an hour previously, and if things had gone well for them, their job should be almost finished.

On our right flank, the South Saskatchewan should have

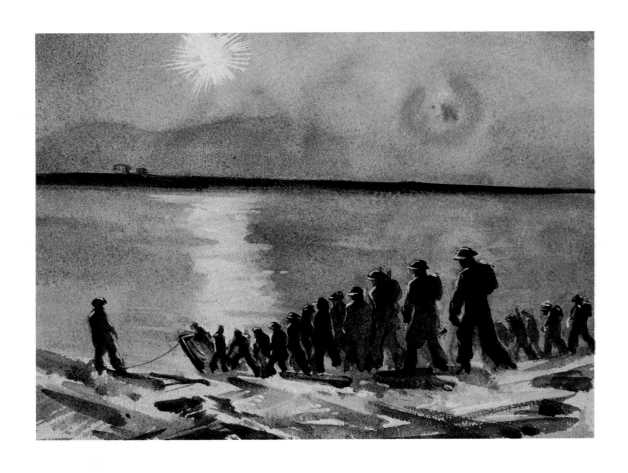

George Pepper *Royal Highlanders of Canada Embarking in Storm Boats* 1944

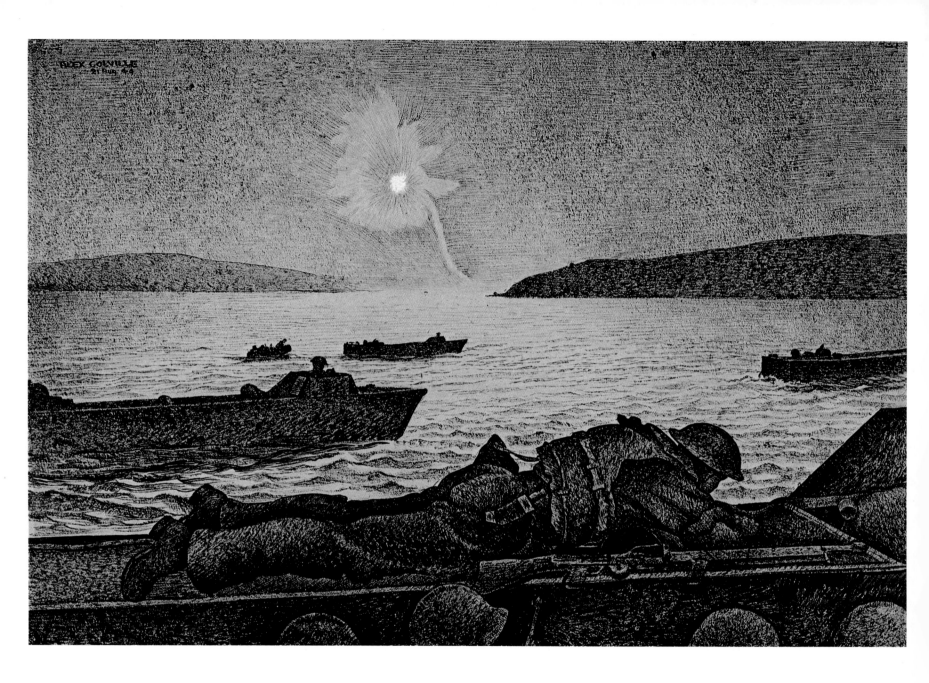

148 Alex Colville *A German Flare Goes Up* 1944

been attacking Pourville, and on our left the Royal Regiment of Canada should have been attacking Puys. I explained to the men what I knew of the plan and what should have been happening. Their nerves were calmed; somebody had produced a pack of tattered cards, and they were soon at their favourite pastime. I think that if they had to wait at the gates of hell, they would sit down and start shuffling.

So far the aircraft had all been ours. Now suddenly a Focke Wulf appeared from nowhere, making straight for us. All the ships in the vicinity engaged it at once, and the soldiers from our flotilla opened up with rifles, sten and bren guns. It twisted away in a half roll, black smoke trailing from its engine. We could see the pilot struggling to get out of his cockpit, but it was too late: the plane dived into the sea. This was our first encounter with the enemy.

Just about then, the Royal Hamilton Light Infantry should have been moving in on White Beach, just below the Casino; the Essex Scottish should have been landing on Red Beach, to the left, close to the harbour, and the Queen's Own Highlanders of Canada were due to land behind the South Saskatchewan Regiment, and push through to meet the tanks, which by then should have made a breach and gone round to their rendezvous at the airport, south of Dieppe.

Quite suddenly, we emerged from the fog and smoke into a bright, strange and sunny world. We had picked up speed and were getting rapidly closer. As the smoke cleared, we could see Dieppe. Some landing craft were coming away from the shore and they were being fired on. Shells were bursting between them, they fanned out, and the big guns gave them covering fire.

Dieppe beach extended for about a mile, and then there was the harbour with rocky cliffs both behind it and beyond it on the extreme left. Intelligence reported that there were guns and machine guns on the cliffs to our right, in the harbour, and also on the high ground to the left of the harbour; and machine guns all along the esplanade and in the hotels facing it. The Casino was heavily defended, and there were some medium guns at Puys, but they should

have been put out of action by now. We knew that the beach was a minimum of 200 yards wide at high tide; at the top of the beach, blocking it off, were rows of strong top quality concertina wire. We should have to get through this, but the preceding troops were supposed to have blasted a way through with Bangalore torpedoes. Beyond the wire, a continuous wall had been formed by joining the hotel walls and closing the streets with concrete slabs eight feet high.

We had been advancing all this time but now the flotilla put on more speed. This was it, we were going in! "All right everybody, blow your Mae Wests up now, get your equipment on and load your weapons."

We increased speed, and some shells started to come our way. With my glasses I could see a grounded and burning tank landing craft below the Casino. Then aircraft flew low over the esplanade and began to lay a heavy smoke screen; it began drifting slowly seaward.

It was now 0700 hours, and we were going on to White Beach, right behind the Royal Hamilton Light Infantry. Although the shelling was not too serious, through a rift in the smoke screen I could see that our troops were still fighting on the beach and that our tanks were firing.

It was time to get ready. Private Goyette came up onto the small foredeck with his bren gun and lay down in a firing position to starboard, and the gunner from the pioneer platoon did the same on the other side. I took my place behind Goyette, as I was to be the second man ashore; a bomb carrier was passed up to me from the hold.

About a hundred yards from the smoke screen, our flotilla put on full speed. Then all hell broke loose. The pall of smoke became a tornado of fire and steel. Every enemy gun must have been trained on it, and it seemed crazy to go in. The smoke was being twisted into a variety of shapes by the exploding shells and bombs. There was a continuous roar, unbroken even for the fraction of a second.

Just before we got to the screen, a sheer wall of water rose in front of us. It must have been thirty feet high, and it dared us to cross it. The C.O.'s R-craft went into the smoke; he was still in the lead, but I wondered how long he would

last. Then tracer bullets began to come through in a criss-cross pattern.

We had so far managed to keep our formation: the C.O.'s boat and then four abreast, six deep, well lined up, as if we were on parade. It was a grand sight, this deployment of little white skiffs. The enemy would hardly imagine we should keep going in the face of such a barrage; but now that we had shown our intentions, and were coming within their reach, they were out to tear us apart. The smoke screen was a flaming vortex. Behind us we could hear our heavy guns firing for all they were worth.

All we could see then was the sky, and that, too, was chaotic as aircraft churned and fired at one another. The ack-ack guns were adding to the turmoil with shells that soared skyward and exploded into black puffs of smoke. Several planes came spinning down, looking like great wounded birds in their death-throes, diving into the green sea.

A mortar bomb hit the water on our port side and I could hear the shrapnel whistling. Another bomb fell ahead, and a piece of shrapnel came through the windshield, nothing else. We had been lucky — so far! Another bomb landed astern and another to starboard. This time several splinters ripped through the panelling, and the explosion knocked our boat off course. The officer at the helm brought it back into line. A corporal called out from below:

"Two wounded this time, Sergeant Brunet and Lance Corporal Taylor."

Sergeant Brunet's face was covered in blood, and a soldier was applying a dressing to Taylor's shoulder.

Two more bombs exploded very near us, and a burst of machine gun fire whistled past our heads; instinctively I ducked. I had a very curious feeling of self-pity. I began to think the enemy was definitely unreasonable to be doing this to me, it was very dangerous and he might kill me. One's normal sense of being under the protection of the law was suddenly withdrawn, and left one feeling terribly vulnerable.

Everybody made himself as small as possible and that included me. I was in my position on deck and very ex-posed; I should have much preferred to have been with the men down in the boat and below the waterline. For a man who had crossed the Atlantic just to fight the enemy, this seemed a curious reaction. I had to remind myself that I was supposed to be a tough sergeant-major of the crack 2nd Division.

We were in the smoke screen for less than a minute, as we were travelling at full speed. Red tracer bullets were coming at us from a hotel straight in front, and I told the gunners to engage that target as soon as they had landed.

The beach was a shambles, and a lot of our men from the second wave were lying there either wounded or dead. Some of the wounded were swimming out to meet our flotilla and the sea was red with their blood. Some sank and disappeared. We stood by as they died, powerless to help: we were there to fight, not to pick up the drowning and the wounded. But the whole operation was beginning to look like a disaster.

The officer brought our vessel to a halt at the water's edge. The two gunners jumped off, ran up the beach, threw themselves down, and opened fire on the hotel windows. I jumped down onto the beach right behind Goyette. I was still carrying last night's heavy load of ammunition I had picked up and the thirty-pound mortar bomb carrier; I dumped the carrier and turned to take more from the man behind me.

The boat had started to back away. I signalled the officer to come forward, but he continued to reverse and some of the men started jumping into the water. One of my corporals was yelling at him to stay near the beach.

The skipper took no notice. It looked as if he was scared stiff, and was not going to wait for us to disembark our mortar. I pulled my pistol out and threatened to shoot him, but he ducked below the foredeck out of sight. The boat backed away faster, and the men from both platoons jumped into the sea which was now shoulder deep.

All this time, the inferno had, if anything, been getting worse. More machine guns were firing at us now that they could see their target. I threw myself to the ground and signalled the men to do the same. I had to consider the best

course of action. The landing craft had gone, and with it our mortars and most of our bombs. There was no hope of getting any more. So we should have to fight as riflemen. I motioned to the men to open out. It was no use yelling; they would not have heard me.

The enemy fire was murderous; there was not only shrapnel from the mortars but shingle thrown up by the explosions. Tracer bullets were cutting the air in every direction, especially across our front. Most of them came from our flanks, and as for every tracer there were four invisible bullets, the air was seething with flying steel.

The whole thing was like being in the middle of a very busy intersection with traffic from four directions at once, and it made one dizzy. It seemed impossible to make the 200 yards of beach without being killed. Nobody could get through that.

Yet we could not stay on the beach in the open, in full view of the enemy. It was only a matter of time before they killed every one of us. The nearest cover was the Casino; so we had to make for that and take it over. It was some thirty-five feet to my right. I got up, and half crouching, moved ten or twelve feet towards it, signalling the men to follow me. Some of them got ready, and I moved over again to the right. When I dropped to the ground, I tried to give the impression I had been hit.

Of my forty-five men, there were four with me. That was all; the others were scattered all over the place. A good many had stayed on the beach, wounded, dead, or playing dead. It was impossible, in the pandemonium, to do anything about reorganizing my platoon.

Further along on our left I recognized three privates from my platoon who had stayed together and appeared to be unwounded: Ulric, who was responsible for maps and communications, Maréchal, my range taker, and Simard, a number three mortar man. I saw them leave the cover of the top of the beach together and make a mad dash across the esplanade.

A machine gun opened up on them. Ulric had reached the wall and hugged it, out of reach. Maréchal fell, badly wounded. The machine gun had ripped his belly wide open and he was holding his guts in with both hands. Simard had spun round and gone back to the cover of the edge of the esplanade.

The firing had stopped. Maréchal was writhing in full view, in mortal pain and yelling for help. Simard could not leave his companion there, so he jumped up and ran out to him. Even though he was short, he was strong, and in a quick fireman's lift he picked his friend up and dashed back to cover with him through a renewed hail of bullets.

Lucien Dumais

Surrender

It was 11:00 a.m., re-embarkation time. As soon as the assault landing craft came in, the men ran down to the water's edge, and the moment the ramps were lowered they rushed the boats, some of which were soon so overloaded they could not get off the beach; but trying to make any of the men disembark was a waste of time. The one thing they wanted was to escape from the hellish fire, which had then risen to a crescendo. The Germans, determined to prevent the evacuation, were shooting with every weapon they had, causing many casualties.

There was a rope hanging over the side, which I grabbed, for I had forgotten about the load on my back, and the pack had filled with water. Try as I might, I just could not pull myself up, and the boat was gathering speed. I yelled for help from the men on board, but with all the noise, they could not hear me.

Before the boat got into deep water, I let go of the rope. I sank like a rock, for my Mae West was only half inflated. I was in about nine feet of water and there was no question of swimming. I tried to get rid of my equipment, but I had fastened it too well. The only thing that would come off was my steel helmet.

I jumped towards the surface and managed to snatch a quick breath of air, but sank again at once. I was getting less and less buoyant. I was choking! The salt water and the sweat on my face were stinging my eyes.

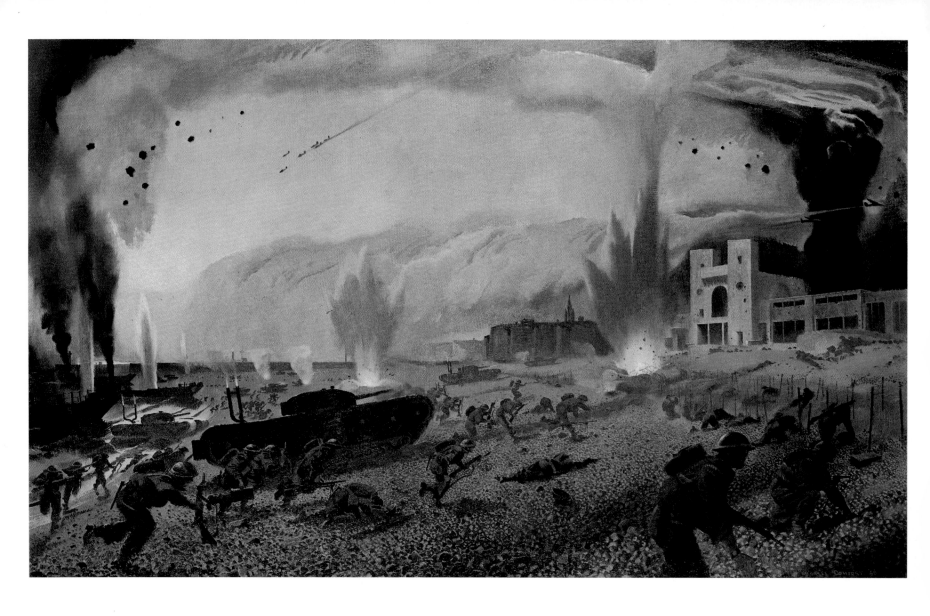

152 Charles Comfort *Dieppe Raid* 1946

After several hours of heavy fighting in which I had risked death any number of times, it seemed I was going to drown accidentally. I said to myself,

"Well, Lucien old bean, this is where you finish your life, in the dirty waters of Dieppe."

Then, with ears humming, I lost consciousness.

I came to with my head out of the water. Before I passed out, I had started to push towards the beach with my feet and arms. The wash of the boats on each side of me must have helped to propel me ashore.

I had swallowed a lot of water, and now I was sick. As I advanced very slowly, the fresh air began to do me good, but I was still very groggy.

So I staggered on through the rain of bullets, and suddenly found myself in the shelter of a burning troop landing craft. My body crumpled; I was just a heap of wet clothes on the beach. After a minute or so, I took my equipment off; I did not think I should need it any more.

There were a number of men lying in the lee of the T.L.C., most of them seriously wounded. The wounded were feverish and needed blankets. The fire inside the T.L.C. had abated somewhat, and I managed to fetch blankets and half-a-dozen water bottles. I had a good drink myself.

Now there was not a ship to be seen and we were quite alone. The sea was coming in and would soon reach us. The enemy were still firing in a leisurely way at any group showing activity on the beach. We were being shot at too, but they could not reach us as we were protected by the hull of the T.L.C. which was tilted seaward. Eventually the incoming tide would drive us out.

The wounded were beginning to get their feet wet from the waves. The M.O. advised me that we should have to surrender soon, or the men would drown. This was a terrible decision to have to make. We should have fought to the last man and the last breath. We had come so far to fight, and all our thoughts had been turned to this objective for three years. We had sufficient weapons and ammo to keep the enemy at bay, and so far we had been successful.

We could hold out for a little longer, but what would be the point? It would not be for glory, because nobody would ever know anything about this last stand. Would it be for a soldier's honour? It would not be an honour to let these wounded men drown. I was responsible for their lives; was I to sacrifice them for the sake of my personal pride?

The M.O. had left me time to think this out, but as if he knew the decision in advance, he was preparing a white cloth on the end of a stick.

"Well, Sergeant-Major? It'll soon be too late."

At last, and almost against my will, I answered,

"Yes, sir, we are surrendering."

I picked up a rifle with a bayonet on it and tied my handkerchief to the end. It was an old khaki handkerchief that had turned yellow with age, so I did not even capitulate under a white flag, but under a yellow rag, the colour of cowardice!

The M.O. went to the forepart of the vessel, but passing him, I went inside and climbed on to the upper deck, where I should be in full view of the enemy. I waved my flag—and was promptly greeted with rifle fire! That was almost enough to cause me to bring down the rifle and answer them in kind; but I remembered the wounded, and hiding myself, continued to wave the flag. Every minute counted.

Some Germans finally showed themselves at the top of the beach, to the left of the Casino, and the M.O., wearing a Red Cross armband and waving his white flag, went towards them.

One of the Germans was yelling at me, but I could not understand him. Then he gestured to me to throw down the rifle and raise my hands. I took the handkerchief from the bayonet and threw the rifle down on to the shingle. The bayonet dug itself in and the rifle stuck, butt end up; the way we mark the spot where a soldier lies wounded or dead. It seemed to symbolize the fact that my military life was over.

Resignedly, I raised my hands above my head and turned towards the town.

Lucien Dumais

High Flight

Oh, I have slipped the surly bonds of earth
And danced the skies on laughter-silvered wings,
Sunward I've climbed and joined the tumbling mirth
Of sun-split clouds and done a hundred things
You have not dreamed of—wheeled and soared and swung
High in the sunlit silence. Hov'ring there,
I've chased the shouting wind along and flung
My eager craft through footless halls of air.
Up, up the long, delirious burning blue
I've topped the wind-swept heights with easy grace
Where never lark or even eagle flew;
And while, with silent lifting mind I've trod
The high untrespassed sanctity of space,
Put out my hand and touched the face of God.

J.G. Magee

Lancaster

I thought of the Lancaster with real affection. It was a sturdy, lovely bird. It was a pretty bird.

Robert Joiner

Lift for Love

While we were away on leave, the ground crew had decorated "L for Love" with a girlie picture on the nose. It depicted a maiden with skirt raised to show a generous expanse of thigh, thumbing a ride in front of a signpost marked "Berlin" one way and "Canada" the other; beneath was the legend "Lift for Love." It was much admired. The ground crew took an intense pride in their aircraft, and had won a prize for the best maintenance.

Jerrold Morris

No regrets

If this is where I get mine, up there where it is cold and clear, on a battlefield where the dead don't lie about and rot, where there is no mud and no stench, where there is moonlight by night, stars, and in the day the wizardry of intriguing cloud formations, and a blue sky above, where a man is free and on his own and the devil and Jerry take the hindmost, if I get mine up there, there must be no regrets. I would have it that way. It is unfortunate that those of us who love life most, the very ones who so keenly seek to live the fullest life possible, must take the long chances that in so many cases cut it short. We are not blind to the odds against us. True, we laugh at them or think lightly of them, but that is because we would have it no other way. I pity those who, living, live in fear of death.

Fuller Patterson

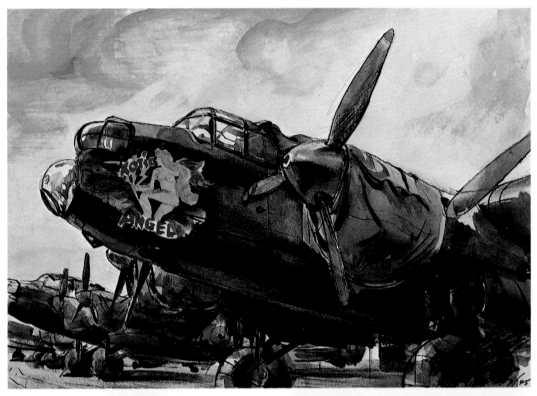

Albert Cloutier *Bluenose Squadron Lancaster 'X' for Xotic Angel* 1945
Fuselage panel *Ville de Quebec* Fuselage panel *Willie the Wolf* 155

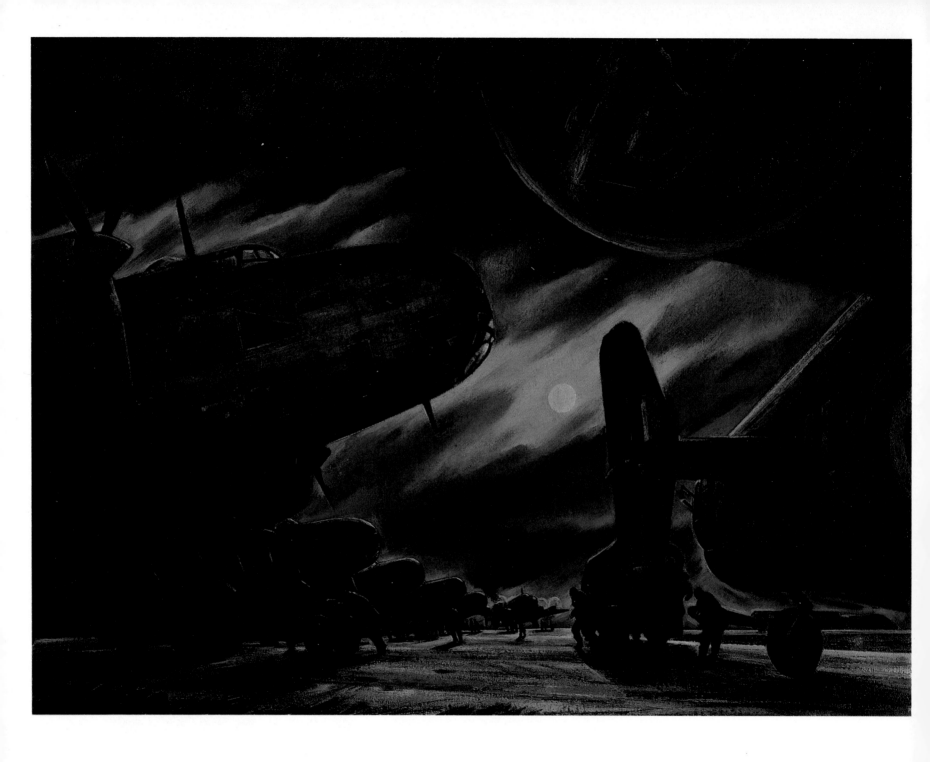

Paul Goranson *Marshalling of the 'Hallies'* 1947

Bomber run

Just before dusk we assembled at headquarters for briefing. The briefing room was on the second floor, and I always climbed those stairs with a feeling of subdued excitement. As the crews filed in through the door, everyone glanced at the map on the wall behind the dais, where the route for the raid was marked out in black tape. Then they knew the worst, and could relax and take their seats, joking about the target or simulating panic. When everyone was settled, Moose would take the stand and call for silence while the roll was called; then the briefing began. First he would give us general facts about the raid, such as the number of aircraft detailed and the concentration; then the Intelligence officer would outline the nature of the target and reasons for the attack. The Met man took over to give us an estimate of weather conditions likely to be encountered, and finally Moose would run over tactics to be employed, and give advice generally. He usually ended up by saying, "Enemy fighters — I don't think you'll have any trouble with them. Good luck."

This time we were to bomb the docks at St. Nazaire, now a German submarine base. We were cautioned to use the greatest care not to drop bombs on the town, and were to bring them back if in any doubt. Takeoff would be at dusk.

I wrapped a scarf around my neck and emptied the pockets of my battle dress; for security reasons we were not allowed to carry any papers on operations. When I got to the hangar, the navigators were working around a large table with their topographical maps and plotting charts. Distances had to be entered on the flight plan with airspeeds and height; then the predicted winds were applied, and groundspeeds and courses to fly worked out. This gave an E.T.A. (estimated time of arrival) for each leg. Navigators made their own calculations, and then compared results with others.

When we had finished we went to the locker room, where the rest of the crew members were wandering in to collect their gear. Dressing up was a long process for the gunners; it was a cold ride in the turrets and they wore as much clothing as they could from woollen underwear to electrically heated suits. On top of this went a Mae West buoyancy jacket and parachute harness.

Outside the hangars we stood around and chatted, waiting for transport. The last rays of the sun spread over the flat landscape and there was a chill in the air. The padre handed out flying rations, and the doctor offered caffeine pills to anyone inclined to be sleepy. We scrambled into vans, packed in tight, the navigators hugging their bags of equipment; at each dispersal a crew dropped off and farewells were shouted.

There was work to be done around the machines in the hour before takeoff. Gas cocks to check, photoflashes to fuse and mount, detonators to load in the secret equipment for emergency destruction and, more often than not, propaganda leaflets to stow near the flare chute. The wireless operator and navigator had to arrange their gear and settle everything handy in their compartments. Finally the selector panel and bombsight were checked. When we were through, we could lie down under the kite and smoke and chat with the ground crew.

It was getting dark; across the field the control caravan had been towed into place, and the headlights of a car showed where the control officer was making his final inspection of the flare path. All around the perimeter navigation lights showed, and engines began to cough; it was time to go. Shane ran up the engines and, at ten minutes before takeoff, we waved chocks away and moved off towards the taxi post. The ground crew stood aside with thumbs up. Other aircraft were ahead of us and we had to wait for the green light to take off. One circuit of the field, and we set course climbing.

Jerrold Morris

Watching Aircraft Take Off for Germany

For Carl Schaefer

Tonight they're the lucky ones
who watch from the tarmac
their comrades lifting up,
who'll later turn in sleep
hearing the engine-roar
of those even luckier ones
who've managed to come home.

And tomorrow night the ones
who've come home will watch these,
the watchers of tonight,
as they lift off, outbound.

And night after night
all that will ever change
will be the aircraft, the faces watching them,

The war certainly will not change,
will have the same lusty appetite
for flesh.

Raymond Souster

The gaggle

I remember so many evenings listening to the heavy sound of the engines coming out of the north of England and swinging east, darkness in front, the setting sun behind. There seemed to be no formation, only what was called "the gaggle." The sound was lost over the channel. Those on the ground mumbled things like "Good luck" and waited until morning for the news.

Bing Whittaker, CBC radio

The fire below

Long before you reached the target area you would see ahead of you a confusing maze of searchlights quartering the sky, some in small groups, others stacked in cones of twenty or more. These often had a victim transfixed, as if pinned to the sky, their apex filled with red bursts of heavy flak. The ground would soon be lit with lines of reconnaissance flares like suspended street lights, here and there illuminating water, perhaps a section of river that you would frantically try to identify. As the raid developed, sticks of incendiaries crisscrossed the ground sparkling incandescent white, until a red glow would show the start of a fire. The Germans liberally sprayed the ground with dummy incendiaries and imitation fire blocks in the neighbourhood of important targets, hoping to attract a share of the bombs. Gun flashes, photoflashes, bomb bursts, streams of tracer of all colours, and everywhere searchlights. Our target runs were like the weavings of a demented bird. With bombs away, we would turn breathlessly into the welcome darkness; sometimes we left fires behind us that could be seen for a great distance.

Jerrold Morris

Fireworks

I have never seen so many search lights as there were last night. You never saw such fireworks as that at the St. John Exhibition. A great red flare bursts and out of it come long silver streamers like some sort of enchanted tree.

Miller Gore Brittain

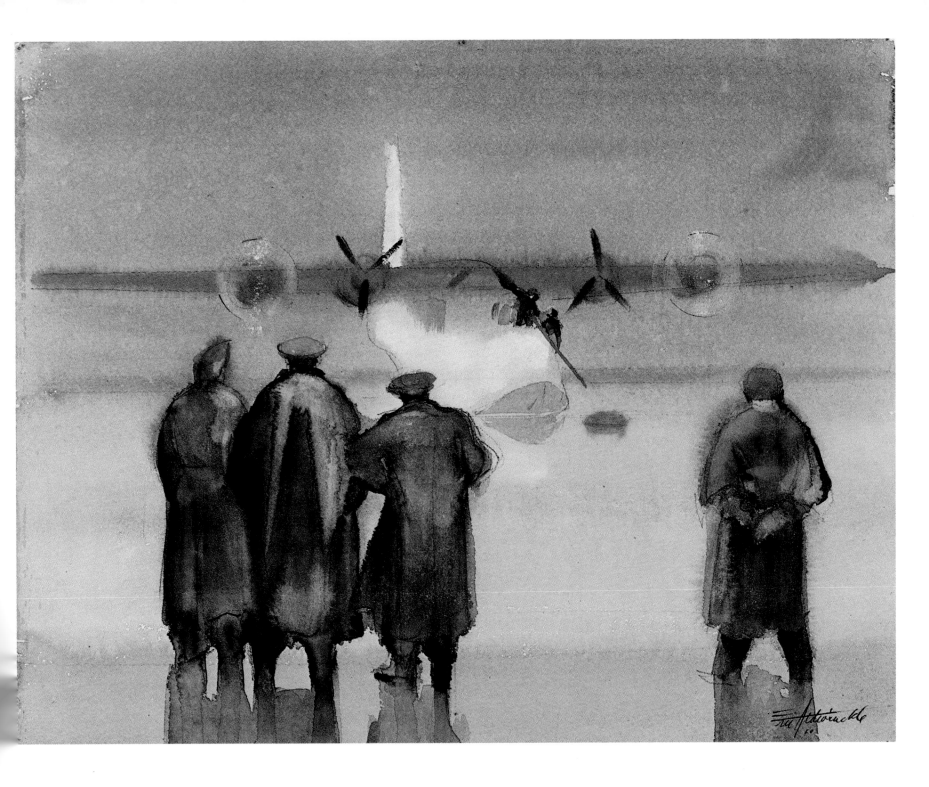

Eric Aldwinckle *Sunderland Buoying up in the Rain at Slipway*

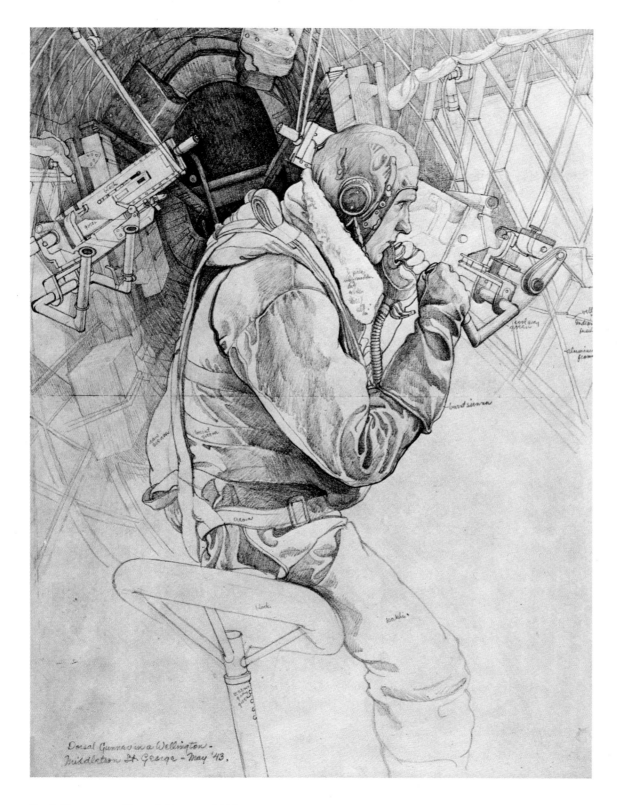

Dorsal Gunner in a Wellington -
Middleton St. George - May '43.

Paul Goranson *Dorsal Gunner* 1943

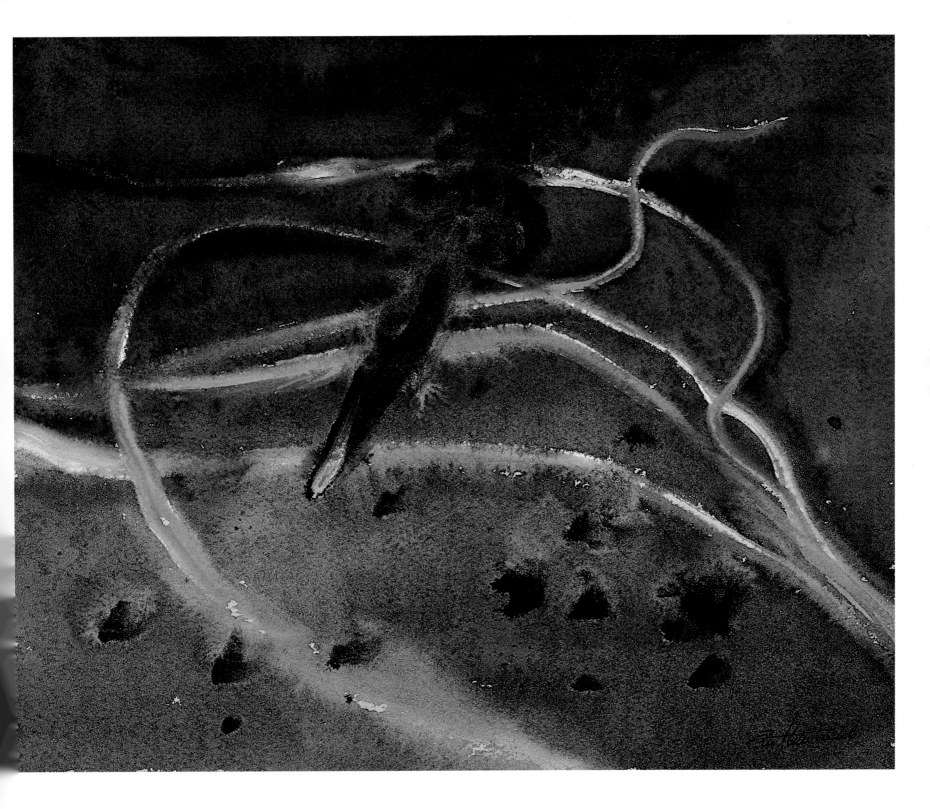

Eric Aldwinckle *Air Battle* 1944 161

Raid on the Ruhr

For Art Servage

Bomb selection switches on,
arming switch, bombsight switch okay,
repeater compass in good working order,
altimeter shipshape —

this, his last check made ahead of time,
left him a minute when he leaned back on his knees
in the bombardier's compartment and looked out
ahead through the moulded perspex nose
of "O" for "Oboe" at the darkness streaked
with yellow beams of searchlights, red, green-blue
of sky-markers, brown puffs of flak-fire,
and dead ahead the ghost-black silhouette
of a Hally banking hard into its bomb-run. . . .

Then he'd had his eyeful of hell: tried to forget
his heart beating faster, sweat underneath his armpits,
frozen feet, cold hands, their four engines' body-shaking
 roar,
tried to bring all his mind's focus back to the head
of his bombsight in front of him swaying
a little like a cobra to the aircraft's motion,
with him the snake-charmer soon to be called
to do his little trick with the bombsight's hairlines,
dropping his twelve canisters one per second
into the growing crimson glow, sending his cargo
of incendiaries whistling down: stoking the fire-storms,
blackening the ruins, piling high the corpses,
("we're going to shift the rubble around a little"
was the way the Briefing Officer had put it). . . .

He crouched now, eyes only on his pet snake,
counting the minutes
to death or deliverance.

Raymond Souster

Diving bird

It was a fine day, and as we turned at the French coast we could see our target lying peacefully ahead of us, surrounded by shoals of green water in the deep blue of the ocean. The Halifaxes jockeyed for position on the run in, and the assault began; it was a fantastic sight. The sticks fell down the entire length of the island, and it seemed to erupt. As we approached, a large piece of cliff fell away into the sea. By the time we were overhead, the ground was obscured with smoke, but we could feel the aircraft jar to the concussion of the explosions. When we finished our run, I decided to go back and watch the rest of the bombing, so I turned left and went down to fifty feet over the sea to make a circuit of the island. There was still a long line of aircraft coming in, and we had a splendid view of the explosions; it appeared as if nothing could live through that hell.

One of the last Halifaxes to bomb came out of the smoke in a shallow climb, dived a little, then zoomed straight up onto its tail in a stall turn to starboard, that brought it diving steeply towards us. Scotty, in the upper turret, called, "That guy can sure handle an aircraft." I thought that, like us, he was coming back to have a final look, but when his dive turned into a slow spiral I began to wonder. He went straight on down and crashed into the sea just beside us. The plane didn't break up, but submerged cleanly like a diving bird, disappearing without even a sign of wreckage. We were so shocked that nobody said anything for a while.

Jerrold Morris

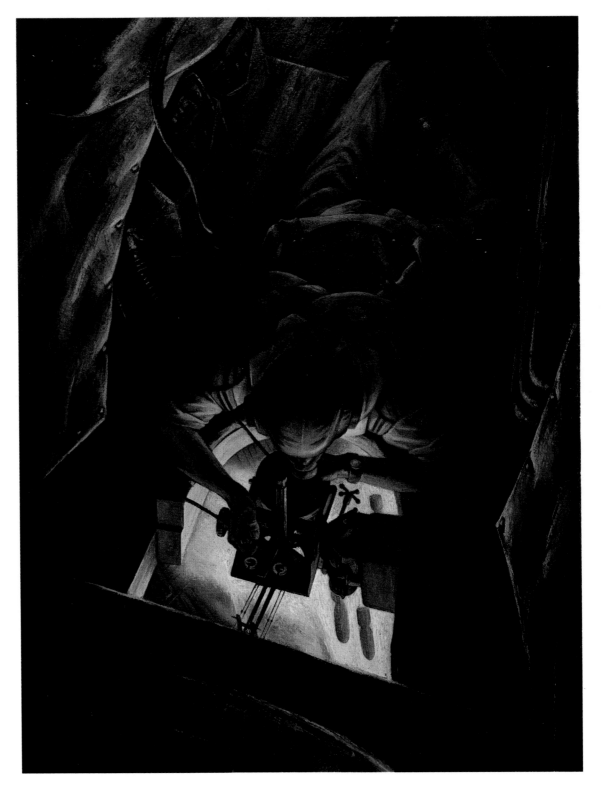

Paul Goranson *Bombs Away* ca. 1943 163

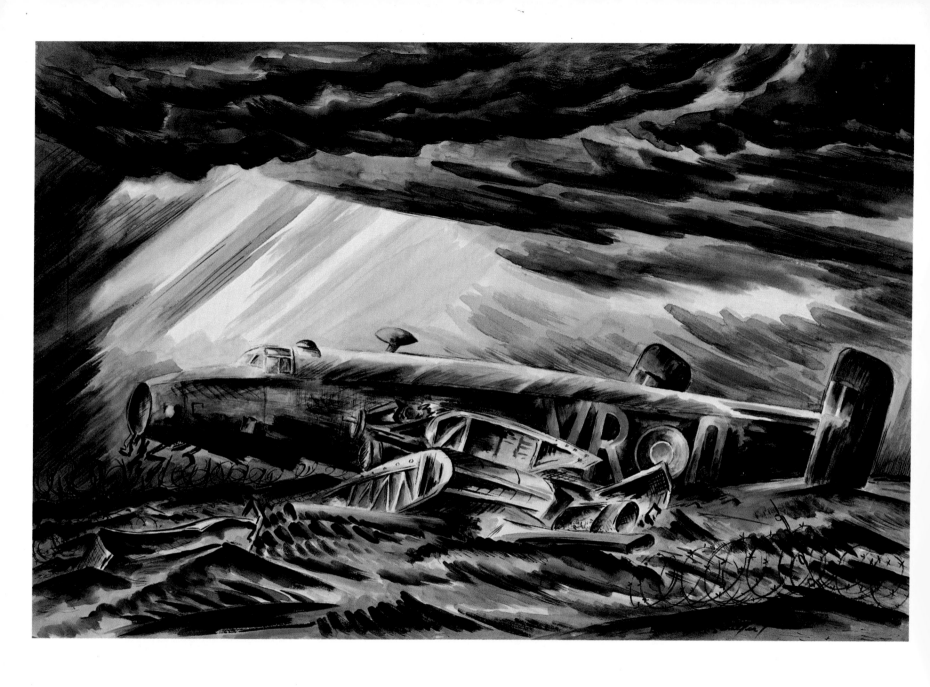

164 Carl Schaefer *Pranged Halifax, 'Q' Queenie of the Rhur* 1944

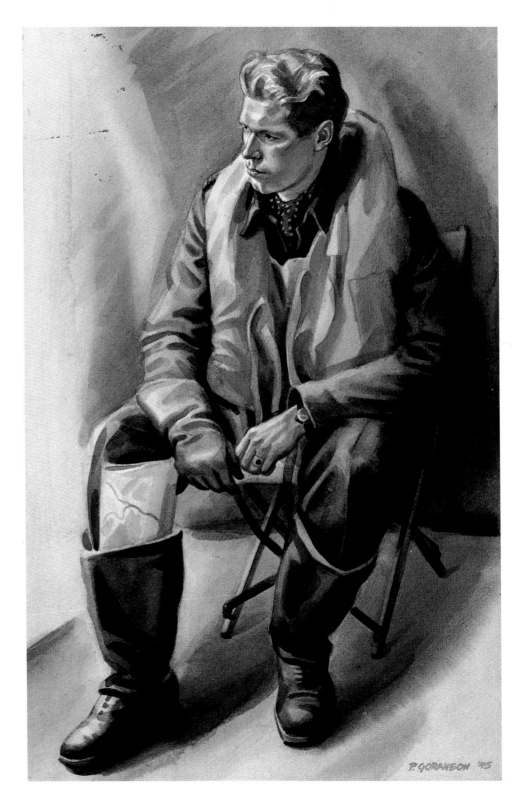

Paul Goranson *S/L 'Hal' Gooding, D.F.C., A.A.M.* 1945 165

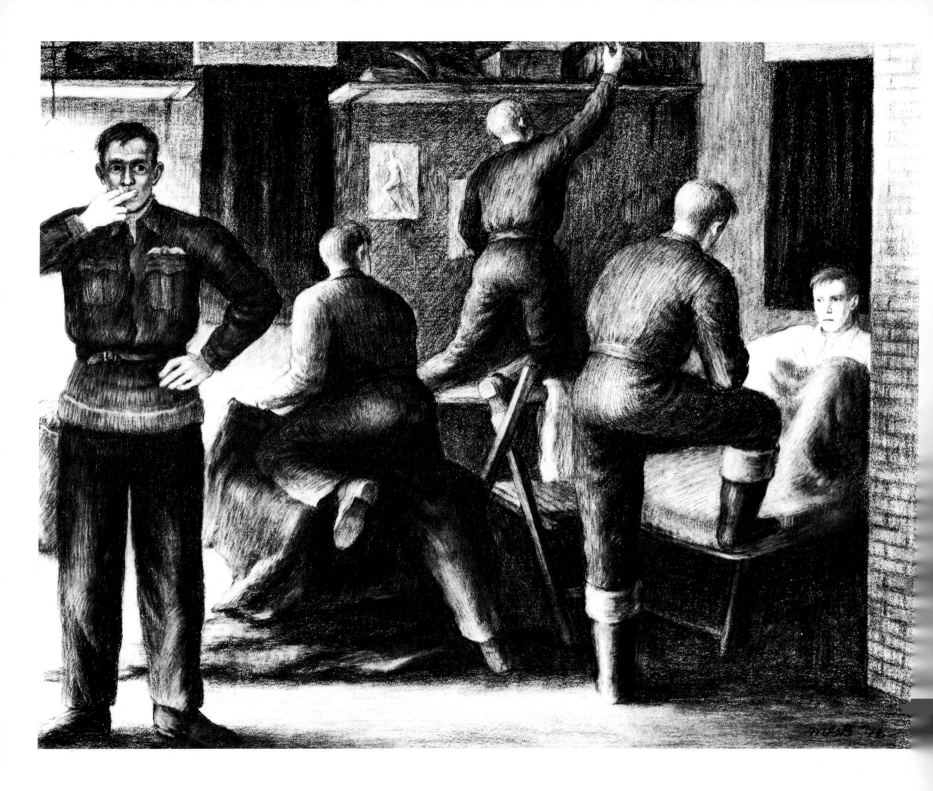

166 Miller Brittain *'G' George Didn't Come Back* 1946

Downed in Belgium

I was a wireless air gunner attached to No. 432 Squadron of the R.C.A.F. We were stationed near York in 1944. On the night of April 28th, our seven-man crew trundled its gear into a flight bus for our twenty-fifth trip. Earlier, at briefing, a sigh of relief had run through the room when the target was announced. It looked easy. Our crew was approaching the magic thirty trips which meant our tour of operations would be complete. None of us were bucking for a gong, and the thought of an easy trip didn't damage our pride at all. After targets such as Berlin, Stuttgart, Frankfurt, Magdeburg and Schweinfurt, a little place called Montzen would be a piece of cake.

So by the time the flight bus dropped us off at our aircraft, we should have been making book. We were odds-on favourites. But we didn't feel that way. We huddled together for a few minutes before climbing into the Halifax, all of us unusually silent.

I remember Philips, our flight engineer, saying, "I've got a feeling about this one, chum." Philips had a young wife in the village near the drome. At the moment, she was sitting alone in a room, waiting for the sound of our engines. Then she would wait the long hours away until the engines returned. It was a tough proposition for a wife; a tougher one for a young husband, but Philips had never betrayed any emotion before an op. That's why it sounded so strange to hear him speak this way before takeoff.

Yet when he spoke I could sense that the others felt the same way about Montzen. I know I did.

We climbed into the bomber, stowed our gear. Then Whaley, the pilot, started up the engines. We taxied out and became airborne at ten o'clock.

F/O Johnny Burrows, our navigator, called out a course. Soon we were out over the English Channel.

The gunners tested their guns. The aircraft shuddered as the Brownings arched tracer into the darkness. Then it droned onwards on an uneventful trip to the enemy coast.

From time to time Johnny Burrows quietly called out a position. Then, inside his blackout curtain, he hunched over his navigation table again. There were seven men in the aircraft. But each was isolated by his duties and his thoughts. It was a lonely quiet night.

The calm, deliberate moments marched on as our bomber droned across Belgium. Then — shortly after one o'clock — we approached the target area. P/O Kevin Doyle, the bomb aimer, prepared to take over the aircraft. The gunners searched the blackness, already reporting bombers which were falling from the sky.

The raid on Montzen was a diversion, designed to draw enemy night fighters from the primary target of Friedrichshafen. The Canadian Six group lost ten of the fifty-four aircraft sent against Montzen. The main force of 144 aircraft which went against Friedrichshafen lost five aircraft.

Doyle had just started his bombing run when suddenly cannon shells ripped through the plane. They came with stunning swiftness out of the darkness. No warning! No sign of fighters! Yet suddenly the plane trembled under the impact, filling with dust and smoke, and the sound of breaking glass and metal ripping against metal. I vaguely felt something hit me in the legs.

Somewhere out in the night, a Messerchmidt 110 — equipped with radar and cannon — closed in for the kill. Because we were on the bombing run, we were unable to take evasive action. We were a sitting duck. In a split-second we—who had patiently sought out our target—had suddenly become the hunted. The interminable seconds ticked by, punctuated by explosions within the aircraft. Doyle called the bomb run, precisely, soothingly. I thought of the bombs, already fused, ready to explode on impact. And the cannon shells which ripped through the bomb bay.

Finally, Doyle shouted: "Bombs gone!"

Whaley and Philips threw the bomber into violent evasive action. After a series of murderous dives and climbs we shook our attacker.

We were safe in the darkness. But only until some enemy navigator was able to lock onto us again with his radar. This

would be a matter of seconds. We beat out several small fires and grimly reported the casualties.

For a time it appeared that we might make it back. Then the night fighters struck again.

The enemy merely stood back out of range of McCoy's .303s and cut our aircraft to pieces. Cannon fire smashed through the Hallie, sending chunks of the big plane falling off into the night. Fire broke out again in at least three places inside the bomber, and a wing was also burning. The intercom was gone, the controls shot away and we were falling.

Through the smoke I saw Whaley beckon us to bail out. We were under our third attack now, burning and dropping completely out of control. Philips scrambled over to the rear escape hatch. He did not appear to be injured. He waved and dropped out into the night. Doyle and I went next.

When I fell away from the aircraft, it rolled over on its back — a gesture typical of a dying bomber. I dropped, semi-conscious. There was no sensation of motion until I hit the ground. When I did hit, a surge of pain shot up from my legs and I blacked out.

After I came to, I tried to stand but couldn't. My flying boots were wet. For the first time I realized that my feet and legs had been riddled with shrapnel. Slowly I unsnapped my parachute harness. Crawling to a ditch, I stuffed it under some branches. The night was quiet and black. I had no idea how far we were from the target area, but as I lay there trying to plan my next move I knew that shock was setting in. I just wasn't thinking straight. So I lay there, waiting for something to happen.

It happened sooner than I expected. A twig snapped like a rifle shot. Then footsteps coming towards me. A lone figure emerged from the darkness. He must have been watching for some time, because he walked directly towards me. He stopped a short distance away, looking at me in silence. He was a farmer, and I indicated that my legs were injured. Without speaking, he took a final look, then turned and left.

I had started to crawl away when five peasants returned a few minutes later. They carried me to a farm house and dressed my wounds.

Gradually, I learned that they were members of the Belgian underground. None of them spoke any English. I spoke neither French nor Flemish. So for days it was impossible to communicate with anybody. Yet I understood when they took my uniform, burned it and gave me civilian clothing. They also provided me with a civilian identification card. I became Oscar Pardon, a tailor.

Donald MacDonald

The Dresden Special

The R.A.F. called it
The Dresden Special . . .

One hundred thirty thousand
charred bodies jammed together
between two bread slices.

But even at that
jolly old Sir Winston
had no trouble lifting it
in his pudgy fingers.

After a bite or two
he smacked his lips, grunting,
Just the way I like Nazis,
very well done . . .

Raymond Souster

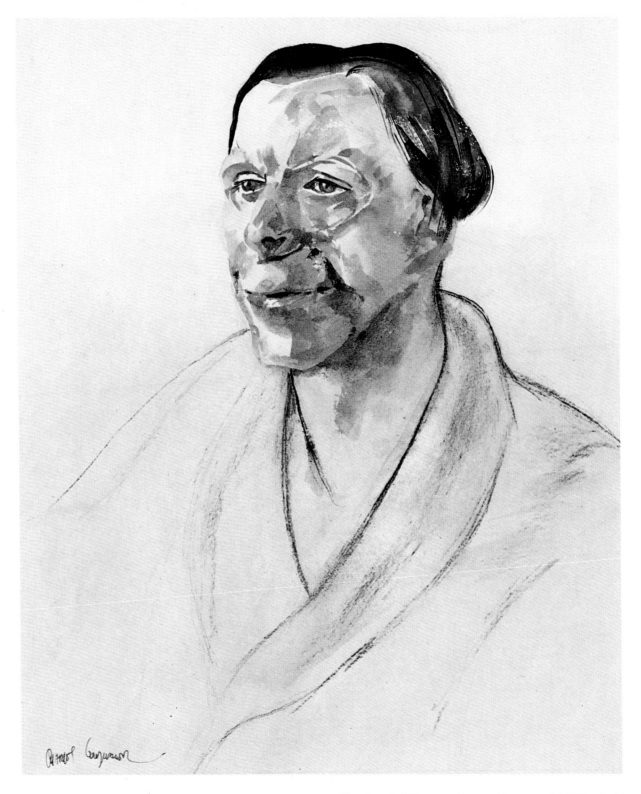

Charles Goldhamer *Burnt Airman with Wig* 1945 169

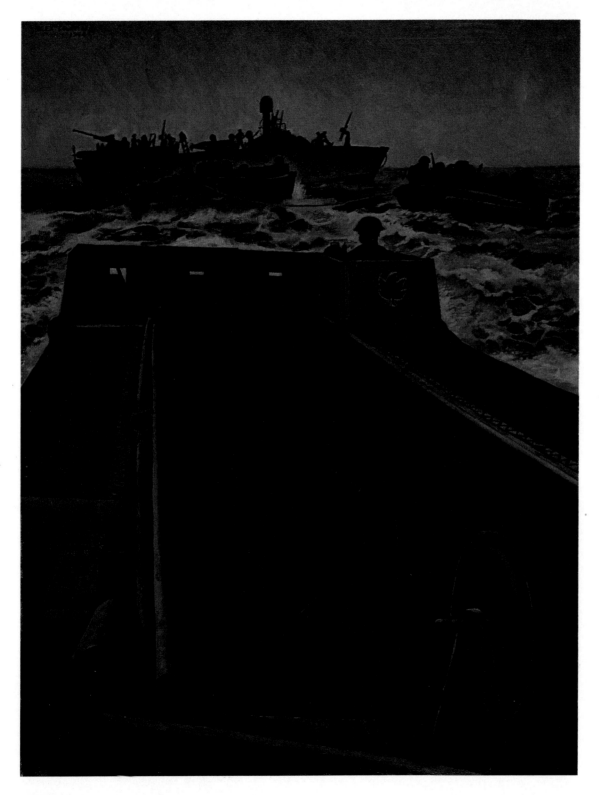

170 Alex Colville *L.C.A.s off Southern France* 1944

Sicilian Vignette

These guns could have worked
disaster in our assault.
So the blood of sleepy Italians
is splashed on a whitewashed wall.

Their boots are under their beds.
Their helmets hang by the door.
And the careful letters from home
are scattered on the floor.

George Whalley

Calabria

This is Matthew Halton speaking from Italy. The Canadians are in action now in country as arid and difficult as the Grand Canyon of Colorado. They have made contact with the Germans and taken several prisoners. They are throwing steel bridges over chasms thirty yards wide. Last night, going forward to our advance posting, I passed file after file of our men, hundreds of our men toiling up the steep roads in the dusk to mount the next attack, to seek our first battle on the mainland of Europe. When I overtook these men they had marched twelve miles over a steep mountain road. They had started at sea level and were now at 4,000 feet. Canadians, marching and climbing in the dusk through the mountains of Calabria, seeking the enemy and battle.

The country where we now have to fight, if the Germans make a fight, is very beautiful but very wild and grim. It was hard enough to advance in Sicily, it will be harder here. The narrow road winds along the side of a canyon 2000 feet deep. The richness of Sicily is gone and instead of orchards and vineyards there are bare rock faces and scattered olive trees and primitive villages. The view we had last night was breathtaking. Below us were the Straits of Messina and a spectacular sunset flamed through the sky. Often we saw our Spitfires, far away, looking like wild ducks against the sunset and occasionally a lone German Focke Wulf very high darting for home like an arrow.

Our huge war machine, including tanks and guns, was somehow making its way along the narrow white roads. If the Germans defended such country in strength I do not see that we could ever take it. But it seems that they do not intend to hold the tip of Italy in much strength. The Italians are already out of the war — they won't fight. Sometimes we wonder if they have received orders not to fight, and the Germans, snarling slowly and stubbornly backward, just haven't got the men and equipment to hold southern Italy for long. So our Canadians march sweating up the mountains from the sea. They stop to drink from one of the few streams which spout from the mountain rock. The villagers gape and stare. They have never seen anything like this before, and never will again. The word "Canada" passes from lip to lip as they watch the big young men and their wonderous machines moving implacably towards San Stefano and the high plateau where they may find battle. Again the feeling of unreality comes over us — Canadians seeking battle in the Calabrian mountains where Greek and Roman fought 2000 years ago.

As dark fell the men were eating their rations under the olive trees or on a small terrace with deep canyons dropping sheer away below. We made our little camp for the night, cooked our tea and stew and went to bed. Going to bed is a simple matter. We simply chose a more or less flat place on the ground, lay down on it and went to sleep. Like thousands of other Canadians in this wild scene we had one blanket each; like thousands of other Canadians we lay watching the stars and the glow of cigarettes and talked about the things at home. Those are the things men fight for. And then we went to sleep. It's morning now and thousands of Canadians have wakened to their hard duty. The scout cars go forward and men listen to the aircraft coming to us out of the sun—ours or theirs?—and the fight for Italy begins. This is Matthew Halton speaking from Italy.

CBC radio broadcast

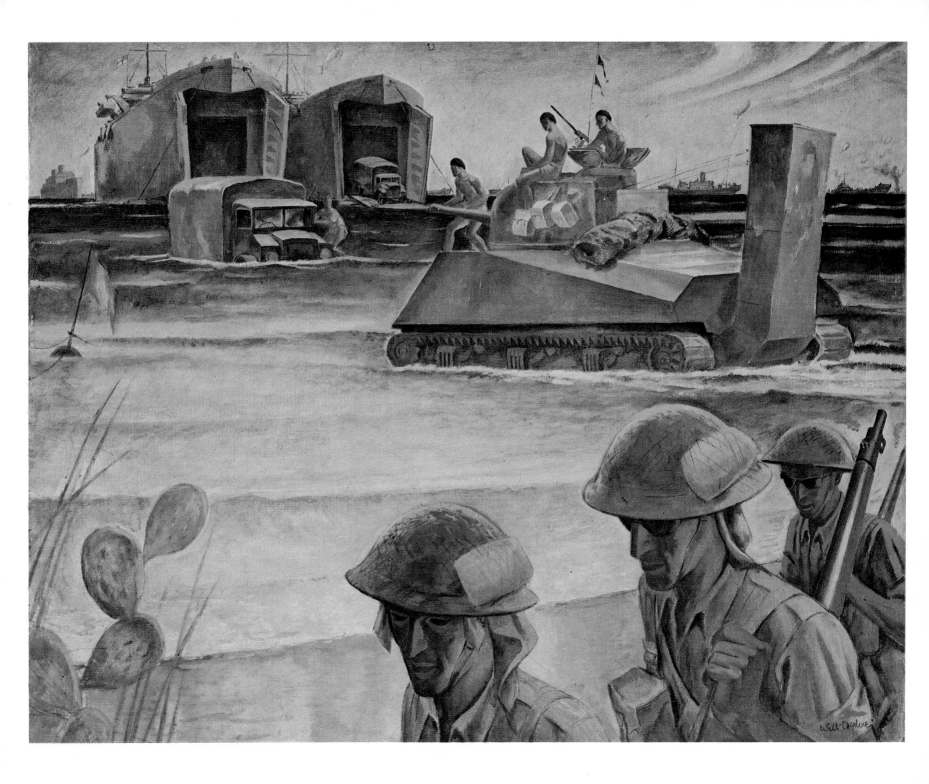

172 Will Ogilvie *Landing in Sicily*

Lawren P. Harris *Tank Transporter Unit* 1944

Lili Marlene

Underneath the lantern, by the barrack gate,
Darling I remember the way you used to wait;
T'was there that you whispered tenderly,
That you loved me, you'd always be
My lily of the lamplight,
My own Lili Marlene.

Time would come for roll call, time for us to part,
Darling I'd caress you and press you to my heart;
And there 'neath that far-off lantern light,
I'd hold you tight, we'd kiss goodnight,
My lily of the lamplight,
My own Lili Marlene.

Orders came for sailing somewhere over there,
All confined to barracks was more than I could bear;
I knew you were waiting in the street,
I heard your feet, but could not meet,
My lily of the lamplight,
My own Lili Marlene.

Resting in a billet just behind the line,
Even though we're parted your lips are close to mine,
You wait where the lantern softly gleams,
Your sweet face seems to haunt my dreams,
My lily of the lamplight,
My own Lili Marlene.

English words by Tommie Connor

Everybody's favourite

Wie einst Lili Marlene, wie einst Lili Marlene. Tenderly, and with haunting effectiveness Lale Anderson broods over this love song and many a lonely soldier is swept away on the currents of emotion which well up in his lonely heart, as this devastating war song reflects the frustrations of his own love life.

> *Vor der Kaserne, vor dem grossen Tor*
> *Stand eine Laterne und steht sie noch davor.*
> *So woll'n wir uns da wiederseh'n*
> *Bei der Laterne woll'n wir steh'n*
> *Wie einst Lili Marlene, wie einst Lili Marlene.*

Everyone hums or whistles the melody. Our German interrogators sing it in German, Isolani sings it in Italian, most of us have one or other of the many English translations, some with the beauty of poetry, others perversely obscene, all finding consolation in an extraordinary enemy love song which has become the favourite of two opposing armies. . . .

Charles Comfort

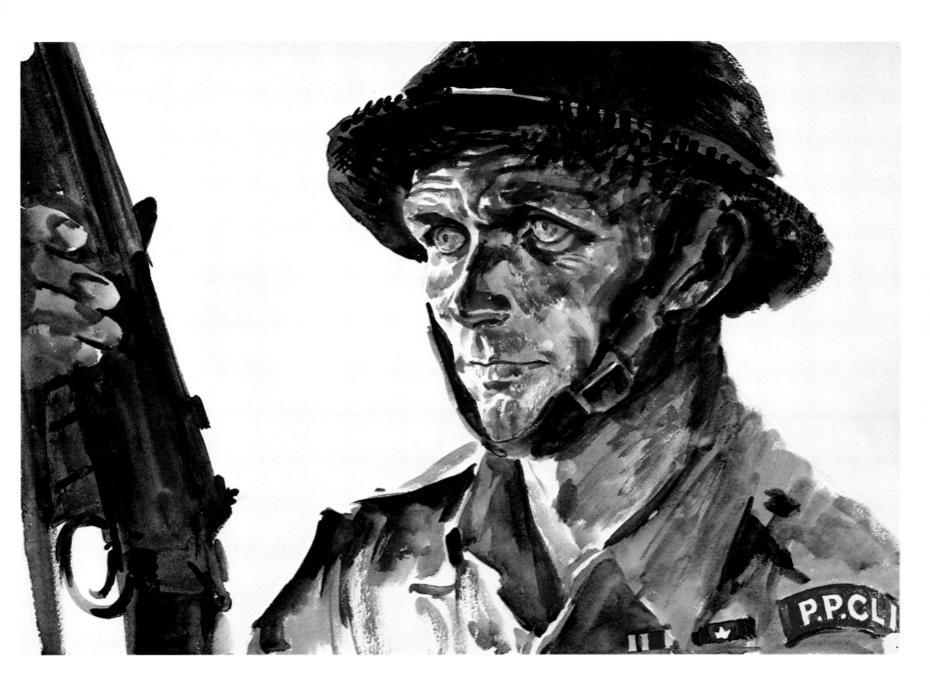

Charles Comfort *Sergeant P. J. Ford* 1944 175

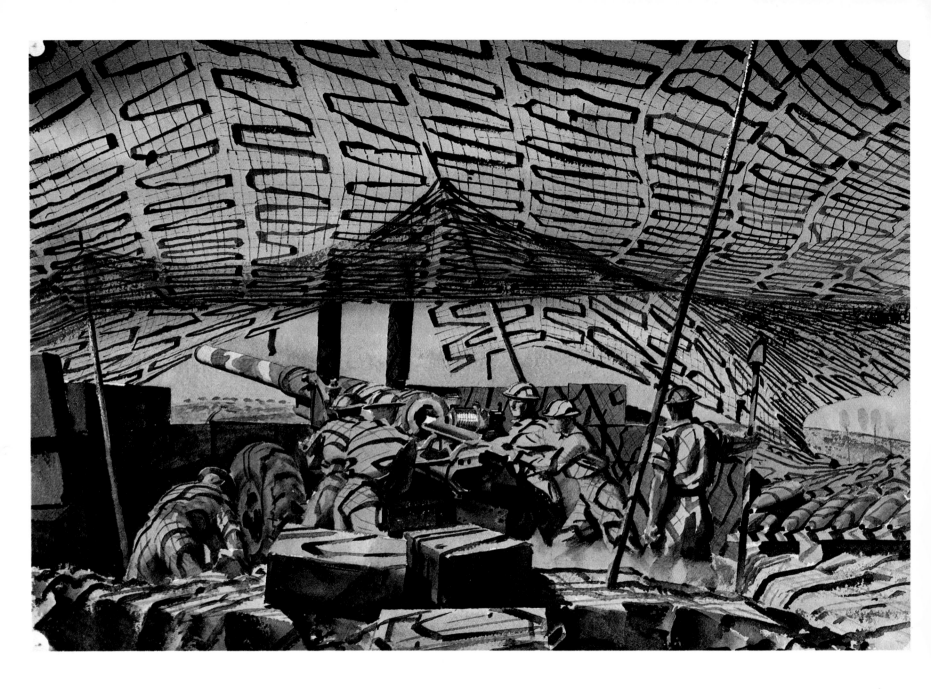

176 Charles Comfort *Canadian 5.5-inch Guns*

Persimmons

Just out of reach they glimmer like a globe,
A plaything for a boy, as round as promised pleasure,
But coloured with a different, luscious century,
Another world that riflemen make eyes at
From underneath steel helmets,
From underneath dry, spurious leaves they wear.

Trudging in single file through unsexed drought,
They whistle the fruit to modify the season,
With dusty voices supplicate green trees
To slake their thirst. But no streams break the heat,
No tantalizing, sweet
Drops stain the webbing of their discipline.

Still the thought of juice buds sweet on their tongues.
 Shoving
The lips of the beckoning fruit apart (a stinger
Like a wasp's probes deep for swooning nectar)
They sluice the sweetness out of their mouths till cool
Along their thighs they feel
A trickle of the girls they dream of loving.

At a momentary halt some break the branches,
Wolf down the fleshy liquor, which a few enjoy
But wonder what it is, a peach or orange?
And then a whistle blows. They fill their tunics
And slinging rifles, packs
And bren guns, move forward into mortar range.

Tonight when digging parties comb the salient
Many a thin-skinned orient orb of sense,
A globe as soft as hand grenades are hard,
Will glimmer in untasted opulence
Crushed to the avid breasts
Of striplings, now wandering through a darkened orchard.

Douglas Le Pan

Morning glory

The imagery of a gun site, detached from its purpose and environment, is a strange fusion of machined surfaces, kinetic routines, and the delicate transparent tracery of the nets. The weapon itself stood silently awaiting zero, a monumental machine of devastating power, its long barrel thrust menacingly upward and outward like some prehistoric brontosaurus peering from its cocoonlike cave for some sign of prey. The crew busied themselves with fuses, charges and ammunition, which stood about in vast stacks. The floor of the shallow gun pit was paved with loose brick, round which the mud oozed like fresh mortar. A wall of sandbags and sand-filled charge boxes formed a protective parapet, while above a canopy of nets and garnish spread a delicate membranous web of camouflage. The five minute signal had gone and the one minute was expected momentarily. The helmeted numbers took their stations and all was in readiness to launch "Morning Glory."

The lanyard was pulled and the gun recoiled behind the monstrous muzzle blast. A flowerlike, pink-edged flame of instant blooming gave place to shocking, numbing sound and a concussion that jumped my equipment clear off the ground. Guns in every direction gouted flame with furious energy. One felt suspended helplessly in some dense exhausting element where sound, and sound only, existed.

Charles Comfort

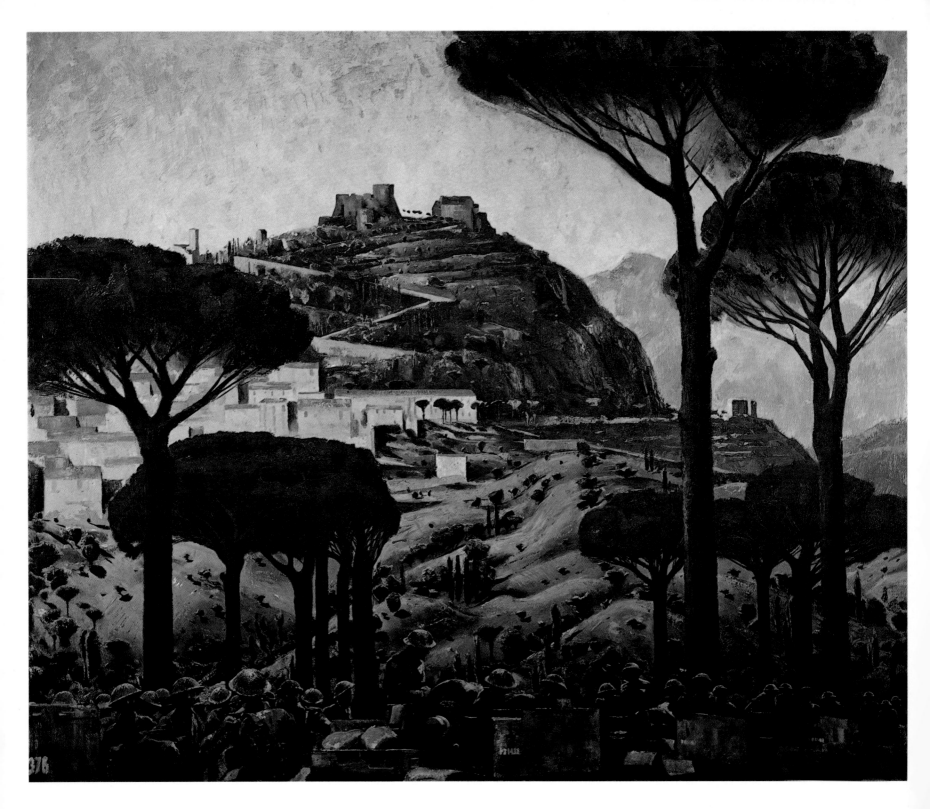

178 Charles Comfort *Campobasso* 1945

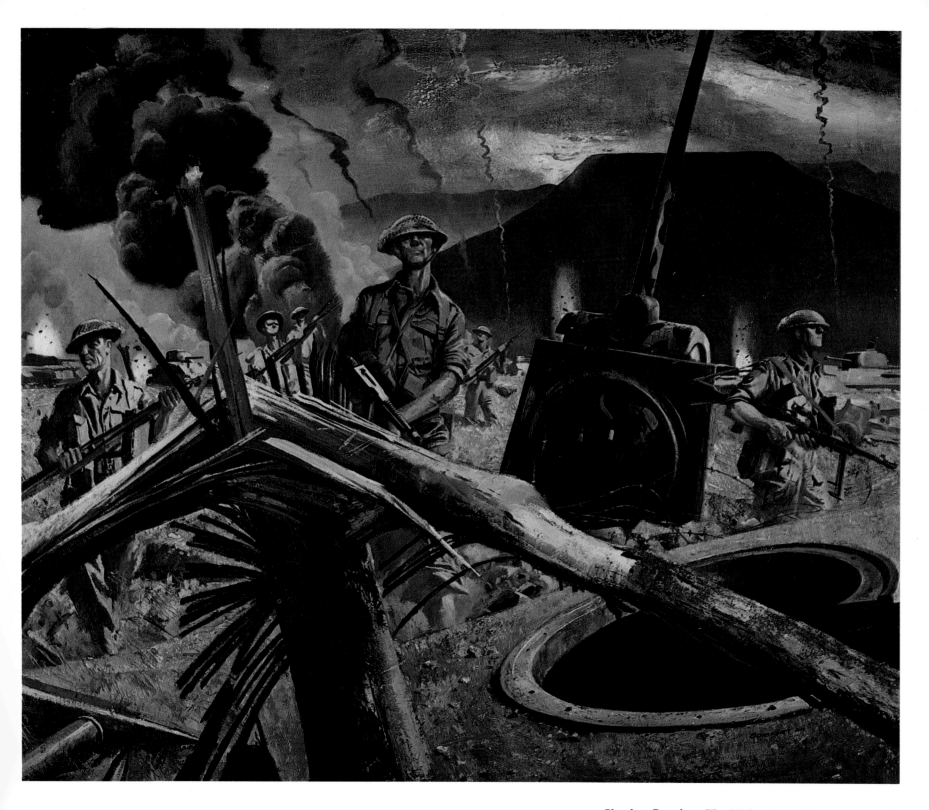

Charles Comfort *The Hitler Line* 1944 179

Killing ground

We turned into an orange grove of fantastic beauty, hung heavily with ripe fruit and knee-deep in gentle grasses which had kept it completely free of mud.

The southern approach to Ortona is flanked by numerous walled villas, in whose gardens stand stately palms and cypresses. These delimited areas, and the villas themselves, provided varied and formidable depth within which the defenders might fight. But seventeen pounders blasted unexpected holes in surprising places and hard-slugging merciless men from the west, wielding machettes, grenades, and bayonets, poured through upon the frantic defenders. Strong points were reduced one by one.

The final gruesome killing ground was the Piazza Vittorio, a beautifully planted public square, fronting the town itself. Over these open gardens the hunted survivors, and the remnants of the rear guard, must withdraw at their peril. At last light scores of them lay among the fading asters and marigolds, grotesquely misshapen in death.

As night fell the Sitreps confirmed what we were all too conscious of, the clawing, tearing brutality of the fighting in the town. The Seaforths and the Edmontons were at the throats of the Paratroopers; it was a mediaeval battle in its close-quarter violence, groping through suffocating dust and smoke, stumbling over upturned furniture and debris, struggling breathlessly in nightmare darkness, felling, clubbing, blasting, shooting it out. "They are above us . . . They are in the next room . . . He is firing from that upper window . . . Where is the Corporal? . . . Hand me that Piat . . . Look out! It's booby-trapped . . . Where? . . . You're sure? . . . Stand back! I'm going to let them have it! . . . Flame jets rip through the splintering door. The screams are lost as an earthquake blast rocks the neighbourhood. Tons of masonry, debris and household effects rush into the street like grain from a hopper. The Jerry sappers are systematically dynamiting buildings into the street in a desperate delaying action. The barriers of rubble are quickly sown with mines and covered by raking fire. Dust and lead and fragmentation fill the flaming night.

The very smell of death and destruction reached us in the orange grove. A holocaust of red glowed in the sky, revealing a ragged skyline as tongues of flame leapt into the night. Downwind from the action the frightful intimate sounds of battle were all too clear: bursts of automatic fire, the Bren and the Schmeisser answering one another, each with its own distinguishing accent. A dozen concurrent dialogues penetrated the blunter, duller, but more profound thunder of the gunning. From the intervening vineyards rose a ghostly vapour, like a shroud winding itself about the town. The most boisterous and profane among us became silent in face of what we witnessed. The morbid fascination of destruction held us in its grip as life and its monuments dissolved before our eyes. Over all, the deafening voice of guns beat a massive dirge like all the unmuffled drums of hell.

Charles Comfort

Ortona

It's December 20, 1943. You wonder what it's like back home. But you slap that aside. You've got to be on your toes for this one. You're carrying the Bren.

The unit, the sergeant tells you, is going to swing north from the crossroads against the town. You glance up, see the odd building silhouetted by fire and explosions. You wonder what it's like for the men in there. Then you think, "Tomorrow I'll be killing them—if they don't kill me first." This first group of houses. Your section goes in, secures, then gives covering fire for the next bunch. Fire and movement. Okay.

It's quiet for a while. You suddenly think of a movie you saw once where the officer leaped up, blew a whistle and shouted, "Let's go, men!"

Only it doesn't happen like that. The noise of the barrage as it smashes into this town called Ortona cuts off just about everything. You feel cold. You feel hot. You're on your feet, moving up. The noise grows louder. It's like nothing you've ever heard before. A Cheese-cutter burps out from

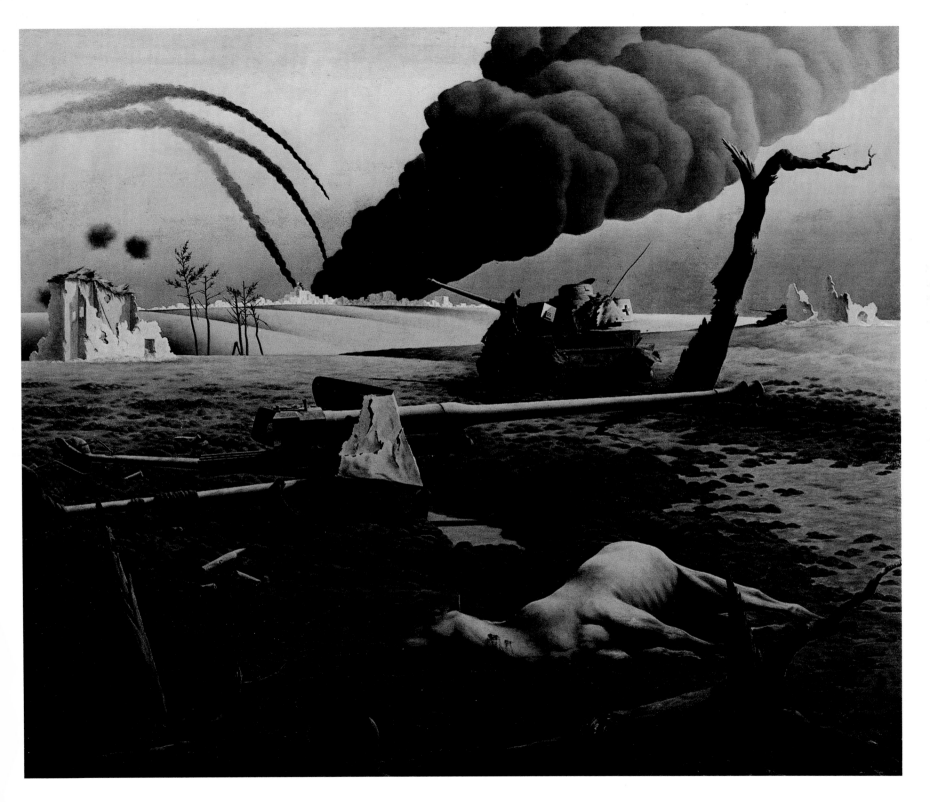

Lawren P. Harris *Battle Ground before Ortona* 1944 181

the dustiness of a new day. You run across a road. A man beside you goes down. Another one cries out. You don't know who they are. You haven't got time to find out.

Now you're in a street. Only it doesn't look like a street. "Bren over there!" And you lug it into the doorway. Set it up. Fire. You see some grey figures in a house up ahead. Fire again. A couple of grey figures tumble down, stir, and are still. You only catch glimpses of this. You're on your feet again, moving. The day goes on. You don't eat. You don't stop. There isn't time. Something crashes beside you. A cloud of dust. Falling bricks. A whine. You see the sergeant grab his middle. Almost in slow motion you watch his Tommy gun hurtle through the air. He doesn't cry out. Just goes down.

A tank moves up behind you. Jarring crashes. Sharp rattles. The corporal yells, "Bren gun over there!" You get it there. You've got one man with you. You're still alive. But you can't hear anything much anymore. You're fighting on instinct now. Instinct, guts, and — what? But you keep moving forward. They tell you to hole up here. You take up defensive positions. It's nearly night again. You sit down. Rest. Rest. You feel nothing. Only a weariness so great you couldn't sleep if they'd let you.

Cliff Bowering

Holding fire

Suddenly I see this German running at us. I didn't know whether he was trying a single-handed charge or if he had anyone with him. So I was going to take a bang at him but my tommy gun jammed. So he put his hands up and looked at me and looked at the tommy gun and saw that it was jammed and gave a little smile and shrugged his shoulders and I gave a little smile back. They're only people. It comes as a shock, really.

Bud Street

Stark silence

Following an intense bombardment, all living creatures except the troops seemed to disappear from the area. This was undoubtedly due to the concussional effects of shell fire. The birds, bees, flies, mosquitos and the bugs would "go underground." It was said that even the earthworms ceased their activities. The silence that followed immediately on the termination of the firing was more intense than that of the grave. When, on occasion, such interludes of silence would incongruously intervene abruptly during the heat of a battle, the starkness of the nothingness would cause the troops to speculate on what unknown and horrible new catastrophe was about to be precipitated.

Edward Corrigan

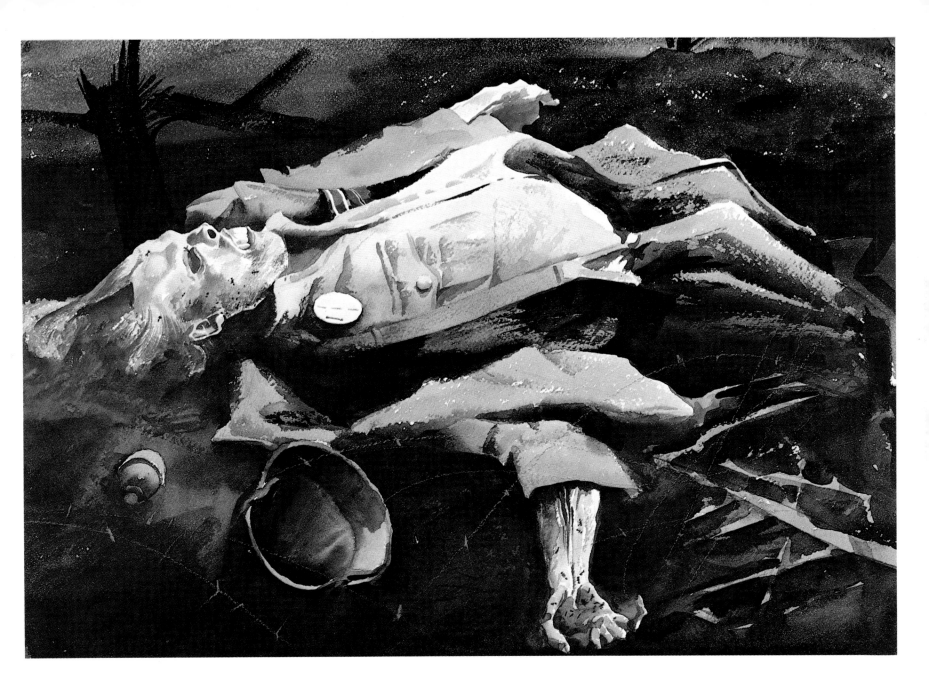

Charles Comfort *Dead German on the Hitler Line* 1944 183

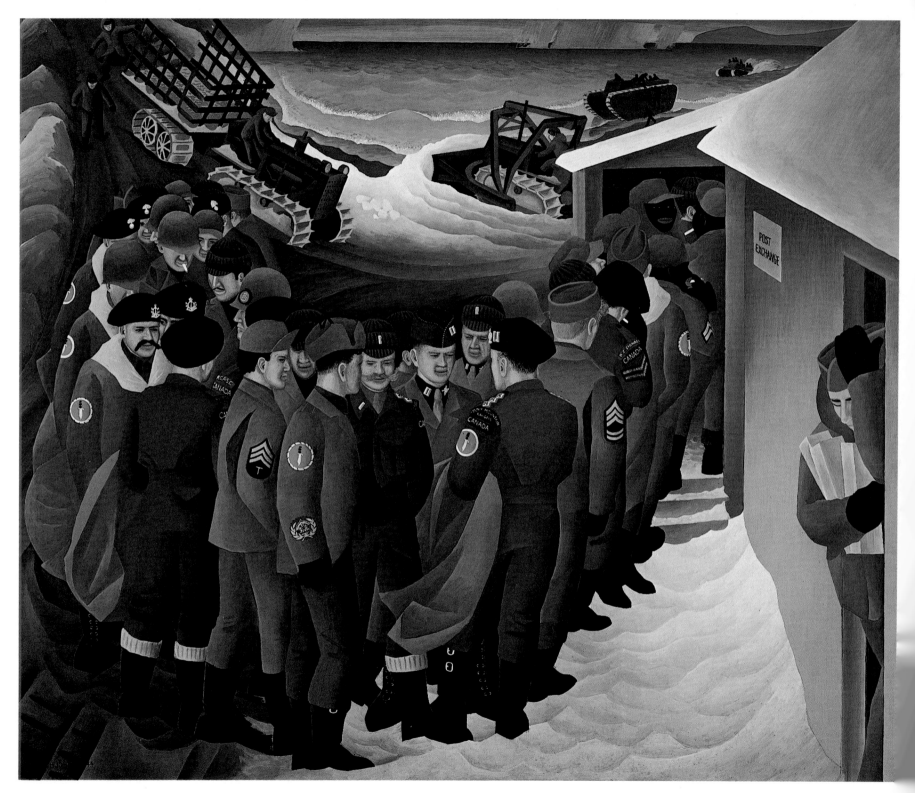

E. J. Hughes *Canteen Queue, Kiska* 1944

Pilgrim Heart, Turn Homeward

Pilgrim heart, turn homeward.
What your quest will win
could only wound you deeper.
Avola cannot tell
the manner of his dying
among the olive trees.

Landing at dawn he marched
along a broad straight road
through a triumphal arch
(built by another's leader
for a victory never won)
into a small village,
sun-drowsy and white.
This was all so strange
and needle-sharp to him
he might well have guessed
its crucial brilliancy.
As the forenoon advanced
they worked through lemon groves
and darker green of olives
toward the bare summit.
Already the fighting
was soiling the morning there.

Perhaps he was musing
on blossoming magnolias
or the prospect of Etna
or letters coming from home:
whatever it was, he never
reached the barren upland.

Pilgrim heart, turn homeward.
There is no relation
between the loving ways
of a man among his own
and the manner of his dying
among the olive trees.

George Whalley

Glad tidings

My dear Lucrèce,

I wrote you a long letter last night. But I can't resist writing you another tonight, because of today's great joy: I had some mail. I threw myself on the letters like a starving man. I read your two letters (air mail) over and over, as well as those from our friends. I lost my appetite and I didn't have dinner; I was too moved, and I had tears in my eyes that I tried to conceal from my comrades.

What filled me with happiness in your letters was, as you can guess, the hope of finally having a little heir. I was mad with joy just thinking of it; you should have waited to tell me about it, for if it's a false alarm, I'll be so unhappy. Could I finally become a "papa"? The word sounds strange to me, and it seems that I shouldn't count on such happiness. I'll be waiting for more news with the greatest impatience. I would be so happy, especially for you, poor Lou, who would finally have a reason to wait without despairing. As for me, what I wouldn't do to cross the ocean! Write to me quickly and tell me if there is really reason to hope. I can't wait to hear from you.

I'll see you soon, my dear; say hello to everyone. With all my love,

Your husband, who dreams only of returning to the country where we loved.

Jacques Gouin

185

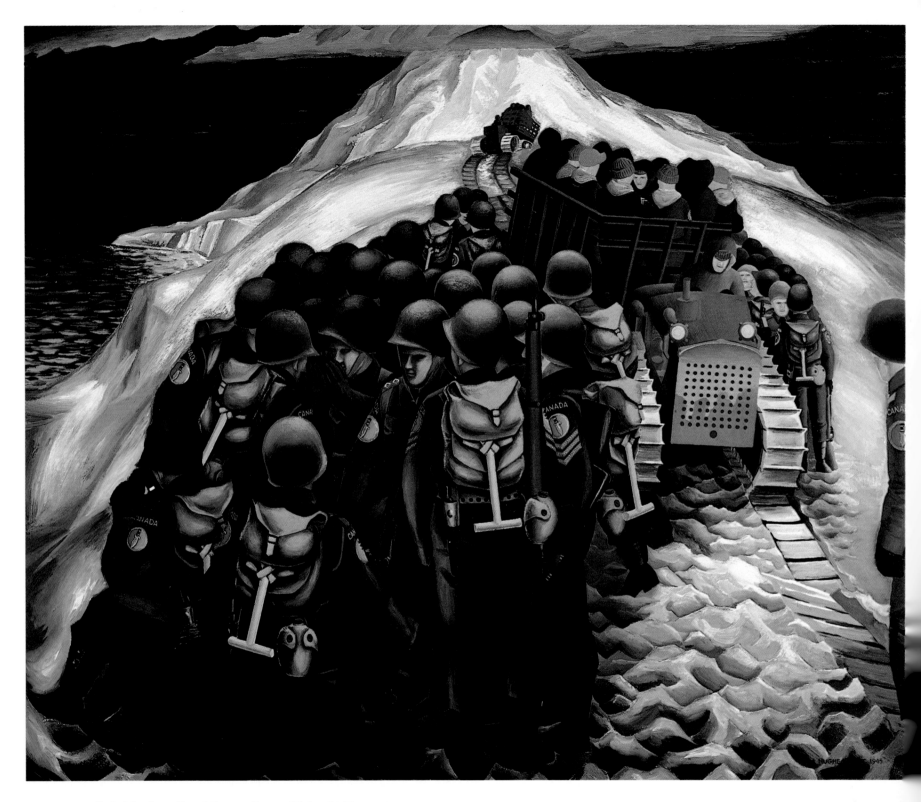

186 E. J. Hughes *Ten Minutes Rest – Kiska* 1945

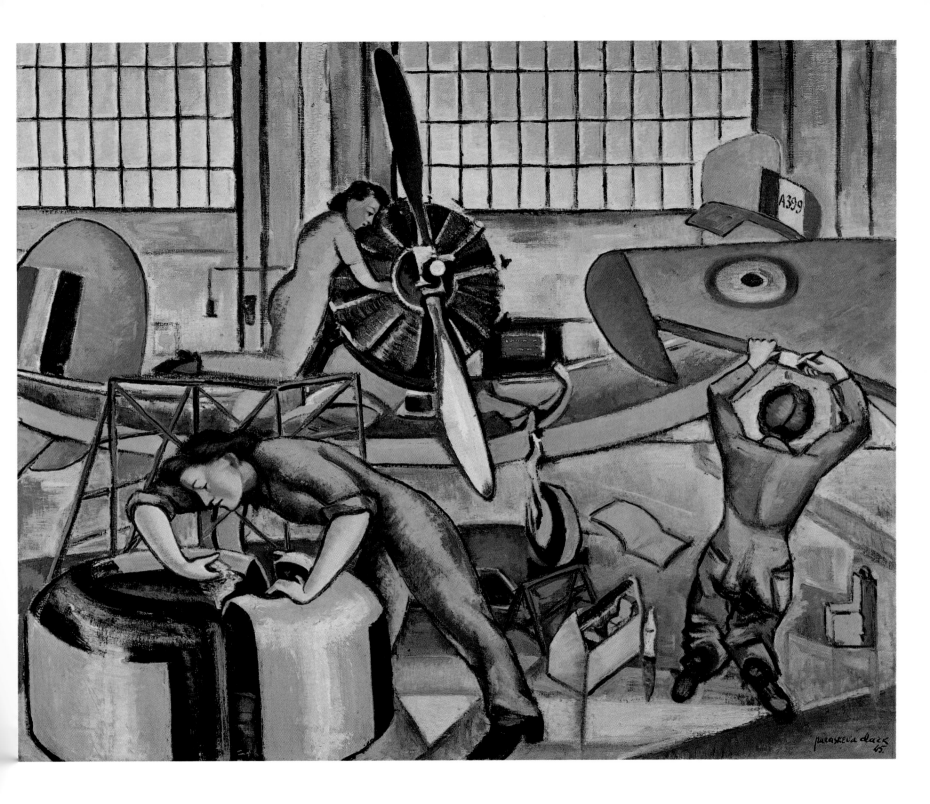

Paraskeva Clark *Maintenance Jobs in the Hangar* 1945 187

Home Front, 1942

Collective paranoia
on a West Coast shuddering
at Pearl Harbour. Those inscrutable
almond eyes, the enemy spies
in quiet tearooms making contact
with a silent-running fleet
deep in the bay. They must be
rounded up, the radio says. See
how they speak among themselves.
Perhaps the flyers read their planted rows.
And in those carefully folded paper flowers
there may germinate the incensed seeds
of sabotage. One hundred thousand
secret agents for Japan found living
in the homes next door are quickly
rooted up and moved inland. The camps
are long, hot rows of roof-tarred huts
with sentries perched above
the barbed wire nest. The children
learn the English alphabet
and scratch words in the campground dust
with sticks. Their parents
tell each other with their eyes.

One more Saturday night,
the marquee sparkling through the mist.
Its neon splashes fleeting patterns
on the backs of black umbrellas.
Silent crowds line up along the street.
The waiting wives of soldiers overseas
exchange their carefully counted coins
for Bijou's silver screen. Tonight
it's Warner Brothers' tear-stained taste
of romance — "Casablanca." Every
upturned face is bathed in flickering
passion, and the time goes by.

Night shift at the plant. The women
wear their hair pulled back in nets
and welders' goggles hide their eyes.
The heavy sheets of steel swing into place
upon the line and move on down towards
takeoff. Red hot sparks fly up
and break the monochrome of dull grey
metal. Sweat slides glistening
down each face. The thing takes shape.
Its deafening demands defeat all
conversation. Other languages arise,
the silent ones. Around the unrelenting
march of steel, community is formed.
The women read each other's bodies, knowing
from the way a neck is tensed, a forehead
smooth or lined beneath the sweat
that letters from the front have come
or have not come. Another bolt
is welded into place.

Joyce Nelson

Six years apart

During the war, for the whole six years, many of us wrote daily to our husbands, sometimes more than daily. We wrote to expiate the loneliness we felt, to talk about the children, to keep the lifeline of daily trivia open, to complain of our living circumstances or to embellish them, of cold rooms, of exorbitant rents, of the difficulties of living with mothers and mothers-in-law. I remember one girl of my acquaintance writing to me that if she had to live in a backhouse, to use the colloquial term of the West, she would never live with relatives again. We wrote to tell of the problems of raising children alone, of birthdays missed, of what it was like not to have anyone to dance with on Saturday night. We braved the censors and our own inhibitions of the day to tell what it was like to go without sex. One of my friends omitted to do that, on the very sound principle that it was better with so much distance between them not to get her man's mind running in that direction.

Jean Margaret Crowe

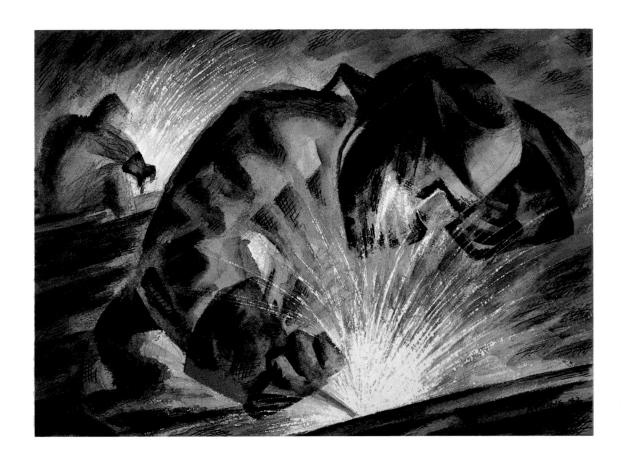

Caven Atkins *Arc Welders by Night* 1942

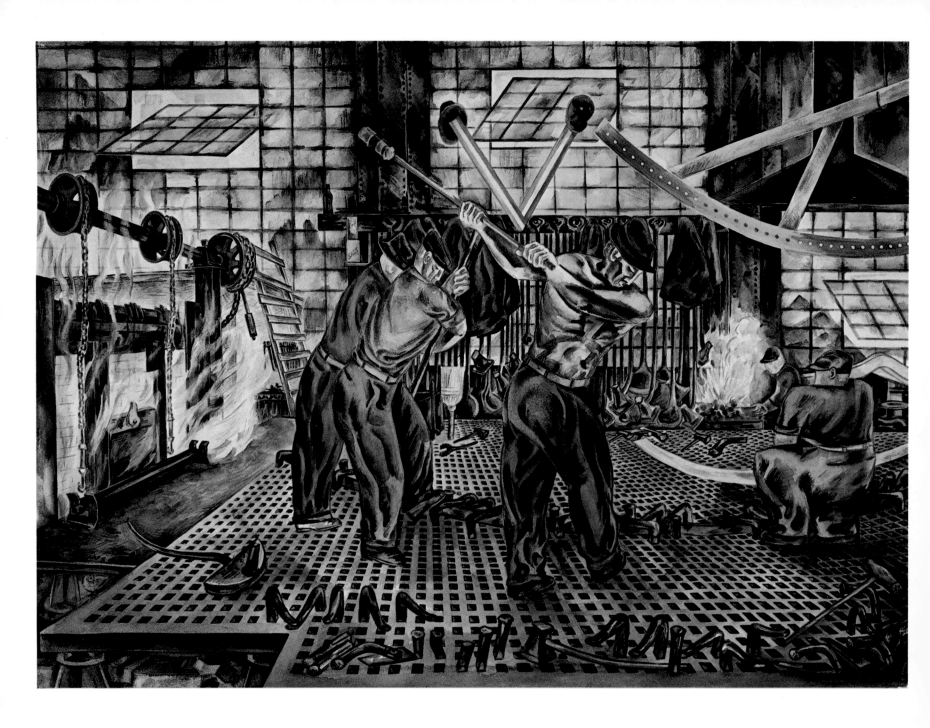

190 Caven Atkins *Untitled (Forging)* 1942

Draft Dodger

I am writing this short story
And every word is true
Don't look away draft dodger
For it's addressed to you.

You feel at ease in the dangers
Back in the old home town
You cooked up some pitiful story
So the draft board would turn you down.

You never think of real men
Who leave home day by day
You think only of their girl friends
That you take while they're away.

You sit at home and read the paper
You jump and yell "We'll win!"
Just where do you get that "we" stuff?
This war will be won by men.

Just what do you think, draft dodger
That this free nation would do
If all the men were slackers
And scared to fight, like you?

So I'm closing this, draft dodger
Just remember what I say —
Keep away from my girl, you dirty bum
For I'm coming home some day.

Jerry Falter, P.O.W.

Japanese P.O.W. camp

August 25th, 1942 A lot of men are troubled with so-called electric feet, a terrible thing, but just another symptom of diet deficiency; right now one of our sgts. is delirious with the pain. Some men brought the news of the death of Jim Chapman. He died on the 14th and was buried on the 15th. One of the saddest things that has happened. He had quinsy and dysentery, was a married man with four children. Chapman had always been so optimistic, so enthusiastic, his booming voice and his hearty laugh were known all over the camp. He enjoyed life, and just living so well. He had lost a lot of weight and used to say it would be a labour of love to put it all back on again.

August 28th Today the Rifles had date pie with a good crust made with peanut oil, yet we get neither oil, pie nor dates, although all supplies are shared evenly between the two units. We cannot help but wonder sometimes.

August 29th We had got nicely to sleep when the lights went on, our officers entered, roused us and called the roll, then left and we were just asleep again when the lights went on again and six Jap officers came in and made a bed check, then we were ordered out on the parade square, regular muster in alphabetical order. A heavy cold rain began to fall, we had had no time to dress, were in pyjamas or underclothes, were soaked in a few minutes. We stood shivering in the wind and rain and darkness, for four-and-a-half hours while the Japs counted and recounted and searched and researched huts. They are in an ugly mood and struck quite a number of us as we covered off and numbered in the ranks.

September 1st Two Rifles died. I will have to give up reading altogether, I am afraid, as my eyes are giving me a lot of trouble. At the instigation of Doctor Crawford the Japs are docking the officers' pay and raising a fund to buy a few extra rations for men who are far below the average in weight.

September 4th Our buns are getting smaller all the time.

September 5th More men are getting the terrible pains in their feet and hobble around on their heels to keep their toes off the ground, can't sleep at night with the queer electric shocks that run through them.

September 6th Twice a day I draw pot permang for a queer rash on my legs called pellagra. It seems to be getting worse all the time. Doc says it's all caused by diet deficiency.

October 2nd More wind and rain. All men getting a throat swab test by Jap M.O. for diptheria. A big ship in harbour with white crosses on it. Another Rifle died; they have lost six since coming here.

October 4th The Japs took away Halbert's pet monkey. He has made an electric toaster and water heater, but must keep them hidden at all times as the Japs confiscate on sight. Another Rifle died.

October 5th Nine Canadians died since moving here. Old Paddy Armstrong today. Clear and hot.

October 6th Another Rifle died. Batallion drawn up in hollow square, one fellow who put an onion in his pocket while on a ration party put in centre, a very solemn warning delivered by O.C. on such conduct.

October 7th Marcel Robideaux and Herb Mabb died of diptheria. I knew them well, more likeable fellows would be hard to find anywhere. We shall miss them.

October 9th W. Moore of "B" Company died today. A supply of diptheria antitoxin finally arrived in camp. One bun a day, but twenty oz. of rice.

October 11th Five men died last night. Like most of the men I am getting dozens of pellagra ulcers on my legs, my tongue is swollen and so sore that eating is a painful business. There is no salt in rice or greens.

October 12th Three Rifles died, one Grenadier. Second throat swab for diptheria.

October 13th Yeast issue has been cut.

October 14th Thomasson died, an old Grenadier, who was on the old police force; it has suffered heavily. The Japs are beating up all men they see without a mask, or anyone going near the dip hospital. Used rifle butts on one man, and broke three ribs.

October 15th A Rifle sgt. died. A spoonful of peanut oil on rice once a day now.

October 16th A Rifle died today, also Forbes of "A" Company, Grenadiers. Total deaths today were three Rifles and Forbes and Eastholm.

Tom Forsyth

Young lovers

I went into nursing training. I remember the war almost by hospital wards. France fell when I was on Ward L, Pearl Harbor was when I was on Ward I, D-Day when I was on night duty in the Ross Pavilion. And my friends after their first holidays at home, and some after the second, began to wear diamond rings pinned to their brassieres and then wedding rings pinned with them. It was absolutely forbidden to marry while you were in training but we did and many did not tell even their own best friends for fear of being expelled.

One short, rosy-cheeked little blonde girl from Truro, N.S. told me one night when we were alone on night duty that she had been married on her vacation, that she had had a seventy-six-hour leave with her husband and that he had gone. "When he comes back," she said, "we will make it on our own. No handouts for us from our families." But he was killed at Dieppe. I remember another who married in her last year, secretly of course. They sat up on the train to New York on embarkation leave and came back the same way because money was scarce. She confided later that the nicest part of the trip and the leave was not the "sex part" although that was good and too private to talk about, but when he covered her gently with his coat on the way back and she thought how good and secure life would be after

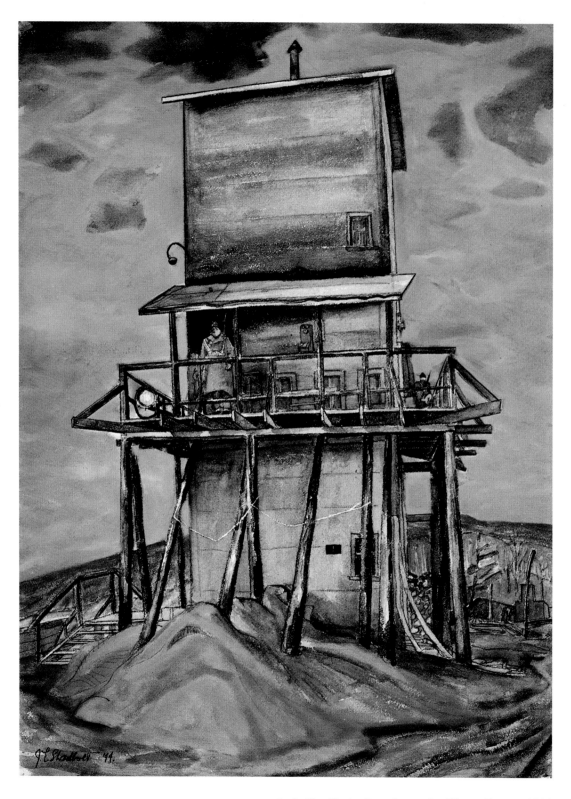

Jack Shadbolt *Guards on the Water Tower* 1944

the war. He was shot down over Cologne the following year.

In 1940 my brother enlisted in the air force. I saw him for the last time on his way through Montreal to Halifax for embarkation. He was a pilot. He was assigned to a Pathfinder squadron and made 38 trips over the Ruhr as the captain of a Lancaster before he was shot down over the North Sea. He wrote me many letters from England. He was desperately lonely. He was only 22 years old. Life for him had not really begun.

I too had married secretly in training. I too wrote every day and sometimes twice a day on the blue forms that gave you a good page of small writing. And the letters that came back; they were the first priority of the day. The mails were uncertain and sometimes there were frightening gaps. I still remember after two weeks without a letter being awakened by one of my friends to go on duty. She had a package of blue Players cigarettes in her hand and I thought it was a letter for me. I still remember that sickening disappointment.

When I finished training I went to live with another nurse whose baby had been born two months after her husband left for overseas. We rented a basement apartment and each took turns looking after the baby while the other worked. It was a strange life segregated from men. We met lots of women in the laundry room and exchanged our opinions and experiences. Some were like us; some not so segregated. Some frankly worried about the return of their husbands. But nobody was censorious about that. It was a kind of sisterhood. It was just the way people were. Neither bad nor good attached to it.

In December of that year we both went home for Christmas taking our one little baby between us. We handed him back and forth across the corridor between the berths on the train as we got ready for bed. My friend and her baby got off the train two stations before me. I went on to my parents' home. My husband was killed two days later on the day before Christmas. My father, a telegraph operator, took the message on the station telegraph key.

Jean Margaret Crowe

A promise

My dear Lucrèce,

I think all the time of the little one you are carrying with so much love. May he be as good, as tender, as pure as you, my Lou; I can't tell you how much I value all the qualities of your heart and mind. If ever I should return from this adventure, I will devote all that remains of my energy and my health to making this child the pride of our lives. You cannot imagine how much it hurts me to be separated from you at a time like this. When I return, I will have overcome so much of every sort of obstacle, physical and especially moral, to be able to face up to life on my own two feet (if I still have them), without demanding useless sacrifices from you. I want only one thing: to see you healthy, giving me a child who will make me forget all of the horrors of this world.

The ocean has never seemed as immense to me as tonight, yet not so immense as this sadness that grows at my heart. But it will pass. Tomorrow is work, getting up early, the routine, another day that brings me closer to you and to my family. Since I've been here, I can scarcely keep my thoughts in order; it's all so disconnected, but the essence is always the same.

I miss you and I love you,

Jacques Gouin

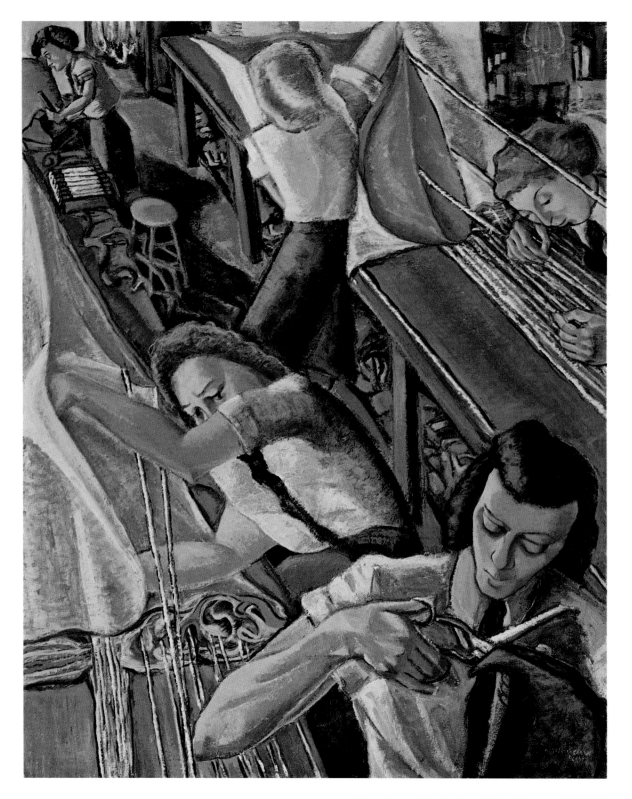

Paraskeva Clark *Parachute Riggers* 1946-47

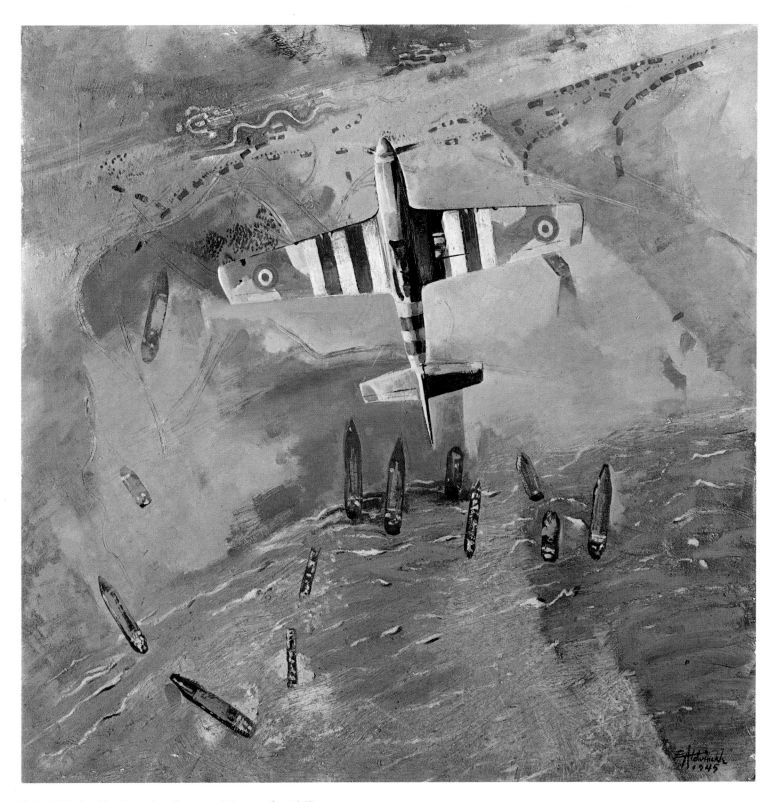

196 Eric Aldwinckle *Invasion Pattern, Normandy* 1945

Armada

At 5:30 a.m. it was daylight—and what a sight met our gaze — a great semi-circle of hundreds of ships lay off the enemy's coast. At 5:31 a.m. the first cruiser opened fire. We were then about 12,000 yards off Bernières-sur-la-Mer. There was no opposition from any shore batteries, in the air or from the sea. At 5:40 a.m. the *Sioux* started to move in. At 5:45 a.m. the shore batteries started to answer. At 6:00 a.m. we were in bombardment position, two miles from the shore. At 7:00 the captain ordered our gunners to engage the enemy. I was on the bridge, sitting in the high chair, and I know now what the expression means "to knock your block off." At 7:34 we were still bombarding and had obliterated our direct target. At 7:40 a.m. we completed our direct bombardment.

Thunder answered thunder, tanks went ashore, guns went ashore, men went ashore, fires broke out, the coast was enveloped in smoke which cleared away and returned in changing faces. By 8:05 a.m. everyone was standing around watching the planes overhead. As those of us who were able to do so breakfasted on bacon and beans we listened to the BBC broadcasting the landing. At 7:57 a.m. the first landing craft hit the beaches. At 8:10 a.m. the first landing craft started to return. By 9:45 a.m. there was a regular ferry service of landing craft. Royal Marines clad as divers in rubber suits had walked on the bottom of the sea exploding mines and removing obstacles. Ships were sunk to make a breakwater. At 11:30 a.m. the *Sioux* closed in for the protection of a long line of landing barges landing men that we knew were Canadians. I never expect my heart to throb at a more thrilling sight of man going gaily to the unknown than of those Canadian men on those landing barges.

Leonard Brockington, CBC radio, on board
H.M.C.S. Sioux

French beach up ahead

Oddly enough your first memory, of all things, is one of being violently sea sick during the crossing in that bloody, wonderful landing craft. It was a rough crossing.

You think back to those last minute peeks at maps and photos, to last minute briefings. To wondering if you were going to remember everything. That dryness in your mouth, the tongue like cotton wool, the cold, unreasoning slab in your belly. The sensation of anticipation that defies description. Your heartbeat trying to outdo the sound of gunfire and bombs. The wondering of what it will be like on the beach.

All the old clichés running through your head. Your nervous smile — but the effort hurts your dried lips.

Somebody laughs, only it sounded more like a croak. And it was too loud. The one-in-every-crowd wiseguy: " . . . Home was never like this . . . not much like the old ferry back home . . . I wonder who's missing me now . . . it's Paris first chance I get . . . anyone for tennis?" . . . and, "Can the chatter back there, we're going in!"

The exact minute has arrived.

The ramp crashes down. You see what looks like ten miles of water, between you and the beach. For the first time you realize two things . . . somebody's shooting at you and there are a hell of a lot of ships on either side. And you're shooting back with a barrage that stuns the imagination.

You're in the water now. In the breakers. You try to remember how to walk in the water and keep your rifle up and dry. Yard by yard you move in. Smoke up ahead, and the noise . . . it's like nothing you've ever heard before, even in the blitz in England. What a difference between this and battle camp. Brother, this is for real!

Wade some more. Shells sloughing into the water near a barge. Chug-crunch! A barge hit. A man goes down and

you lunge forward in fear. But he's up again—only stumbled. Beach up ahead. Another man down. He doesn't get up. Tracer to the left. Machine guns. Planes diving in—R.A.F. You lovely babies from hell!

In the background the steady rumble and swoosh of the Navy guns. God bless 'em! Softening up, they called it. And all last night and this morning pounding, pounding, pounding the pride of the Third Reich.

Your head tucked into your shoulders like a boxer weaving toward his target. Smaller target that way? Crouching lower as you walk, pretending you can't be seen—maybe.

Your mouth dryer still. Hoping you don't have to speak, because you couldn't. Rifle up higher. You're on the beach. Rifle at the port. Shells coming in on the right. Machine guns. Men falling. Funny, no one around you has been hit. This isn't so bad after all.

You think pretty clearly after that. Now you know what all that training was for. This is the job and things are going well. Too easy . . . a dull smack, a groan. The man beside you goes down, doesn't move. Face in the water. You move on. Sniper? Sniper, hell! that's a machine gun. Let's go. Up to the seawall and down and wait for orders. Orders.

The tanks didn't get in ahead of you like they planned. Just one of those things. You move on. Town called Bernières. One company badly shot up. Not yours, thank God.

Back on the beach. Indescribable chaos. No, not chaos. It looks that way, but it's all part of the plan. Already they've landed ammunition by the tons, rations, bulldozers, trucks. The barrage balloons are up. The backdrop is there . . . the greatest armada ever created by man. Compared with this, the Spanish sailed against England with a two-bit fishing fleet.

You look at all this and suddenly feel safe and secure. We've got the strength and the support. We're on the beach to stay. We've landed in France. We're on our way!

Cliff Bowering

Spectacle

We fired no more shots that day. Towards evening, with a singular beauty of sea and sky, suddenly appeared in the heavens the greatest spectacle that any of us had ever looked upon. We stood like the first star-gazers looking at the first comet. Hundreds of R.A.F. or R.C.A.F. planes, black and white, shining in the sunshine, came from the English coast towing great gliders packed with parachute troops. They proceeded beyond the beach and we could see the airborne troops in yellow, red, green and blue parachutes landing upon the inland meadows. I saw three planes shot down.

When the great fleet of planes had returned I sat on the deck wondering about a little tanker that was turned upside down, looking at the sea dappled in green and blue underneath the descending sun, watching some wild ducks flying and noting some cans of food floating by and some spars of wood and occasionally some gruesome relics that showed that for some men the day had gone more hardly than it had for us.

When night fell the red warning came for enemy aircraft overhead. A few bombs and flares were dropped and then the whole fleet let off its guns and its rockets. For half an hour, amid an unbelievable din that fractured one's eardrums, all the illumination that you've ever seen at the Toronto Exhibition or the Calgary Stampede lit the heavens that watched over the bay. The last gun ceased firing and peace descended on our little section of sea.

Leonard Brockington, CBC radio
on board H.M.C.S. Sioux

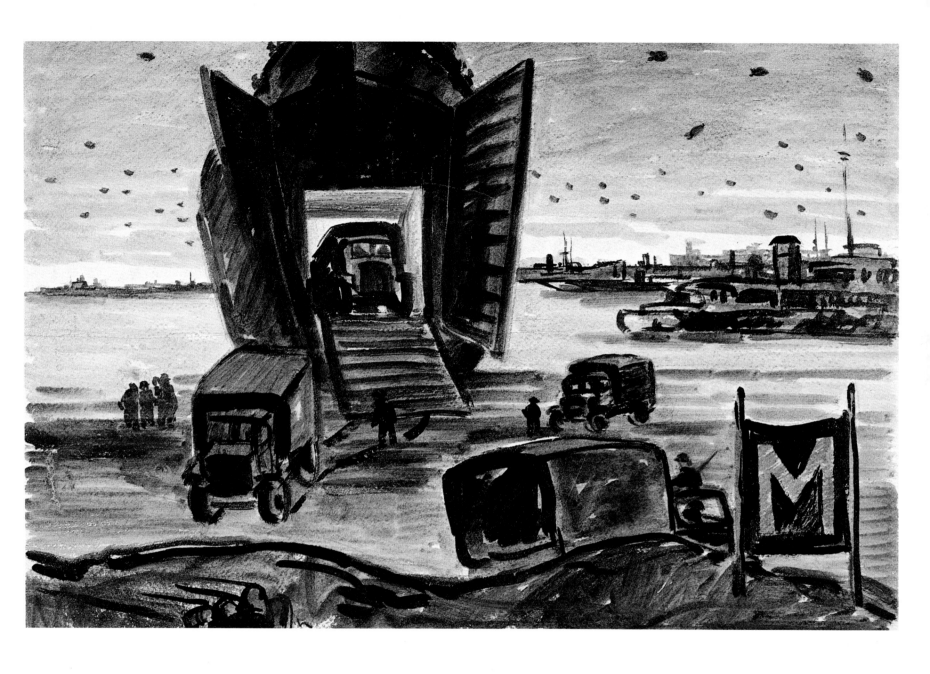

A. G. Broomfield *Unloading L.S.T. 2 Mike Beach, Juno Sector, Normandy, June 1944* 1944 199

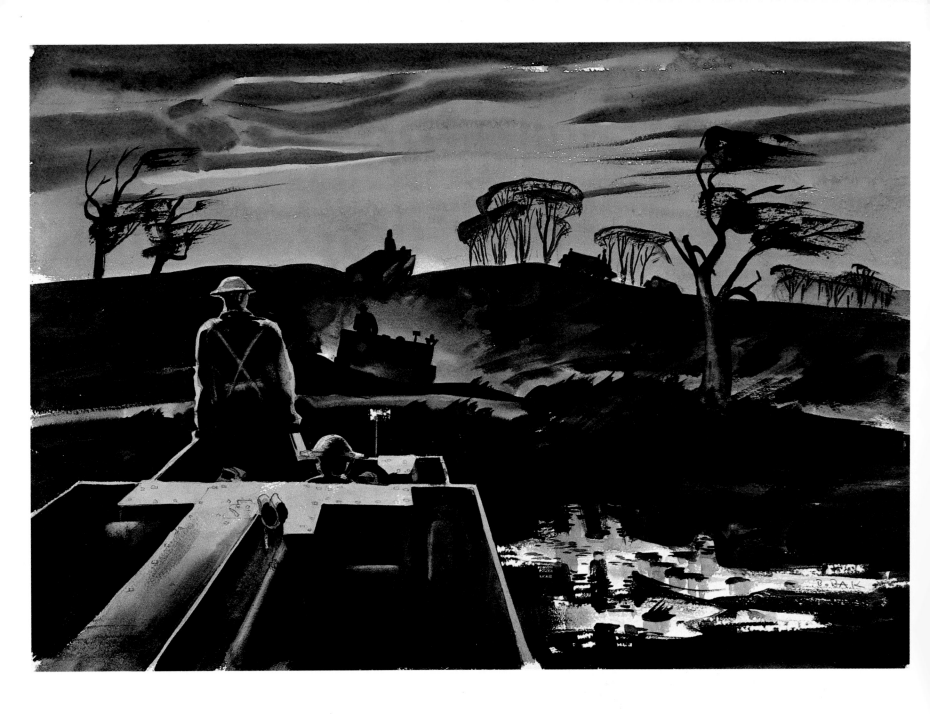

200 Bruno Bobak *Carrier Convoy after Dark* 1944

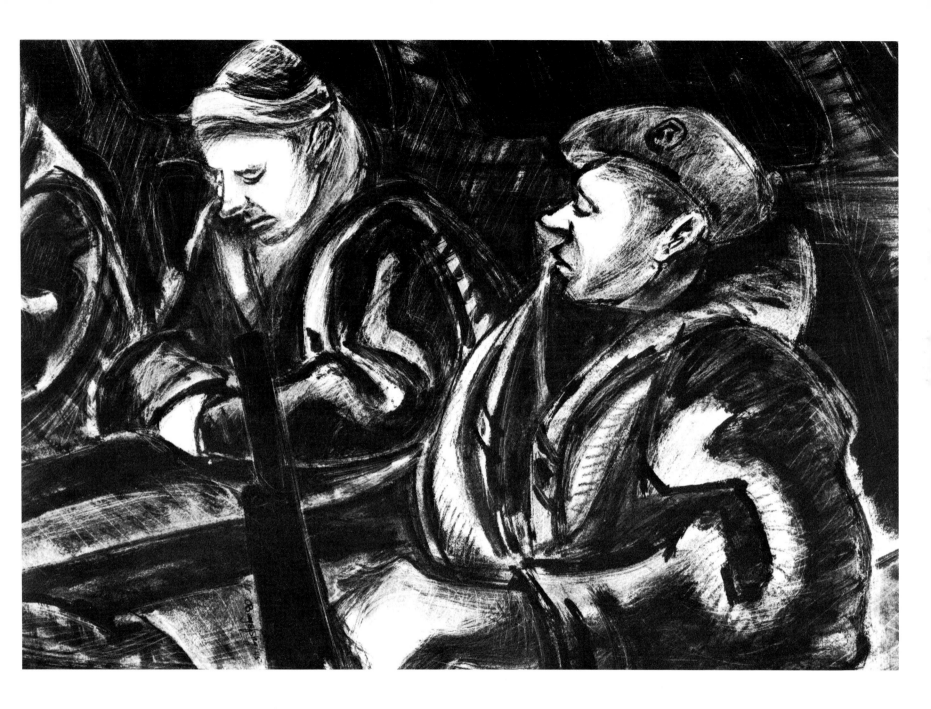

Aba Bayefsky *Troops Being Flown to France* 1945 201

Dear Mother

June 14, 1944

Your last letter was written on the 5th of June and mailed on the 6th of June.

The 6th of June! What a day for us! The war should be over by Christmas. I cannot say much about our activities, but I can say that I haven't been in action yet. Keep your fingers crossed Mom and keep asking the Lord for a little help for me.

I am No. 1 on a Bren gun and don't mind it. A kid from Cape Breton by the name of Baker is my No. 2. I chum around with a lad named George S. Thompson from Niagara Falls. He is a swell fellow and we have had a lot of fun together.

Mother, I am no fatalist or anything but big things will be coming off soon, and we are going to be right in there pitching. I can talk straight to you and know you won't be too upset about anything, and Dad has been through it all before.

Since I have been in the Army I have learnt more about people and customs and life in general over here than the average soldier in the Infantry could learn in five times as many years. It has made me realize just what a wonderful family I have and what a perfect place home was.

Mum, dear, please don't worry about me. I am well and fit and trusting in the Lord for future security and asking Him to keep you all well until we are together again.

Art Wilkinson

The news

Dear Doris,

Yesterday morning when I came to work someone said "The Invasion has started," and it had come through on the radio. I was in the tube station standing in queue for a ticket. The girl in front of me said to the tube ticket man —

"The second front has begun"—"Oh," said the ticket man, and flicked her ticket across the counter. One of the boys went home and brought his radio to the office and we had it turned on all day. One of the batmen picketed the local newsstand and bought up all the papers. They didn't even publish an extra, being England, and the English. General Eisenhower broadcast to Invasion country and at night the King spoke.

I was sitting in a pub at the time and it was full of Australian airmen, British army officers, WREN officers and American N.C.O.s and officers and a few Canadians. The radio was very noisy and everyone stopped drinking when it was announced the King was going to speak and all listened. When the National Anthem was played at the close, everybody solemnly rose to their feet and stood at attention and then there was an embarrassed silence while the barmaid scurried around collecting dirty glasses and then everyone was very jovial.

Kathleen Robson Roe

Another reality

Today forenoon we passed five bodies floating on the surface — two airmen and three seamen. One of the former was sitting bolt upright, as if in a chair, held so by his life jacket, head and shoulders out of the water. An occasional wave now and then washed over him, smoothing back his hair as if with a comb. This gruesome sight seemed to fascinate some of the newer members of the crew, to whom a casualty was something one read about in the papers. It brought home to them rather abruptly the fact that war is more than bands and uniforms, seeing the world and being a hero in the home town.

I.J. Gillen

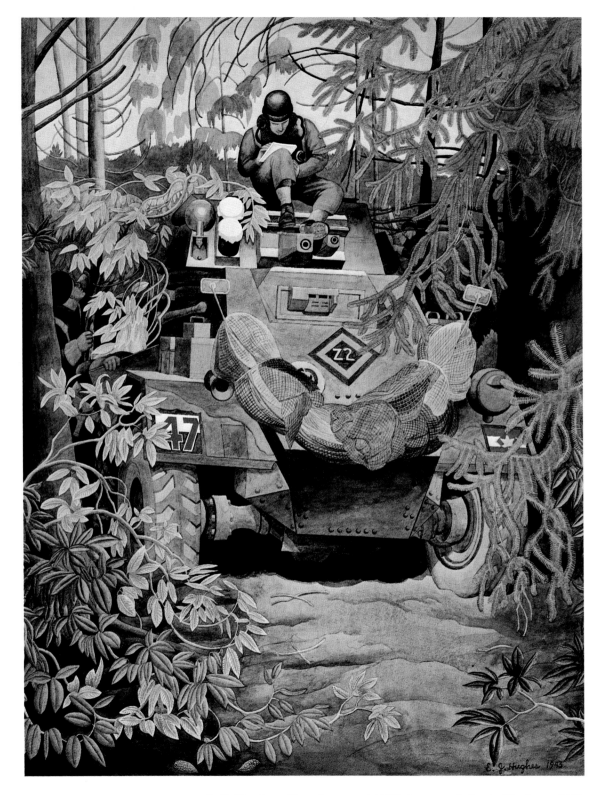

E. J. Hughes *Signalman and RCD Armoured Car in Harbour* 1943

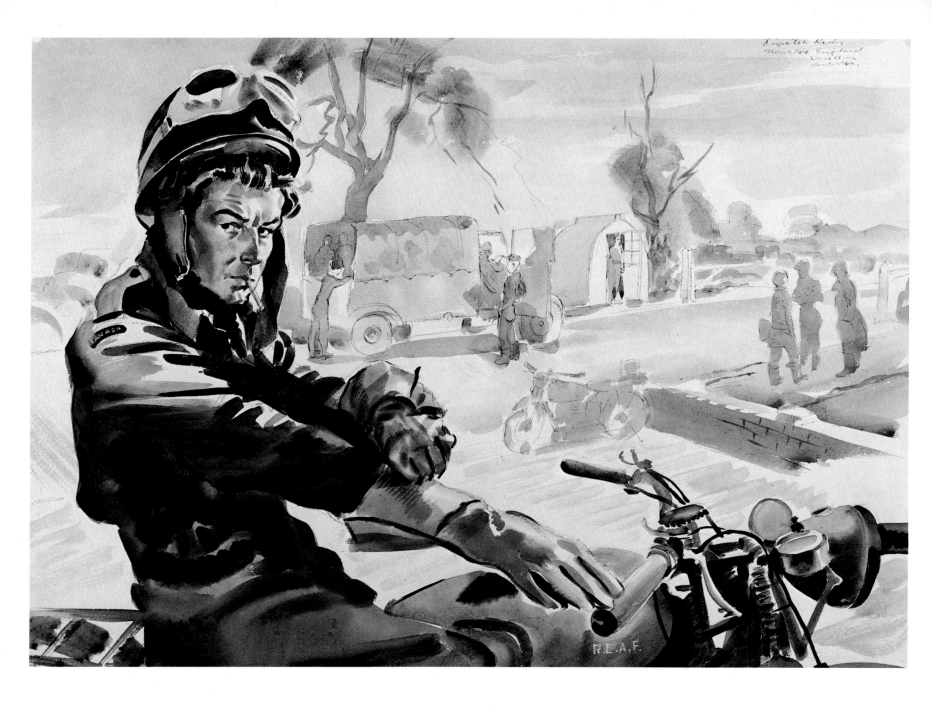

Donald Anderson *Dispatch Rider* 1944

Welcome

Soon all of us were loaded into several open lorries, sitting where we could on top of bedrolls and packs, clutching our bags and steel helmets. We drove through town after town amid lines of cheering lads, while French people leaned from upper storey windows to throw flowers and kisses, calling out, "Vive les Canadiennes!" At last we were on the famous road "Maple Leaf Up," main highway from Normandy to final victory in Germany. Orchards and fields all along the way were occupied by some Army or Air Force unit. Nearly every kilometer we sang "The Maple Leaf Forever" and "O Canada," to let any lads still unaware of it know that sixty Canadian girls had come to share their job.

Many times our convoy was forced to a stop, and at every stop, some lads would dash over to shake hands and talk.

"Gee! It's good to see you girls over here!"

"Girls! They're Canadians — they speak English!"

"I got two Jerries today —"

"We'll run all the way to Paris so we can dance with you there."

"Good going, girls!"

"Gosh — women!"

"How far are you going, girls?"

"What's your hospital?"

They asked any old thing just to get an answer in their own language, and of course there were the usual wolf calls. But we saw many tears too; before long a lot of us were feeling drops trickle down our own faces.

Jean Ellis

Normandy 1944

Forget about what's on the beaches. Tide,
wind and the blind muffling drift of sand
will care for that. Deeper inland, here
where the apples taste only the rumours of gales,
the wounds are subtler. One obliterating
sweep of a bulldozer crushes for all time
a sunken lane which never knew harsher uses
than murmur of lovers in mothlight. What do we care
for the splintered stillness of a Norman tower,
soiled (had it not been destroyed) by iron-shod
boots and spotter's glasses and the predatory
snap of a sniper's rifle? What to us
is the gnarled and immemorial apple orchard
under whose trees we heap up ammunition,
dig foxholes and write V-letters home?
The tanks have made destructive harvesting
of fields patiently waiting for the scythe.
The bearded pale gold wheat and the poppies know
the sudden limp impersonality
of violent death. In Bayeux, while the guns
thunder round Caen preparing the final assault,
the houses, as though bemused, stare with blind
eyes at the tanks clattering over the cobbles
and the crowning impertinent insult of the jeeps.
And there's no wandering with a market basket,
no passing the time with gossip at a corner.
The silent villagers' eyes are dull, bewildered
with wondering how the refugees are faring.

Whether we do it or the enemy,
this second death in no wise rights the first.
Perhaps we need this blindness, need this hangman's
smiling complacency, because we know
the Army of Liberation strips the country girl
and, laughing, sets her to walk her native streets
naked and humbled in the lewd eye of the world.

George Whalley

Calculated risks

August 8, twenty-six years to the day when, in World War I, Canadian, British and Australian troops hit the Germans at Amiens in an onslaught which famed General Ludendorf called "the Blackest Day of the German Army." The Germans around Falaise didn't know at 10.59 p.m. on August 8, 1944, that a black day was at hand; that even blacker ones were to follow.

H-Hour (11:00 p.m.). Whistling five-pounder shells. Not high explosives, but coloured marker shells to pinpoint targets for the waves of R.A.F. bombers assigned to soften up the Germans for the big push. And the gunner boys were dead on.

The night is filled with flashes as bombs hurtle down. Stick after stick, rolling crash after rolling crash. How can anything live in there, German or Frenchman?

H plus thirty minutes. Tanks and infantry move in. The gunners, back on the job again, lay in a thunderous, devastating rolling barrage in front of advancing troops. Searchlights and Bofors tracers mark the way, light up the night.

They're through the heavy fire zone—the killing ground—thanks to the armoured carriers, and near the objectives with few casualties. Behind come the marching foot-sloggers. The barrage helps them, but bitter fighting is encountered. Flame-throwers roast out the most stubborn of Hitler's storm troops.

The hours roll on and the scene is of two juggernauts locked in mortal combat. Allied planes come in to support with bombs again. Some fall short. Our own men are hit. Many casualties. Some men curse the airmen for a while. But it is a calculated risk. And sometimes it is all but impossible to tell friend from foe. The battle rages on.

Cliff Bowering

Tank advance

Suddenly German resistance stiffens, halts advancing troops. Days of close-in fighting pass by. Medical officers are forced to the limit of their endurance. Troopers manning their Shermans count high losses. Infantrymen are experiencing their toughest moments since before Caen.

A new attack is needed, with powerful support, to break through the fanatical defenders of Falaise. This time they use smoke, firing ahead of the tanks and infantry to cover the advance from the deadly pockets of antitank guns bristling across the line. The dust, great swirling clouds of choking dust, helps — and hinders.

Infantrymen moving in with tanks watch with horror as tank after tank is hit, fired, and men tumble from turrets, their overalls afire like blazing bundles spewed forth by miniature volcanoes. The sickening smell of burning flesh assails the nostrils, is gone as the advance continues.

Cliff Bowering

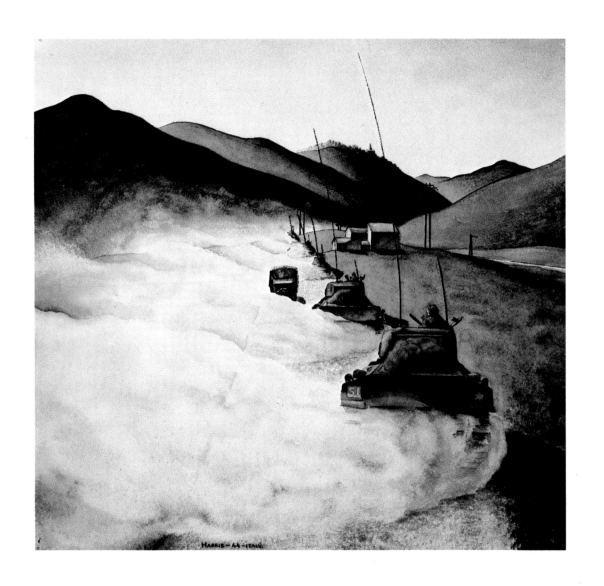

Lawren P. Harris *Tank Convoy* 1944

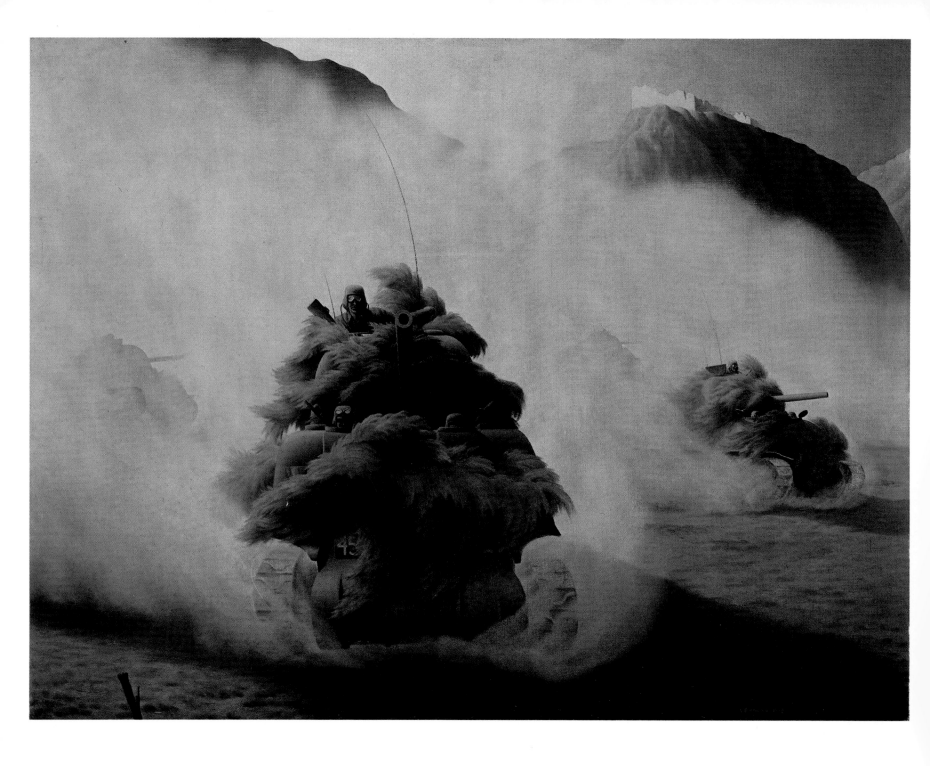

Lawren P. Harris *Tank Advance* 1944

Behind the battle

All the way back to Caen, the yellowing fields are dotted with slit trenches, guns, tanks and vehicles. You have learned to live in holes in the ground—seldom getting out when in the front line, and when in the rear areas never moving far from a hole, and always with one ear cocked for the whisper or whine of mortar or shell. You drink water always warm, always heavily chlorinated, smelling like bleach, drawn from the Orne where every hour of the day a body of a man or cow floats by. If your stomach is strong, you still spoon into your Steak and Kidney Pudding or M. and V., often from the can warmed by the sun.

All day long the guns rumble and the Tiffies dive down through the frantic black puffs of flak, releasing their swooshing rockets on targets south of St. André.

In a blast shelter at the back door of what remains of a large stone house, an exhausted soldier is sleeping on the bare cement floor. A red hen has been killed and plucked and the feathers are everywhere. In his restless sleep the soldier has rolled in them and he's covered with them. They even stick to his face. The earnest young major, who came in only five days ago as a lieutenant, is now commanding the company, and wants to discuss a plan he has when it gets dark for "using the knives very quiet" to destroy the Germans in the house next door. But you can't take your eyes off the weary soldier in the dirty, rumpled battledress lying in the feathers. Somehow he typifies the utter exhaustion and endless misery which is the lot of the infantryman. Reduced to accepting the barest subsistence level, snatching food for his belly and rest for aching legs whenever and wherever he can, he waits for the next orders to go forward.

Waiting for the guns to come up, you wander alone among slit trenches of the recently vacated infantry position. Here and there in the wheat and sandy holes lie crumpled sacks of battledress which a few days ago were men. You pause before the body of a captain lying face down half out of a shallow trench, his head resting on one arm — as though asleep. Curious as to whether he was

Royal Hamilton Light Infantry, Essex Scottish, or Royal Regiment, you bend down and read his shoulder flash—"4 R.C.A." (Royal Canadian Artillery).

With a shock you realize you have stumbled on the spot where quiet, gentle Jack Thompson died. One of the very few chosen for long service leave to Canada just before D-Day, you recall how eagerly you questioned him when he got back to England. What was it like for a man to return to his wife after many years separation? "Incredibly beautiful," he said reverently and his eyes glowed with the memory. But then he frowned and said, "But I don't know whether these leaves are good or not — you see I left my wife pregnant." As you turn away from the sad remains of this kind man, you wonder if your eyes are wet for Jack's baby who'll never see her father, or for your own baby girl whom you've never seen.

George G. Blackburn

Next of kin

July 11, 1944

My dear Mr. and Mrs. Duncan,

It is with my deepest regret that I have to write you a letter of this nature, please forgive me if I may sound brusque, but I must confess my surroundings are none too cheerful and secondly I'm not a very good writer of these types of letters, I shall have to be hard and I hope you will understand and realize the whole thing.

Your son was my Platoon Commander for a very short time and met with an accident which proved fatal. I know you will be informed through the War Office of his death, but it was his and our request that whichever met his fate or misfortune we would write to the next of kin.

It was an agreement between your son and us as a platoon so I hope you don't mind me writing to you.

Well, I might say we all feel it very bad and can't quite realize that he has left us, as the boys of the old platoon got on very well indeed with him and respected him in every way that was possible, he was and did prove to be a "Great

Guy" and was known to us as "Dunc," a little unusual maybe but he was one of us and a part of the team which had a job of work to do. I can say this with great pride, that he will always be remembered by his boys and myself, that never once did he forget his duty to us, we were first and foremost in everything that concerned him and his platoon, he was an officer, which the lads take to.

The lads and myself buried him in an orchard which we now hold, it's not a very picturesque place, we buried him in as good a grave as is permitted under these conditions. It really looked nice even tho we were at war, they turfed it and placed a pot of roses over the grave, then we secured some whitewood from a nearby village and made a cross of it, really it is the best I've seen anyone do since I've been in this battle.

You needn't worry about his burial, it was all in the very best of respect and honour to the dead. I am trying to get a photograph if possible of his burial ground, which I will forward to you without fail.

I must close now with the regret of the whole platoon and myself on your sad bereavement.

Yours,

M. Brimble

W.K.E.

It is his hands that I remember:
scholarly hands with the firm
delicacy of a musician's.
When he held a book
his fingers savoured the texture
of paper and binding.
It seemed as though he knew
by touch the mysterious
artistry of the letter
perfectly formed, the perfect
balance of a page;
and when you watched his strong
sensitive fingers you shared
the depth of his delight.

You cannot imagine hands
so spiritual and gentle
turned to the uses of war.
It is not to be wondered at
that in the first autumn
before the bitter fighting
startled the desert solitude
a random bomb killed him.

George Whalley

Missing leader

From Sergeant Brimble's letter of August 25th, 1944 to Don Duncan's brother, Jim

He was a great loss to us. The little things he did for us made him popular, little things like buying milk, eggs, etc. and not taking our money for it. So there you have it, that's the best I can do, so I hope you'll understand sir. I don't like writing about it, it brings back too many memories, you may think me soft-hearted sir, but things like that get me. All I can say is that your brother was avenged to the fullest when we got to grips with the Boche a few days later. We didn't forget Dunc; it was "Don't forget one for Dunc" and sir let me tell you there were no prisoners taken by his old platoon. We had that little satisfaction but what we wanted mostly was for Dunc to have led us. We have never had such a good officer in charge of the platoon. No red tape if you know what I mean, that's what we appreciated and liked about him. Now I must close, as things are warming up, and my slit trench is a favourite with the stuff flying around.

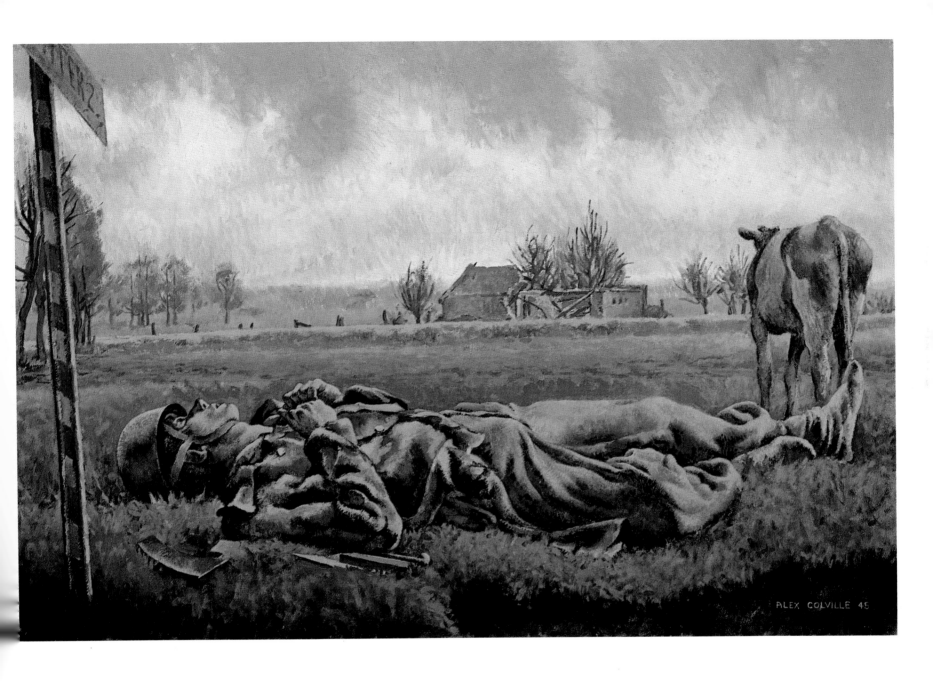

Alex Colville *Tragic Landscape* 1945 211

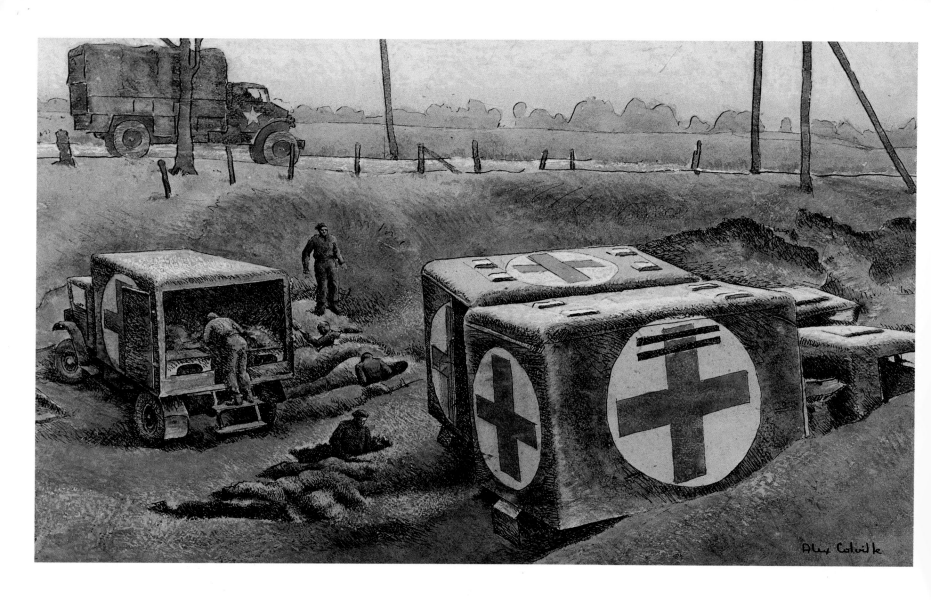

Alex Colville *Casualty Clearing Post* 1945

Sisters of mercy

Next morning the Matron was at our tents before we were up. "I have come to ask a favour," she said. "A huge convoy is coming in from the front, with hundreds of casualties. My staff cannot handle them all. Will you girls help us?" At once the nursing sisters dressed quickly, grabbed a bite of breakfast, and reported for duty.

Soon clouds of dust were seen down the road, then a long line of lorries moving slowly and carefully came into view. When the first one stopped, stretchers carrying wounded men were taken out and placed in rows on the large tarpaulin. All the boys were badly hurt and many were unconscious. Some had arms and legs almost severed. Others had already undergone emergency amputations. Yellow field dressings covered a variety of wounds. The men all wore their mud-caked bloody uniforms; all were mercifully under the influence of morphine or other drugs. The heat was stifling, smells were terrific, and millions of flies came swarming around.

Connie and I went down the long rows of stretchers with cigarettes on a tray, trying to be cheerful though it was a struggle not to burst into tears. Saying things like "Hi-ya, chum. Anything we can do for you?" sounded slightly silly and very inadequate, but the boys appeared to like it.

Cigarettes were given to all who were conscious, and lit for those who couldn't light their own. Then cups of tea were poured for all who were allowed it after medical inspection, and was it ever welcome!

"Will you take my boots off, Sister?" one boy said faintly. He was very pale, and his eyes were closed. Kneeling down by the stretcher, I struggled with the laces, and finding them hopelessly knotted, took scissors and cut through them. Even then I had to tug hard before the boots came off, as the poor lad's feet were horribly swollen. His socks were so rotten with perspiration that they practically fell off; the smell was indescribable. I washed some of the blood and dirt off his face, then wiped his feet, and a blissful smile appeared. "Thanks, Sister, that feels wonderful," he said slowly, still not opening his eyes. "I haven't had my boots off . . . for two weeks now." After that I removed many more pairs of boots; the expression on the men's faces was touching. Even those who were unconscious would wriggle their toes in relief.

I was assigned a row of twenty-five beds and told to remove the patients' clothing, bathe them, and have them ready for further examination by the M.O. Parts of uniforms had to be cut off, and I was so afraid of hurting the men that my fingers were all thumbs and I shook like a leaf at times. Many of the patients were delirious and kept calling out "Mother" or some name all day long. It required constant effort to hold them down and keep their hands tied to the sides of the bed so they would not tear off their head bandages. At mealtimes many had to be fed, as they were blind (mostly temporarily, from head wounds), had lost a hand, or were so badly wounded that they were helpless.

New arrivals were undressed and put into pyjamas. One lad was so completely rigid that I had to have an orderly help get his clothes off, as I couldn't move him. He spoke with difficulty, his eyes stared straight ahead and his neck was stiff. The Nursing Sister said to give him five sulfa pills. When I said, "Open your mouth, son," he asked, "Will they make me sleep, Sister? I haven't closed my eyes for four days." I knew perfectly well that sulfa was given to ward off infection, but I said, "Swallow them, laddie. You'll relax and sleep afterwards." He opened his mouth like a wee bird and took all five one after the other, while I stroked his head.

He did relax, and finally slept, probably because he knew he was not alone. Fear is a terrible thing when one is alone but it fades to some extent with company, as many of us found during that summer of 1944.

Other jobs assigned to us were washing out the eyes of boys who had been burned in tanks, moving cast-bound legs into a more comfortable position, adjusting pillows, shooing away flies, and just talking. The last was by no means least. It seemed to be a help to have a woman there fussing over them as their wives, mothers or sweethearts would have done if they could.

Jean Ellis

The Road to Nijmegen

December my dear on the road to Nijmegen
between the stones and the bitten sky
was your face

Not yours at first
but only the countenance of lank canals
and gathered stares
(too rapt to note my passing)
of graves with frosted billy-tins for epitaphs
bones of tanks beside the stoven bridges

and old men in the mist
hacking the last chips
from a boulevard of stumps

These for miles and the fangs of homes
where women wheeled in the wind
on the tireless rims of their cycles
like tattered sailboats
tossing over the cobbles

and the children
groping in gravel for knobs of coal
or clustered like wintered flies
at the back of messhuts
their legs standing like dead stems out of their clogs

Numbed on the long road to mangled Nijmegen
I thought that only the living of others assures us
the gentle and true we remember as trees walking
Their arms reach down from the light of kindness
into this Lazarus tomb

So peering through sleet as we neared Nijmegen
I glimpsed the rainbow arch of your eyes
Over the clank of the jeep
your quick grave laughter
outrising at last the rockets

brought me what spells I repeat
as I travel this road
that arrives at no future
and what creed I can bring
to our daily crimes
to this guilt
in the griefs of the old
and the graves of the young

Earle Birney

Interlude

A deep silence lies over the whole front, broken only now and then by a creaking in the ancient wooden shaft of the mill as a gust of frigid wind tries to move the giant, skeleton vanes hanging outside. Your signaller tries to write a letter, but he seems to spend more time blowing on his fingers to keep them from freezing.

Below the window on the snow-covered fields, sloping down into the valley and the German border, lie dozens of broken gliders. In front of the gaping mouth of one is an abandoned jeep, and in another can be seen the bowed, helmeted heads of American soldiers machine-gunned as the glider landed four months ago.

Across the silent, white valley, dotted here and there with lifeless farmhouses, the dark, evergreen mass of the Reichwald ridge frowns down, mysterious and formidable — reputed to be so dense and easily fortified that it forms the lower bastion of the Siegfried Line. Although battalions of Germans lie in wait out there, and you are certain every farmhouse cellar shelters some of them, days go by without spotting a sign of life though you sweep the valley with your field glasses from dawn to dusk.

For about four out of every five days mist and fog reduce visibility to a couple of hundred yards. Today is a rare day — sunny and bright, and even colder than usual. They report from the guns that the ammunition thermometers register a low of five degrees fahrenheit.

In all the weeks you've taken your turn in Observation

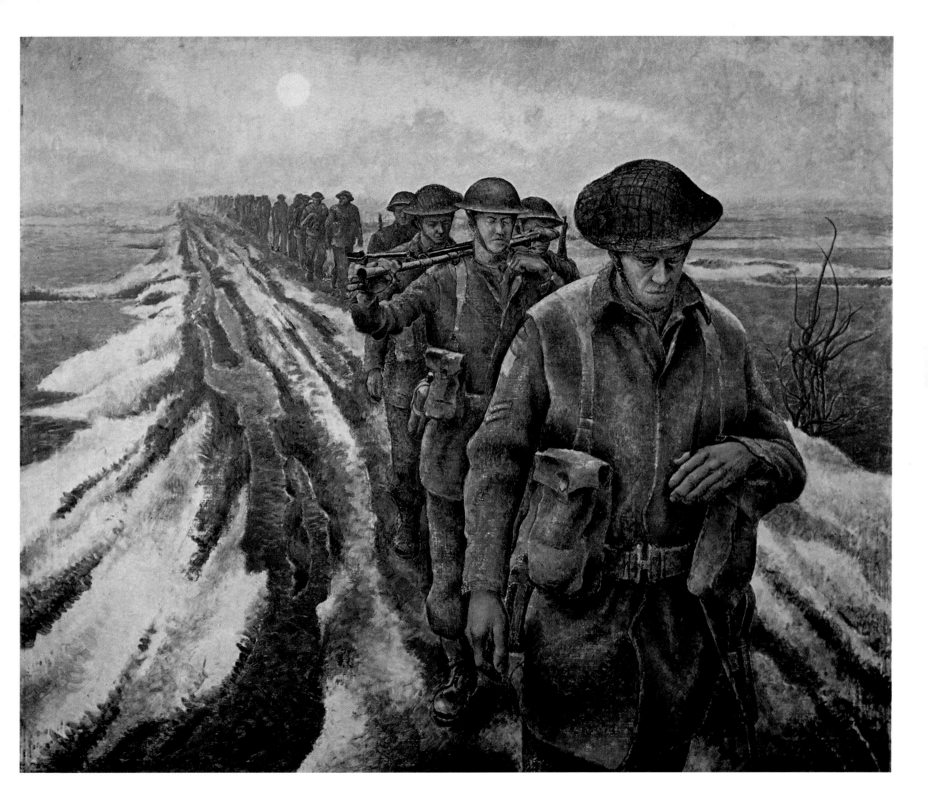

Alex Colville *Infantry, near Nijmegen, Holland* 1946 215

Posts along the Rhine and this ridge, the only movements you've seen have been some wisps of smoke from a couple of chimneys, a German Shepherd dog trotting between a house and a barn, and one distant German soldier running at full tilt a crazy pattern through the snow-covered open fields in the valley, disappearing and reappearing, for more than half an hour, never once approaching one of the farm buildings or giving a clue to his mad venture.

Like the Germans, our infantry lie concealed all day in cramped, straw-floored slit trenches, or if they're lucky in dugouts or farmhouses, waiting patiently for hot food and drink to be brought up after dark.

But in spite of the discomforts and long periods of boredom interspersed with brief periods of fear, there seems to be no limit to the ingenuity of men trying to make the best of what's available. Where conditions allow — such as back at the gun positions — dugouts have been made unbelievably comfortable with improvised stoves, bunks and, in the case of at least one gun battery, electric light tied into the local power line.

Soldiers will work on a project for days even if it's only trying to lure the sole surviving cow from a slope in full view of the enemy into a barn where she can be safely butchered. They manufacture gasoline stoves which could compete with flame throwers — requiring the boiling of gasoline in a closed Jerry tin and allowing the fumes to shoot out a nail hole into a loosely arranged brick oven. When the fumes are ignited, the roaring flames compete with the German jets that periodically try to bomb the Nijmegen Bridge. Others spend hours modifying their dress to conform to current fads. For instance it's currently fashionable among the gunners to cut the arms out of great coats and sew them into leather jerkins, ever since the German camouflaged parkas picked up in Antwerp were taken away from them along with the German vehicles and Schmeizers they'd acquired along the way. (The reason given by the Brass was that you couldn't tell a Canadian from a German without a program, particularly at night when they were both using burp guns.)

George G. Blackburn

Flashback

December 12, 1944

Back again in trenches, the December rain and hail, one day clear in four, two hours of windy sunshine per week, mud literally to the ankles. On some days, we lie in the mud, and the warmth of our bodies keeps it soft, while the wind thickens it or freezes it where we are not lying. I keep telling myself my father's generation of soldiers did this for four years and that I have it easy. In the daytime we can't move about, as we are in full view of the Germans. We sit and wait for the end of our battalion tour of duty out here, keeping an eye on the enemy's rather careless movements, report them, and watch with a sort of spectator disengagement the results of our mortar and shell fire.

We eat twice a day, morning and night. Food is brought down a twisting, slippery path, mined along the fringes, under cover of darkness and between scattered bursts of enemy fire, for they know our prandial habits. Then we pass it out from dugout to dugout, so much to this, so much to that, an extra portion to those who were out on patrol last night. We try to keep the rain out of the bread, and the dirt from the trench tunnels out of the mess tins, as they are passed back and forth in the slow rain, with sometimes grunts of gratitude, sometimes cursing, with ponderous oaths when the food is poor, dirty, cold or scanty. But, miraculously, the men are O.K. What is called their "morale" is, in fact, really quite high. They take the difficulties of our position very well, all are faithful to their duties and maintain a sharp watch; I make them keep their weapons meticulously clean. Anybody would have his hands full who tried to come through this position. Paradoxically, the worse the weather, the hotter our tempers. We blame everything on the Germans—muddy food, wet and soggy feet, numb fingers fumbling with rifle parts and oil, ditch-crawling with empty food-containers that are being returned to the company office.

Donald Pearce

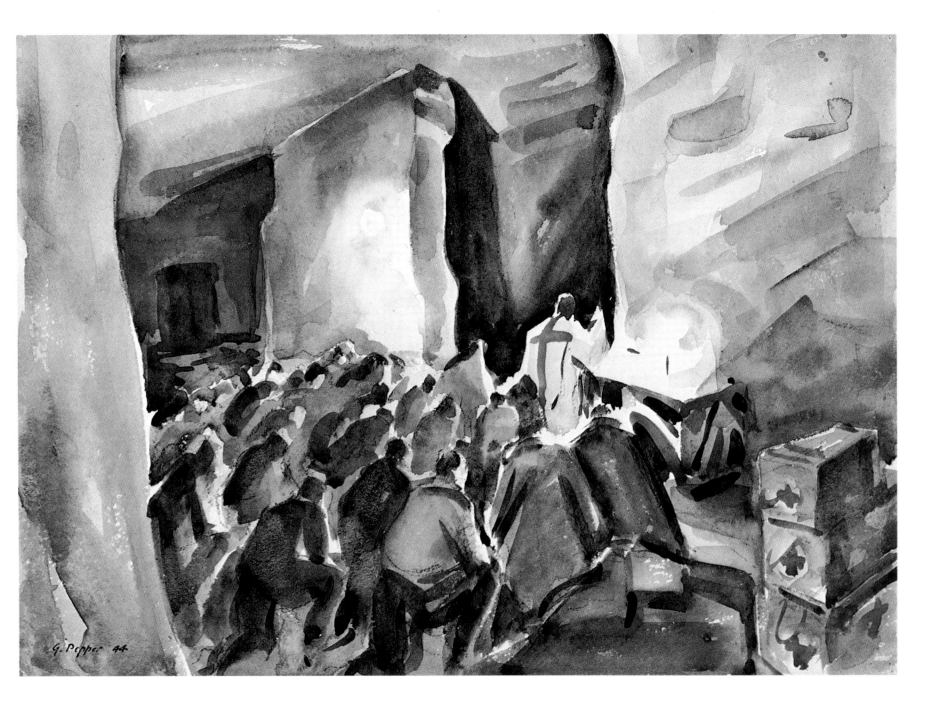

George Pepper *Mass in the Fleury Caves* 1944 217

Numb

For more than two hours that afternoon he'd run, crouched and crawled behind the furious, flashing geysers and drifting smoke of a roaring twenty-five-pounder barrage, across muddy fields ploughed by enemy mortars and shells, while overhead the grey sky was torn by cracking, black puffs of airbursting 88s. Although he'd been among hundreds moving forward — vaguely conscious of long, irregular lines of men extended to his right and left — he, like every man in the attack, had felt alone, naked and vulnerable. And somewhere back there among those brain-numbing, raging explosions and sights of buddies falling, something inside him snapped. When his company reached the farmbuildings that were the day's objective, he crawled into a dark corner of the cowstable and sat down on the concrete floor in a puddle of icy water. Now he stares at you with sightless eyes, completely still and unmoving except for the occasional quiver of one hobnailed, muddy boot. When you ask the major why something isn't being done for him, he tells you the drill is to leave cases like this alone for a few hours. If it's not really authentic battle exhaustion, he'll eventually get up and move around.

It's growing dark and soon everybody becomes preoccupied with enemy counter-attacks. It's getting on towards dawn before the situation is stabilized to the point where anyone can relax. Only then does someone remember the boy sitting in the puddle out in the cold, dark cowstable.

They carry him down the cellar steps, still rigid in a sitting position, and put him down on a pile of potatoes. They talk to him encouragingly and try to feed him hot tea, but he doesn't respond in any way. They light a cigarette and shove it into his mouth, but they have to remove it for he makes no effort to puff it. Finally they decide to let him rest until he can be evacuated in the morning. When they try to lay him down, they have to force his torso backwards while holding his legs down. They cover him up with a blanket, but his sad eyes remain wide open, staring up at the ceiling the rest of the night, locked on some secret horror.

George G. Blackburn

By a thread

They began to shell the corner in earnest. They kept it up all afternoon, all evening, all night, all next morning, right up to noon. They hit the crossroads several times before evening, and dropped a large shell smack in the middle of the barn across the road. Every three minutes they sent a real big one over. It growled and groaned for several seconds before it struck.

Smaller shells, fired from a much closer range, and probably over open sights, began to burst all around us, four, five, and six at a time. Sergeant Noonan sat in a chair in the middle of the room and casually read a newspaper. I sat on the floor and tried to discuss the war with a forced easiness. A few hid under mattresses. One man lay down and slept, apparently quite unconcerned. Someone found a gramophone and began playing it as loudly as possible, Dutch dance music, something about "I'll make an expedition to the North Pole ice," the rest I couldn't translate. But I will never forget the tune as long as I live. The music served to cover up the sound of the approaching shells so that all we heard was their explosion just outside. Superficially this seemed a good idea; but I finally hated it, and tried all the harder to hear the thin whine and whistle of the arriving shells underneath the music. Most of the time my mouth was absolutely dry, my hands wet, my stomach in a tight lump. I was angry, too, angry at the whole situation, not at anybody. It was clear that at any moment we could be blown up. Each shell seemed coming directly into the room. Conversation had entirely ceased. But my anger was much stronger than my fear. I felt with needle-keenness that my life was hanging by a thread, and depended on nothing more than the accuracy of some stupid grinning boy behind a field gun; that my life made no more sense than the sewing machine in the other corner, or the tea kettle on the stove; that I was completely reduced to impotence or, worse still, to insignificance, and that there was no special virtue about me which in any way made me more likely to survive this target than anybody else, than anything else, in fact. I cursed and hated the complete idiocy of

it all. I sank so low that I began wondering which chair or place in the room would be the safest to be sitting in.

But it was less fear than disgust that really filled me; for I did not have the slightest inclination to hide under mattresses or quilts as some were doing. I did not hate the Germans, but execrated the war as a whole. Some of the boys prayed silently. There is a saying, subscribed to by the toughest men in the army, that there are no atheists in the front lines, that everybody prays under shell fire. There was one atheist in that room, and it was I. I could not have forced myself, had I wanted to, to prayer. I watched others praying and felt sorry for them, for I knew they had lost their reason, or had never had any. The idea of God disgusted me as much as the war, and I felt that only a weak-minded person could drag theology into this stark and meaningless room. So, instead of taking God's name into my heart, I took it in vain again and again, silently, though others may have thought me praying. Next day the shelling lifted—our flanking troops forced the Germans to retire—and we moved on to a new area.

Donald Pearce

Dead young Germans

They lie sprawled here and there between the barn and the house. Your shells had caught them in the open as they were trying to get at you and the Royals crouching behind the crest of the dike. Most of them lie as they fell, but some are squirming and dying in agony, ignored by the Royals' stretcher-bearers who are fully occupied attending their own wounded. You are overcome with inexpressible horror.

Until now you have never had occasion to pause on the ground immediately afterwards, and walk among men dead and dying from the high explosives and flying steel you had called down on them. Over the past four months you'd fired tons of shells on suspected enemy positions, but if you saw any movement at all, it was as though you were watching a movie playing in your field glasses of shells bursting among little distant figures running for cover.

Once in front of Dunkirk you'd caught eighty or more of them in the open, attacking a company of the Royals trapped between a canal and flooded land. Many fell and disappeared in the flashing, black puffs of your shells. You'd watched with a sense of pleasure and satisfaction, mumbling to yourself a grim litany — "That's for big, always-smiling Jack Cameron who, while he was your roommate in England, wrote every night to his wife with whom he'd shared only a two-day honeymoon before leaving for overseas; and that's for Grace's gentle Uncle George who died on duty as an air raid warden in Birmingham; and that's for . . . "

But now, staring down at the young German whose boots have just stopped twitching, you feel confused as you fight down a flood of compassion that threatens to overwhelm you. You tell yourself that had he got the chance to use that Schmeiser lying beside him, you might well now be lying dead here instead of him. But logic doesn't work, and then you know you'll never be quite the same again. Time and again in the months ahead you'll shell them with hate in your heart, but never, never again, with the simple, straightforward satisfaction and enthusiasm of that young forward observation officer in front of Dunkirk.

As you gain control of your emotions, you notice the dead man's jack boots are almost new, and you wish you had a pair like them so you could pull them off at night and dry your feet. And when a counter-attack came in, you could pull them on again without having to lace them up. As though reading your mind, a rough voice behind you says—"Nice boots eh! Why don't you take them?" Receiving no reply, and undoubtedly sensing your queasiness, the sergeant reaches down, yanks off the boots and hands them to you. You mumble, "Uh . . . thanks," and, gingerly holding them by your fingertips, dump them into your Bren Gun Carrier that has just arrived, grateful to be rid of them, for the warmth of the dead man's feet still breathes up from within the leather. But a couple of days later when they are cold, you will cut them down into Wellingtons and wear them with great comfort.

George G. Blackburn

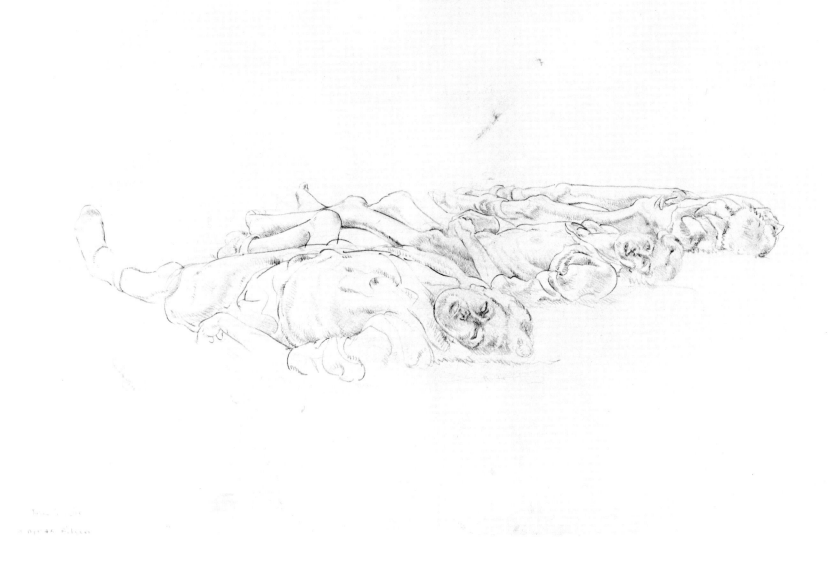

220 Alex Colville *Dead Women, Belsen* 1945

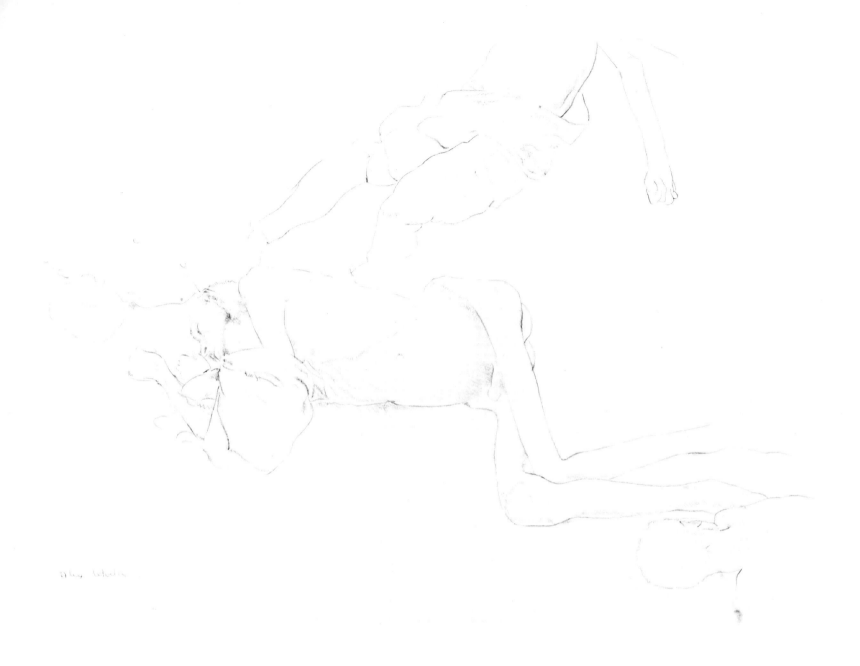

Alex Colville *Bodies in a Grave* 1945

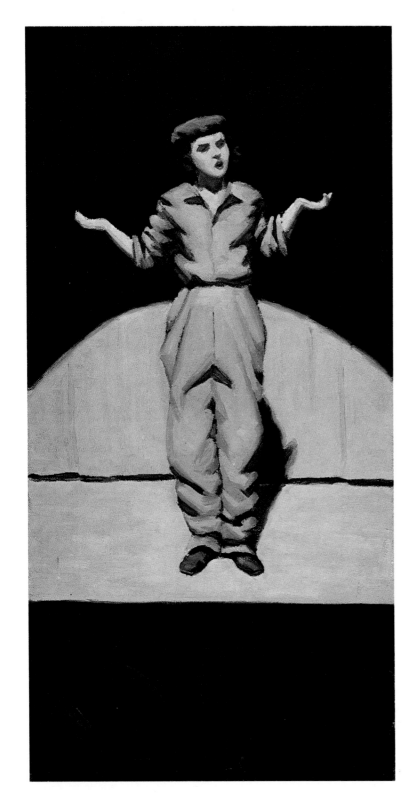

222　　T. R. MacDonald *You'll Get Used to It*

A common terror

When will it all end? The idiocy and the tension, the dying of young men, the destruction of homes, of cities, starvation, exhaustion, disease, children parentless and lost, cages full of shivering, staring prisoners, long lines of hopeless civilians plodding through mud, the endless pounding of the battle line. I can scarcely remember what it is like to be where explosions are not going off around me, some hostile, some friendly, all horrible; and exploding shell is a terrible sound. What keeps this war going, now that its end is so clear? What do the Germans think of us, and we of them? I do not think we think of them at all, or much. Do they think of us? I can think of their weapons, their shells, their machine guns, but not of the men behind them. I do not feel as if I were fighting against men, but against machines. I need to go up in an airplane and actually see German transport hauling guns and ammunition, see their actual armies; for everything that happens merely comes from a vague beyond, and I cannot visualize the people who are fighting against me. The prisoners that come over hills with their hands up, or who come out of houses with white cloths waving — they have no relation, almost, to anything for me. I can't connect them with the guns they have just laid down, it seems like forcing something to do so. It is becoming hard for me not to feel sometimes that both sides are the common victims of a common terror, that everybody's guns are against everybody ultimately.

There are times when I feel that every bit of fighting is defensive. Self-defence. If a machine gun nest is attacked and wiped out by us, by my own platoon, I do not feel very aggressive, as if I had attacked somebody. It is always that I have defended myself against something that was attacking me. And how often I have thought that there might be a Rilke out there in a German pillbox. If I could only see them, as in battles long ago, at close range, before engaging them. In our wars, the warring sides are getting farther and farther apart and war is getting more and more meaningless for the field warriors, and more meaningful for the domestic warriors in factories and homes. Will there come a time when hundreds of miles separate the warring fronts? When long-range weapons and the ghastly impersonality of air attacks are the means of war? It is already a very impersonal thing. When a soldier is killed or wounded his buddies, shaking their heads, merely say, "Poor old Joe. He got it. Just as he was going up that hill, he got it." As if to imply that he was merely in the wrong place at the wrong time, and that life and death are only matters of luck and do not depend on the calculations of human beings at the other end of a self-propelled gun. When we were in our static positions around Wyler Meer and Nijmegen, the enemy became real to me for the first time. I watched him for weeks, saw him dig, run, hide, fire, walk. And when I went on patrols into his territory, there was meaning in that, too, for I knew where he was, I knew his habits. So that while we were probing the cuticle of the enemy, so to speak, he was real; but now when we are ripping into his body, he has disappeared and has turned into something read about in the papers. But the guns remain, manned by soldiers who are so meaningless to us that when they shoot a fellow, all we can say is, "He got it."

Once I used to get quite a thrill out of seeing a city destroyed and left an ash-heap from end to end. It gave me a vicarious sense of power. I felt the romantic and histrionic emotion produced by seeing "retribution" done; and an aesthetic emotion produced by beholding ruins; and the childish emotion that comes from destroying man-made things. But it is not that way any more. All I experience is revulsion every time a fresh city is taken on. I am no longer capable of thinking that the systematic destruction of a city is a wonderful or even a difficult thing, though some seem to think it even a heroic thing. Well, how is it done? Dozens upon dozens of gun crews stationed some two or three miles away from the city simply place shell after shell into hundreds of guns and fire away for a few hours — the simplest and most elementary physical and mental work — and then presently the firing stops, the city has been demolished, has become an ash-heap, and great praise is bestowed on the army for the capture of a new city.

It is all so abysmally foolish, so lunatic. It has not the dramatic elements of mere barbarism about it; it is straight scientific debauchery. A destroyed city is a terrible sight. How can anyone record it? — the million smashed things, the absolutely innumerable tiny tragedies, the crushed life works, the jagged homes, army tanks parked in living-rooms — who could tell of these things I don't know; they are too numerous to mention, too awful in their meanings. Perhaps everyone should be required to spend a couple of hours examining a single smashed home, looking at the fragmentation of every little thing, especially the tiniest things, from kitchen to attic, if he could find an attic; be required, in fact, to list the ruined contents of just one home; something would be served, a little sobriety perhaps honoured.

It is disgusting (that it should be necessary, is what galls me to the bones) that a towering cathedral, built by ages of care and effort, a sweet labour of centuries, should be shot down by laughing artillerymen, mere boys, because some-body with a machine gun is hiding in a belfry tower. When I see such a building, damaged perhaps beyond repair after one of these "operations," I know only disgust. The matter of sides in this war temporarily becomes irrelevant, espe-cially if someone at my elbow says, like a conquering hero: "Well, we sure did a job on the old church, eh?"

A job has been done on Europe, on the world, and the resulting trauma will be generations long in its effects. It is not just the shock of widespread destruction, of whole cities destroyed, nor the shock which the defeated and the homeless must have suffered, that I am thinking of: it is even more the conqueror's trauma, the habit of violence, the explosion of values, the distortion of relations, the ascending significance of the purely material, the sense of power, and the pride of strength. These things will afflict the victors as profoundly and for quite as long a time as the other things will afflict the victims; and of the two I am not sure that a crass superiority complex is the more desirable. Perhaps I underestimate our ability to return to normal again.

Donald Pearce

Germany, May 5, 1945

Official V-E Day came two nights after our arrival. Feelings were mixed. All messes held celebrations with a rum ration handout and there was much noise and gaiety, but also an undercurrent of sadness. Here and there unsmiling faces were in sharp contrast to the prevailing merriment. Mine was one of them. I sat alone in my bedroom looking down on the crowd, wondering whether any lessons had been learned or any lasting good accomplished. Victory would not bring back my husband or thousands of other men who had given their lives. Victory would not restore sight to the blind or health to shattered bodies. Victory would not wipe out the memory of horrors from children's minds. But at least the world would have a chance to recover sanity; if people worked as hard for peace as they had for war, some good might be accomplished . . .

The sound of singing interrupted my dark thoughts. Across the road was a British unit, and to accordion accom-paniment, a hundred and twenty English lads were singing like inspired choirboys. A nursing sister joined me at the window and we listened, entranced. But that accordion was so inadequate! "Do you suppose they'd like one of our pianos?" I asked. There were two downstairs in the lounge. At once we sought out the mess president, who agreed we ought to share, calling out to the boys, "If you'd like a piano, come over here and get it!"

In two minutes about twenty of them rushed across the street, literally carried a piano outside, then placed it in the middle of the road. One of their officers sat down, ran his fingers over the keys, and drew out lovely melodies dear to everybody. The boys gathered around, many from our mess joined them and for hours, far into the night, the whole group stood around that piano and sang. Most of the selections were old favourites—"In the Gloaming," "Drink to Me Only With Thine Eyes," "Annie Laurie," "Rule Brit-annia," "Maple Leaf," "White Christmas" — songs con-nected with home and happy days. One boy had a lovely high tenor voice, and sang descants with exquisite effect.

Darkness fell, but a huge bonfire was started a few yards

down the road and by its light the concert went on. As time passed the flames were fed with old carts, fenceposts, wheelbarrows, anything portable—probably the citizens of Leer were very angry, but what right had any German to protest a little innocent destruction? Afterwards many wild tales went the rounds about V-E Day celebrations in different parts of the world, particularly in cities far removed from the firing line. How true they were I don't know, but I can testify that these boys, all with combat experience, celebrated victory in simple homey fashion. Their joy and relief could not have been greater, but expressing it in music satisfied them. Perhaps, too, the bonfire symbolized for them the lights of home which they hoped soon to see again—and any light was thrilling after years of blackouts. Civilians thousands of miles away may have got drunk, but these lads were content to stand in the middle of a road in a German village, singing around an old piano. Villagers stood in doorways and on the streets, mutely watching.

Jean Ellis

London

It looked as if all the people in the world were gathered in the old city, because many people were wearing costumes of one kind or another for the occasion. Beer and liquor that had been saved for months were produced in unbelievable quantities and apparently nobody in the town was thirsty for two days. In block after block, people had moved their radios out onto the front lawns or sidewalks and had tuned them all to the same program, so as to completely fill the night with music. Pianos lined the streets, as many as fifty per street in some districts; and again all played the same music for street dancing. Dining room tables, practically bending with food, drink, punches, cake, jammed the sidewalks; all people, all service personnel especially, ate and drank freely and danced about them. Bonfires and burning effigies of Corporal Hitler glowed at every other corner. The people danced half-mad dances about the flames. Children squealed, women sang, men shouted. In one case, there was a giant snake dance three blocks long.

Nobody had a home and everybody's home was the property of everyone else. The King and Queen made their traditional progress to the poor areas, and the bombed sections of the city; and they moved through a solid mass of compressed flesh which extended for over a mile. Nothing could be heard above the roar; the roaring never stopped, fed by thousands of lungs and voices. It stopped once only, when Churchill appeared on a balcony; they worship him. Only a demi-god could have stopped that roaring. He did it simply by appearing. He waited a moment in the tingling silence of a thousand eyes, bowed deeply, and the roar went up again as if to separate the clouds.

Donald Pearce

I'll Never Say Goodbye Again

I'll never say goodbye again,
I'll never make you cry again,
I'll never say goodbye again
To you.

Though we're apart, you're in my heart,
Memories come back to me
Of happy hours that yesterday
We knew.

At the end of each day
In my dreams I'll drift away
To the harbour where my dreams will
Come true.

And when the clouds roll by again
With rainbows in the sky again
I'll never say goodbye again
To you.

Elmer McKnight, P.O.W., Japan

Manna from heaven

The last day we worked on the Marsuto docks was the 18th of August, 1945. That morning on our way out to work a B-29 went over at a great height dropping millions of leaflets. They looked like snowflakes fluttering down; the air currents would take a great swirl of them in one direction and then back again. They began to fall several hundred yards ahead of us. The Jap civilians were picking them up and reading them. When they saw us they began tearing them up. Our guards were running back and forth along the sides of the column to make sure we did not pick any up.

On August 23rd we got a new camp commandant. A huge sign twenty feet by thirty feet was erected on a hill behind the camp, black and orange, lettered "P.O.W." for identification by aircraft. On August 25th a flight of American planes flew over our camp, wheeled, circled, dived and rolled. We all crowded into the square and waved and yelled our heads off. That afternoon two different flights came over and dropped some toilet articles, cigarettes, chocolates, books, magazines etc. Thereafter every second or third day the B-29s began to come over and opening their bomb bays would vomit forth forty-gallon steel drums full of food supplies. Too often they broke away from the parachutes and dropped like stones and when they hit the ground they crumpled up like paper. It was maddening to see tomato juice sprayed all over the ground.

A Japanese woman 200 yards outside the camp was struck by a case of canned peaches. One of our men saw a drum dropping through the tree tops; he leaped right out of his wooden sandals and ran. When he went back to look for his sandals they were beneath the drum. Several bales crashed through the roofs of our huts. One pilot dropped a bale right through the middle of the P.O.W. sign, others dropped their loads as far away as half a mile from camp. We had to form a picket line around the outskirts of the area to keep the Japanese civilians away. Most planes flew too low and did not give the chutes a chance to open, but the ones who flew high and judged accurately provided a wonderful spectacle for us. When the chutes opened and slowly drifted down they were a beautiful sight. They were white, blue, red, orange and green. They were fascinating to watch because they brought food and food meant life.

Tom Forsyth

Lost children

Once the war was over, getting home became everybody's chief concern. During long summer evenings in the wards small groups of patients discussed their plans for rehabilitation. Some were eager and full of bright ideas. Others remained silent and sullen, because they had no desire to go home. In many cases their marriages had broken up during the war. Perhaps the wife at home had been playing around, perhaps the husband had found other interests, or they had just drifted apart during the long separation. Then there were boys sick at heart because some girl was waiting with a full hope chest, and they didn't want her any more, or wanted somebody else. Other men hated the thought of going back to dull jobs or uncongenial families.

All of us in the services were a group of lost children, I felt. So many had been five or six years away from home, leading a most unnatural existence at a time when life should be sweetest and fullest. We lived herded together. Privacy was unknown; we ate food cooked in great quantities, all tasting the same, with the same menu repeated day after day. Many of us dared not share our deepest thoughts with anyone, and feared ridicule for having any thoughts at all. Most soldiers longed to have homes and lead a natural life but this privilege was denied them, and they were different from what they would have been under other circumstances. It wasn't that they wanted to be different ... they so often thought of those at home, and prayed fervently for understanding.

Jean Ellis

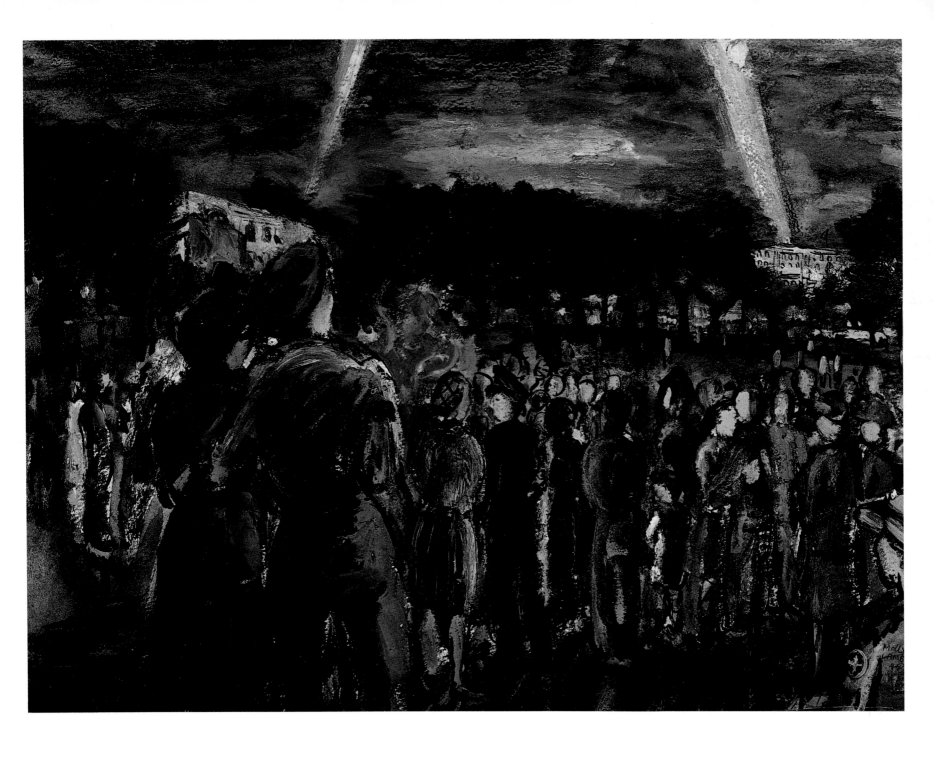

Molly Lamb Bobak *V-J Celebrations* 1945 227

Betwixt and between

There was an unreal, aimless quality to those first few days. Free of censorship and those personal restraints that you had imposed on your letter writing when you thought you might not live to get a reply, you could now write long letters home and say exactly what was in your heart. And every time you got a chance to be alone, you studied snapshots and tried in vain to recall the sound of her voice. The dream of going home would now actually come true. The thought was intoxicating. But try as you would, it was impossible to completely suppress the feeling that this was only a temporary pause before another push, or at least another training scheme — there'd always been another.

Everyone was tired, emotionally drained, and with almost unlimited opportunity for sleep, many found it difficult to drop off in the disconcerting stillness. While others who hadn't been conscious of having dreamt in months started having dreams and nightmares.

George G. Blackburn

Home voyage

Seven thousand of us were sailing for Halifax — servicemen, servicewomen, and a few dependents. In my stateroom, built to accommodate four comfortably, twenty-three girls occupied double-decker bunks. In the adjoining room were twenty-five girls, a six-week-old baby, and a small black spaniel smuggled aboard by a W.R.N.S. character. Between the two staterooms, and "accommodating" the forty-eight girls, the baby and the dog, were four biffies and four tiny wash-basins. Just to make everything completely jolly, five of the girls in my dormitory were pregnant and addicted to "morning sickness."

We sailed at dawn to the stirring strains of "Maple Leaf Forever" and "O Canada" played by an army band.

On board life became a series of orders and directions.

Day and night the public address system belched forth instructions. The old goat at the microphone was continually calling for someone to report to so-and-so or such-and-such. If at any time during the trip you were fortunate enough to become part of an interesting conversation, the P.A. system was bound to interrupt you by calling off a horrible list of names, the owners of which must do this and that. Of course, everybody stopped talking to listen for his or her own name. On, on it went. When the announcer ran out of names, he read off a list of lost articles which must be returned to the Orderly Room without delay. Everything, in fact, must be done without delay. Get up without delay. Wash without delay (because water was turned off between 8:00 a.m. and 4:00 p.m.). Queue for meals without delay. Queue for a seat in the Officers' Lounge without delay. Clear the decks without delay. Before long the phrase ran through everyone's mind like the rhythm of train wheels over ties — "de-da, de-da." Then there were the military police. Their word was law. You mustn't go down this corridor in *that* direction. You mustn't leave your stateroom at any time during the trip unless you lugged along that ghastly life preserver.

Two meals per person per day were served. Each meal had four sittings and your card indicated which one had been allotted you. Mine was the fourth sitting, which meant breakfast at 9:00 a.m. and the evening meal at 6:00 p.m. As the water was turned off at 8:00 a.m. and the washroom queue formed hours before that, it was good technique to scramble out about 5:30 a.m., and when well washed and drained, crawl back into bed until the P.A. bellowed "Attention please! All passengers holding Fourth Sitting cards will now queue for breakfast without delay!" By that time you had completely lost interest in breakfast.

If you did summon enough strength to join the Dining Saloon queue, however, the room presented a very refreshing appearance when you finally reached it. White cloths and shining silver graced the tables; the French waiters wore white jackets; delicious food was served in large quantities. But at evening meals, the soup was likely to be your undoing. After you had staggered down the steps to

the Dining Saloon, deposited your life preserver on the back of your chair, and faintly smiled a "Good evening" to your table companions, along came that soup and ruined everything by swaying dizzily from side to side in its great plate. Then you just quietly excused yourself and made for the stairs in a cautious but hasty manner, praying that you'd reach the deck in time.

The entire deck was a confusion of bodies—some sprawling, some leaning against funnels, some just leaning against other bodies. Here one could breathe, however, and for two days out of the five there was sunshine. You acquired a bit of sunburn and looked healthy, while all the time your insides were a complete vacuum. About noon each day the foresighted furtively withdrew a large, well-buttered bun from their pockets and proceeded to munch on it. However, if you hadn't stayed in the Dining Saloon long enough to stow away a bun, you went hungry.

Entertainment on the trip was provided entirely by the various queues. When you saw three or four passengers in a group suggesting single file, you joined them. Suddenly a few more came up. Before long the line wound out of one room and down a long corridor and the fun was on. From the end of the line came a question "What's this queue for?" Nobody knew. It was a queue and it must have some object, or—horrible thought—had that first group merely been chatting? We had become a group of professional pan-handlers ready for any handout! Oh, thank goodness, it really is a genuine queue . . . the door of a wicket is finally open . . . but not even the old hands know whether it will be cigarettes, chocolate bars, gum or Coca-Cola that will be offered for sale. One morning a very British officer was ahead of me in such a queue and after slowly moving forward place by place for over an hour, on reaching the wicket he was handed a bottle of Coca-Cola. I can still hear him screaming, "But I don't *like* Coca-Cola! I thought this was a cigarette queue!"

After five days, tension increased. We were nearing Halifax. Aircraft circled over our heads, bidding us welcome. Seagulls came out to meet us. At last land was sighted, and everybody scrambled to the top of the highest point available. Cheers went up, binoculars were passed from hand to hand, and landmarks were pointed out.

Closer and closer we sailed. Canada *was* our own, our native land . . . never had the words meant so much. Necks were craned to catch a first glimpse of Halifax. Tears flowed down many cheeks, while other faces wore a grim, set expression which defied onlookers to detect any sign of emotion. Suddenly Halifax harbour fireboats appeared, shooting off huge sprays of water as a welcome to the thousands of Canadian boys and girls who had risked their lives and futures for their country's safety. The band on the docks started up, and "O Canada" sounded sweeter than ever before. The big ship nosed into the harbour, her passengers seething with expectancy.

At last we came down the gangplank . . . rushed away from the dock . . . and were stopped short by a huge sign. Before our startled eyes, like a welcoming smile, was the all-too-familiar Canadian Army road sign, enlarged, its wording slightly altered. Now it read

MAPLE LEAF — HOME!

Jean Ellis

229

Introduction to the Catalogue

Catalogue entries are arranged alphabetically by artist's surname. If several works by an artist are listed, these generally appear in chronological order.

Only the basic cataloguing documentation is included here; information as to provenance, exhibitions, literature, as well as artists' biographies must await future publication.

Measurements are in centimetres, height preceding width. With prints, if no impression mark is noted, the recorded measurement pertains to paper size. When the format for drawings or water colours has been designated by the artist as other than paper size, this is termed "image." Inscriptions are given if believed to be in the artist's own hand and when descriptive of the subject portrayed. The usual abbreviations are used for location of inscription: upper right (u.r.), lower right (l.r.), upper left (u.l.) and lower left (l.l.). Where no medium is stated in conjunction with inscription colour, it should be assumed to be the same as that of the work itself. General remarks discussing title and subject may be found towards the end of each entry. Other data as to embossed marks or watermarks appear where relevant.

The works in the exhibition have been drawn from the Canadian War Museum, except for those by David Milne, which were retained by The National Gallery of Canada in 1971. Accession numbers are therefore those of the War Museum permanent collection.

There are two additions to the exhibition which should be mentioned here. *Willie the Wolf* is a panel cut from a Halifax bomber originally assigned to No. 426 Squadron (Thunderbolt) in July 1944. It did not carry out operations with this squadron, but was transferred to No. 408 Squadron (Goose) in August 1944 where it completed 58 operations. *Ville de Quebec* is a panel cut from a Halifax VII four-engined bomber that completed 53 operational sorties with Nos. 427 (Lion), 429 (Bison) and 425 (Alouette) Squadrons between September 1944 and April 1945.

Jennifer C. Watson

Catalogue

Eric ALDWINCKLE (1909-)

1. *Air Battle*, 1944
Water colour and black ink on paper, 28.8 x 35.1 cm
Signed (l.r., in black ink): Eric Aldwinckle
VERSO (u.l., in black ink): "Air battle" Water Colour 14 x 11 Normandy August 1944/B9 Recce Wing/F/l E. Aldwinckle/Flaming aircraft and vapour trails/and Flack burst
Remarks: Beginnings of another blue water colour verso
10627

2. *Invasion Pattern, Normandy*, 1945
Oil on canvas, 85.3 x 85.5 cm
Signed and dated (l.r., in red): Aldwinckle 1945
Remarks (label from verso since removed): "Invasion Pattern" Oil, 30" x 40" (sic)/ Normandy, July 44/sketches-/Canvas finished RCAF/O/S H.Q. London Feb 45. Impression of the landing beaches at Grey-sur-mer [Should be Graye-sur-Mer], Normandy, Mustang A/C with D-Day pattern. This pattern of 3 white and 2 black stripes was painted on all allied aircraft to avoid confusion. Below are ships L.T.S. (sic)/ Disgorging transport/F/L E. Aldwinckle [War Museum card]
10679

3. *Sunderland Buoying up in the Rain at Slipway*
Water colour and pencil on paper, 27.4 x 35.2 cm
Signed (l.r., in black ink): Eric Aldwinckle/ FO
VERSO (copied from backing since destroyed): SUNDERLAND BUOYING UP IN RAIN AT SLIPWAY/422 SQUADRON-LOUGH ERNE June 1
10732

Donald ANDERSON (1920-)

4. *Officer's Quarters Aboard Troopship*, 1944
Brown ink, umber water colour and pencil on paper, 37.5 x 50.3 cm
Signed and dated (l.r., in brown ink): Donald —/Anderson 7/44
VERSO (u.r., in pencil): Officer's quarters aboard troop ship./20¼" x 15"/brown ink &

umber water-colour/R.C.A.F. O/S H.Q, London/21 Aug. 44
10807

5. *Dispatch Rider*, 1944
Water colour, ink and pencil on paper, laid down on board, 37.8 x 55.7 cm
Inscribed, dated and signed (u.r., in brown ink): Dispatch Rider/Nov. 3/44 England/ Donald—/Anderson
VERSO (u. centre, in pencil): <u>Title</u>. "Dispatch Rider"/<u>Description</u> Lac. Dalton. W. of Ottawa is a/dispatch rider attached to Station/H.Q. Croft, Yorkshire. He carries official/mail documents, and operational films./<u>Medium</u> water-colour/<u>Size</u> 15½" x 22¾"/<u>Date</u> Nov. 3/44. R.C.A.F. Station Croft./field sketch
10768

Caven ATKINS (1907-)

6. *Arc Welders by Night*, 1942
Water colour, black ink and pencil on paper, 28.1 x 39.5 cm
Signed and dated (l.r., in black ink): ATKINS 42
VERSO (u.l., in pencil): "ARC WELDERS BY NIGHT" No 1/CAVEN ATKINS/AUGUST 19th 1942/982 OSSINGTON AVE/ TORONTO ONT.
14039

7. *Untitled (Forging)*, 1942
Water colour and pencil on paper, 58.3 x 79.8 cm
Signed and dated (l.l., in water colour): ATKINS 42
14057

Cyril BARRAUD (1877-)

8. *Entering Ypres at Dawn*
Etching with surface tone, Imp: 25.6 x 40.4 cm; Paper: 32.5 x 51.1
Signed (l.r., in pencil): Cyril H Barraud/
Remarks: The bridge over the canal on the road to Ypres from Elverdinge (Belgium), October 1917.
8039

Aba BAYEFSKY (1923-)

9. *Troops Being Flown to France*, 1945
Charcoal and black ink on paper, laid down on board, 34.2 x 48.7 cm
Signed and dated (l.l., in black ink):

ABayefsky/45
VERSO (on mount, u. centre, in blue ink): Troops being flown to France in RCAF Dakota/13½" x 19½"/charcoal & ink/#437 Squadron Blakehill Farm/sketch made March 45/completed at RCAF O/S H.Q. April 45
10883

Harold BEAMENT (1898-)

10. *Burial at Sea*
Pastel and pencil on green paper, 24.7 x 32.8 cm
Signed (l.l., in red pastel): Harold Beament
10006

J.W. BEATTY (1869-1941)

11. *Alblain Saint-Nazaire*
Oil on canvas, 182.7 x 214.6 cm
Signed (l.l., in sepia): J.W. BEATTY
Remarks: Saint-Nazaire, town, western France, seaport at mouth of Loire River. Harbour enlarged and modernized in First World War to receive British and American expeditionary forces. 1st Division landed at Saint-Nazaire (1915).
8102

Bruno BOBAK (1923-)

12. *Carrier Convoy After Dark*, 1944
Water colour, ink and pencil on paper, 39.7 x 56.6 cm
Signed (l.r., in pencil): BOBAK
VERSO (u. centre, in pencil): Fri July — 14 — 1944/Carrier Convoy after dark./Canadian Fusiliers./13 Cdn Inf. Bde./Leyburn — York, Eng.
11912

Molly Lamb BOBAK (1922-)

13. *CWAC Wedding in the Seminary's Chapel*, 1945
Conté and pencil on paper, 30.5 x 45.8 cm.
Inscribed (l.r., in red; twice): 38.
VERSO (l.r., in pencil): CWAC Wedding/Apeldon/22 Sept 45 (l.r., in dark blue ink): CWAC Wedding at (scratched out) in/ the Seminary's (1st Can./Army Group H.Q.) Chapel./Sept 1945.
Remarks: Beginning of a pencil sketch on the verso, possibly representing two figures.

14. *V - J Celebrations*, 1945
Oil on paper, 44.1 x 60.8 cm
Signed and dated (l.r., in red ink): MOLLY/
LAMB/45
VERSO (u.l., in red ink): VJ Celebrations/
Hyde Park, London/August 1945./Oil on
paper/approx. 23" x 18" . . .
12106

15. *Private Roy, Canadian Women's Army
Corps*, 1946
Oil on masonite, 76.3 x 60.7 cm
Signed and dated (l.r., in magenta): MOLLY
LAMB/BOBAK 46
VERSO (u.l., in black): . . . "PTE. Roy."
C.W.AC"/CANTEEN WORKER. by/Lieut.
M.L. BOBAK. APR. 46./SIZE 24" x 30
12082

Miller BRITTAIN (1912-1968)

16. *Sam Wakes Us Up*, 1945
Conté on paper, Image: 64.8 x 48.4 cm;
Paper: 75.8 x 53.2 cm
Initialled and dated (l.r., in conte): MGB '45
Remarks (inscription VERSO, ?in artist's
hand): . . . Sam Wakes us UP. (4.a.m.)/. . .
(memories 78 sqd.)
10891

17. *Airmen in a Village Pub — Yorkshire*, 1946
Oil and tempera on masonite, 63.6 x 50.9 cm
Initialled and dated (l.r., in dark brown):
MGB/'46
Remarks: VERSO, RCAF label:
TITLE:'AIRMEN IN A VILLAGE PUB/—
YORKSHIRE'/SIZE: 20" x 25"/MEDIUM: OIL
& TEMPERA/F/LT M.G. BRITTAIN
10884

18. *'G' George Didn't Come Back*, 1946
Pencil and conté on paper, Image: 51 x 65 cm;
Paper: 54.1 x 69.5 cm
Initialled and dated (l.r., in conte): MGB '46
Remarks: ?Possible question as to title. On
War Mus. card, copied from cardboard
backing since destroyed: 'B. Baker Didn't
Come Back'/19³/₄ x 25¹/₂ Black Conte/
(Memories of 78 SQDN) (Uncovered when
paper removed). Alternately: G. George
Didn't Come Back/Black Conte (19³/₄ x 25¹/₂)/
(Memories of 78 SQDN).
Previous catalogue gives the title as: 'G'
George Didn't Come Back
10886

Leonard BROOKS (1911-)

19. *Atlantic Convoy*
Water colour, black ink, pencil and charcoal
on paper, 47.6 x 75.8 cm
Signed (l.r., in pink water colour):
LEONARD BROOKS
Inscribed (l.r., in black ink): NORTH
ATLANTIC CONVOY-
VERSO (?in artist's hand): Atlantic Convoy
Remarks: The spiraled Red and white striped
band indicates ship belonged to 5th Escort
Group, "Barber Pole Brigade." [War
Museum card]
10078

20. *Potato Peelers*
Tempera on paper, 32.7 x 38.4 cm
Remarks: VERSO, label: RCNO 234 S/Lieut.
F. L. Brooks./TEMpeRA "POTATO
PEELERS" 15" x 12¹/₄" . . .
10160

A. G. BROOMFIELD (1906-)

21. *Unloading L.S.T. 2, Mike Beach, Juno
Sector, Normandy, June 1944*, 1944
Water colour, coloured chalks and pencil on
paper, laid down on board, 39 x 57.3 cm
Signed (l.r., in black water colour):
AGBroomfieldF/L
Inscribed and dated (l.l., in black water
colour): UNLOADING L.S.T. 2 MIKE
BEACH, JUNO SECTOR, NORMANDY,
JUNE 1944
14374

Paraskeva CLARK (1898-)

22. *Maintenance Jobs in the Hangar*, 1945
Oil on linen, 81.5 x 101.9 cm
Signed and dated (l.r., in black): parasKEva
clarK/45.
14085

23. *Parachute Riggers*, 1946-47
Oil on linen, 101.7 x 81.4 cm
Signed and dated (l.r., in grey-yellow):
parasKEva clark/46-47
Remarks: Chutes are handled by five
airwomen who operate Trenton's Parachute
section. [War Museum card]
14086

Albert CLOUTIER (1902-1965)

24. *Bluenose Squadron Lancaster 'X' for Xotic
Angel*, 1945

Water colour, pencil, black ink and ?gouache
on paper, 25 x 35.4 cm
Signed and dated (l.r., in black ink):
Cloutier/45
Remarks: (copied from back of mat):
"Bluenose Squadron Lancaster "X" for Xotic
Angel"/back from overseas. Dartmouth N.S.
25 July/45/W.C. 10 x 14/52 Lancs were
brought back from the European Theatre
(#Gp) to Dartmouth/to be used as trainers
for the Pacific Theatre crews being formed./
Most aircraft were decorated with X symbol
installed with their call letter,/some of which
displayed great originality of design/F/L A.E.
Cloutier
10905

Alex COLVILLE (1920-)

25. *A German Flare Goes Up*, 1944
Water colour, black ink and pencil on paper,
38.8 x 57.2 cm
Signed and dated (u.l., in black ink): ALEX
COLVILLE/21 Aug. 44
VERSO (u.l., in pencil): RCNO 203/"A
GERMAN FLARE GOES UP"/INK &
WATERCOLOUR/15" x 22"/15 Aug 44/LT.
D.A. COLVILLE
10189

26. *L.C.A.s Off Southern France*, 1944
Oil on linen, 101.4 x 76 cm
Signed and dated (u.l., in grey-blue): ALEX
COLVILLE/1944
Remarks: (label, verso): Lieut. D. A. Colville/
"L.C.A.'s Off Southern/France"
L.C.A. abbreviation for Landing Craft,
Assault
10192

27. *Dead Women, Belsen*, 1945
Pencil on paper, 32.3 x 50.2 cm
Signed (l.l., in pencil): Alex Colville
Dated and inscribed (l.l., in pencil): 29 Apr 45
Belsen
VERSO (u.l., in pencil): LT DA COLVILLE/
"DEAD WOMEN"/(THESE BODIES WERE
LYING/OUTSIDE OF ONE OF THE/HUTS.
AS I MADE THE/DRAWING, THE
NUMBER OF/BODIES INCREASED.)/NO 1
CONCENTRATION CAMP./BELSEN,
GERMANY/29 APR 45/2 BRT ARMY
Remarks: Belsen village, north-west
Germany, after 1945 in Lower Saxony. With
nearby Bergen it was site of large and

infamous concentration camp during Hitler regime. [Columbia Lippincott Gazetteer]
12143

28. *Bodies in a Grave*, 1945
Pencil on paper, 32.5 x 49.6 cm
Signed (l.l., in pencil): Alex Colville
VERSO (u.l., in pencil): LT DA COLVILLE/ "BODIES IN A GRAVE"/NO 1 CONCENTRATION CAMP/BELSEN, GERMANY./1 MAY 45/2BRT ARMY
12123

29. *Casualty Clearing Post*, 1945
Water colour and black ink on paper, Image: 29.5 x 50 cm; Paper: 32.2 x 52.8 cm
Signed (l.r., in black ink): Alex Colville
VERSO (u.l., in black ink): LT DA COLVILLE/"CASUALTY CLEARING POST"/SKETCHED 27 FEB 45 — COMPLETED 27 MAY 45/NEAR UDEM, GERMANY./14 FD. AMB, 3 CDN INF DIV/ 11" x 20" (APPROX)
Remarks: Ambulances of the 14th Canadian Field Ambulance, 3 Canadian Infantry Division take shelter, and prepare to evacuate casualties during the fighting at Udem. Udem, Germany. April 1945 [War Museum Card]
12133

30. *Tragic Landscape*, 1945
Oil on linen, 60.9 x 91.6 cm
Signed and dated (l.r., in light grey): ALEX COLVILLE 45
VERSO (l.r., in Pencil): COLVILLE
 (u.l., in black): CAPT. D.A. COLVILLE/"TRAGIC LANDSCAPE"/near Deventer, Holland/3rd Cdn. Inf. Div./April, 1945
12219

31. *Infantry, near Nijmegen, Holland*, 1946
Oil on linen, 101.6 x 122 cm
Signed and dated (l.l., in brown): ALEX COLVILLE 1946
VERSO (canvas overlap; u.r., in pencil): WHITE LEAD 20 DEC 45
 (u.l., in black): "INFANTRY"/CAPT. D.A. COLVILLE/JANUARY, 1945/NEAR NIJMEGEN, HOLLAND/3 CDN INF DIV . . .

Charles COMFORT (1900-)

32. *Dead German on the Hitler Line*, 1944
Water colour, red chalk, pencil and black ink on paper, 38.8 x 56.8 cm

VERSO (l.r., in pencil): DEAD GERMAN SOLDIER on the HITLER LINE:/This corpse had undoubtedly been lying unburied since the battle of 23 May. I am not given to painting/lugubrious subjects of this kind, but at least one horror/picture is not inept in this situation./
The name of this (left blank) is unknown. His identity/disk bore the symbols, — "2 Kp. ERS, BH 195-479" This I/turned over to the H/Capt McLean, Padre of the 48th Highrs of Canada./He was to turn it in to Graves Regt., who in turn were to/arrainge (sic) for burial.
 (l.r., in pencil): PONTE CORVO: 22 JUN 44
Remarks: Pontecorvo, town in south-central Italy on Liri River. Almost completely destroyed by air and artillery bombing (1943-44) in Second World War [Columbia Lippincott Gazetteer].
12272

33. *The Hitler Line*, 1944
Oil on linen, 101.6 x 121.7 cm
Signed and dated (l.r., in crimson): COMFORT 44
VERSO (centre, sideways in blue ink): "THE HITLER LINE/by/MAJ. C.F. COMFORT
 (above centre, sideways in blue ink): . . . Nov. 1944
VERSO (l. vertical crosspiece; t. in pencil): LEAD GRN (?) 17 Jul 43/" " 22 Aug 44
 (l. vertical crosspiece) t., in black ink): 1 DIV/#163
Remarks (from label, verso): "THE HITLER LINE"/Infantrymen of a Canadian Division clearing a German strongpoint/on the Adolf Hitler line. Remnants of a Canadian Infantry Section/clearing a German Tank Turret pill-box, (PAN ZERTURM) which received/a direct hit from one of our 17 pounder Anti-Tank guns. In the/background may be seen MONTE D'ORO with its characteristic flat top./From an oil painting by Maj. C.F. Comfort. November 1944. Monte d'Oro, in South-Central Italy near Liri River.
12296

34. *Sergeant P.J. Ford*, 1944
Water colour, pencil and ?ink on paper, 38.8 x 57.1 cm
VERSO (l.r., in pencil): PIEDIMONTE D'ALIFE, 15 July 44
 (l.r., in pencil): SGT. P.J. FORD

P.P.C.L.I./Sgt Ford joined the P.P.C.L.I. in June 1936./At the outbreak of war he came overseas with his unit as/a L/Cpl./In March '43 he was attached to 5 Bn Hampshire (46 Div.)/Then fighting in North Africa at CHEMICAL CORNER near BEJA in/ TUNISIA, with the rank of Sgt./In Aug. '43 he was returned to England, and joined his unit/at ORTONA in Jan. 44. Since that date Sgt Ford has served/in the Support Coy. (M.G. grp.) taking part in all actions/in which the P.P.C.L.I. have been engaged./ Sgt. Ford comes from ESQUIMALT B.C.
Remarks: Piedimonte d'Alife, town in Southern Italy, north of Caserta. [Columbia Lippincott Gazeteer]
12282

35. *Campobasso*, ca. 1945
Oil on linen, 127.3 x 152.9 cm
VERSO (u.l., in black): "CAMPOBASSO"/ MAJOR C.F. COMFORT/. . .
 (stretcher; l. centre, in pencil): 1st Grd., LEAD — 18 NOV. 45/2nd Grd. LEAD —29 NOV. 45
Remarks: The troops in the foreground belong to the 4th Princess Louise Dragoon Guards (4th Recce Regt), the reconaissance unit of the 1st Canadian Division [statement by artist, 28 July 1972; War Museum card] Campobasso, town, south central Italy. In Second World War damaged (1943) by air bombing and fighting. [Columbia Lippincott Gazetteer]
12244

36. *Dieppe Raid*, 1946
Oil on canvas, 91.4 x 152.4 cm
Signed and dated: Charles Comfort '46
VERSO (in black ink): "DIEPPE RAID"/ Major C.F. Comfort . . .
 (stretcher; l.r.): 1st GRD LEAD 25 Jan 46/2nd GRD LEAD 18 Feb 46
Remarks (label, verso): "DIEPPE RAID"/ Painted by Major C.F. Comfort/This canvas is an effort to reconstruct the scene on "RED and WHITE" beach fronting the town of DIEPPE when the great reconaissance in force was undertaken at dawn 19 August 1942.

Troops of the Royal Hamilton Light Infantry are attacking across the shingle of "RED" beach towards the Casino shown at the right. The time is 0540 hours, or fifteen minutes after the first flight of tanks touched

down (Para. 208, C.O.R.). The tobacco factory burns in the town, while overhead Bostons lay smoke over feature "Bismarck," and the town (Para. 186, C.O.R.). Great care has been taken to represent the topography of the scene with reasonable accuracy. The width, gradient and character of the beach, the Casino now demolished, Fisherman's Church, the piers and the seawall are all properly related to each other.

Material consulted to implement [sic] this reconstruction included the following:-/ D.H.S. Rpts. Nos. 83, and 130. Combined Operation Apt. on Opn. "JUBILLEE" [sic]. The official German Report on the operation. The official German Film. Official photographs, and maps, etc., etc. [War Museum card]
12276

37. *Canadian 5.5-inch Guns*
Water colour, pencil and black ink on paper, laid down on board, 36.5 x 53.7 cm
VERSO (? in artist's hand): Charles F. Comfort/Canadian 5.5 inch guns . . .
12247

Maurice CULLEN (1866-1934)
38. *The Sunken Road, Hangard*, 1918
Oil on linen, 86.3 x 111.9 cm
Signed and dated (l.r., in rust brown): M Cullen/18
VERSO (?in artist's hand): Bailluel (Artois)
Remarks: The road from Hangard is up the hill in the direction of the Hangard Woods, which formed a support to the German first line trenches on the Somme. This section was literally battered to pieces by the Canadian artillery and finally captured by our troops on 8th August 1918. [War Museum card]
Hangard Wood just outside Hangard near Luce River, Artois being the area (battle of Amiens, 8-18 August 1918. Bailluel, town, northern France, near Belgian border. Destroyed (1918) in First World War, it was rebuilt in National Flemish style and damaged once more in Second World War. [Columbia Lippincott Gazetteer]
8141

39. *No Man's Land*, 1919
Oil on linen, 183.2 x 244.8 cm
Signed and dated (l.r., in dark grey): M Cullen/19

VERSO (label; u. centre, in ink): "No Man's Land" (?artist's hand)
Remarks (label; verso): "On 30th June 1964 General A.G.L. MacNaughton saw this picture and expressed an opinion that the landscape depicted by Captain Cullen was probably that scene looking East towards Mouchy-le-Preux between Arras and Cambraie (sic)." [War Museum card]
8149

Gerard DE WITT (1884-)
40. *Canadian Troops Entering Cambrai*
Etching and aquatint with surface tone, Imp: 33.8 x 45.3 cm;
Paper: 51.3 x 65.1 cm
Signed (l.r., in pencil): Gerard de Witt
Remarks: In this Plate the artist depicts the entry of the/Canadians to the city of Cambrai a few hours after its/fall. The setting sun of an October evening in 1918,/and the dense clouds of smoke rising from the ruined/ portion of the two together produce a dramatic scenic/effect never to be forgotten by those present on the/memorable occasion. The name "Cambrai" will live ever/in the heart of every Canadian — the pivot of the great/advance to Victory! [War Museum card]
8936

Orville N. FISHER (1911-)
41. *Recruits Wanted*, 1941
Water colour and pencil on board, Image: 27.9 x 35.8 cm; Board: 36.3 x 51.1 cm
Signed and dated (l.r., in maroon water colour): ORVILLE N. FISHER — 1941
Remarks (Label, VERSO): RECRUITS WANTED/Sentry at District Depot,/ Lansdowne Park, Ottawa. Autumn,/1941.
12584

Charles GOLDHAMER (1903-)
42. *Burnt Airman with Wig*, 1945
Water colour over charcoal on paper, Image: 33.8 x 27.3 cm; Paper: 50.1 x 39.3 cm
Signed (l.l., in grey ink): CHARLES GOLDHAMER
VERSO (u.r., in grey ink): "BURNT AIRMAN WITH WIG"/R.C.A.F. HOSPITAL — EAST GRINSTEAD./WATER COLOUR — 15¹/₂x20/AUG. 5 1945
SGT. JAMES F. GOURLEY — R.AF —

536215/CHARLES GOLDHAMER F/L
Remarks: East Grinstead, residential urban district, North Sussex, England.
11237

Paul GORANSON (1911-)
43. *Oh Reveille*, 1942
Pencil on paper, laid down on board, 35.5 x 51 cm
Signed and dated (l.r., in pencil): Sgt. P.A. Goranson '42
Remarks (label, VERSO): OH. REVEILLE!/ Barrack clean up at 6:30 A.M. in the Sergeants' Mess/No. 1 Manning Depot, Toronto, Jan/42./(pencil drawing 20" x 13¹/₄")/Sgt. P. A. Goranson
Top edge of paper perforated; probably torn from a sketchbook.
11423

44. *Bombs Away*, ca. 1943
Oil on canvas, 101.8 x 76.3 cm
VERSO (u.r., in red pencil): "BOMB'S AWAY!"
(u.r., in black): F/L P. GORANSON
Remarks (label, verso): "BOMBS AWAY" F/L P. GORANSON/A bomb-aimer of the R.C.A.F.'s Desert Air Force (331 Wing) releases his bombs over the target, as seen by the artist/on an operational trip over Pisa, Italy — September, 1943. This Wellington Bomber Wing was then stationed at/ Kairouan-Zina, Tunisia. . . .
11327

45. *Dorsal Gunner*, 1943
Pencil, water colour and black ink on paper, laid down on board, 49 x 37.5 cm
Inscribed and dated (l.l., in pencil): Dorsal Gunnar [sic] in a Wellington-/Middleton St. George — May '43.
VERSO (Re-copied inscription): "DORSAL GUNNER"/-Wellington Bomber/R.C.A.F. Station, Middleton/St. George-May/43/F/L P.A. Goranson (unsigned)
11356

46. *S/L "Hal" Gooding, D.F.C., A.A.M.*, 1945
Water colour and pencil on grey paper, laid down on board, 53.4 x 34.1 cm
Signed and dated (l.r., in light brown): P. GORANSON '45
Remarks (label, VERSO): . . . SQUADRON LEADER "HAL" GOODING, D.F.C., A.A.M. of Ottawa, Ont./Commanding

Officer of 440 Squadron, R.C.A.F. succeeding S/Ldr. A.E. Monson, D.F.C./ Served with 111 Squadron, Western Air Command in/Aleutions [sic] — June 42 to Aug. 43./Overseas in 44 with 111 Squadron, converting to/440 Squadron, R.C.A.F./ Eindhoven, Holland, — Jan./45./ (Watercolour)/13^1/$_2$ x 21.
11373

47. *Marshalling of the "Hallies"*, 1947
Oil on canvas, 76.1 x 101.4 cm
Signed and dated (l.r., in grey-blue): P. GORANSON 47
VERSO (u.l., in black): "MARSHALLING OF THE HALLIES"
(u. centre, in black): HALIFAXES OF THE FAMOUS 419 "MOOSE" SQUADRON MARSHALL AT DUSK AGAINST WUPPERTAL GERMANY,/MAY, 1943, FROM THEIR BASE AT MIDDLETON ST. GEORGE, DURHAM, ENGLAND./OIL — 30" x 40" . . .
(u.r., in black): F/L P.A. GORANSON
Remarks (Label, VERSO): . . . Pictured are MK2 Halifaxes, which carried no front gunner nor mid-upper gunner. In left foreground a ground crew is seen/operating a battery cart. Air crew, right foreground, arrive after the marshalling and hurry to their "kites." "VR" on the fuselage/identifies the squadron./Oil painting — 30" x 40" Completed July, 1947
11402

Lawren P. HARRIS (1910-)

48. *Battleground before Ortona*, 1944
Oil on linen, 101.5 x 121.7 cm
Signed and dated (l.l., in black): L.P. HARRIS — 1944.
VERSO (u. canvas overlap, in black): . . . HARRIS "BATTLE GROUND BEFORE ORTONA."
Remarks (label, VERSO): . . . From the SAN LEONARDO — VILLA GRANDE ROAD. Knocked out PZ./KW4s and 7.5 PAK Anti-Tank Gun. Smoke Trails from rocket/ propelled H.E. projectiles (15 cm NEBELWERFER) over ORTONA./Smoke from burning petrol lorry. From a painting by/Capt. L.P. Harris. November, 1944.
12657

49. *Tank Advance*, 1944
Oil on linen, 75.8 x 101.2 cm
Signed and dated (l.r., in ochre): L.P.HARRIS — 1944.
Remarks (label, verso): . . . "TANK ADVANCE"/Tanks of the 3rd Cdn Regt (GGHG) moving/into action . . . in the MELFA RIVER area/Ruins of Abbe di MONTECASSINO on MONASTERY HILL in background. Oil painting by Capt. L.P. Harris.
Location is probably in 5 Cdn Armd Div assembly area near/Forme d'Aquino 6-7 miles East of Melfa before moving up/to pass through the breach in the Adolph Hitler Line. [War Museum card]
Monte Cassino, most famous monastery of Italy, Latium, on a hill, overlooking the town of Cassino. Abbey buildings were destroyed, after their seventeenth-century restoration, by a concentrated Allied air bombing in 1944. The German garrison, which had used the abbey as a fortress, withstood the bombing in previously dug caves, but the buildings were demolished and most of their art treasures destroyed. [Columbia Lippincott Gazetteer]
12722

50. *Tank Convoy*, 1944
Water colour with ?black ink on paper, 24.7 x 26.3
Signed, dated and inscribed (l.l., in black): HARRIS-44-ITALY.
VERSO (l. centre, in black): (HARRIS).#37./ "TANK CONVOY." SHERMAN TANKS of 2 CDN. ARMD. REGT. (Ld·S.H) iN CONVOY ON ROAD TO/BOVINO-DELICETO R.R. STATION TO ENTRAIN foR CASERTA./ TOWN of BOVINO CENTRE BACKGROUND. NAPLES-BENEVENTO-FOGGIA/ELECTRIC R.R., POWER LINE, AND HIGHWAY./20 APR 44./ITALY.
12723

51. *Tank Transporter Unit*, 1944
Water colour with ?black ink on paper, 25.3 x 33.8 cm
Signed, dated and inscribed (l.r., in dark brown): HARRIS-44-ITALY.
12725

E.J. HUGHES (1913-)

52. *Signalman and RCD Armoured Car in Harbour*, 1943

Gouache and pencil on illustration board, Image: 57.2 x 42.9 cm; Board: 59.6 x 46.8 cm
Signed and dated (l.r., in dark brown): E. J. Hughes 1943.
VERSO (u.l., in blue ink): Signalman (sic) and R.C.D. Armoured Car/in Harbour./near Pulborough
(u. centre, in blue ink): June/43
(u.r., in blue ink): 1st Armoured Car R (R.C.D.)
Remarks: Pulborough, town west Sussex, England.
13005

53. *Canteen Queue, Kiska*, 1944
Oil on linen, 102.1 x 122.2 cm
Signed and dated (l.l., in red-brown): E. J. HUGHES 1944
VERSO (canvas overlap; u. centre, in black): . . . "CANTEEN QUEUE" KISKA CAPT. E.J. HUGHES
(centre, in black): . . . "CANTEEN QUEUE/HUGHES/November 1943
Remarks: Kiska Island, of Aleutian Islands, south-west Alaska. In Second World War it was occupied (1942) by Japanese and garrisoned by ca 10,000 troops. Heavily bombed, and cut off by recapture (1943) of Attu, the island was evacuated August 1943, by Japanese, just prior to U.S.-Canadian landing. [Columbia Lippincott Gazetteer]
12794

54. *Parade Ground on Kiska*, 1944
Carbon pencil and pencil on paper, Image: 54 x 71 cm; Paper: 56.5 x 73.5 cm
Signed and dated (l.r., in black): E. J. HUGHES 1944
VERSO (u.l., in blue ink): . . . "Paradeground on Kiska"
(u.l., in blue ink): Win. Gren.
(u.r., in blue ink): (carbon pencil) done at Ottawa April/44
(u. in blue ink): (Troops of Winnipeg Grenadiers drilling on bulldozed parade square — Maple hill in background — troops in middle distance returning to camp from fatigues on the beach)
Embossed mark, l.l.: STRATHMORE/USE EITHER SIDE (encircling thistle)
Remarks: Beginning of sketch VERSO in black and sanguine conté; ?trees and buildings indicated.
12956

55. *Ten Minutes Rest — Kiska*, 1945
Oil on linen, 101.5 x 121.7 cm
Signed and dated (l.r., in red): E.J. HUGHES
SEPT. 1945
VERSO (u.r., canvas overlap, in black): "TEN
MINUTES REST" DURING A ROUTE
MARCH. WINNIPEG GRENADIERS.
WINTER 1943-44.
 (u., in dark blue): . . . "(~~THE RACE
ROAD.~~" (scratched out) KISKA CAPT. E.J.
HUGHES
13053

Jack HUMPHREY (1901-1967)
56. *A Canadian Sailor*
Oil on masonite, 76.1 x 61 cm
Signed (l.r., in light grey): Jack Humphrey
VERSO (backing board; u.l., in pencil): Jack
Humphrey/Port of Sailor
 (backing board; u. centre, in pencil):
PORTRAIT OF A SAILOR"/BY JACK
HUMPHRY (sic)
 (backing board; l. centre, in Pencil):
sailor boy
Remarks: Preparatory sketch of recto in oil on
verso.
4568

A. Y. JACKSON (1882-1973)
57. *Houses of Ypres*, 1917
Oil on linen, 63.4 x 76.1 cm
Signed and dated (l.r., in blue oil): A Y
JACKSON/17
VERSO (?in artist's hand): HOUSES IN
YPRES
Remarks: An oil on panel sketch of the same
subject was sold by a niece of Mr. Jackson
privately c. 1963 . . . Given by Mr. Jackson to
his niece (or friend of niece?) in 1919. [War
Museum card]
Ypres, town western Belgium. Site of 3 major
battles (1914, 1915, 1917) in First World War,
when town was almost entirely destroyed;
since rebuilt. [Columbia Lippincott
Gazetteer]
8207

58. *Screened Road to "A"*, 1918
Oil over pencil on linen, 86.3 x 111.5 cm
Signed and dated (l.r., in mauve): A.Y.
JACKSON/MAR '18
VERSO (u.l., in pencil): Capt Godenroll(?)/
Ottawa Ont

(u., in green crayon): Screened Road
to ("A")
 (u.r., in sanguine chalk):
UNFINISHED
8188

C. W. JEFFERYS (1860-1952)
59. *85th Battery at Firing Practice*, 1918
Pencil with black and white water colour on
paper, laid down on board, 24.5 x 45.4 cm
Signed, inscribed and dated (l.l., in dark
grey): C. W. JEFFERYS/PETAWAWA./SEPT.
'18
Inscribed on mount (l.l., in pencil): Training
Artillery men for the Siberian Expeditionary
Force. 85th Battery/Gun Crews practising
Indirect Firing. Field Telephone in
foreground receiving directions from
Observation Post in advance of Battery/. . .
Embossed mark l.l. on mount:
STRATHMORE (?) BOARD (encircling
thistle)
Remarks: Petawawa, village south-east
Ontario, on Ottawa River. Site of Military
Camp. [Columbia Lippincott Gazetteer]
8251

Franz JOHNSTON (1888-1949)
60. *Beamsville*, 1918
Oil over charcoal on linen, 183.4 x 137.5 cm
Signed (l.l., in blue): Frank.H.Johnston 1918
VERSO (l.l., in pencil): Winsor/OKN
Remarks: It appears that the painting is either
unfinished or a pentimento exists, for the
airplane above centre towards the right is
only vaguely indicated with charcoal.
Beamsville village, southern Ontario, near
Lake Ontario, west of St. Catharines
[Columbia Lippincott Gazetteer]
8258

61. *Looking up into the Blue*, 1918
Gouache and pencil on board, 57.5 x 72.1 cm
Signed and dated (l.r., in pencil): FRANK H
JOHNSTON AUG' 18
8267

Arthur LISMER (1885-1969)
62. *"Olympic" with Returned Soldiers*, ?1919
Oil on jute, 123.1 x 163.1 cm
Signed and dated (l.r., in green): A.
LISMER/19[?]
Remarks: A closely similar oil sketch in the

War Museum collection (acc. no. 7749)
although inscribed on the verso in the artist's
hand as: 'Aquitania' with/returned soldiers/
Halifax. N.S. Feb 1919./Arthur Lismer; is yet
described on the recto by a brass plaque as a
study for the 'Olympic' with Returned
Soldiers. Major Wodehouse, however,
catalogued the panel as "The Olympic with
Returned Soldiers," Hence, the date is
tentatively given as 1919, the recto
inscription being undecipherable.
8363

63. *Departure of a Troopship*
Lithograph, Imp: 41.2 x 32.8 cm; Paper: 63.6
x 48.8 cm
Signed (l.r., in pencil): A. Lismer.
Watermark (towards r. edge at u.r., r. centre.
l.r.; cut off at l. edge at u.l., l. centre, l.l.):
DRESDEN/PAMPHLET
8377

Frances LORING (1887-1968)
64. *The Rod Turner*
Cast bronze, ht: 66.8 cm.
Signed on base (r.side at r.): LoRing
8500

T. R. MACDONALD (1908-)
65. *You'll Get Used to It*
Oil on linen, 60.9 x 30.3 cm
Signed (l.l., in red): TRMACDONALD
13213

Pegi Nicol MACLEOD (1904-1949)
66. *C. W. A. C. Beauty Parlour #1*, 1944
Water colour, charcoal and coloured pencil
on paper, 63.3 x 48.6 cm.
Inscribed, dated and signed (l.r., in green
pencil): CWAK (sic) BEAUTY/PARLOUR/
AUGUST 1944/PEGI NICOL MACLEOD.
14158

67. *C. W. A. C. Officer*, 1944
Water colour and crayon on paper, Image:
75.9 x 55.9 cm;
Paper: 76.4 x 55.9 cm
Inscribed (u.r., in pencil): S.K. Johnston Lt.
Inscribed (l.r., in pink pencil): C.W.A.C.
OFFICER/GLEBE BARRACKS
Signed and dated (l.l., in pink pencil): PEGI
NICOL MACLEOD/AUGUST 1944
14164

68. *Untitled (WRCNs in Dining Room)*
Oil on panel, 73.2 x 65.4 cm
Signed (1.1., in green): PEgi Nicol/
MACLEOL (sic)
Remarks: WRCN abbreviation for Women's
Royal Canadian Navy
14231

H. Mabel MAY (1884-1971)
69. *Women Making Shells*
Oil on canvas, 182.3 x 214.5 cm
8409

David MILNE (1882-1953)
70. *Concert at the "Y," Concentration Camp,
Kinmel*, 1918
Water colour and pencil on paper, laid down
on board, 29.1 x 43 cm
Signed, inscribed and dated (1.1., in black
with pencil): David. B.Milne/Kinmel Park
Camp/Dec.21 18
VERSO (label, in pencil): Kinmel Park Camp
(scratched out)/Demobilization (scratched
out) Centre/Concentration Camp./The
concert at the "Y"/Last night in Blighty-/the
men start for Canada/at four in the morning.
Remarks: (as last 3 lines) . . . to entrain for the
shipping port. [War Museum Card]
8513

71. *Bramshott, Interior of the Wesleyan Hut*,
1919
Water colour and pencil on paper, 35.3 x 50.5
cm
Signed, inscribed and dated (u.r., in black):
DAVID B. MILNE/BRAMSHOTT/APRIL 4-19
VERSO (label, in black ink): 12 Bramshott-/
Interior of the Wesleyan/Hut.
Remarks: Bramshott, town in eastern
Hampshire, England.
8541

72. *Courcelette from the Cemetery*, 1919
Water colour and pencil on paper, 35.4 x 50.7
cm
Signed (1.1., in black): DAVID B MILNE
Dated (1.r., in black): JULY 26 19
Inscribed (1. centre, in black):
COURCELETTE
VERSO (u.1., in purple): COURCELETTE
FROM THE CEMETARY (sic)
Remarks: Once a village in Picardy, destroyed
during Battle of the Somme.
8478

73. *Neuville-Saint-Vaast from the Poppy Fields*,
1919
Water colour and pencil on paper, 35.4 x 50.9
cm
Signed, inscribed and dated (u.1., in black):
DAVID B. MILNE/NEUVILLE ST VAAST/
JULY 5 19
VERSO (u.1., in purple): NEUVILLE ST
VAAST/FROM THE POPPY FIELDS
Remarks: Pencil sketch of recto (?) on verso.
Neuville-Saint-Vaast, Village in north France
near Arras. Completely rebuilt after First
World War [Columbia Lippincott Gazetteer]
Nearby are large British, French and German
military cemeteries and allied memories of
battle of Arras (1917). 8453

H. J. MOWAT (act. World War I-1949)
74. *Counter Attack*
Conté and grey and brown wash with
highlights of white on board,
Image: 29.1 x 45.8 cm; Board: 34.1 x 49.4 cm
Signed (1.1., in conté): MOWAT.
Inscribed (1.r., in pencil): 11½ x 18
Remarks: On the verso is an unfinished
vertical sketch in conté showing a group of
soldiers passing through trees.
(Label, verso): Vol. II/Chap. IX-Page 204/
Counter-attack/The ground in front of them
had/absolutely no cover./No. 330 [Canada in
Flanders]
Mowat joined Salmagundi Club, New York
in 1909.
8564

75. *A Night Raid*
Conté and grey wash with highlights of
white on board, Image: 45.8 x 31 cm; Board:
50.6 x 38.1 cm
Signed (1.1., in white): MOWAT.
Remarks: (label, verso): Vol. III, Chap. IX—
Regina/Leaving the trenches, the party/
moved cautiously forward./No. 325. [Canada
in Flanders]
8564

76. *Stretcher Bearers*
Conté and black wash with highlights of
white on board, Image: 49.2 x 35.1 cm; Board:
50.7 x 38 cm
Signed (1.r., in white): MOWAT.
Remarks: The work of the stretcher-bearers in
this section was especially commendable.

[Canada in Flanders, vol. III] [War Museum
card]
8567

77. *Trench Fight*
Conté and grey wash with highlights of
white on board, Image: 45.9 x 31 cm; Board:
50.8 x 38 cm
Signed (1.1., in white): MOWAT.
Remarks (label, verso): Vol. III, Chap. IV/His
followers fling themselves/forward in a fury
and not one/German in that sector of the/
trench escaped the steel./No. 328 [Canada in
Flanders]
8562

Rowley W. MURPHY (1891-1975)
78. *"Prince Ship" Under Air Attack*, 1943
Oil on linen, 102.4 x 121.7 cm
Signed (1.r., in dark blue): ROWLEY
MURPHY
VERSO (stretcher; u.1., in blue): NO-1-
AUG- 1943
 (stretcher; u. centre, in blue): NO-1-/
AUG./1943/RWM
 (stretcher; u. centre, in pencil):
Princ[e] [cut off]
Remarks (label, u.r.): Lieut. R. Murphy,
R.C.N.V.R./"PRINCE SHIP UNDER AIR
ATTACK"/Oil Painting, 40" x 48"
10495

Arthur NANTEL (1874-1948)
79. *7 A.M., April 22nd, 1915*
Water colour with some ?gouache over pencil
on paper, 24.6 x 32.4 cm
Signed (1.r., in vermillion): A.NANTEL
Inscribed and dated (1.1., in vermillion):
YPRES 22 AVRIL .15
Remarks (label, verso): . . . "7 a.m. Apr. 22nd,
1915"/The gas has been launched. The
French/are in full retreat; the Germans are/
advancing behind the black cloud,/using
flares to light their way. Ger./aeroplanes are
dropping coloured/lights to direct their
artillery fire./(St. Jean on the right)
8629

80. *Christmas Eve in Giessen Camp*
Water colour and pencil on paper, laid down
on board, 25 x 25.4 cm
Remarks (label, VERSO): . . . "CHRISTMAS
EVE IN GIEESEN (sic) CAMP"/The evening
jollification which began with fairly orthodos

(sic) dancing, gradually/became a wild farandola in and out/around the chimneys of the hut.
GIESSEN — near Frankfurt. Apparently may be spelled both ways [Encyclopedia Britannica]
8621

Lillias Torrance NEWTON (1896-)
81. *Portrait of Private Alexander*
Oil and pencil on panel, 26.7 x 21.7 cm

Jack NICHOLS (1921-)
82. *Atlantic Crossing*, 1944
Pencil and water colour on paper, 73.7 x 58.9 cm
Signed and dated (1.1., in pencil): JNichols/JULY 1944
Embrossed mark 1.r.: — "OWL" BRISTOL BOARD — (encircling image of an owl)
10502
83. *Joining Ship* (formerly 'Shore Leave')
Pencil and water colour on paper, 73.7 x 58.9 cm
Embossed mark, 1.1.: — "OWL" BRISTOL BOARD — (encircling image of an owl)
Remarks: (From Naval Historian) "Joining Ship" — When a sailor moves he takes all his gear with him, including his hammock. In this informal study of a sailor climbing the brow, or gangway, of his new ship the artist has caught the look of speculative alertness as the young man "Sizes Up" his new home. [War Museum card]
10533

Will OGILVIE (1901-)
84. *Parade*, 1941
Pencil and gouache on paper, 28.1 x 37.6 cm
Inscribed (1.1., in pencil): Note made at FARNBOROUGH Oct/41
 (u.1., in pencil): 75 (circled)
VERSO (u.1., in pencil): Farnborough Oct 41
Remarks (label, VERSO): Canadian Base Units/FARNBOROUGH, HANTS
Farnborough, urban district north-east Hampshire, England.
13497
85. *Landing in Sicily*
Oil on linen, 96.3 x 121.8 cm
Signed (1.r., in brown): Will Ogilvie'/
VERSO (u. centre, in black): LANDING IN

SICILY — PACHINO PENINSULA — 1 Cdn DIV./"D" DAY 10 JULY 1943/MAJ. W.A. OGILVIE
 (stretcher; u. centre, in black ink): PACHINO PENINSULA SICILY 10 JULY 43 THREE RIVERS REGT.
 (stretcher; u.1., in black ink): OGILVIE
 (down r. side, in pencil): UNFINISHED — HOLD FOR CAPT OGILVIE
 (canvas overlap; r. centre, in dark ink): OGILVIE
Remarks: Pachino, town in south-east Sicily.
13420

George PEPPER (1903-1962)
86. *Mass in the Fleury Caves*, 1944
Water colour and pencil on paper, 25.4 x 35.5 cm
Signed and dated (1.1., in black ink): G. Pepper 44
VERSO (centre, in blue ink): Mass in the Fleury Caves/Near CAEN, FRANCE./G. Pepper/Sunday, 30 July 44.
13729
87. *Royal Highlanders of Canada Embarking in Storm Boats*, 1944
Water colour on beige paper, Image: 26.8 x 33.3 cm; Paper: 29.2 x 35.6 cm
VERSO (above centre, in black ink): BLACK WATCH EMBARKING IN STORM BOATS./NIGHT CROSSING OF RIVER TRENT/EXERCISE KATE/NEAP HOUSE, LINCS./MAY 44 G. PEPPER
Remarks: Indications of later inscriptions prescribing "mat to here," do not follow image lines designated by artist.
River Trent flows through Lincolnshire, England.
13769

G. A. REID (1860-1947)
88. *Forging 4-inch Shells*, 1918
Pastel and charcoal on green paper, laid down on brown paper, 30.2 x 35.2 cm
Signed and dated (1.r., in pencil): G. A. Reid. 1918 —
Remarks (inscription on brown paper mount, 1.r., in pencil): 9. Forging 4' Shells — Canadian Allis/Chalmers Company, Toronto . . .
8700

J. Ernest SAMPSON (1887-1946)
89. *Armistice Day, Toronto*, ca. 1918
Oil on linen, 152.8 x 91.7 cm
Signed (1.1., in black): SAMPSON
VERSO (label; u.1., in black ink): "November 11th 1918"/Price $500/JErnest Sampson/246 Confederation Life Blg./Toronto
Remarks: . . . ARMISTICE DAY, TORONTO, 1918. 60 x 30./With great rejoicing and thankfulness the Dominion/celebrated with their Allies throughout the world the announcement of the signing of the Armistice on the 11th. November/1918 brining to a close the European conflict. The Treaty/of Peace with Germany was signed at Versailles on the 28th,/June, 1919. It is officially recorded that 628,462 bore/the badge of Canada, and that 60,660 met death and passed on. [War Museum card]
8795

Carl SCHAEFER (1903-)
90. *Pranged Halifax, "Q" Queenie of the Ruhr*, 1944
Water colour and some black ink over charcoal on paper, laid down on board, 69.6 x 105.2 cm
Signed (1.r., in black): C. Schaefer/
VERSO (board; u.r., in pencil): RCAFSTATION MIDDLETON ST. GEORGE/CO. DURHAM #6 BOMBER GROUP/MARCH 23, 1944/WORKED UP #1. K.T.S. RCAF, TORONTO./FEBRUARY 1946.
 (board; u. centre, in pencil): WATERCOLOUR 27-³/₈ x 41-³/₈"
 (board; u.1., in pencil): "PRANGED HALIFAX. Q. QUEENIE, BATTLE OF THE RUHR, 1944"/HALIFAX MKII AIRCRAFT 419 SQUADRON MADE BELLY LANDING/ON RETURN TO BASE FROM RAID ON GERMANY AFTER/37 TRIPS.
Remarks: K.T.S. abbreviation for Composite Training School Ruhr, region west Germany. Devastated by Allied air attacks in Second World War.
11864

Jack SHADBOLT (1909-)
91. *Guards on the Water Tower*, 1944
Water colour, gouache, pencil and conté on paper, 77.5 x 55.6 cm
Signed and dated (1.1., in pencil): J. L. Shadbolt '44

VERSO (1.1., in black ink): Guards on The Water Tower./POW. Camp, Petawawa, Ont./Lieut. J. L. Shadbolt
14261

Thurston TOPHAM (1888-1966)

92. *Guns, Dust and Moonlight*, 1918
Water colour on board, 26.6 x 21.3 cm
Dated and monogrammed (1.r., in blue): 19⊤18
VERSO (u.1., in pencil): Dust, moonlight & guns
 (u., in pencil): this scene is on the Albert-Bray road, near Mèaulte
 (1.r., in pencil): Thurston Topham/of the Arts Club/51 Victoria St/Montreal (?different handwriting)
Remarks: France; road between Albert and Bray-sur-Somme
8855

93. *9.2-inch Howitzers, A Night Shoot*
Water colour and pencil on paper, 8.5 x 13 cm
Signed (l.r. water colour making the inscription visible): T.Topham
VERSO (u.r., in pencil): 'nine point two' howitzer/a night shoot
8884

94. *Moonrise over Mametz Wood*
Water colour and pencil on brown paper, 13.3 x 18.3 cm
Inscribed and signed (1.r., in white): MAMETZ/T. Topham
VERSO (u., in white): MOONRISE OVER MAMETZ WOOD
 (centre, in white): GUNNER Topham/WARD XI/MOORE BARRACKS?
 (paper attached to verso, in black ink): Moonrise over Mametz Wood/-sketch from the corner/of Fricourt Wood.
Remarks: France; possibly in connection with Allied offensive 1916. Battles of the Somme, 1916, and Albert, 1916 (Capture of Montauban, Mametz, Fricourt, Contalmaison and LaBrisselle) . . . 1-13 July
8893

F. H. VARLEY (1881-1969)

95. *Canadian Soldier*
Oil on linen, 101.9 x 81.6 cm

Signed (1.r., in dark brown): VARLEY/ (thumbprint)
14289

96. *For What?*
Oil on linen, 147.2 x 182.8 cm
Signed (1.r., in brown): F.H.VARLEY
VERSO (stretcher; u. centre, in blue): No 138 "For What"?/Capt Varley
Remarks: : The scenery in the background was tentatively ientified by General A.G.L. MacNaughton as being the Somme. (Summer 1964). [War Museum card].
8911

97. *German Prisoners*
Oil on linen, 127.5 x 183.7 cm
Signed (1.r., in sepia): F.H.VARLEY
VERSO (horizontal crosspiece; r., in pencil): last Phase
Remarks: Paint strokes on the verso, ?possibly for a sketch.
8961

98. *The Sunken Road*
Oil on linen, 132.4 x 162.8 cm
Signed (1.r., in crimson and beige): F.H.VARLEY
VERSO (u.1., in brown ink): SUNKEN. ROAD. . . .
Remarks: Paint strokes on verso, possibly ?beginnings of a sketch.
8912

Tom WOOD (1913-)

99. *Gun's Crew*, 1945
Oil on linen, 76.2 x 101.7 cm
Signed and dated (1.1., in yellow): TOM WOOD 1945
VERSO (stretcher; u. centre, in pencil): "GUN'S CREW" TOM WOOD Lt. (SB) RCNVR
10572

Florence WYLE (1881-1968)

100. *Munitions Worker*
Cast bronze, ht: 66.3 cm (incl. base)
Signed on base (r. side, centre): Wyle
Stamped on base (verso, 1.r.): GORHAM (?) CO. FOUNDERS/OBEE
8521

Exhibition Schedule

November 4 to December 4, 1977.
Rodman Hall Arts Centre,
St. Catharines, Ontario.

December 9 to December 31, 1977.
The Robert McLaughlin Gallery,
Oshawa, Ontario.

February 3 to March 1, 1978.
Sarnia Public Library and Art Gallery,
Sarnia, Ontario.

March 22 to May 7, 1978.
McCord Museum,
Montreal, Quebec.

June 2 to June 25, 1978.
Mount St. Vincent University Art Gallery,
Halifax, Nova Scotia.

August 16 to September 4, 1978.
Canadian National Exhibition,
Toronto, Ontario.

October 2 to October 22, 1978.
Confederation Art Centre,
Charlottetown, Prince Edward Island.

November 4 to December 4, 1978.
The Gallery/Stratford,
Stratford, Ontario.

January 10 to February 11, 1979.
Burnaby Art Gallery,
Burnaby, British Columbia.

March 3 to April 2, 1979.
The Norman Mackenzie Art Gallery,
Regina, Saskatchewan.

May 16 to June 23, 1979.
Glenbow—Alberta Institute,
Calgary, Alberta.

July 5 to August 19, 1979.
Winnipeg Art Gallery,
Winnipeg, Manitoba.

September 12 to October 31, 1979.
Agnes Etherington Art Centre,
Kingston, Ontario.

December 1, 1979 to February 29, 1980.
Canadian War Museum,
Ottawa, Ontario.

Credits

Design/ Don Fernley
Photography/ Michael Neill and The National Gallery, Ottawa
Colour Separations and Jacket Printing/ Herzig Somerville Limited
Printing/ Ashton-Potter Limited
Paper/ Imperial Offset Enamel
Binding/ The Hunter Rose Company
Translations from French/ David Toby Homel

Printed and bound in Canada